In this interdisciplinary study, Beth S. Wright examines the profound impact that contemporary debates on history, the central focus of French intellectual and political activity in the first decades of the nineteenth century, had on painting. Analyzing the narrative strategies of historians such as Barante, Marchangy, Chateaubriand, and Thierry, Wright then demonstrates how artists created visual analogues to these various historical constructions. Works by Ingres, Géricault, and Delacroix, as well as rarely seen works by the Troubadour school and contemporary book illustrations, are used to shed new light on Romantic historical painting and its immediate cultural context.

PAINTING AND HISTORY DURING THE FRENCH RESTORATION

PAINTING AND HISTORY DURING THE FRENCH RESTORATION

ABANDONED BY THE PAST

BETH S. WRIGHT

University of Texas at Arlington

CAMBRIDGE
UNIVERSITY PRESS

PUBLISHED BY THE PRESS SYNDICATE OF THE UNIVERSITY OF CAMBRIDGE
The Pitt Building, Trumpington Street, Cambridge CB2 1RP, United Kingdom

CAMBRIDGE UNIVERSITY PRESS
The Edinburgh Building, Cambridge CB2 1RU, United Kingdom
40 West 20th Street, New York, NY 10011–4211, USA
10 Stamford Road, Oakleigh, Melbourne 3166, Australia

First published 1997

Printed in the United States of America

Typeset in Sabon

Library of Congress Cataloging-in-Publication Data

Wright, Beth Segal.
Painting and history during the French Restoration : abandoned by
the past / Beth S. Wright.
p. cm.
Includes bibliographical references and index.
ISBN 0–521–57203–7 (hardcover)
1. Narrative painting, French. 2. Narrative painting – 19th
century – France. 3. History in art. 4. Romanticism in art – France.
I. Title.
ND1442.F85W75 1997
759'.4'09034 – dc20 96–44266
 CIP

Publication of this book has been aided by
a grant from the Millard Meiss Publication Fund
of the College Art Association.

A catalogue record for this book is available from
the British Library.

ISBN 0 521 57203 7 hardback

CONTENTS

ILLUSTRATIONS

ACKNOWLEDGMENTS

I WOULD LIKE TO THANK the National Endowment for the Humanities and the University of Texas at Arlington, whose Research Enhancement Award and provision for a leave of absence made it possible for me to write this book, and the College Art Association, whose Millard Meiss Publication Fund funded the inclusion of color plates. Dorothy Johnson gave unstintingly of her time, energy, and expertise, offering innumerable insights for the entire manuscript. Mary Sheriff made valuable suggestions on a chapter in an early draft. Lee Johnson graciously shared his expertise regarding Delacroix's work. Jacques de Caso, who directed my dissertation on Scott and French painting, presided over my initial interest in this subject, and I have benefited greatly from his teaching, scholarship, and encouragement through the years.

For their gracious assistance, I would like to thank those members of the staff of the Bibliothèque Nationale who work in the Salle des imprimés, the Hémicycle, the Salle des périodiques, the Cabinet des estampes, the enquiry desk at the Salle des catalogues, and the Service de reproduction, and the staff of the Bibliothèque de l'Arsenal. At Cambridge University Press, Beatrice Rehl, Fine Arts Editor, gave her enthusiastic support to this book's development from the very beginning; Christie Lerch's skills as a copy editor have helped to make the text more readable. It has been a pleasure to work with them, and with Holly Johnson, in preparing this book for publication. The support and encouragement of family members, some of whom are no longer living, has been essential to my successful completion of this book. I appreciate the good-humored flexibility demonstrated by my sons Benjamin and Joshua, who have lived with this project for years and have spent several summers in France. Finally, and always, my love and gratitude to my husband Woodring.

PAINTING AND
HISTORY DURING
THE FRENCH
RESTORATION

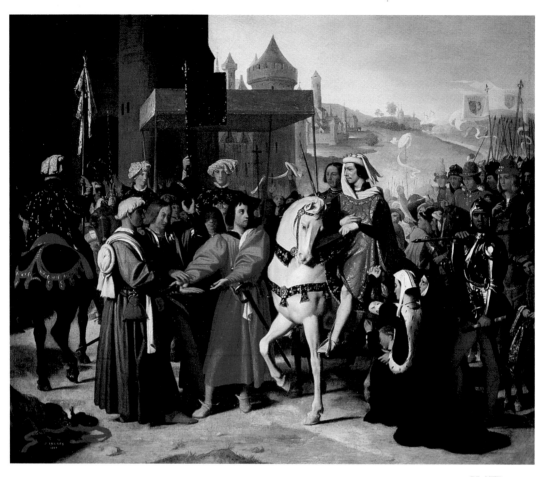

PLATE 1

Jean-Auguste-
Dominique Ingres,
*The Entry into Paris
of the Dauphin,
Future Charles V*
(1821). Hartford,
CT, Wadsworth
Atheneum. Oil on
panel, 47 × 56 cm.
(Photo courtesy
Wadsworth Athe-
neum, Hartford.
Gift of Paul
Rosenberg and
Company.)

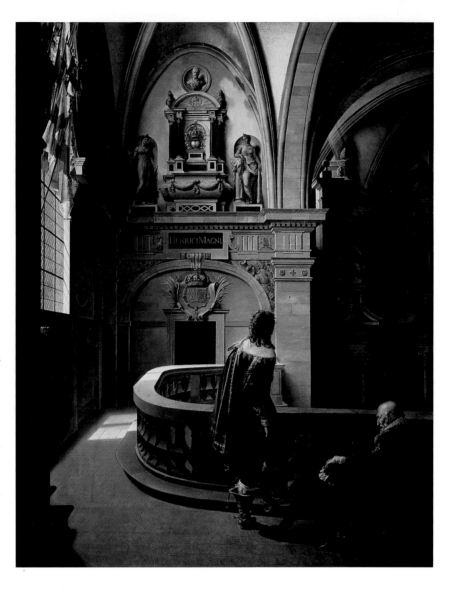

PLATE 2

Marie-Philippe
Coupin de la
Couperie, *Sully
Showing His
Grandson the
Monument Contain-
ing the Heart of
Henri IV* (1819).
Oil, 2.11 × 1.78 m.
Pau, Musée
National du Châ-
teau de Pau. (Photo
courtesy Musées
Nationaux, Paris.)

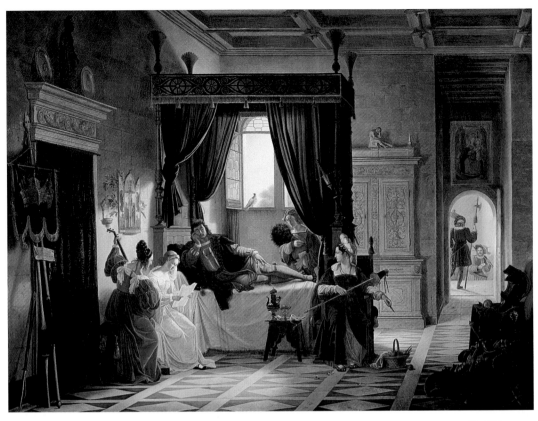

PLATE 3

Pierre Révoil, *The Convalescence of Bayard* (1817). Paris, Musée du Louvre. Oil, 1.35 × 1.78 m. (Photo courtesy Musées Nationaux, Paris.)

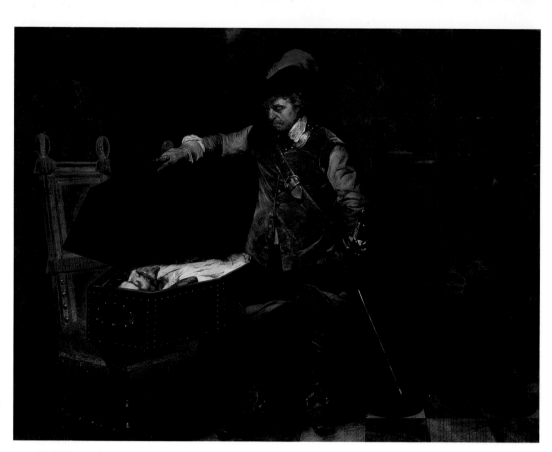

PLATE 4

Paul Delaroche,
Cromwell (1831).
Nîmes, Musées des
Beaux-Arts. Oil,
2.25 × 2.92 m.
(Photo courtesy
Giraudon/Art
Resource, NY.)

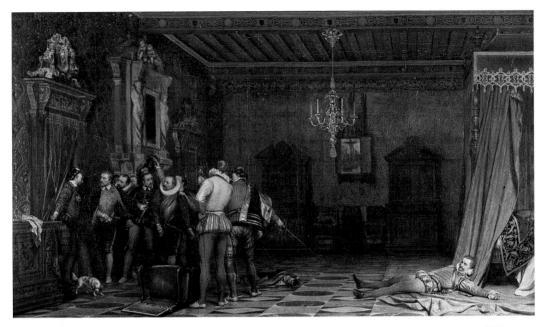

PLATE 5

Paul Delaroche, *The
Assassination of the
duc de Guise*
(1834). Chantilly,
Musée Condé. Oil,
57 × 98 cm. (Photo
courtesy Giraudon/
Art Resource, NY.)

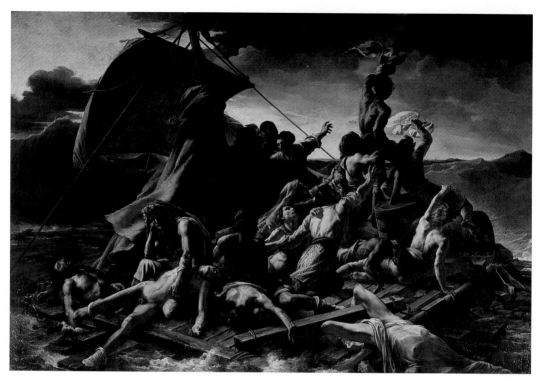

PLATE 6

Théodore Géricault,
*The Raft of the
Medusa* (1819).
Paris, Musée du
Louvre. Oil, 4.91 ×
7.16 m. (Photo
courtesy Musées
Nationaux, Paris.)

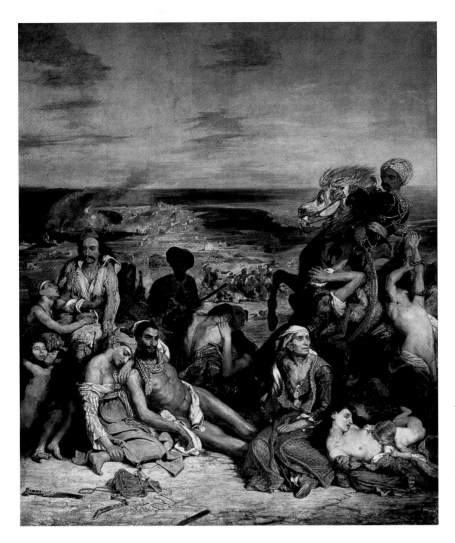

PLATE 7

Eugène Delacroix,
*Scenes from the
Massacres at Chios*
(1824). Paris, Musée
du Louvre. Oil, 4.17
× 3.54 m. (Photo
courtesy Musées
Nationaux, Paris.)

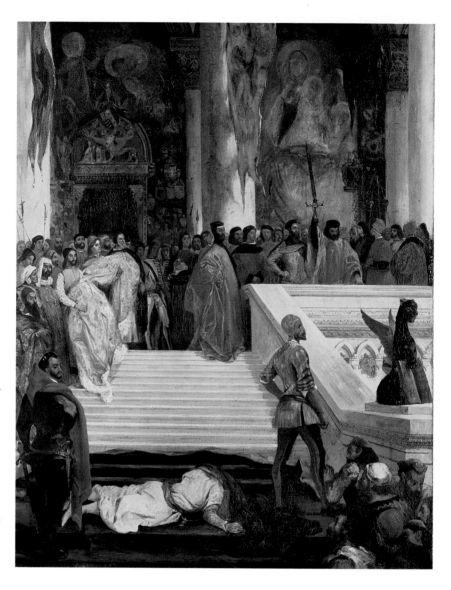

IMAGING THE PAST
IN 1827
A NOTE ON METHODOLOGY

INGRES'S painting *The Apotheosis of Homer* (Fig. 1) is an exemplary summation of his credo; its creation, repetition, and elaboration occupied forty years of his life.[1] An allegory of art itself, it unites in an eternal present creative immortals from past ages, who come in procession to witness the deification of their common ancestor. Ingres selects and poses each painter, sculptor, architect, and author in a family tree of genius, one that will resist the winds of fashion. He gives prominence to those of classical antiquity, with the line of descent proceeding from Sophocles, Aeschylus, and Euripides to Corneille and Racine. On the left we see Apelles lead Raphael by the hand; below them, Virgil serves as guide for Dante, and Poussin proudly poses in the foreground. In contrast, Michelangelo is in Phidias's shadow; Tasso and Shakespeare are only beginning to enter.

But their movements are frozen, their glances stilled. Raphael's living community of creators who moved through time and space in *The School of Athens*, clearly an inspiration for Ingres, is transformed by him so that erudition is embedded in amber: the sacred space is compressed into rhythmic rising lines, the quotations of Raphael's or Poussin's self-portrait are divested of unique brushwork. Beauty has been distilled out of chaotic and corruptible nature and offers itself eternally to us as an icon.

We sense throughout this work an iron control over historical dynamism. This control is evident most clearly in Ingres's decision to present the composition laterally, as if it were an easel painting; it had originally been commissioned as a ceiling decoration in the new Musée Charles X, nine rooms in the Louvre dedicated to Egyptian and Etruscan antiquities. Such a timeless and eternal allegorical presentation, which soared above stylistic relativism and anecdotal representation, presented in such an antidynamic, anti-illusionistic ceiling, would be completely appropri-

ate for a place where iconic art was enshrined in a museum within a museum.[2]

When *The Apotheosis of Homer* was included in Ingres's retrospective exhibition at the Exposition Universelle in 1855, Théophile Gautier, the apostle of art for art's sake, deified Ingres himself, placing that noble and exemplary artist on the central throne.[3] Ingres had walled himself into art's sanctuary, to contemplate the beautiful. And here we become aware of the problematic aspects of such iconicity. Ingres's words to his students are well known: "Let me hear no more of that absurd maxim: 'We need the new, we need to follow our century, everything changes, everything is changed.' Sophistry – all of that! Does nature change, do light and air change, have the passions of the human heart changed since the time of Homer? 'We must follow our century': but suppose my century is wrong?"[4] His compatriots could not agree, for they felt themselves to be cast out of the paradise of eternal beauty, into the ceaseless flux of historical time. As Benjamin Constant lamented, "What shall man do, without memory, without hope, between the past that abandons him and the future that is closed to him?"[5] They were seeking a way to overcome this rupture and to reintegrate themselves into historical time.

Gautier, who preferred the absolute, pure, timeless beauty conveyed in Ingres's *Homer,* believed that Ingres's austere preference had not only defined his sublime achievement, but also alienated him from his contemporaries, who were "stirred by contemporary passions and excited by the ideas of their time":

> He alone represents in our time the high traditions of history painting, of the ideal, and of style. He has, for this reason, been accused of lacking modern inspiration and of ignoring the world around him, in short, of not belonging to his time. The accusation is perfectly just . . . This kind of art, which owes nothing to chance, which is heedless of changing fashions and fleeting interests, seems cold, I know, to unquiet spirits and has no appeal for the masses, who do not understand synthesis and generalization.[6]

This was indeed the accusation that greeted Ingres's *Homer* on its unveiling in 1827. Furthermore, critics decided, by proceeding allegorically Ingres was avoiding the challenge of true historical painting. And this was the central artistic dilemma of his age: how to paint historical truth, as understood in 1827, without forcing art to decline from its high tradition.

From the founding of the Académie Royale in the seventeenth century, historical painting had been placed at the apex of the genres, because of its communication to the viewer's soul and intellect of moral precepts that had been distilled from past examples. Perhaps it would be more accurate to describe history painting as "intellectual" painting, for it included mythological, religious, poetic, and dramatic subjects as well as historical subjects. The distinctions made between history painting

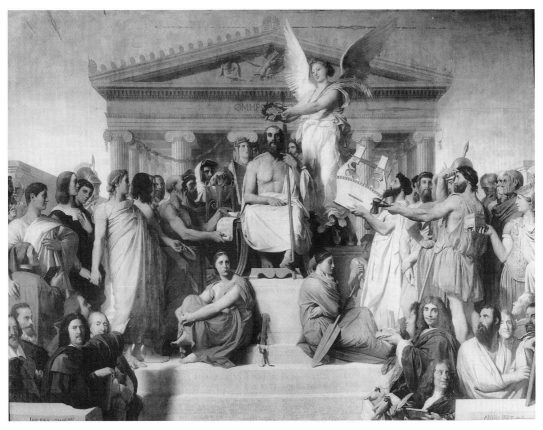

FIGURE 1

Jean-Auguste-
Dominique Ingres,
*The Apotheosis of
Homer* (1827).
Paris, Musée du
Louvre. Oil, 386 ×
515 cm. (Photo
courtesy Musées
Nationaux, Paris.)

and genre painting were predicated on the accepted distinction between truth and fact: clarity of eternal meaning, as opposed to illusionistic material description. The two types of painting were differentiated in their purpose, their scale, their compositional orientation, their selection of physical actions, their handling of form, color, light, costume. History painting had been defined according to Aristotle's recommendations for tragedy, the presentation of moral action, not for history, which Aristotle considered mere chronological coincidence.

Even before the Revolution, the distinctions between history painting and genre painting began to blur, as didactic specificity became more and more desirable in the description of singular heroes and events. In 1774, when the comte d'Angiviller began to commission a series of paintings and sculptures of French heroes, his intentions were at least as much patriotic as they were aesthetic. Artists responded to these intentions by following portraits by contemporary artists and representing historically specific costumes and sites. The importance of context was stressed for these singular yet exemplary individuals.[7] After the eruption of the French Revolution and during the Empire, David and other artists struggled to correlate indelible sights with immutable meaning.[8] But a climate sympathetic to free experimentation in the narration and depiction of historical subjects developed only after the Napoleonic censor-

ship was lifted, after the Bourbons returned. The subject of this study is the relationship between artists and historians during the Restoration, from the return of the Bourbons in 1814–15 to the July Revolution in 1830.

We shall be examining the works of artists who attempted to do what Ingres insisted was impossible: those who struggled to create works in the highest tradition of history painting, which would be not only great art but also true history. For them, "history" could no longer mean lapidary precepts that could be conveyed allegorically. For them, "history" had all the complexity of existence: physical and psychic three-dimensionality. Experience, densely concrete and dynamically subjective, could not be expressed in iconic hieraticism. How was this protean sense of history, one that insisted on narrative rather than dramatic literary expression, to be expressed in visual terms?[9]

Narrative is extraordinarily flexible; it may convey events in chronological sequence, or as diachronic description and explanation, or as synchronic experience.[10] Modern interactive texts demonstrate the myriad varieties of narrative structure. Similarly, the meaning of a narrative may be recomposed by readers who choose different orders of reading: linear, deductive, associative. Allegorical iconicity riveted the viewer's attention on the visual forms that communicated the intellectual meaning. But it was also possible for artists to convey narrative meaning through visual choices, not simply to represent the actions contained within a narrative; they could utilize spatial juxtapositions, repetitions, perspectival changes, inclusion of symbols, combinations of different moments in the same visual field, or fluctuations in the depiction of form, atmosphere, or light, all visual choices employed to render the temporal flexibility of verbal formats. But the translation of narrative into visual form requires both a sensitive and flexible artist and a prepared viewer, in order for all the subtleties of narrative insight to be communicated and recognized.

When the nine rooms on the courtyard side of the Louvre's new Musée Charles X opened, critics (classicists and Romantics alike) and administrators found allegory cold and boring. Instead of allegorical summation, they desired the direct impact of historical experience; instead of atemporal stasis, the temporal specificity of anecdotes and acts. They hailed, for example, Horace Vernet's *Julius II Ordering Work on the Vatican* (Fig. 2), where Raphael's world came to life as lucid documentation.[11] In his painting, papal and artistic portraits and preparatory designs for Saint Peter's and for Raphael's design for the fresco *The Meeting of Attila and Leo I* are casually sequenced instead of being formally grouped. It is as though we stumbled for ourselves into a scene that would later take on meaning, once the works being commissioned came to their magnificent conclusion. We delight in becoming historical voyeurs, peering back into the past.

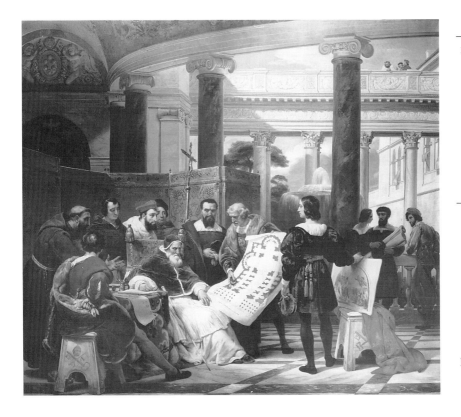

FIGURE 2

Horace Vernet,
*Julius II
Commissioning
Projects for
the Vatican and
Saint Peter's
from Bramante,
Michelangelo, and
Raphael* (1827).
Paris, Musée du
Louvre. Oil. (Photo
courtesy Musées
Nationaux, Paris.)

Ingres proposed to transcend history in allegory, and that choice was criticized. Vernet proposed to view a historical moment, and was praised for doing so. Today we recognize that Vernet's work presaged the decline of the expression of meaning into the illustration of anecdote.[12] Such scenes promised their audiences direct access to earlier times, an unmediated experience of the past. This feigned lack of mediation, of clarification, was achieved through meticulously illusionistic concrete components that denied the intervention of the artist's brush, and compositions that appeared to "be" instead proclaiming their birth from the artist's brain. By appearing to suppress aesthetic intervention, by appearing to sacrifice temperament, style, touch, the artist promised the audience their own view of the past itself.

But that is to simplify historical meaning into "objectified" facts and into events that "take place"; it is to simplify the visual communication of that historical meaning into representation of material factors. Vernet's anecdotal scene of Renaissance patronage was certainly an important approach to communicating historical meaning in visual terms, but it was not by any means the only possible approach. The audience in 1827 recognized that the choice was not simply between atemporal allegory and historical representation. We long not simply to *see* the past, but to *know* it, to empathize with and comprehend it: not simply to see its protagonists in action but to understand their motivations. There was a third possibility for historical painting, an experiential rather than

representational one, exemplified by Delacroix's *Death of Sardanapalus* (Fig. 3), also exhibited in the Salon of 1827.[13]

The history of this Assyrian king (related by Ktesias and Diodorus Siculus), whose dissolute life ended in the destruction of his empire, had been adapted by Byron into a reading-drama in which Sardanapalus experienced a metamorphosis from effeminate epicurean to magnanimous ruler. The tragedy centers on the conflict within the heart of an autocrat as he struggles to reinvent himself as a liberal and philanthropist and finally realizes that his attempt to will Utopia into being has led to civil war. Throughout the play, Byron destabilizes the roles and characterizations of Sardanapalus and his beloved concubine Myrrha, subverting military, political, and religious decorum. Sardanapalus's psyche is the true site of action. After a premonitory nightmare, which Sardanapalus relates to Myrrha, he evacuates his family and loyal servants and ensures the safety of his palace's treasures, even sparing a herald's life and giving him a golden goblet, so that his last act will not be a wrathful one.[14] He prepares to immolate himself on the funeral pyre that has been constructed onstage around his throne, according to his orders; Myrrha joins him there as the curtain falls.

Byron had conceived of Sardanapalus as a man who reacts to defeat by enemies and betrayal by friends by questioning the possibility of human achievement, retreating to his core self and finding sustenance in passionate love.[15] In his own interpretation, Delacroix probed more deeply into this characterization by retaining the bed on which Sardanapalus had writhed during his nightmare, transforming it into the base for the funeral pyre. Instead of a veiled scene of physical death, Delacroix depicted an orgy of destruction of treasures: gems, horses, slaves, and concubines. Spectators would enter into the thoughts of this voluptuary who is struggling to reinvent himself as the world breaks in to destroy him.

Delacroix forced spectators to adopt the "viewpoint" of its hero. There is no three-dimensional "logic" to the location or scale of the forms. Space is tilted upward and twisted dynamically. The foreground objects and figures rush past the picture plane into our space; the background sight of Nineveh in flames could be a dream or a painting as easily as a place. The turbulent emotions that Sardanapalus struggles to contain behind an impassive expression are unleashed in a perspectival torrent down the bed. Even more frightening than this lack of physical location is our inability to retain our moral stance when witnessing a massacre. Delacroix insists that we empathize with his antihero, that we savor the beauty of his treasures as they are destroyed; as we recognize sights of horror, we revel in physical beauty and admire luxury. Delacroix presents a garland of female forms that twine upward from the stabbed concubine to the woman dying on the bed with her back to us, to Aischeh who has already hanged herself from a column in the back-

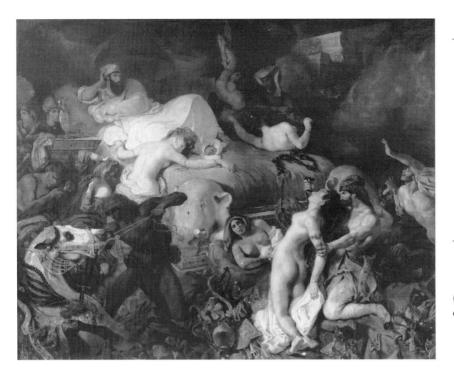

FIGURE 3

Eugène Delacroix,
*The Death of
Sardanapalus*
(1827). Paris, Musée
du Louvre. Oil, 3.95
× 4.95 m. (Photo
courtesy Musées
Nationaux, Paris.)

ground. Repeated pearls in the horses' trappings invite our eye to wander across the foreground; golden and jewel-encrusted objects tumble into our space. The curving scabbard for the knife that is ready to impale the concubine in the foreground curves in the same arc as her arm, so that a violent threat becomes a rhythmic pattern. The result is that we cannot impose a logical order of viewing on the work; we must enter into its terrifying, and terrifyingly attractive, experience.

Our ability to understand Ingres's *Apotheosis of Homer* depended on our previous knowledge of art: artists' portraits and the significance of their creations. Our ability to understand Vernet's *Julius II* depended on our previous knowledge of the historical facts of Renaissance patronage. In both cases, meaning could be represented, either allegorically or realistically. But Delacroix's *Sardanapalus* functions associatively, "resurrecting" the inner life of the Assyrian king. Instead of presenting a group of artist-icons to the modern audience or creating the physical illusion of a past moment, Delacroix invites the audience to fuse past and present by identifying, in 1827, with the motives and emotions of a man from ancient Nineveh. Instead of embodying conception in allegorical form or describing it in material form, Delacroix was "painting thoughts," as he wrote in his journal in 1822.

I have deliberately selected canonical works, Ingres's *Homer* and Delacroix's *Sardanapalus*, so that we may recognize not only the stylistic polarity evident to all in the Salon of 1827, but the fact that the stylistic differences between the works of Ingres and Delacroix (and Vernet, who is generally omitted from modern discussion) that we have

just examined are due in great part to their differing conceptions of history, and of how historical meaning could be made visually accessible. We cannot hope to understand the work of such erudite, insightful, and gifted men as Ingres and Delacroix, artists who sought to maintain the mission of historical painting, unless we reintegrate the entire spectrum of historical depiction and, even more fundamentally, unless we understand the meaning of history itself for artists and for their audience during this period.

It is a commonplace today to speak of historical meaning as "constructed" rather than "recovered." Frequently, this construction is obtained through analogies between personal and past experiences, as Sir Lewis Namier stated:

> One would expect people to remember the past and imagine the future. But in fact, when discoursing or writing about history, they imagine it in terms of their own experience, and when trying to gauge the future they cite supposed analogies from the past; till, by a double process of repetition, they imagine the past and remember the future.[16]

This was the approach taken by the French in 1815, dragging themselves onto the shore of peace after surviving the shipwreck of revolution. They could find a way to "remember" the future by imagining the past through historical analogies, analogies between Cromwell and Napoleon, for example. For them, history was a political statement, made retroactively.[17] In the visual arts as well, the politicized sense of history resulted in aesthetic choices that were recognized as declarations of political partisanship, as the critic Auguste Jal confessed in his review of the Salon of 1827.[18] He saw these works as political opinions, and his reviews of them were political polemics. This intellectual and political interpretation extended beyond discussions of theme (or invented discussions of purported themes), into the union of theme and content with formal expression. Artists' decisions regarding theme, text, and visual presentation were often made (or assumed or desired to have been made) according to political intentions.

Thus, for the artists and their audience in 1827, the pictorial expression of a historical subject was the distillation of a four-stage process of comprehension: of events, of political analogies that made those events resonant for a modern audience, of textual strategies of interpretation by historical writers, and of visual expression by artists informed by all of the preceding developments. My intention in this book is to reintegrate this situation for the modern audience: to describe how history was imagined in images, how it was perceived, in the double sense of comprehended and depicted.[19] My aim is to recover that historical meaning by reintegrating visual style, historical subject, and political interpretation. In so doing, I hope that this study's interdisciplinary methodological approach, conceptual framework, and documentation will be helpful

not only to those interested in art history and cultural studies, but also to those in literary analysis and in historical rhetoric.

The revolution in French historical writing that occurred during the Restoration, a revolution that sought to describe historical meaning through narrative description, forced a crisis in pictorial representation. This sense of the past, which could not be expressed allegorically, which sought to represent the appearance of the past as accurately as possible and to express its inner life as effectively as possible, challenged traditional guidelines to historical depiction.

During the Restoration, the serious investigation of historical meaning was by no means confined to historians, precisely because of their conception of historical truth. Historians recognized (as we do) that since we understand the past through our imaginative construction of it, a novelist's insight may be more valid than a historian's. Augustin Thierry not only reviewed Scott's novel *Ivanhoe* and wrote his history of the Norman Conquest under its inspiration; he cited Scott as a scholarly source, and so did other historians in his circle. Artists, novelists, dramatists, and historians were colleagues in close communication with each other, and they even alternated roles. Delacroix wrote historical novels; Ary Scheffer's brother, Arnold, was both a historian and an art critic, as was Thiers. We must keep this disciplinary fluidity in mind when we consider the creation and reception of historical paintings.

The modern audience agrees that truth is constituted subjectively; that there is no one, preexisting, objective truth.[20] Roland Barthes and Hayden White have described how the historian constructs meaning in the same manner as any author of a text: through the selection of a subject, the assessment of the relevant data, the arrangement of the data into a sequence that proves a point or comes to closure. They have argued cogently for the linguistic analysis of historical texts. Barthes insisted on the productive tension between an external event and its constitution in imaginary narrative structures. The function of both historical and fictional discourse was to constitute, not to represent. Any ostensible "objectivity" in describing a tangible reality outside the text was not only impossible but destructive, since it made it impossible to deduce the dynamic truths at work.

But the application of Barthes's insights to art of the early nineteenth century has been more problematic, since he stressed the impact of photographic representation on the new conceptions of history and time that arose in the middle of the nineteenth century.[21] Those influenced by his approach who have turned their attention to visual responses, many of them superb scholars of historiographic rhetoric, have sought to establish a line of development that is object oriented and representational. This view has been most helpful for the visual arts when it has described what Stephen Bann termed "the materialization of the past" in the development of museum collections.[22] But Delacroix, and Romanticism in

general, have been excluded from the discussion. Bann, for example, traces a lineage from the diorama through Delaroche to the modern cinema, seeing additive description and the concrete "useless detail" as the hallmarks of both visual realism and historical truth.[23] Although this direction was certainly an important one during the Restoration, it was by no means the only one. Contemporary critics were aware of the problems facing historical representation, given the new recognition of the complexity of historical meaning and the subtlety of literary rhetorical strategies. Their reviews argued for the inclusion of more expressively oriented pictorial responses, insisting that to define historical truth as accurate external appearance was to accept a false polarity between the historically valid and the pictorially potent.

Hayden White's contribution to the understanding of historical thought and its representation in narrative has been very helpful to art historians who wish to comprehend the entire range of historical depiction. Affirming the unity of efforts to comprehend reality (past and present) during the early nineteenth century, he took the grammar established by linguistic theorists for analyzing poetic or figurative language and applied it to nineteenth-century historians, arguing that meaning was "emplotted" according to linguistic strategies. His discussion of the Romantic emplotment of history as an extended metaphor that functions associatively rather than representationally is particularly helpful for our understanding of Delacroix's approach:

> The metaphor does not *image* the thing it seeks to characterize, *it gives directions* for finding the set of images that are intended to be associated with that thing. . . . it does not give us either a *description* or an *icon* of the thing it represents, but *tells us* what images to look for in our culturally encoded experience in order to determine how we *should feel* about the thing represented.[24]

White has compared a historian's stylistic freedom in writing an interpretation of an event or situation to the freedom that we extend to Constable or Cézanne when we examine their interpretation of a landscape. We judge the success of their works not by their transparency to a preexisting object, but by their internal consistency, and by their ability to provide the viewer with the codes that permit a linkage between image and representational archive.[25] We should proceed as Bann and White have suggested, gauging the intentions and the successes of historical narratives and depictions during the Restoration according to this standard, alert to visual and linguistic subtleties that convey historical conceptions.[26]

In art historical studies, until very recently, the complex aesthetic and the intellectual situation of historical representation has been fragmented, even polarized, between aesthetically and culturally directed studies. Delacroix's historical paintings have rarely been examined side

by side with those of Delaroche or Vernet. Often Delacroix's Romanticism was described as pure visual expression, whose visual qualities would be enslaved if their origin in a preexisting event and its textual presentation were examined too closely. Delaroche's and Vernet's works were considered as transparent thematic presentations, disregarding those artists' imaginative contribution evident in composition or spatial juxtaposition.

This false polarity began as a defensive maneuver during the July Monarchy, when critics like the poet Baudelaire, who admired Delacroix's ability to express the meaning and the mood of a literary text without reducing art to illustration, perceived the threat that narrativity posed to pictorial potency. If historical painting meant Horace Vernet's anecdotal representations, then Delacroix's art had to be assessed on aesthetic rather than interpretative grounds. Thus, although Baudelaire fully recognized Delacroix's expressive union of form and content, he suppressed analysis of the artist's conception and interpretation of the subject, to concentrate on a color that "thought for itself" (instead of slavishly repeating the choices already present in real objects), a painting style that could "project its thought at a distance" even before the subject was recognizable, through the musical harmony of tones.[27]

It was Léon Rosenthal, at the beginning of the twentieth century, who initiated the recovery of the stylistic spectrum of Restoration painting, reintegrating Ingres and Delacroix into his discussion of the change in historical painting during the Restoration and the July Monarchy, a change that he related to the revolution in historiography at the end of the eighteenth century and beginning of the nineteenth century.[28] Art historians rediscovered the political motivations for commissions and acquisitions and the political implications of critical commentary.[29] It is time for us to place these advances in a framework that is sensitive to historical insights, linguistic protocols, and aesthetic strategies, so that we will be able to recover the full intellectual complexity of nineteenth-century historical art.

We cannot understand the visual choices made by artists, we cannot understand the views expressed by critics (often, during this period of extreme censorship, historians themselves like Thiers or historical dramatists like Vitet), if we sever the art world from its cultural context, which includes the developments in historical literature. We cannot understand the political intentions in historical literature, evident in thematic selection and textual content, if we sever them from their narrative expression, their "historiographical poetics," in Ann Rigney's phrase. Thus, I shall be taking the interdisciplinary methodological approach that this subject requires, but that has not been fully utilized until now because of the isolation of those working in art historical and cultural studies from those working in historiographic rhetoric and literary analysis.

Equally, we cannot understand the desperate efforts to redefine histori-

cal painting, in an age that was redefining history itself, unless we
ground them in the aesthetic debates on historical art. The debates con-
cerned the academic rationale for the use of "local color," the redefini-
tion of action from Aristotle's usage, the stylistic gamut of historically
valid and pictorially potent works, and the problematic impact of illus-
trated texts. Without explication of the aesthetic imperatives guiding
genre hierarchy, compositional orientation, and thematic selection, the
innovative aspects of these historical depictions may be ignored or misun-
derstood. Without consideration of the guiding principles of meaning as
well as taste, and of the way in which political polemics were cast as
aesthetic preferences, Restoration critical literature is often bewildering;
it has yet to be explored as fully as it deserves to be. In sum, without
knowledge of the range of historical approaches in literature and in art, a
knowledge based not only on biographies and subject matter but on the
analysis of the texts and paintings themselves, their nuances of phraseol-
ogy, their temporal fluidity, their visual address, the modern audience
cannot comprehend the way in which historical meaning was evident to
artists and their audience during the Restoration.

Before I describe the structure of my argument, let me explain the
rationale behind my focus. My purpose in this study is to analyze a
problematic encounter, the historical approaches that posed the greatest
challenge to the visual arts, not to survey the magnificently varied tapes-
try of French pictorial and historical activity during the Restoration.
Since those problematic approaches were descriptive narration and psy-
chic address, some familiar figures will appear only briefly or be ex-
cluded. Ingres will be assessed as a medievalist but not as a neoclassicist.
Vico and Cousin will not be discussed, because their philosophies of
history, tending toward Neoplatonism and Hegelian idealism, could eas-
ily be adapted to the visual arts.[30] Guizot and Thiers, historian-
politicians of major significance during the July Monarchy, appear only
briefly as art critics.[31] The limpid clarity of their language and their
presentation of a chronological sequence of physical actions did not pose
the visual problematic that I am investigating here. Finally, although
Michelet's Romantic "poetics" of historical narration has been the sub-
ject of much excellent work, work that has profoundly influenced my
ideas on Romanticism in general, he had barely begun to have an impact
on the visual arts by the end of the Restoration, and so he is only
occasionally cited.[32]

The sequence of my discussion is both methodological and chronologi-
cal. In Chapter 2, I explain why Aristotelian guidelines to historical
narration could no longer satisfy those who had experienced the French
Revolution, and I introduce the economic and political factors that were
to influence the aesthetic debate. In the succeeding chapters, I describe in
three inter-related essays (Chapters 3–5) three approaches to represent-
ing the past that were concurrent in early nineteenth-century French

painting; approaches that were oriented toward object, gesture, and thought. The first approach was the pious viewing of relics; its style of representation (the Troubadour style) resembled its medieval subject matter. Meticulously accurate local color served as a homage to a lost, Catholic, monarchical civilization. The second approach was the witnessing of catastrophe: a specialty of Delaroche's. The pathos and violence that had been historical fact were now carefully encapsulated in a staged anecdote. The third approach was the resurrection of the past from within: Delacroix's Romantic fusion of the spectator's emotions and thoughts with those of a protagonist from another age.

I examine these three pictorial styles by comparing them with three different rhetorical strategies for writing history that were utilized during the same period. In Troubadour depictions, the balance between figure and architectural background is reversed. Hallucinations of ruins are severed from time, to serve as "relics," precious remnants of the past as it once was, which, if contemplated by the pious, can arouse memories and emotions in the heart of the present-day observer. This exhortatory and picaresque approach, in which physical details of local color are lovingly described, was utilized by the Ultraroyalist author Marchangy.[33] Delaroche's dramatizations of catastrophe are comparable to Chateaubriand's attempts during the Restoration, in his polemics and his historical texts, to "close the drama of revolution" for the returning Bourbons, insisting that they had learned God's lessons from their revolutionary calamities, and that the proof was their establishment of a constitutional monarchy. Both Marchangy and Chateaubriand wrote texts that looked back to the past. Marchangy feigned to "chronicle" the past, as if he were still within it. In *Les Quatre Stuarts* (1828), Chateaubriand swerved back and forth from distant past (the British Civil War in the seventeenth century) to recent past (the French Revolution). The Liberals, however, who wished the Revolution to continue, saw past and present as a seamless whole. Thus, their prose stimulated "resurrection": the multifocal psychic as well as physical evocation of historical experience, as described in Thierry's theoretical articles and his *Histoire de la conquête de l'Angleterre par les Normands* (1825), inspired by Walter Scott's historical novel *Ivanhoe*. This multifocal, experiential approach to the past is what we find in Romantic paintings by Géricault, Ary Scheffer, and Delacroix.

I have taken this methodological approach of assessing texts and images together, both those that are directly related (as in the case of Delaroche's *Cromwell*, his *Charles I Mocked by Cromwell's Soldiers*, and his *Strafford on His Way to Execution*, all three based on scenes described in Chateaubriand's *Les Quatre Stuarts*) and those that are comparable in their themes, their approach to local color, and their temporal expression, so that I may convey as clearly as possible the preoccupations of and the methods used by the artists, historians, and

critics of the Restoration themselves. Because the modern audience is often unfamiliar with the original historical event, and almost always unfamiliar with the textual account that the nineteenth-century artist consulted, textual citation and textual analysis are essential in order to reconstruct meaning. The difference between a plot summary and a literary analysis is obvious, but even now discussions of works by Delacroix, one of the most sensitive and active interpreters of literature, cite the title of the text that inspired him but fail to analyze its interpretative viewpoint, evident in such aspects as the use of dialect, the sense of temporal fluidity, and the compression, expansion, omission, and juxtaposition of events. Similarly, my selection of critics' responses, a more extensive and more representative selection than may be usual, not only explains the critics' historical and political viewpoint, but also illuminates the intellectual situation in which these artists were proposing these works.

I have been guided throughout my discussion by the need to describe the situation as a whole, and therefore have selected works that best exemplify the three historical viewpoints. Some canonical artists (Ingres, Géricault, Delacroix) appear in a new light; other artists, particularly those in the Troubadour school, may be new to some readers. Illustrative vignettes are integrated into the discussion; the pressure that illustration exerted on historical painting is an underlying issue throughout and is directly, albeit briefly, addressed in my conclusion.

The story that will be unfolding is one of gallant attempts to fight an impossible battle. The urgent challenge, brilliant solutions, and ultimate recognition of crisis offer us one of the most fascinating subjects in nineteenth-century art history, as well as one of the most significant. I hope that my efforts to shed light on this problem will lead to further exploration on common ground.

"EVERYTHING IS OPTICAL"

THE REVOLUTION IN HISTORICAL NARRATION AND THE DILEMMA OF HISTORICAL PAINTING

I N 1819, the art critic Etienne-Jean Delécluze summarized the conservative view of the moral aim of historical painting. The historical painter's purpose was exhortation, elevation of the soul; that of the genre painter was didacticism, through mimesis. Because of their differing goals, historical and genre painting necessarily had to take divergent visual routes, toward idealism or realism. The genre painter was an "alert observer of mores"; such details had to be sacrificed by the historical painter, so that the moral action could be revealed:

> I term "history painting" that work in which an artist, after having chosen a sorrowful or charming subject, takes up the main aim of painting an action, sacrificing everything in order to make it clear. Thus, he will be faithful in his description of costume, site, mores in order to inform the viewer that the scene is laid in Greece, Rome, or France; but he will always sacrifice such secondary details whenever they would distract from the attention that should be given to the main action. But, on the contrary, I term "genre painter" the artist who is an alert observer of mores, who uses an action to teach the viewer about the unusual costumes and odd customs of the era. Thus, the history painter is he who tries his best to show us an action; the genre painter is he who shows us mores. We make this same distinction between tragic and comic authors. Whether you accept or reject my definition, praise or criticism should not be directed at me. I have taken it from Aristotle's *Poetics* and simply applied it to painting, which he also discusses elsewhere.[1]

ARISTOTLE, HISTORICAL PAINTING, AND HISTORIANS

Delécluze was right to point out that the academic theory of historical painting followed Aristotle's definition of tragedy. What he did not ad-

mit, however, was that Aristotle had raised tragic and poetic literature above historical narrative because of their power to reveal truths, as philosophy did. Poetry was superior to history precisely because it was an invention, not a reaction to coincidence. History was tied to facts.[2] Historical narration was obliged to diffuse the guiding action into subdivisions linked by mere chronological sequence. But, Aristotle insisted, the plot of a great dramatic or poetic work should not follow a merely episodic sequence; it should demonstrate irresistible causation.[3] Plot was the motive force of poetic or tragic unity; through the carefully constructed plot, incidents were linked causally, so that they could exemplify a moral truth.

Aristotle's dramatic theory influenced academic pictorial doctrine, affecting the hierarchy of genres, compositional arrangement, and the visual transformation of optical reality. The traditional goals of historical painting, the highest of all pictorial genres, were inspiration, moral improvement, and instruction, as well as visual delectation, and the former far outweighed the latter. Félibien's rationale for genre hierarchy, proposed to the Académie de Peinture et de Sculpture in 1669, was not simply based on technical competence (incorporating landscape and still life into figural painting) and thematic selection (requiring erudition as well as direct observation), but on the creative artist's triumph over material fact and ability to influence the observer's imagination.[4] Throughout the eighteenth century and the nineteenth century, classicist aesthetic theoreticians maintained this distinction between history painting's moral address and genre painting's material truth.[5] In 1792, for example, Robin compared history painting to literature by Homer or Euripides; genre painting, based on factual examples, was comparable to biography or history.[6]

Since the moral action was the motivating principle of pictorial as well as dramatic art, logical causality had to be visually evident in a unified, comprehensible, "legible" composition. Disparate concrete objects had to be organized into a coherent visual effect, so that the moral meaning of the actions could be revealed. This visual unity could be achieved only by sacrificing optical equality, which endowed all objects, animate and inanimate, with similar descriptive detail. Instead, the figural subject had to be established as the primary focal point, through such devices as central placement, strong light on the figures of the protagonists, and the blurring of detail toward the edges of the canvas.

This is precisely the advice that we find offered by and to Enlightenment historians, who were profoundly influenced by Aristotle. History was described as philosophy teaching by examples, a mirror of moral precepts.[7] History's goal was loftier than didactic instruction; it was the inculcation of wisdom. Enlightenment historical narration was formalist: prescriptive, rather than descriptive. The historian should not be immersed in the event, but should stand back and present posterity with

only its most salient aspects. Thus, the historian's narrative presentation should be based on Aristotle's strictures on epic and dramatic literature: unified moral action and the elimination of distracting episodes.

Historians compared themselves to painters (classicist painters, it went without saying), who did not reflect events but clarified them and organized them hierarchically. In 1752, Voltaire wrote, of his *Siècle de Louis XIV*, "My aim has been to make a great picture of events that are worthy of being painted, and to keep the reader's eyes trained on the leading characters. History, like tragedy, requires an exposition, a central action, and a dénouement."[8] In 1770, Garnier compared historians to painters, who, keeping their gaze firmly fixed on the significant aspects before them, would "find a luminous point of view from which the reader could easily allow his gaze to embrace the entire sequence of facts, a pregnant principle of which each particular fact would be only a development or consequence."[9] In 1787, Marmontel, reiterating Cicero's definition of history as the light of truth and the school of life, insisted that such lessons could be conveyed only when a serious discussion, worthy of interesting posterity, had rid itself of boring and frivolous details.[10]

But this view of history was based on the assumptions of permanency and unilateral meaning. If human hearts were always and everywhere identical, then these moral precepts would not be subject to coincidental aspects such as temperament or culture, which would need to be detailed pedantically. Aristotle had insisted on the primacy of plot over character; tragedy was an imitation not of human events but of their meaning.[11] Hume built on this premise by insisting that events were mere repetitions of universal principles, iterations of eternal moral precepts, which should be the focus of historical analysis. He wrote in 1748:

> It is generally acknowledged that there is a great uniformity among the actions of men, in all nations and ages, and that human nature remains still the same, in its principles and operations. The same motives always produce the same actions: The same events follow from the same causes . . . Would you know the sentiments, inclinations, and course of life of the GREEKS and ROMANS? Study well the temper and actions of the French and English: You cannot be mistaken in transferring to the former *most* of the observations you have made with regard to the latter. Mankind are so much the same, in all times and places, that history informs us of nothing new or strange in this particular. Its chief use is only to discover the constant and universal principles of human nature, by shewing men in all varieties of circumstances and situations, and furnishing us with materials, from which we may form our observations, and become acquainted with the regular springs of human action and behavior.[12]

But French citizens in 1815 knew that they were no longer the same people they had been in 1789. They knew that the course of events had proceeded coincidentally as well as intentionally. The French Revolution

broke apart the secure assumption of permanent meaning that could be expressed in universal emotion. In this chapter, we shall examine the changes in historical narration after the impact of the Revolution, when traumatic memories encouraged new styles that privileged vivid description and psychic identification. New expectations of historical truth forced a reevaluation of historical painting.

SEEING THE PAST THROUGH MEMORIES
AND ANALOGIES

In 1815, as the dust settled from twenty-five years of revolution, invasion, and political turmoil, the French looked to the past to enable them to understand why catastrophe had overtaken them. The generation of historians who had lived through turbulent historical events sought salvation in historical literature. For Chateaubriand, historical comprehension meant the ability to assuage his guilt at surviving: "Why did I survive the century and the men with whom I shared the date and hour of birth when my mother inflicted life on me? Why have I alone remained, to look for their bones in the shadows and dust of a world in ruins?"[13] Edgar Quinet's own traumatic memories made him aware of history's significance and vitality:

> The invasions of 1814 and 1815 had left a foundation of memories through which I saw everything. The collapse of a world had been my first lesson. I sought in the past anything that resembled those great upheavals that had been the first sight to strike my eyes. Because of these analogies, history, which had been dead for me, became a living thing.[14]

Barante was even more candid when he explained the relationship between his own experience and the development of his new sense of history; his frightened generation had seized historical narration as a weapon of self-defense. They had experienced the impact of world events on individual lives; history would reveal the underlying causes of terrifying political fluctuations, and a knowledge of history would be their protection from coming cataclysms.[15] Barante promised that historical studies would not only decipher the past but secure the future:

> we had seen so much history made that we wished to find in the past something of what we had seen and lived through. And furthermore, our experiences had now given us the key to understanding things in a way impossible for even men of genius who had lived in an age of peace and order ... what makes our century eminently historical is that now, all moral sciences explain through narration. Instead of renovating systems, they wish to describe them; instead of judging them, they attempt to explain the circumstances in every epoch that produced them. They are less interested in the errors committed than in what made those errors necessary. In every way possible, historical

studies are working for progress, seeking in the past reasons for us to entrust ourselves to the future, giving the historian the exalted mission of serving as a prophet.[16]

It was universally accepted that this generation was the first to understand history, the first to sense its vitality and its meaning. Thierry reassured his fellow Frenchmen that their experiences had given them a priceless legacy:

> Every sensible man, instead of being satisfied with monarchical or republican abstractions from writers of the ancien régime, should consult his own memories and use them to verify what he has read or heard about those events of another day. He will soon sense something alive under the dust of time. For there is not one of us, men of the nineteenth century, who does not know more than Velly, Mably, even Voltaire himself, of rebellions, conquests, the dismembering of empires, the fall and restoration of dynasties, and democratic and despotic revolutions.[17]

Chateaubriand, Quinet, Barante, Thierry were expressing views that were shared by the entire nation: authors, readers, artists, critics, and spectators.[18] History, now a "living being," as Quinet had said, had to be redefined through new forms of historical writing, which could integrate traumatic memories into comprehensible meaning and so ensure the nation's future stability.

MEMORY, OPTICAL SCINTILLATION, AND THE BROKEN MIRROR OF MORAL PRECEPTS

After 1815, French historians hoped that subjective and partial memory could contribute to a cultural viewpoint, expressed in imagery that would be both vividly personal and resonant with national meaning. This history centered on memory, was constructed out of tormented survival, traumatic loss, and the conviction that retrieving the past would ensure a better future.[19] Citizens would then be able to pass from their individual, partial, and involuntary memories to the collective, willed construct of national memory-history.

This sense of the past insisted on the specific nature of a place, a portrait, a monument. It also utilized the specific facts of one event to throw light on another, in "comparative history," the typological interpretation of the recent past through its resemblance to the distant past.[20] Both conservative and liberal historians established their control over traumatic memories of the recent past by perceiving a relationship between recent events and events in the distant past, particularly those that had occurred in England during the sixteenth and seventeenth centuries: imprisonment and execution of monarchs, civil war, military interregnum, restoration, and the substitution of another dynasty. The French

and the British had their catastrophes in common. In order for these analogies to be truly instructive, instead of mere propagandistic glosses, they would have to be examined in detail. Villemain, warning against succumbing to the "puerile interest of contemporary allusions" in 1819, concluded that the remedy was meticulous description of unique circumstances: religion, site, mores.[21]

When victims of a catastrophe wish to compare experiences, they insist on concrete, detailed narration. If we suffer a physical injury, we reassure ourselves and predict our survival by making an inventory of our symptoms. Similarly, the historian Macaulay sought to diagnose the symptoms of revolution:

> As the history of States is generally written, the greatest and most momentous revolutions seem to come upon them like supernatural inflictions, without warning or cause. But the fact is, that such revolutions are almost always the consequences of moral changes, which have gradually passed on the mass of the community, and which ordinarily proceed far before their progress is indicated by any public measure. An intimate knowledge of the domestic history of nations is therefore absolutely necessary to the prognosis of political events. A narrative, defective in this respect, is as useless as a medical treatise which should pass by all the symptoms attendant on the early stage of a disease and mention only what occurs when the patient is beyond the reach of remedies.[22]

After their Revolution, the French urgently needed to ascertain such a political prognosis. Thus, they needed to study the specific details of characterization that Macaulay insisted upon, and that Marmontel had found boring and frivolous. They insisted on a vivid narrative, rather than a clarified enactment, for they were now seeking a way to render actual experience rather than its eternal moral lesson. They wished to study the contrapuntal play of multiple protagonists upon each other, to sense psychic as well as physical experience. But, as Mercier recognized at the trial of Louis XVI, that was impossible. The very vividness of the experience prevented its logical analysis and its linguistic synthesis. There were too many participants, whose principles were constantly being replaced by new ones. There was no explanation of events, not even continuity between them. Experience was "optic," a dizzying flux of details:

> of all I saw there, nothing can be described as it occurred, that would be impossible, unimaginable, history cannot achieve that. Well, that is the way that it is with noteworthy days. I was there, but I didn't know where I was; that is, I didn't know the dangers and fascinations that surrounded me. Since all revolutionary crises are composed of infinitely small factors, they generally surprise the eyewitness. Almost all of them have not only been unexpected, but unbelievable . . . And yet those who were there attempt to explain the causes of this or that revolutionary event. They confuse time, place, and people. How is the

historian to solve this problem? How is he to avoid being misled by his own point of view, when those who have taken the greatest pains have been distracted by this incessant, inordinate optical flux?[23]

Carlyle, who cited Mercier's phrase in his own *History of the French Revolution* (1837), described experience as a "Chaos of Being":

> every single event is the offspring not of one, but of all other events, prior or contemporaneous, and will in its turn combine with all others to give birth to new; it is an ever-living, ever-working Chaos of Being, wherein shape after shape bodies itself forth from innumerable elements. And this Chaos . . . is what the historian will depict, and scientifically gauge, we may say, by threading it with single lines of a few ells in length! . . . Narrative is *linear*, Action is *solid*.[24]

How were historians to provide narratives that were vividly descriptive yet did not disintegrate into mere successive details? How were they to narrate "optical flux"?

When we say that we learn from the past, we are reassuring ourselves that historical meaning exists under the chaos of sensory experience, awaiting our recollection and our figuration in narrative representation and explanation. Recently, Ricoeur has explained the transition from episodic experience to a unified and constant message according to three levels or dimensions: "within-time-ness," "historicality," and "deep temporality."[25] The first level, the insistent and repetitive "now" of physical experience within the natural environment, gives us chronological measurability and succession: hours, seasons, years. In the second level, flat chronology is superseded by configuration or narrative emplotment. The succession of "nows" reaches a conclusion that is satisfying in terms of chronology and meaning.[26] This achievement of configuration, "making sense of our past," allows us to move into the future with confidence. Temporality, the third level, is the psychic fusion that unites past, present, and future: an existential deepening of time into three dimensions. The current of past time is reentered by one in the present and is fully known. The current of sensory chaos is mastered, but without being choked off into isolated acts or analytical judgments. After the Revolution, French historical writing experimented with all three approaches, each appealing to a different political audience: the hallucination of the "now" in fragments (preferred by Ultraroyalists); the willed configuration of meaning in dramas (preferred by Conservatives); and temporal fusion in psychic resurrection (preferred by Liberals).

POLITICS AND HISTORY:
EULOGY, ANALOGY, EMPATHY

"The best way of giving the government your political opinions is to publish a good history of France": this theory held true for both Conser-

vative and Liberal historians during the French Restoration.[27] Historians had political as well as scholarly intentions. They sought lessons in the past and wrote descriptions of the past that were intended to prepare present-day citizens for the future.

The three historians whose works we shall be examining all had active careers in politics. Marchangy served as the government prosecutor for the Carbonarist La Rochelle conspirators in 1822; Thierry was a Carbonarist. Chateaubriand, author of *Du Buonaparte et des Bourbons* (1814), was one of Louis XVIII's ministers at Ghent, where the king had taken refuge during Napoleon's Hundred Days (March 28–July 8, 1815). He became ambassador to Britain in 1822. Political sympathies formed their style and directed their choice of subject matter. Marchangy, an Ultra, lamented lost civilizations. Chateaubriand, a Conservative, framed analogies between events in the present and those in the past. Thierry, a Liberal, resurrected cultures through empathic insight. In the following chapters, we shall examine how the approaches that Marchangy, Chateaubriand, and Thierry employed in literature, which I shall call, respectively, "phantasmagoria," "dramatization," and "psychic identification," were mirrored in or directly affected the visual representation of history.[28]

Their three approaches were reflected in three visual avenues to historical evocation: through object, gesture, or insight. History could be understood as the lucid viewing of concrete fragments of the past, the witnessing of actions in the past, or the present's emotional identification with the past. Each of these approaches had a unique contribution to make in the ongoing struggle to redefine historical representation. Each of them throws light on a separate aspect of pictorial theory. The first, phantasmagoria, was related to the growing importance of local color. Previously, local color had been a reticent descriptive factor; now it conveyed the pious meaning of a painting. The second approach, dramatization, reinterpreted Aristotle's moral dramatic action as physical and temporal action and thus unbalanced the meaningful visual instant. The third approach, psychic identification, fragmented centralized and unified compositions, creating multifocal works that could address the spectator's empathy, imagination, and memory as well as sight. These models for historical narration were produced simultaneously, but there was a chronological sequence for pictorial developments. The homage of painters of the Troubadour school to the relics of iconoclasm points back to the Revolution, whereas Romantic depiction of thought rather than object points forward to stylistic developments during the latter half of the nineteenth century.

Marchangy and Barante's Ultraroyalist histories exemplify the first stage of imagining the past, "within time." Barante realized that readers who had themselves been witnesses to great events wished to see the original actors, the original sites, just as they observed in concrete detail "the great drama in which we are all actors and witnesses."[29] Mar-

changy's history, *La Gaule Poétique, ou l'Histoire de France considérée dans ses rapports avec la Poésie, l'Eloquence et les Beaux-Arts* (1813–17), and historical fiction, *Tristan le Voyageur, ou la France au XIVᵉ siècle* (1825), were written while the writer and many French people still felt an agony of loss: they needed to return to the tombs of dead ancestors, to study the fragments that remained as a legacy from the past. Catastrophe had covered the landscape with ruined buildings, visual testimony to the destruction of a past civilization's political structure and religious beliefs.[30] Marchangy and Barante intended the viewing of such relics to awaken the audience's nostalgic piety, and so lead them from the concrete to the spiritual. Marchangy wrote: "Observation, as well as taste and feeling, almost always grasps only details; thus, their depiction immediately claims the reader's attention, directs it to what has been seen, and renews within him memories and impressions."[31] As Barante later argued in the Chambre des Pairs, supporting the founding of the Musée de Cluny, the sight of medieval antiquities would awaken a hunger to know the events that lay behind these evidences of past existence, a far more urgent hunger than that awakened by texts: François I's spur, Diane de Poitiers' mirror would "engrave memories on the soul through the eyes."[32]

Almost immediately, however, historians worked to integrate "within-time" into "historicality," seeking a meaningful integration of experience. The second, "dramatic," stage of historical comprehension was hailed in 1824 in an article in the *Revue Européenne* on the state of French historical studies. It described the historical viewpoint during antiquity and the Middle Ages: naïve, curious, its audience was satisfied by poems or chronicles that recounted the actions of heroes. Then, during the philosophical eighteenth century, men had the leisure to engage in dissecting the rationale behind such actions. The gain in intellectual rigor, however, had been at the cost of historical vivacity and truth. Events had been denatured, becoming mere data cited to prove a general theory. But now social conditions made it imperative that historians reveal the multifaceted nature of heroes and how they had influenced the development of political institutions.[33]

"Dramatic" history was both the most conservative form of historical narration and the most popular. Unlike the "chronicle" of medieval life (which appealed to the aristocratic elite), dramatic biographical history was appreciated by a mass audience. Chateaubriand's *Les Quatre Stuarts* (1828) was written as an attempt to proclaim closure of the "drama of revolution" for the present-day Bourbons, whose lives had so many unhappy similarities with those of the Stuarts.[34] The "personified" version of "dramatic" history sought its lessons in the lives of individuals such as Joan of Arc or Christopher Columbus, incarnations of their age. The character of the hero or heroine was evident in a gesture, a saying, an action.[35] When history was considered according to this conservative historical

viewpoint, the focus was on a sequence of actions encapsulated in time, a viewpoint that could easily be translated into pictorial enactments.

But Liberal historians attacked dramatic historical writing on the grounds that it oversimplified social situations, reducing them to clashes of personality in the lives of leaders. Instead, the focus of the Liberal historians was on the cultural situation that had made such leadership inevitable:

> History proves that revolutions are the inevitable, necessary, irreversible result of the way in which people have been governed over a long period of time. A revolution can occur only if oppression has preceded it . . . A short-term, superficial view personifies revolutions in men: thus the Reformation is Luther; the first English Revolution is Cromwell; the second William; the Terror is Robespierre; the Empire is Napoleon . . . Those who think this way find it easier to understand men than matters, and when they have insulted the former, they think that they have assessed the latter. But those who have some idea of events and ages relate cause to effect.[36]

Liberals, during the Restoration, insisted on the historical importance of cultural experience. Saxons, Greeks, Gauls had played a major role in their respective nations' evolution, though invasion and oppression had hidden their efforts beneath a dynastic imprimatur in a multitude of ways, from physical violence to the suppression of idiomatic vocabulary. But how could historians write the history of those who had not been in power, who had been unable to commission verbal or visual testaments? How were they to speak the thoughts of the dead?

In his *Histoire de la Conquête de l'Angleterre par les Normands* (1825), Thierry enjoined the reader of his history to let his imagination "repeople the land" of eleventh-century England with the heirs of the Norman Conquest and their Saxon serfs:

> Let him imagine their situation, their concerns, their different languages, the glee and insolence of the former, the wretchedness and terror of the latter, everything that accompanies two great populations engaged in a war to the death . . . These men have been dead for fully seven hundred years, their hearts stopped beating with pride or anguish seven hundred years ago, but what is that to the imagination? For the imagination there is no past, and the future itself is in the present.[37]

For Michelet, history was not the contemplation of fragments that had belonged to past existence or the witnessing of the edifying actions of heroes. History was the apotheosis of humanity, the fusion of time, "resurrection."[38] In 1842, he dreamed that the dead were imploring him to speak for them:

> a throng weeping and lamenting . . . who want to live again . . . "We died, still stammering. Our pitiful chronicles confirm that . . . May someone come who knows us better than we ourselves do, to whom God has given a heart and ears to hear . . . the sad, shrill voice and the

feeble breath . . ." . . . We must hear the words that were never spoken, which remained in the depths of hearts (excavate yours, they are there). We must make the silences of history speak, those fearsome organ pauses when history speaks no more and that are precisely its most tragic tones . . . Precious urn of times past, the pontiffs of history bear it and pass it on to each other, with such pity, with such tender care! (no one knows it better than they themselves), as if they were bearing the ashes of their father and their son. But is it not themselves?[39]

Michelet, speaking for and to the dead, speaks to himself as well, as the priestly procession rises above the coffin of chronology. Such a vision could not be rendered through concrete relics or the staging of a moment. The third, Romantic, approach sought the third level of temporality: a psychic fusion of past with present. For Romantics like Thierry or Michelet, history was neither nostalgia nor the witnessing of catastrophe. It did not seek to retrieve what had been lost, nor did it wish to be present at the moment of loss. History was still present, through the magical resurrection of the dead, who were, who are, ourselves.

This inner experience of identification and resurrection required a completely different visual language from that which could describe external, concrete, temporal aspects. Michelet's description of the spirit of France in the first year of the Revolution was freed of any ties to chronology or place:

> *geography* itself is *annihilated*. There are no longer any mountains, rivers, or barriers between men . . . Such is the power of love . . . *Time and space*, those material conditions to which life is subject, *are no more*. A strange *vita nuova*, one eminently spiritual, and making her whole Revolution a sort of dream, at one time delightful, at another terrible, is now beginning for France. *It knew neither time nor space*.[40]

Carlyle had sought to narrate experiential history, Mercier's "optical flux." Describing such seminal but invisible events as the coming of the Iron Age, Carlyle warned: "The inward condition of Life . . . is the same in no two ages; neither are the more important outward variations easy to fix on, or always well capable of representation."[41] How could the psychic experience of historical events be described in narrative? Could this new sense of history be rendered in visual terms?

We have seen how Aristotelian guidelines to historical narration ceased to hold sway. We must now turn to consider challenges to Aristotelian guidelines in the visual arts, and the impact of political and economic factors on aesthetic goals.

PAINTING THE PAST:
THE SIGHT OF SENTIMENT

To elevate the soul and move the heart, historical paintings not only had to depict significant themes in an ideally beautiful manner, they had to be created in a scale and placed in a site in which their public address

could be effective. As an essayist wrote in 1797, for a competition on the question "How may the arts influence the mores and governance of a free people?", it was a matter of "the sight of sentiment."[42] Paintings of life-size figures in monumental scale could be supported only by monarchical or national institutions, by the Church, or by major collectors, whose taste, critics hoped, would be similar to that of the court: enlightened connoisseurs. As we saw in Chapter 1, this delicately balanced harmony among historical precept, elevated style, and monumental scale began to come apart even before the Revolution.

The distinction between historical painting's moral address and genre painting's realistic replication was reiterated with increasing desperation during the Restoration by those who supported the "beau idéal." Those wishing to maintain the moral impetus of historical painting by placing large-scale works in public sites were careful to define their purpose aesthetically rather than intellectually or thematically, and so maintain the hierarchical priority of historical painting (philosophical truth) over genre painting (material fact). They warned that patriotic subjects from modern history could have an adverse effect if they lost their moral impulse; that is, if illusionistic, differentiated description of modern costumes, accessories, and architectural sites broke up the essential elements of classical beauty: the broad and pure masses of tone, and the informed but simplified lines of the human body. Quatremère de Quincy, defender of neoclassical idealism and secrétaire perpétuel of the Académie Royale des Beaux-Arts, took the opportunity, in delivering his eulogy for Girodet in 1825, to decry Napoleon's having "drafted painting into the army."[43] Earlier that same year, he had delivered an address to the Institut de France on the "abuse" of depicting modern subjects in painting, concluding that only the ignorant, the vulgar, or hypocrites who vaunted their patriotism in order to destroy their nation's artistic genius would wish to see depictions of modern historical subjects.[44] Even those who appreciated the Troubadour artists' selection of themes from national history worried that their small-scale presentation of the themes mitigated against the paintings' moral impact on viewers. The royalist Miel urged the government to commission such paintings as large-scale works that could be placed at the sites of the original events.[45] This brings us to the economic factors that influenced historical art: whether such paintings were officially commissioned for public sites or acquired after the fact by private collectors, and how they became available for the public to see in exhibitions and graphic reproductions.

POLITICS, ECONOMICS, AND AESTHETICS: VIEWING AND REVIEWING HISTORICAL ART

Miel and Quatremère de Quincy were voicing their concerns in an age when centralized control over artistic employment, exhibition, and criti-

cal reception was being challenged. Given the economic and political factors mandating monumental scale and public sites for historical art, we can understand why the idea of exhibiting academicians' art works had originally been viewed with alarm. Historical painting should be visible in the palaces and churches of France. What reason could there be to exhibit them separately, if not sordid commercialism? In the original Salons, no entrance fee was charged, and no works that were for sale were permitted exhibition space.

But during the Restoration, the situation was fragmented, even within the royal family. The government of Louis XVIII and Charles X commissioned not only classicist religious paintings for churches (remedying Revolutionary vandalism), but Troubadour works for the Galerie de Diane at the Château de Fontainebleau. Troubadour paintings formed an important part of the collection amassed by Charles X's son, the duc de Berry, and his wife, who preferred small-scale works with high finish.[46] Meanwhile, Charles X's cousin, Louis-Philippe, the duc d'Orléans, commissioned Napoleonic subjects from Horace Vernet.[47]

The taste for small-scale modern works was cultivated by art dealers for commercial reasons. This affront to artistic centralization was often described by classicists as a moral conflict between didacticism and greed, evident in an aesthetic conflict between high and low art. In their eyes, the former, traditional history painting, at the apex of the genres, was moral in its intent, elevated in its style, monumental in scale, and supported by national institutions. The latter was lower, lesser, smaller in every way: appealing momentarily to the eye and the heart instead of permanently transforming the soul, stylistically realistic or even trompe l'oeil, small-scale works made for the delectation of individuals in their homes.[48] Binant, Giroux, Gaugain, Sazerac and Duval-Lecamus, Schroth, and Arrowsmith were a few of the dealers who provided not only commercial support for artists, but a venue for their art to be seen in public, both the original paintings and engravings after them. Their taste (and that of their clients) was for sentimental subjects described with an immaculate finish, whether by earlier artists (seventeenth-century Dutch masters or Greuze) or by modern artists (Troubadour painters), as well as by the dramatically expressive Delaroche and Horace Vernet and the painterly Romantics Constable, Bonington, and Delacroix.[49] Henri Gaugain exemplifies this trend toward establishing an alternative site of exhibition for small-scale works in the Romantic style, as well as graphic reproductions of them. After 1829, his commercial "expositions" of modern art, for which he charged admission at the "Musée Colbert" (actually just rooms in the building that housed his lithographic firm), challenged the free-of-charge but stylistically restrictive "exhibitions" of the Salon du Louvre. Given the economic pressure that modern artists faced as a result of the government's reduction of its arts budget and its refusal to make the Salon an annual event, even Farcy, who detested Romanticism, was forced to ap-

prove of Henri Gaugain's offering artists a place where their works could be seen.[50]

The cultural impact of these private exhibitions by dealers and by artists (the most celebrated example being Horace Vernet's private exhibit in 1822 of Napoleonic paintings that had been excluded from the Salon) was extended by the publicity offered by sympathetic critics, who acknowledged that such exhibits (and such reviews) were challenging the hegemony of the juried Salon and the official press. Even before the Revolution, private pamphleteers had challenged the official reviewers of the Salon. During the Restoration, the introduction of the mechanical press in 1823 made publication less expensive (by the July Monarchy, the number of journals had doubled), and intermittent freedom from censorship meant that journals expressed a broad spectrum of political opinions, ranging from the Ultraroyalist *Oriflamme* and Chateaubriand's *Conservateur* to the right-wing *Moniteur universel, Journal des Débats, Quotidienne, Gazette de France,* and *Drapeau blanc;* to the Liberal opposition *Constitutionnel, Minerve Française, Censeur Européen, Courrier français, Revue encyclopédique, Album, Pandore,* and *Miroir des spectacles;* and the radical *Globe* and *Producteur.*[51]

The critics who reviewed historical paintings in these newspapers were balancing expectations regarding the moral address of historical painting (as opposed to genre painting's material truth), expectations regarding the formal aspects of historical painting (which could range from Neoplatonic ideal beauty through individuated, naturalistic beauty through expressively distorted form and overt brushwork), expectations regarding the public address of modern art (incorporating the factors of scale and site), and expectations regarding history itself (which, as we have seen, directly reflected a modern political stance). Critics, particularly the Liberal ones (Bonapartists, Orléanists, Republicans, and Saint-Simonians) who supported Romanticism, frequently insisted that it was impossible *not* to conflate politics with aesthetics.

There were several reasons why aesthetics and politics intersected in this way, and why I shall be signaling the political as well as the aesthetic position of critics when citing their reviews. First, and most pragmatically, most of the critics were neither artists nor art professionals and were far more interested in thematic choice than in pictorial interpretation. Second, many of these men had turned to art criticism when their military careers abruptly ended with Napoleon's abdication; Jal, Stendhal, Etienne Jouy, Anthony Béraud, Amand-Denis Vergnaud are well-known examples. Their support for Romanticism was at least in part an attack on Bourbon institutions that supported classicism and royalist private collectors whose taste often ran to Troubadour works.[52] When Jouy and Jay reviewed Vernet's exhibition, they were validating their own past support of Napoleon, as well as Vernet's anticlassical aesthetics and his right to challenge the state mechanism for exhibition.[53] Third,

because of the government's strict censorship of the press, which made openly political journalism dangerous, many art reviews (by Royalists and Liberals alike) were written and read as political statements. This does not mean, however, that such politically intended reviews were devoid of artistic insight. In fact, because their discussion centered on the historical significance of the subject, which is of paramount importance for our concerns here, we often find politicized tracts about modern events in France and Greece valuable assessments of the issues facing the modern historical painter. The Liberal critics' discussions of Géricault, Ary Scheffer, and Delacroix often provide the most perceptive analyses of the problems of modern historical painting, as well as the most sympathetic responses to Romantic aesthetics.

It will be helpful to imagine an aesthetic continuum for the most perceptive and influential critics during the Restoration, and to see how it parallels (or at times contradicts) the range of historical and political opinions. Aesthetically left of center, and particularly relevant to our interests, were the historian–art critics, most notably Thiers (though Guizot had reviewed the Salon of 1810) and the historical dramatist and art critic Vitet.[54] The politically Liberal historians Thiers, Vitet, Guizot, Rabbe, and Arnold Scheffer advocated specificity in the description of cultural mores in historical texts and the presentation of material truth rather than atemporal beauty in the visual arts. Thus, they supported the modern school of historical painting led by Delaroche and Horace Vernet, politically Liberal and pictorially moderate, given their realistic replication of modern objects and their compositional innovations. Farther left of center, both aesthetically and politically, were those willing to promote artistic free expression (even to the limits of Delacroix's radical abstraction) and a popular rather than monarchical interpretation of history. The pro-Romantic *Globe* was led by Carbonarists; after 1831 it became an organ of Saint-Simonian social idealism, as was the *Européen,* where Piel and Buchez published their diatribes against Delaroche.[55] Alternatively, the early Romanticism of Victor Hugo (who had vowed to be "Chateaubriand or nothing") combined Christian, Gothic spiritual address with Ultraroyalist political sentiments, and was published in the journals *Conservateur littéraire* and *Muse française.*

Aesthetically right of center were the advocates of the classical "beau idéal," who defined historical painting according to its communicative formal beauty; most prominent were Charles-Paul Landon and Etienne-Jean Delécluze.[56] Delécluze, a former student of Jacques-Louis David, defended modern French art against attacks from two opposing directions, censuring the ugliness of realism and the unintelligible sketchiness of Romanticism, brushwork which he compared to the blowzy Rococo style fashionable during the ancien régime.[57] Other former students of David carried on his liberal politics and his suspicion of official art institutions, as well as his classicist formal preferences. Pierre-Alexandre

Coupin published in and later edited the Liberal *Revue encyclopédi-que.*[58] The *Journal des Artistes,* an explicitly anti-Romantic journal, with a staff composed of former Davidians, was established in 1826 by Charles Farcy, who had also published pamphlets against the Bourbons and had founded the Société Libre des Beaux-Arts in 1830.[59] Auguste-Hilarion, comte de Kératry, was a supporter of the Davidian school and a Royalist, but his reading of Diderot sometimes persuaded him to sacrifice formal purity to expressive power.[60] It should be clear by now that the complex critical debate cannot be framed along strictly politically partisan lines, whether Liberal or Conservative; it must be followed simultaneously on all three levels: historical, political, and aesthetic.

We began with Delécluze urging the application of Aristotelian theatrical guidelines to historical painting, without admitting that Aristotle had written them for tragic and poetic rather than historical literature. In 1829, Jacques-Nicolas Paillot de Montabert, like Delécluze a former student of David, was willing to go even farther than Delécluze to save art from the pedantic visual effects of the Troubadour artists and the shocking dramatic effects of Delaroche and the Romantics. In order to rescue historical painting from the abuses of the past thirty years, he went so far as to define historical painting morally, philosophically, and poetically, but *not* historically. Paillot de Montabert warned artists to be wary of assessing historical works according to their subject matter, mimesis, erudition, or emotional impact. He insisted that Troubadour optical illusions and dramatic historical spectacles did not achieve the goal of true historical painting, which was "morally beneficial" beauty.[61]

But he was speaking into the wind. During the Restoration, the past was no longer considered a storehouse of moral precepts. Now, historical narrative was being framed in a multitude of ways, including a series of unique moments, described with full visual specificity. Now, Aristotle's unity of action in a plot was replaced by the vivid description of facts, of episodes. Now, seeing history through analogies, surrounded by the concrete ruins of the past, memories's meaning lay in material presence: in relics. The historical painter could depict moral meaning and emotion through material elements, addressing the spectator's imagination through the concrete resurrection of another age. In the next chapter, we shall see how Troubadour artists adapted traditional guidelines of historical painting in response to new assumptions of historical meaning.

"PRECIOUS RELICS FROM THE SHIPWRECK OF GENERATIONS":
THE MORALITY OF LOCAL COLOR

INGRES'S *Entry into Paris of the Dauphin, Future Charles V* (Fig. 4, Pl. 1) is a small, jewel-like vision of a past time: chaotic reality is transformed into tesserae, flat and brilliant decorative elements.[1] The scintillation of spectacle controls the viewer's comprehension of actions and events. In 1356, after Jean II (le Bon) was defeated at Poitiers and captured by the English, his son became regent. But monarchical rule was resisted by the Estates General, led by the provost of merchants Etienne Marcel, whose followers wore hoods. Their resistance was encouraged by Charles II, king of Navarre, cousin of the former king and pretender to the French throne. In March 1358 the dauphin had to flee Paris, fearing for his life. In May, the bloody peasant uprising known as the Jacquerie broke out; it was suppressed by the nobles and those loyal to the dauphin. Marcel prepared to give Paris to the king of Navarre, but loyalists, led by the alderman Jean Maillart, discovered and foiled the plot. Marcel was murdered at the Porte Saint-Antoine, when he attempted to open the gates of the city. The dauphin entered Paris a few days later, on August 2, 1358. In the painting, the ominous prelude to this joyful return in 1358 – defeat in battle, bourgeois and peasant revolts, conspiracy, and assassination – is confined not only to a corner of the scene, but to the animal kingdom: the mongrel dog gnawing on the hood in the lower left, just above the artist's signature.

The work was commissioned by the comte de Pastoret as testimony of his loyalty to the returning Bourbons.[2] His ancestor Jehan de Pastoret, first president of Parliament, plays a central role, welcoming the dauphin with head uncovered and hands outstretched. Joy at the dauphin's safe return is justified by the dauphin's willingness to reconcile the warring factions in his kingdom: a kneeling woman with her child, supported by a nun, predicts his generous act of restoring lost property to the family of his former enemy. But our eyes are distracted from the hands layered in

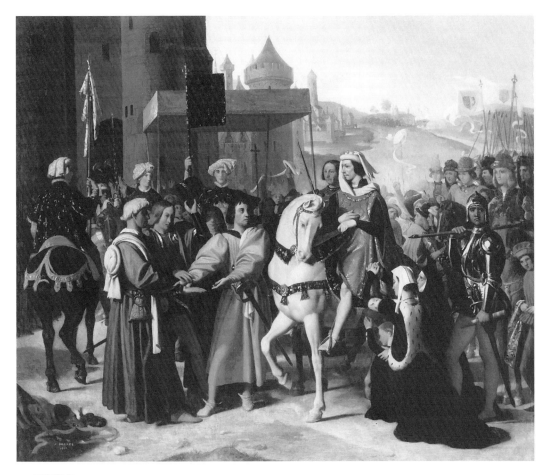

FIGURE 4

Jean-Auguste-
Dominique Ingres,
*The Entry into Paris
of the Dauphin,
Future Charles V*
(1821). Hartford,
CT, Wadsworth
Atheneum. Oil on
panel, 47 × 56 cm.
(Photo courtesy
Wadsworth Athe-
neum, Hartford.
Gift of Paul Rosen-
berg and Company.)

gestures of fealty to the harness of the horse, which is suddenly reined back from the loyalists, and our gaze slides from the hands knit together and held aloft in petition to the ermine trim that loops back in response. The stiff dorsal and frontal presentation of the heralds at left, further frozen by the verticals of dais and flags, is overwhelmed by the brilliantly embroidered gilt fleurs-de-lis; the profile stance of the soldier at right, who faces toward us (Ingres's self-portrait), is overshadowed by the glaring reflections from his armor. The crisp presentation of costumes and accessories halts time and transforms the scene into a jigsaw puzzle of material elements, all of them significant, for all of them testify to the physical embodiment of the past. The past arranges itself into a medieval miniature, a chronicle by Froissart as seen by Fouquet.[3] As a modern imitation of medievalism, it asserts both that the past is over and that it can be recaptured by hallowing its visual elements, much as a modern pilgrim contemplates the remnants of a martyr, contained in a jeweled reliquary. Brilliant but static, spectacle conveys the meaning that had been the province of moral action.

Ingres's pictorial approach in this work is very different from the allegorical ideality of his *Apotheosis of Homer* (Fig. 1), but in both cases

his selection of a visual style was correlated with the subject matter. He thought that a subject from the Middle Ages, a period of feudal loyalty and Christian spirituality, required the accurate presentation of its beautiful costumes, for they expressed the age's fidelity and mysticism.[4] We could assume that the same principle applied to the visual style of the clothing's depiction: brilliant colors, applied without intervening tones to link them into presumed three-dimensionality, recall illuminated manuscripts.

Such antiquarianism had a moral intention. Girodet, although, like Ingres, a student of David, nevertheless was drawn to pay homage to the spiritual grandeur of French medieval culture by describing its concrete elements with pious accuracy. In a poem, Girodet advised French artists to paint medieval battlements, or rooms whose walls were patterned with coats of arms, or even dungeons, for there everything spoke of love, honor, valor, piety, and fidelity to liege and lady: "their character was portrayed in their decor."[5] If character were evident in decor, then historical meaning could be found in object instead of in action. Thus, the most appropriate visual style for depicting the meaning of medieval history, intellectually as well as chronologically, would be a style of picturesque naïveté, one that humbly retraced the fragments of this virtuous past and reconstructed, in radiant reality, the beloved but lost objects and culture of the past. Illusions of antiquarian objects would serve as precious relics on which the modern viewers could focus their senses, to arouse memories and emotions. In this chapter, we shall see the aggrandizement of local color from an instructive but ancillary aspect in historical painting to its source of moral meaning.[6]

Aristotle had insisted that spectacle was unnecessary, that tragedy could obtain its effect on the soul without performance, solely through narration of the plot.[7] Even before the Revolution, however, and increasingly during the Empire and the Restoration, aesthetic theoreticians and artists had insisted on an accurate observation of antiquarian details to situate a scene in time. In such works, "local color" was to be adjusted from constant and unvarying truth toward accurate coincidence, though without distracting attention from the moral action.

The Troubadour works that we shall be examining in this chapter functioned differently, for in them local color became a participant in the action, and even at times the motive force behind moral and expressive address. This new sense of local color was passionately committed, rather than lucidly documentary; although it celebrated objects, it was by no means objective. Grief for those who had been destroyed, for decapitated kings and queens and for guillotined, imprisoned, and wounded loved ones was deflected onto ruined objects. Optical illusions of those objects were created, in the hope that radiant relics would be able to reestablish the tie to the beloved dead and resurrect the past. In this chapter, we shall see an evolution from a figural art predicated on

moral action to an art in which precious relics solicited the attention of royalist spectators, to awaken their living memories.

Archaeological fragments were "mute but incontrovertible witnesses to the shipwreck of generations," said the antiquarian-engraver Nicolas-Xavier Willemin in his preface to a multivolume, beautifully illustrated treasure-house of such "precious relics."[8] When those whom we love die, we treasure the fragments of their past existence that remain in our possession. Our love, our memories, and our yearning to prolong our union with them even after the termination of their span on earth make us invest even the most trivial keepsake with emotion. The careful illusionism that we shall see applied to broken columns, to urns, to mausolea was not pedantry but piety: honoring the lost past by portraying its physiognomy with absolute specificity. The spectator was expected to take a similarly pious role: to attach memories and emotions to the objects depicted with such radiant clarity, and to meditate on these relics of past civilization. As the historian Barante would say in 1843, in his speech arguing for the creation of the Musée de Cluny, "Memories engrave themselves on the soul through the sight of relics."

If we find it difficult to understand how passionate emotion could be aroused by object rather than by subject, by decor rather than by figure, we should remember that the shift in the role of local color was accelerated during the Revolution, inspired not only by pious grief but by terror. Richard had fled Lyon in 1793, when it was besieged by revolutionary forces. In July 1794, the day after he arrived in Paris to visit his brother, he watched Louis XVI's sister, Madame Elizabeth, being taken to the guillotine. During the Revolution and thereafter, the active focusing of memory on the relics that remained, combined with their severing from narrative context, was a mechanism of defensive control, as well as one of remembrance. Memories of death and destruction, which were unbearable and yet had to be borne, could be assuaged through viewing an illusion of the past's reappearance.

Meditating on a relic and viewing an action require that the spectator adopt entirely different roles. The Troubadour painters Richard, Révoil, Bouton, and Coupin de la Couperie wished to elicit a meditative, contemplative response from their viewers, and so encouraged them to scrutinize each object in turn rather than immediately comprehending an action through a centralized, pyramidal grouping. The concrete fragments of history became the guiding force of the work's inspiration, thematic selection, compositional arrangement, and technical finish, even to the point of overwhelming the figures. Thus, these artists had to completely reinvent the rules of visual composition. The paintings were bound to be given a hostile reception by classicist critics. What is surprising is that these artists were willing to make such an attempt at all, that their productions were acquired by the government

and the court, and that some critics welcomed their efforts. In these unusual, object-oriented works, we see the exaggerated repercussions of a viewpoint that permeated all Troubadour painting, and that affected all historical painting: the insistence on the increasingly specific description of local color.

Consonant with this orientation toward object rather than figure is the denial of narrative context for the scene, the elimination of action. As we shall see, memories of the traumatic impact of the French Revolution, actual corporeal destruction, resulted in an emotional deflection onto the archaeological fragments that remained, making of them a spectacle without narrative transition, a "phantasmagoria." This term (literally, the conjuring up of fantastic images before an assembly) was invented to describe Robertson's magic shows. There, narrative explanation was cut apart into spectacles that were beads on a chain, each inviting the optical and emotional investment of the audience, and each, by its truncation as well as its successful creation, reassuring the spectators that they were in a world that was under control. Robertson's spectacles were paralleled in historiography by Marchangy's "phantasmagoric" texts: detailed descriptions of topography, architecture, mores, decor in deliberately archaic vocabulary, which first persuaded a modern reader that he or she was present at the site of a ruin and then, through imperious solicitations to all of the senses, resurrected the past life at that site, so that the reader found him- or herself inserted into a way of life that no longer existed. In Marchangy's texts, meaning emanated from decor and mores, not action; hence, mores and decorative setting required careful observation and detailed description, to present charismatic illusions. Like Robertson, Marchangy presented these successive experiences to his readers without explanatory transition. But whereas Robertson was a scientific entrepreneur, Marchangy had a pious and a political motivation for his adoption of this phantasmagorical methodology. For him, the ruins on the devastated landscape of France were not only mournful markers of what had ceased to exist; they were also signs of the civilization that had flourished when they had first been erected, and they could guide the present generation back to the right road. Stepping back to honor "the tombs of our fathers" was the first step to take into the future.

We see a graphic demonstration, in more ways than one, of the approach that Marchangy took in his texts in the evolution from dramatic action to a moral local color that occurred in images of Mary Stuart between 1784 and 1819. This historical personage had been perceived during her own lifetime as a religious and political martyr; during the late eighteenth and early nineteenth century she would take on the weighty analogy to the modern queen Marie-Antoinette, another foreign, Catholic princess put to death by ungrateful, heretic subjects. In

PAINTING AND
HISTORY DURING
THE FRENCH
RESTORATION

FIGURE 5

François-Anne
David, *The Death of
Mary Stuart, Queen
of Scotland, Decap-
itated by the Order
of Elizabeth I
(1587)*. In Le
Tourneur, *Histoire
d'Angleterre repré-
sentée par figures*
(Paris: David,
1784), *tome* 2,
facing p. 105.
(Photo courtesy
Bibliothèque Nation-
ale de France, Paris.)

our first image, an illustration from Le Tourneur's 1784 *Histoire d'An-
gleterre représentée par figures* (Fig. 5), moral action creates meaning;
physical action is the center of the composition.[9] Mary Stuart kneels at
the block like a saint awaiting the blow that will give her martyrdom.
The executioner swings his sword aloft, toward the smoking torches
held by two cringing assistants. The witnesses can scarcely bear to
watch; one is already exiting off to the right. Mary's pedestal-stele is a
rude cross, whose shadow extends at the center out of the picture space
into our own. We are seeing the act of decapitating a queen, an act of
brutal violence and moral apotheosis. That action dictates the arrange-
ment of figures, the suppression of ornate decor or costume, the deepen-
ing shadows and shocking flare of torchlight.

 The same approach was taken in 1789 by an artist working in En-
gland, John Francis Rigaud, when he was commissioned to create a suite
of seven paintings to accompany a musical piece by an amateur com-
poser on the theme of the imprisonment, execution, and funeral of Mary
Stuart.[10] The engravings after these paintings later became so popular
with royalists lamenting the executions of Marie-Antoinette and Louis
XVI in 1793 that a set was engraved by Antonio Zecchin and published
by Suntach in 1794, with lengthy captions in French. Two images from

FIGURE 6

John Francis
Rigaud, *Mary
Queen of Scots at
the Block* (1789).
Engraving by A.
Zecchin (Paris:
Suntach, 1794).
(Photo courtesy
Bibliothèque Nation-
ale de France, Paris.)

FIGURE 7

John Francis
Rigaud, *Mary
Queen of Scots
Beheaded* (1789).
Engraving by A.
Zecchin (Paris:
Suntach, 1794).
(Photo courtesy
Bibliothèque Nation-
ale de France, Paris.)

the set, one of the queen kneeling at the block as the executioner raised his axe (Fig. 6), the other of the executioner displaying the severed head (Fig. 7), demonstrate Rigaud's graceful arrangement of figures in an agonic extension of the queen's death, as well as his willingness to portray the gruesome aspects of martyrdom: the severed head, the neck still pouring blood.

Classicists found the visual impact of these gruesome aspects so overwhelming as to be psychologically unbearable and pictorially impermissible; they offended decorum. When Landon reviewed these two scenes in 1804 (in an article accompanied by illustrations), he was forced to admit that "the sight of the axe suspended over the head of this interesting victim makes a strong emotional impact."[11] By now the French hesitated to depict the uncomfortable parallel of a decapitated queen at that gruesome final moment. Troubadour painters chose instead to portray scenes of imprisonment or the announcement of the death sentence, as in Vermay's *Mary Stuart Receiving Her Death Sentence* of 1808 (Fig. 8) and similar depictions of Mary Stuart by Richard in the Salon of 1814, or by Rumeau in the Salon of 1819, scenes of

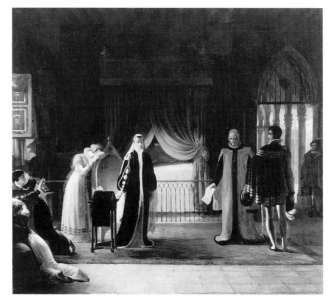

FIGURE 8

Jean-Baptiste
Vermay, *Mary Stuart
Receiving Her
Death Sentence*
(1808). Arenenberg,
Napoleonmuseum.
Oil, 1.60 × 1.27 m.
(Photo courtesy
Napoleonmuseum,
Arenenberg.)

resignation and pious submission, in which the visual interest was de-
flected from the protagonist's physical action to the quiet resonance of
illusion in the setting.[12] Reading Vermay's painting from left to right,
after a brief introduction of grief-stricken waiting women, who kneel in
the left foreground and twist away from and toward their queen, we
see a composition that is a rhythmic succession of verticals, whether
provided by figures or by furniture: the flat shutter, the legs of the prie-
dieu, the metal grille, the silhouetted columns. The final stage of this
evolution was reached by Garneray in his *Mary Stuart, Queen of Scot-
land* (Salon of 1819), where the tiny queen, gripping a crucifix for
consolation during her incarceration, is visually overwhelmed by her
prison. The tracery of the stone balcony above her provides a flashing
alternation of tone that dominates the small grilled window below it.
This painting, despite its obvious anachronisms in costume, was used
as the model for *Marie-Antoinette au Temple* (Fig. 9), paired with
Louis XVI au Temple (where the king appears in modern dress), in
engravings by Nyon and Lefebvre that were issued in 1823.[13] The
meaning of martyrdom is no longer expressed corporally, it is offered
through subtle decorative cues: the support that prayer provides at the
moment of death, the soul's apotheosis after imprisonment and execu-
tion. Those who could not bear the sight of a raised axe could contem-
plate the prison walls of the Temple. These works by Vermay and
Garneray do not simply indicate a retreat from revolutionary violence:
they are advances toward a different historical truth. The traumatic
experiences of the French Revolution broke apart the permanence of
precept. Memories and analogies insisted on being rendered in con-
crete, loving detail.

FIGURE 9

François-Jean
Garneray, *Mary
Stuart* (1819).
Engraving by Nyon
and Lefebvre,
entitled *Marie
Antoinette au
Temple* (Paris: Janet,
1823). (Photo
courtesy Biblio-
thèque Nationale de
France, Paris.)

THE DANGEROUS "COMPOSITE GENRE": CRITICS RESPOND TO TROUBADOUR WORKS

Classicist critics were concerned that historical painting's elevated style
was being reduced to genre painting's materially truthful descriptions. In
1815, one critic warned that Troubadour painting was dangerous be-
cause it reversed true historical painting's principles:

> Let us now turn to the representation of historical events taken from
> modern history, and painting that represents these events in a style
> ordinarily used for genre subjects; this type of painting one could call
> "the composite genre," because of its mistaken principle . . . a type of
> painting whose danger I cannot emphasize enough . . . the mixed
> genre, which represents the important aspects of our history in a me-
> ticulous, detailed manner; in this type of painting the accessories are
> always more carefully represented than the figures, and since they
> occupy a larger space, they become the major interest, so that, instead
> of seeing the historical event depicted, you have the portrait of the
> period's historical decor.[14]

In 1814, faced with Richard's portrayal of Mary Stuart taking commu-
nion in her prison, the critic Delpech found it necessary to completely
recompose the work, in order for it to serve as a depiction of a historical
subject. Given Richard's presentation, Delpech stated, a more accurate
title would have been "Scene of a Prison, in Which One May See Mary
Stuart, Queen of Scotland, Taking the Eucharistic Wafer." The queen
was in the background; her figure was subordinated to the light playing
on the walls and ceiling vaults. But, Delpech wrote, if Richard had

depicted such a subject as a history painter would have done, he would have been guided by the need to make the emotions of the woman the principal point of interest. She would have been placed in the foreground, in a pose that expressed her nobility and her majesty, and any accessories that could have distracted the viewer's attention from her graceful and poignant form would have been eliminated. Every element in the work would have expressed her sublime resignation and confidence in divine salvation: form, clothing, even facial features, which, although specific enough to make the figure a recognizable image of a particular historical personage, would nonetheless have been ennobled. In this way, Delpech concluded, a particular moment of history would have been impregnated with eternal meaning in historical art.[15]

The balance between subject and decor, between action and mores, defined historical art. In 1822, Delécluze, the most articulate supporter of classicism, argued that the detailed reconstruction of the past destroyed art, whose purpose was emotional suasion, not material illusion. He complained that Coupin de la Couperie had made a fundamental error in his *Valentine de Milan* when he utilized a similarly detailed pictorial style throughout the entire work, whether for the chapel's stones or for the tearful heroine. Naturally, the spectator's sight was distracted by this enormous and detailed architectural scene, instead of being moved by the widow's grief. But only an impassive human being saw everything in equal detail. Emotion should dominate concrete illusion in art as it did in reality, when the sight of a fellow human being in tears would blind us to every other sight.[16]

And yet this equalization of detailed description throughout the composition is precisely what we saw in Ingres's *Entry of the Dauphin,* and what we see as well in Bouton's *Charles-Edward* of 1819 (Fig. 10).[17] Charles-Edward Stuart ("Bonnie Prince Charlie" or "The Young Pretender") landed in Scotland in 1745, initiating the second Jacobite uprising, and quickly raised an army from the Highland clans to support his claim to the British throne. His grandfather, James II, had fled to France in 1688 after the Glorious Revolution, which had overturned the Stuart dynasty in favor of William of Orange, ridding Britain of a Roman Catholic ruler.[18] The Salon *livret* described his unsuccessful effort to lead a Jacobite rebellion and his flight into exile, fearing for his life, here assisted by the charitable Flora Macdonald. Like Mary Stuart's imprisonment and execution, this was a poignant subject for royalist, Catholic émigrés.

Charles-Paul Landon, neoclassical artist and art critic and the Restoration monarchy's official Salon commentator, reviewed Bouton's *Charles-Edward* harshly. The emotional and historical meaning of the subject, a demonstration of patriotic loyalty, could not be evident in this architectural scene in which the figures were barely perceptible:

Strictly speaking, this is nothing more than a painting of architectural ruins, given an imposing historical title, or, rather, a painting in which the artist has thought that he has represented a historical event because he has included a few figures. But these figures are so small, relative to the scale of the work as a whole, that they are only accessories to the architecture, which is the true subject. The figures are barely visible, and as soon as you notice them, you ignore them in order to study the painting's background, where the beautiful execution is done in silvery, harmonious tones.[19]

Landon was absolutely correct. Bouton did concentrate on architecture and sculpture to carry his message; in the Archives du Louvre, the exiled prince is described as "taking refuge in the tomb of his ancestor." Monuments orient the compositional focus and provide the symbolic meaning. Charles-Edward's precarious situation is visually evident in the missing center of the column to his right and the freshly mutilated architecture (which Landon pointed out); their sharp edges can almost be read as wounds. The change of dynasty is conveyed by the change from rounded Romanesque to Gothic trilobite arches. The tomb sculpture of a kneeling figure, on the right, directs our attention to Flora Macdonald, just arriving to aid the exile. But even after taking all these cues into account, the modern viewer is hard put to disagree with Landon. The architecture overwhelms the figures, optically and expressively.

When Bouton exhibited his *Saint Louis at the Tomb of His Mother* (Fig. 11) in the same Salon of 1819, Landon admitted that the optical illusion of architectural fragments, particularly the enormous column that receives the most intense highlights, was completely successful and had been greatly praised. But, he complained once again, it was evident that the column had been the artist's first concern. As a historical painting, the work was fatally flawed, because the spectator's attention was constantly directed to the column instead of the king. Bouton had created an architectural painting and then simply inserted a historical figure into it.[20] Two objects frame Louis IX: the empty throne (with a carved head surveying him) and the column, which appears to cut off the limbs of the tomb sculpture. The pious mourner stands before a void. Once again, as we saw in Bouton's *Charles-Edward*, architectural monuments, settings, fragments were not simply decorative aids to the visual presentation of a subject, but the meaning of that subject, and therefore the composition's motive force.

In his memoirs, Richard explained that his method of composing a painting, from *Sainte Blandine* (1801) at the very beginning of his career, had been to seek inspiration from the viewing of an architectural fragment, and only then to relate it to a figural theme.[21] In Richard's *La Duchesse de Montmorency* (Fig. 12), exhibited in the Salon of 1817 and bought from the Salon by Louis XVIII, the composition and

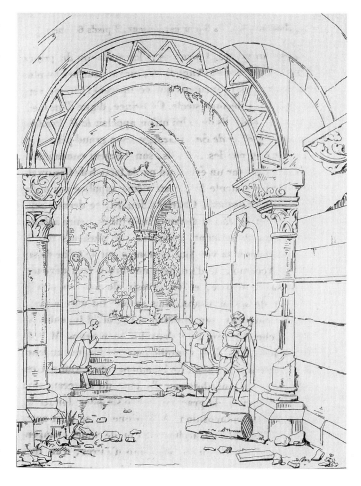

FIGURE 10

Charles-Marie
Bouton, *Charles-
Edward* (1819).
Engraving by Le
Normand, in
Charles-Paul
Landon, *Salon de
1819* (Paris:
Imprimerie Royale,
1819), plate 36, in
vol. 2, facing p. 55.
(Photo courtesy
Bibliothèque Nation-
ale de France, Paris.)

the theme centered on the mausoleum, surrogate of the lamented duke.[22] The winged genii of mourning dance above the head of the reclining duke, twining garlands around the urn that holds his heart. Seated near us in the darkness, the widow gestures back toward a scene that glows with the incandescent beauty of lost happiness. Richard has concentrated luminosity, three-dimensionality, activity in this dearly departed distance. Jal, who generally supported the Romantics' emotionally expressive works and was willing to accept compositional innovations, found the work charming and hoped that Richard would paint others in this vein. He warned, however, that there were "sacrifices" that needed to be made, which would have to include a readjustment of the visual balance between the figures in the foreground and the architecture in the background.[23]

In Coupin de la Couperie's *Sully Showing His Grandson the Monument Containing the Heart of Henri IV* (Fig. 13, Pl. 2), exhibited in the Salon of 1819, traditional expectations of focus and physical location were completely reversed.[24] Though removed from the spectator in space and time, the monument dominates the scene. Only after the viewer has satisfied him- or herself with its details does he then scrutinize the

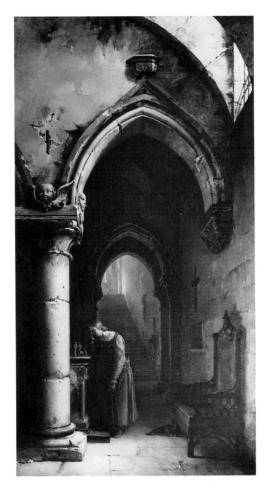

FIGURE 11

Charles-Marie
Bouton, *Saint Louis
at the Tomb of His
Mother* (1819). Oil,
2.10 × 1.12 m.
Fontainebleau,
Musée National du
Château de Fontaine-
bleau. (Photo
courtesy Musées
Nationaux, Paris.)

repoussoir grandson in the foreground, who serves as the viewer's surro-
gate. This youth, dressed in violet, his laces and satins shimmering in the
raking light, makes the titular hero, Sully, merely a tertiary interest.
Compressed into the shadows on the right, reduced by his seated posi-
tion to the dimensions of the railing, Sully almost retreats into his tomb
before our eyes.

Classicist critics decried the prominence of the tomb in the back-
ground. It was overly detailed; its complicated architecture, rendered
with such insistent clarity, occupied the eye and attention of the specta-
tor and thus destroyed the unified effect of the painting.[25] Delécluze was
shocked by Coupin de la Couperie's anti-Aristotelian art:

> I have hesitated to discuss Coupin de la Couperie's work with the
> history paintings, but the achievements of the principal figure have
> convinced me to do so. Sully, weighted down with age, comes with one
> of his grandsons to visit the site where Henry IV's heart is entombed.
> This composition would have seemed perfect to me if the painter had
> not distracted attention from his figures by painting the monument in
> which the king's heart is laid with such puerile care. This fault seems to
> me, and to everyone else, so shocking that it destroys the interest that

FIGURE 12

Fleury-François
Richard, *La
Duchesse de Mont-
morency* (1817).
Engraving by
Mauduit (1829).
(Photo courtesy
Bibliothèque Nation-
ale de France, Paris.)

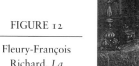

FIGURE 13
(*facing page*)

Marie-Philippe
Coupin de la
Couperie, *Sully
Showing His Grand-
son the Monument
Containing the
Heart of Henri IV*
(1819). Oil, 2.11 ×
1.78 m. Pau, Musée
National du Châ-
teau de Pau. (Photo
courtesy Musées
Nationaux, Paris.)

the main group should command. It is this lack of taste, this offense against decorum, that made me decide to place the painting in the group designated as "episodic."[26]

Révoil's *Convalescence of Bayard* (Fig. 14, Pl. 3), exhibited in the Salon of 1817, was another painting that shared these compositional qualities of hyperattention to optical illusion in the accessories and diminished visual emphasis on the figure.[27] The artist had accepted a commission to paint the scene of Bayard's death, a unique and morally instructive act. Instead, he painted the hero's convalescence in Brescia, in a bourgeois household crammed with every comfort, a scene that would be appropriate for any wounded warrior. Each object glows, from the dove of peace on the window sill to the pensive hero.

The royalist Miel was torn between approval of the theme and concern that its mode of depiction repressed its expressive value. He praised the superb illusions of material objects, but his extensive review also pointed out an interpretative problem that arose from this scintillating illusionistic manner. His description reproduced his own experience of deciphering the work. First he saw the window in the back of the room,

which threw a strong Italianate light on the entire scene. Seeking repose on forms that were less luminous, his eyes wandered through the room, falling on the bed of the invalid, and then recognized other figures, less evident than the backlit objects because they were half in shadow. The objects themselves (architecture, curtain, furniture) were attractive to see

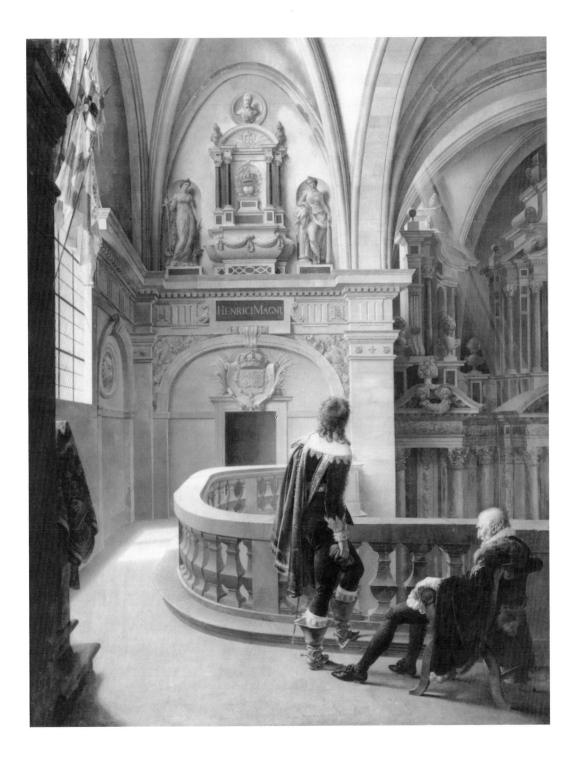

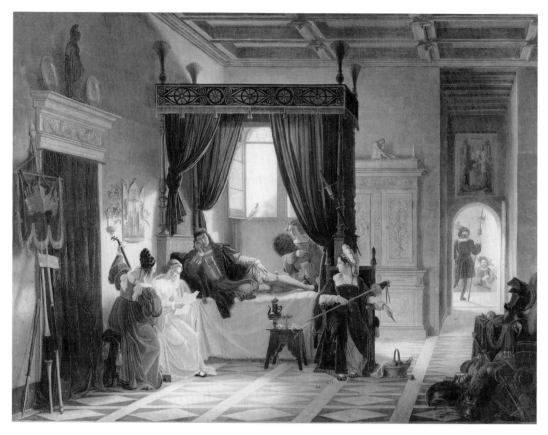

and to consider, for they recalled memories of chivalric times, when
religious symbols were omnipresent. But, pursuing this train of thought,
the critic came to a flaw in the work. Reading the words on the banner,
he realized for the first time that he was seeing not simply a knight, but
Bayard himself:

> I finally know who these people are. Why wasn't that apparent before?
> Because the people are subordinated to the excessively numerous and
> dominant accessories; because the composition, which would serve
> quite well for a family scene, is not appropriate for a historical paint-
> ing, even one of the private life of a historical character. I have de-
> scribed this work as I scrutinized it and understood it, and my criti-
> cisms and praise are the direct result of that experience.[28]

Révoil had taken up Girodet's challenge: to describe character in decor.
We are encouraged to look, and look again, and once again, at each
item. Révoil's constant reflective agitation of surfaces becomes a vigor-
ous tonal alternation that, as Miel pointed out, makes it almost impossi-
ble for the spectator to read the painting as a dramatic encounter of
human beings agitated by strong emotions.

What are these works' salient qualities? Unlike figurally oriented Trou-
badour paintings, such as Ingres's *Entry of the Dauphin*, they do not
offer the spectator a centralized focal field whose climax is a moral

action. In striking departure from academic expectations of historical painting, they are embodiments of historical presence, rather than enactments of historical meaning. In these compositions, instead of immediately comprehending the meaning of a central action through a gesture or a facial expression, we are forced to contemplate each memory-impregnated object. The visual instant of meaning is broken apart, and aspects of concrete reality are now the vehicle for an urgently pious emotionality, at times scintillating in an insistently equalized illusion. These works could move viewers only by appealing to their prepared imaginations, primed with memories, as well as to their scrutiny of the scene on the canvas. For such spectators, the mausolea, the urns, the backlit objects behind a convalescing invalid become mute but living witnesses, "precious relics rescued from the shipwreck of generations," as Willemin had said of archaeological remains. Let us now examine how academic definitions of local color were adapted to this new emotional urgency under the impact of the French Revolution and then consider the parallels between these unusual Troubadour works and historical texts by Barante and Marchangy.

THE BIRTH OF A MORAL LOCAL COLOR: ERUDITION AND SENTIMENT BEFORE THE REVOLUTION

In the seventeenth century, "local color" had been seen as a subjective delusion; hence, its pictorial inclusion was considered a defect. "Local" (as opposed to actual) color resulted from the object's being seen in a particular place. But during the eighteenth century, definitions of "costume" and "mores" moved toward the privileging of concrete accuracy.[29] As early as 1720, Coypel united sensory impressions and spiritual elevation when he deemed historical painting superior not only to all other genres of painting, but even to historiography, because its mimesis could extend the moral benefits of the genre to a wider audience than the elite who read historical texts or attended performances of tragedies: to children, the illiterate and the uninformed, or foreigners who were not bilingual. Its vivid imitation of every visible object made it a magical force that could transport the spectator everywhere and make the dead come to life again:

> our art is not only able, as eloquence and poetry are, to represent memorable historical events to the soul, the glorious deeds of those great men whose fame has lasted for generations; but, in representing their own features, it makes them return from oblivion, makes them, in other words, live again before our eyes.[30]

Absolute fidelity to the material aspects of a culture (costume, architecture, flora, fauna) also meant that the artist would be transmitting the

less visible aspects of that culture: its laws, its taste, its habits.[31] By 1792, Watelet subsumed all aspects of historical truth under concrete illusion: costume was the exact observation of mores, laws, character, chronology, facts of a place and time, as well as the material properties of the objects that were depicted.[32]

At the same time that erudite depiction was described as an aid to spiritual elevation instead of a pedantic distraction, a sentimental interest in the Middle Ages was aroused by popularizations of medieval tales. These novels (*romans*) were described as *romanesque* because of their fabulous, chimerical quality: they were thought to be like the medieval *romaunt,* or romance, whose plots were invented to describe mores and set in motion a series of adventures.[33] They were sentimental, rather than passionate or epic; feats of arms and amours occurred, unmotivated by innate hubris. In picaresque historical romances, events were successive but not contingent, in a sequence of illusory but incremental experiences that could not be resolved into a climax.[34] The eighteenth-century fascination with medieval romances helped prepare the groundwork for a new historiography by offering a view of history that was relativistic. Each age expressed its nature in its mores. In classical historical paintings, the meaningful moral action of tragic or poetic literature insisted on expression in centralized figural compositions, set in reticent decor. But in the Troubadour works that we have been examining, we have seen a visual approach that paralleled these detailed narratives of life in which mores were the subject.[35] This was precisely the issue that concerned such classicist critics as Delécluze: the romance's concentration on details of chivalric culture reflected prejudices rather than passions and hid human beauty beneath a visor.[36]

Before the Revolution, however, this sentimental erudition was a costume applied on top of meaning, not meaning itself. We see this illustrated in 1788, literally, in Marillier's vignettes for the comte de Tressan's popularizations of medieval romances.[37] In this plate, captioned "Put your hand in mine," which accompanied Antoine de La Sale's *Histoire et plaisante chronique du petit Jehan de Saintré et la dame des Belles Cousines* (Fig. 15), Marillier placed the lovers in an oratory in which carvings, windowpanes, emblazons, and tapestry patterns destroy any three-dimensional illusion and break up the page into tonal tesserae.[38] This is a far more assertively medievalist decor than the one captioned "Yes, you will be Comtesse de Mayence," which appeared in a comparable scene of medieval lovers by the same artist in the same volume: *La Fleur des Batailles de Doolin, Comte de Mayence* (Fig. 16). These two illustrations underscore the continuation of figural primacy in most early Troubadour works. In spite of the rich details of local color that are present in *Jehan de Saintré* and absent in the *Comte de Mayence,* the plates are fundamentally identical: scenes of lovers who kneel in adoration and lean forward to embrace. The decor is an enrichment, not

FIGURE 15

Clément-Pierre
Marillier, "Mettez
votre main dans la
mienne, et de ce
moment regardez-
moi comme votre
unique votre tendre
Amie." Engraved by
De Launay, in *Petit
Jehan de Saintré et
la Dame des Belles
Cousines.* In
*Oeuvres du comte
de Tressan* (Paris:
Nepveu & Aimé-
André, 1823), vol.
8, facing p. 29.
(Photo courtesy
Bibliothèque Nation-
ale de France, Paris.)

FIGURE 16

Clément-Pierre
Marillier, "Oui,
vous serez Comtesse
de Mayence."
Engraved by De
Gherdt, in *La Fleur
des Batailles de
Doolin, Comte de
Mayence.* In
*Oeuvres du comte
de Tressan* (Paris:
Nepveu & Aimé-
André, 1823), vol.
3, facing p. 397.
(Photo courtesy
Bibliothèque Nation-
ale de France, Paris.)

an explanation. But in the paintings that we have seen by Bouton, Rich-ard, Révoil, and Coupin de la Couperie, precisely the opposite occurred: figures were subordinated to the architecture, which carried the mean-ing. As classicist critics immediately realized, in these historical paintings composed according to the "composite genre," artists were portraying character rather than plot; decor rather than figure had become the visual focus. The minuscule figures were accessories to the architecture, which was the true protagonist. The human beings, instead of dominat-ing their environment by their great character, which they expressed in actions of enduring significance, surrendered to the overwhelming force of their time and place.

Such a fatalistic view of human capability, and the consequent passion-ate grasping onto the objects that remained, resulted from the traumatic experience of revolutionary terror, which stimulated phantasmagorical illusion and passionate antiquarianism.

THE LEGACY OF THE FRENCH REVOLUTION: VANDALISM, PHANTASMAGORIA, AND TROUBADOUR INSTRUCTION THROUGH RUINS

The collapse of the Bourbon monarchy in 1792 was followed by the accelerating pace of traumatic events of 1793: the trial and execution of Louis XVI, royalist rebellions in the provinces (in particular the Vendée and Lyon), military setbacks against the Austrian forces, the assassina-tions of Le Pelletier de Saint-Fargeau and Marat, the trial and execution of Marie-Antoinette, and arrests and executions of thousands of citizens.

In the words of the Convention, "Terror is the order of the Day." Death, and the threat of death, were everywhere, and fear was controlled by aggressive self-defense: the destruction of human enemies and their surrogates. Architectural surrogates were destroyed (church monuments were deconsecrated and royal and aristocratic property was nationalized); illusory theatrical surrogates were destroyed in Robertson's phantasmagoric theater. Conversely, the passionate yearning for beloved ones who had died meant that their mausolea, imbued with their presence, took on a hallucinatory vitality. These currents were literally incorporated in Alexandre Lenoir's Musée des Monuments Français, created from Revolutionary debris: as we shall see, a construction of meaning out of chaos and destruction. In graphic arts, theatrical illusions, and museum arrangements, the fragment, the remnant of past material existence, became meaning itself; memories and emotion were invested in its pious contemplation, which became the moral purpose of the work. Narrative meaning, expressed in figural action, was replaced by iconic charisma, radiating from fragments of the past.[39]

We may understand how these defensive reactions operated on a psychological level if we consider a modern parallel: post–traumatic stress syndrome. In this disorder, the sufferer is subject to "hyperarousal," the sudden, overwhelming, impact of sensory and iconic memories that are devoid of narrative context. These memories are useful in that they serve as partial controls against the complete realization of past pain and terror. However, because they are not fully integrated, they also encourage repetitive, compulsive behaviors. An oscillation is set up between "intrusion," the flood of unbearable emotion that results from reliving the trauma, and "constriction," numbed detachment in a trancelike state. The sufferer attempts to defend him- or herself against trauma by compartmentalizing knowledge, emotion, and physiological response.[40] Keeping this definition in mind, particularly as it relates to the emotions of royalists, let us examine the deflection of interest from figure to fragment in Bourbon propagandistic prints, Troubadour paintings, and Robertson's phantasmagorical spectacles.

Bourbon propagandistic images of this period frequently presented fugitive profiles of the late royal family, pressed against their memorials. In Grussaire's engraving *The Mysterious Urn,* of 1794 (Fig. 17), as the caption explains, phantom profiles of Louis XVI and Marie-Antoinette face each other to form the sides of the urn in a reversible illusion above the tomb in which these "precious ruins" are interred, mourned by a female figure who represents France. The profile of the king's sister, Madame Elisabeth, appears on the right, above him; those of his son and daughter face each other, positioned along the central branch of the weeping willow to the left.[41] Vices (represented by the many-headed serpent) have been vanquished; the storm is passing, and a new day is dawning. The message is clear: despite Bourbon deaths, royalists should

not relinquish their hope of a future restoration. Active light effects, vertical rays thrown up by the sun and horizontal gleams echoed by the placid waters and the hydra's scales, attempt to overpower the fitful lightning flashes at right. But our eyes are drawn back to the flat phantasmic profiles. They have no depth, no animating details; but France, by facing in the same direction as her departed monarch, provides a solid and energetic repetition of their direction and design. Our viewing is a process of optical oscillation between the profiles of king and queen and the heavily ornamented urn, an oscillation between the lost figures and their fetish, which is increasingly powerful, both visually and emotionally. Loss makes their remains precious, and their mausoleum, their reliquary, takes on a radiant aura.[42]

Radiantly powerful illusion, able to summon up the beloved dead and destroy terrifying enemies, was a feature of Etienne-Gaspard Robertson's "phantasmagoria," performed at the Pavilion de l'Echiquier in Paris in 1798 and, from 1799 to 1802, in an abandoned Capuchin convent near the Place Vendôme, where the remnants of aristocratic corpses, and coffins accumulated from desacralizations and demolitions, formed an appropriate decor.[43] Robertson's magic lantern apparatus projected an illuminated image on a wall or on a gauze screen; by setting the apparatus on rollers (like our modern camera dollies), he could increase or decrease the size of his apparitions (Fig. 18). Synaesthesia maximized the visual and emotional impact of his "phantasms." His audience, people from all levels of society and of all political persuasions, entered a dark cavern and saw figures from horrific, melancholic, and sentimental subjects, from Young and his daughter to Petrarch and Laura, accompanied by lugubrious music and sound effects such as rain or the tolling of funeral bells; these acoustic effects were extended by ventriloquists (first his common-law wife Eulalie Caron, then Fitz-James and Comte). Themes were not linked causally or stylistically; the temptation of Saint Anthony could be followed by Proserpine and Pluto enthroned, and then by a Druidic sacrifice at an oak tree. By 1802, when he left Paris for eastern Europe, his enterprise had been so successful that his former assistants had opened competing phantasmagorical shows; Robertson had been forced to sue them. Such theatrical performances were not enactments of a plot, but demonstrations of optical, and frequently topical, illusions.

Robertson's subjects, their visual and emotional address, and their popularity can be directly ascribed to the Terror, and the terror that succeeded it.[44] Frequently his thematic repertory appealed to royalist tastes: the decapitation of Robespierre, Charon ferrying Nelson to the Elysian Fields. But on a more basic level, his summoning up of the celebrated, recent dead (Roberjot, Desaix) or victims of a recent catastrophe (the fire at the Théâtre de l'Odéon) was a means of establishing control over chaos, as well as of reestablishing a link to both leaders and beloved

FIGURE 17

Grussaire, *The Mysterious Urn* (Paris: de Jaqot, 1794). (Photo courtesy Bibliothèque Nationale de France, Paris.)

ones who had passed into eternity. His memoirs, published thirty years later, when he could openly acknowledge the delicate diplomacy necessary for raising the newly dead victims of continually changing regimes, reveals (at times with a great deal of humor) his self-conscious conflation of scientific performance with political charlatanism. Robertson cited an article, published in 1798, in which the author, impressed by the magician's ability to make each member of the audience see his or her heart's desire, described how a dandy saw the ghost of his beloved, a Swiss that of William Tell; in a phrase of Robertson's modern biographer, "resurrection à la carte." An indiscreet member of the audience asked him to raise the ghost of Louis XVI but was told: "I lost that recipe after the eighteenth of Fructidor." The climax was reached when the master magician called up a crowd of victims in bloody shrouds, by combining such ingredients as demagogic speeches and the orders to massacre prisoners in Aix, Marseille, and Tarascon, and by pronouncing the dreaded words "conspirators, humanity, terrorist, justice, Jacobin, Girondin."[45]

I see Robertson's orchestrated arousal and reassurance in his phantasmagorical spectacles as having served as a release mechanism for

FIGURE 18

A performance of Robertson's phantas-magoria. Frontis-piece, Robertson [Robert], *Mémoires récréatifs, scien-tifiques et anec-dotiques* (Paris: Wurtz, 1831). (Photo courtesy George Eastman House, Rochester, NY.)

traumatic memories, comparable to the "therapeutic theater" (Jan Goldstein's term) of Robertson's contemporary, the psychotherapeutic practitioner Philippe Pinel, who sought to "shake up the pattern of thought" for the insane in his care at Bicêtre and the Salpêtrière through dramatic confrontations, complete with costumes.[46] Robertson's phantasmagorical theater controlled contemporary history by truncating time, presenting iconic illusions severed from a linear narrative. Robertson's illusions were terrifying to see in a dark cavern, but hadn't the audience already experienced the far more terrifying reality of Robespierre's rule? We can easily imagine the emotions of a Parisian audience in the late 1790s that witnessed the illusion of Robespierre's ghost climbing out of his tomb, then suddenly exploding into pieces. They appreciated not only the convincing appearance of the specter, but the fact that it obeyed its controller.[47]

In Bourbon propagandistic prints, we have seen the radiant force of commemoratory objects, invested with the aura of beloved but fugitive figures. In Robertson's shows, the consolation of control over traumatic experience was achieved through the summoning up and the destroying of convincing illusions of topical figures. These were royalist assumptions of control through the creation of illusory objects and the destruction of illusory enemies. Radical assumptions of control were more concrete: arrest, imprisonment, the guillotine. Influence was also exerted over object surrogates of enemies, in the sacking of churches and the destruction of monarchical monuments. The most influential of these Revolutionary demonstrations against inimical object surrogates was the Convention's order to destroy the Bourbon tombs at the Royal Abbey of Saint-Denis (renamed Françiade) on August 1, 1793.[48] Workmen interred the corpses in trenches, as if they had been newly guillotined enemies of the Revolution; the lead and bronze from their coffins were melted down for national defense. Fifty-one tombs were destroyed

within three days. The abbé Grégoire, a supporter of the revolution from the day he had sworn his oath in the Jeu de Paume, could only deplore such "vandalism," a term he invented to indict modern barbarians who were destroying the nation's artistic heritage.[49]

Henri IV Exhumed (Fig. 19), a print published in 1817 and dedicated to Louis XVIII, presents a sight from the exhumations of October 12, 1793, which evoked paintings and poems for the next twenty years. The legend describes the "profanation of the tombs" by "sacrilegious hands" and insists on the almost miraculous state of preservation of the corpse of the illustrious ancestor of the Bourbons:

> the first coffin taken out was that of Henri IV, who died on May 14, 1610, aged 57. The icy remains of this good-hearted prince were in a state of perfect preservation, a fact that impressed the spectators with admiration and respect. One would have thought that he was only sleeping . . . This coffin was placed between the pillars of the subterranean area of the church and publicly exhibited for a time, and each person hastened to come and contemplate these precious relics that brought back such touching memories.[50]

Just as the text insisted that the king was not dead, so the image insisted that his monument took on life; his sleeping body appears to be interred vertically, impressed into the pillars until stone becomes flesh, but now incorruptible flesh. For royalists, these mutilated monuments were eternally vitalized by having contained the corpses of the celebrated. Abbey and monarch were one. Henri IV had been assassinated by the religious fanatic Ravaillac. Now his tomb was sacked by fanatical revolutionaries, testimony to the surrogate destruction of Louis XVI.

On February 22, 1805, Napoleon ordered the basilica of Saint-Denis restored, to become an imperial sepulcher and site for expiatory monuments to the memory of ancient dynasties.[51] The next year saw a flood of texts and images lamenting the destruction at Saint-Denis, including Richard's (lost) painting exhibited in the Salon of 1806. A poet wrote: "A new death has struck the tomb . . . the patricidal blows of iron bars break marble and reveal Henri's corpse." Another exclaimed of the vandalized abbey: "I hear the walls cry out."[52] Architecture became flesh, carrying the burden of meaning and expressiveness.

This emotionally charged stone detritus from Saint-Denis was used by Lenoir for his Musée des Monuments Français, a literal edification.[53] A student of the painter Doyen, in 1791 Lenoir had been given the position of director of a storehouse of nationalized art relics at the former convent of the Petits Augustins in Paris. In 1793, after the violation of the tombs of Saint-Denis, he decided to create a didactic collection out of their relics. The Commission des Arts recognized his efforts and gave him the title of curator in 1794. In 1795, the Comité d'Instruction Publique transformed the storehouse into a permanent museum, which remained in operation until an edict by Louis XVIII on April 24, 1816,

reestablished Saint-Denis as a royal sepulchral site and ordered that the monuments be returned to their original sites and their ancestral owners.

Chronological arrangement was an essential part of Lenoir's artistic didacticism, for he meant his collection to be a consoling, controlled view of the historical and chronological record of French sculpture. The aesthetic qualities of the works would explain the progress of French civilization, from its infancy under the Goths, through its apogee under François I and its decadence in Louis XIV's reign, to modern neoclassical heights.[54] Mercier, when he visited the storehouse at the Petits-Augustins, commented that it was appropriate to see the impact of revolutionary vandalism in a chaotic jumble of bizarre juxtapositions: antiquities, medallions, columns, statues of every age, the "true mirror of our revolution."[55] This chronological chaos was retained in the entry hall of the final museum, as we see in Vauzelle's view of it, entitled *The Introductory Room of the Musée des Monuments Français*, as it appeared in 1812 (Fig. 20); this was the first of four plates, each with a different vantage point, describing that enormous space of 41 by 11 meters and its examples of sculpture from antiquity to the seventeenth century.[56] Reading from the left foreground to the right background, we see Diane de Poitiers' tomb (with wooden figures by Germain Pilon), a 9-foot twisted marble column erected to the memory of Henri III, Michel Auguier's obelisk commemorating the Orléans-Longueville family, and Mazarin's mausoleum by Coysevox.

We would expect visitors to be bewildered by such an amalgamation, or simply pensive, like the thoughtful figure in the shadows on the left, but curiosity, confusion, or meditation were not the only emotions experienced by visitors. The artist also included an agitated dog on the right. Retreating, barking, his tail raised, the animal seemed to discern a presence in these disparate mausolea and memorials. Did their inhabitants still retain the spark of life? That was Michelet's thought: that the tomb sculptures were sleepers, not inanimate material artifacts erected to honor the memory of the dead.[57] This sense of a living culture was emphasized throughout the rest of the museum, where, in contrast to the introductory hall's soul-stirring chaotic jumble and the garden's chronologically unrelated tombs, Lenoir had carefully arranged each age in its own room.

Lenoir's purpose in arranging his museum and "elysian garden" had been to move as well as to instruct visitors. He wished to make the past an active presence, to resurrect the dead. In a passage that he wrote after the violation of Coligny's tomb, Lenoir implored the warrior to rise once again and avenge his second death, punishing the vandals: "How can sacrilegious hands profane you, and the insolent eye of a criminal survey you, without your moving? Revered spirit, dear to those who are civilized, rise, arm yourself with the Eumenides' whip of vengeance, and punish this sacrilege!"[58]

If this cry could no longer be heeded by the ghosts of the dead, then

FIGURE 19

Henri IV Exhumed.
Print conceived and
designed by F. H.
Langlois and T. de
Jolimont, aquatinted
by Chataignier and
de Bovinet (Paris:
Bance, 1817).
(Photo courtesy
Bibliothèque Nation-
ale de France, Paris.)

the monuments would defend themselves. In 1819, in *La Gaule Poétique,* a work that we shall be examining in detail later in this chapter, Marchangy described an event from this period of revolutionary vandalism. Significantly, he placed it in the context of the original Vandals, Scandinavians who had sacked Paris during the Dark Ages. This passage occurs in the section describing the siege of Paris by the Normans and is accompanied by an illustration, entitled *The Warriors Turned Pale* (Fig. 21). Marchangy's text must be quoted in its totality:

> The somber cloisters, long corridors, sepulchral vaults of this abandoned and silent abbey strike the Scandinavians with terror. Ready to step over the threshold of the church, they stop as if held back by a supernatural force. Suddenly, one of their sibyls senses something, and, using the long scepter that these special women carried, she separates the thorns that were covering a tomb. There she is surprised to find a runic inscription. She approaches and, her hair standing on end with horror, she reads these words to the amazed company: "Ragenaire, chieftain of the Scandinavians, having dared to penetrate the temple of the Lord, was beaten by an invisible hand and fell dead in the midst of his warriors, who, fleeing these miraculous precincts, abandoned this

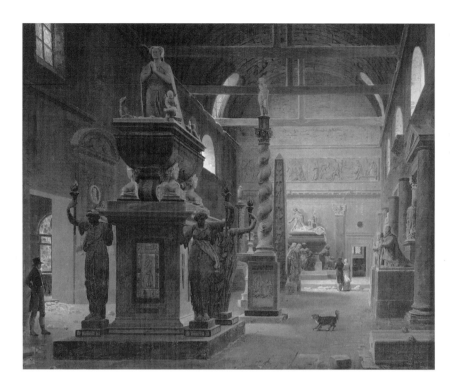

FIGURE 20

Jean-Lubin Vauzelle,
*The Introductory
Room of the Musée
des Monuments
Français* (1812).
Paris, Musée
Carnavalet. Oil, 60
× 74 cm. (Photo
courtesy Artists
Rights Society, New
York/SPADEM,
Paris. © 1997
Artists Rights
Society (ARS), New
York/SPADEM,
Paris.)

monument to him." At these terrible words, which echoed in the Gothic edifice, the warriors turned pale and, fearing even to glance at the church doors, they quickly fled the place marked by a divine vengeance.

The material situation, the peril of foreign invasion, is countered by a material defense. The silent, dark, massive spaces of the abbey awe the invaders, who hesitate to destroy the royal tombs out of instinctive respect. Marchangy then makes time (engraved into the architecture) perform a miracle, just as his text shifts in tense from present to past: the past will overpower force by predicting the future. The inscription deciphered by the priestess is a curse upon the very invaders who stand before the tombs, a premonitory defense by the dead.

Immediately after this passage, in a note on the same page, Marchangy compared these Scandinavian barbarians to the vandals of the Revolution, who had destroyed the sacred monuments of the Christian French kings, and who had been frightened away in one case by a brave ventriloquist. Citing (with issue and page number) a passage from the *Journal des Arts,* Marchangy described how M. Comte (Robertson's ventriloquist-assistant) had hidden in a corner of a church and convinced "a band of vandals" that "images of the saints" were speaking to them. Through this "ingenious stratagem," Comte succeeded in preserving "artistic monuments, consecrated by piety."[59] Monuments had come alive. The concrete material was imbued with meaningful memory. Historical resurrection had been achieved.

FIGURE 21

*The Warriors
Turned Pale*
Tinted engraving in
Marchangy, *La
Gaule Poétique*
(Paris: C.-F. Patris,
Lecointe, & Durey,
1819), 3rd ed., vol.
4, facing p. 165.
(Photo courtesy
Bibliothèque Nation-
ale de France, Paris.)

This pious reassembling of the fragments of the past, in order for
royalists to resurrect past civilization, is evident in Heim's *Transfer of the
Remains of the Kings from the Place Called "Cemetery of the Valois" the
Eighteenth of January 1817 at Saint-Denis* (1822) (Fig. 22), painted for
the sacristy of Saint Denis itself, which describes the ceremonial reburial
of the bones from the royal tombs.[60] The lurid torchlight, the winding
processional up toward the abbey's portal, the deep ditch into which the
bones had been thrown, which seems a wound in the earth: the deep
emotions that are aroused by this event find their focal point in the skull
and bones that the marquis de Dreux-Brézé tenderly lifts out of the
coffin in the foreground, as if he is delivering a child from a dead mother.

The royalist sense of history that evolved out of the experience of
Revolutionary catastrophe needed to reclaim the concrete relics of the
past, reclaim the French patrimony. In this new view of history, universal
precepts and objective analysis had to be replaced by descriptive specific-
ity, for meaning resided in the precious relics of the past. This was
precisely the approach taken by the royalist historians Barante and
Marchangy.

FIGURE 22

François-Joseph
Heim, *Transfer of
the Remains of the
Kings from the Place
Called "Cemetery of
the Valois" the
Eighteenth of Jan-
uary 1817 at Saint-
Denis* (1822). Oil,
665 × 445 cm.
Sceaux, Musée de
l'Ile-de-France.
(Photo courtesy
Giraudon/Art Re-
source, NY.)

BARANTE AND THE ERROR OF IMPARTIALITY

The history of chaotic periods could never be written unless "impartial-
ity" was foresworn, Barante affirmed in 1828, in an article on the develop-
ment of historiography up to the present day. The smooth syntheses of the
Enlightenment, created after the fact by professed omniscient observers,
were completely inadequate for the rendering of rebellion, anarchy, or
invasion, as his contemporaries should know from their own recent expe-
rience of history's convulsions. Historical narrators observed the original
events, they served as witnesses. Barante praised medieval histories for
their satisfaction of this criterion: their reports of what they had seen
were chronicles or memoirs, written in detail from an individual perspec-
tive. Truth arose out of detailed observation.[61] In his work *Histoire des
ducs de Bourgogne de la maison de Valois, 1364–1477* (1824–6),
Barante called for modern historians to renounce the false dignity of
judgment and provide modern narrative chronicles that could be visual-
ized in vivid detail: "the faithful representation of the truth, or, rather, the
striking impact that the sight of events produces on our spirit."[62]

FIGURE 23

Achille Devéria, *An Officer Announcing the Death of Charles VI to His Son the duc de Touraine (1422).* In Barante, *Histoire des ducs de Bourgogne de la maison de Valois,* 3rd ed. (Paris: Ladvocat, 1825), vol. 5, p. 115. (Photo courtesy Bibliothèque Nationale de France, Paris.)

Barante's *Histoire des ducs de Bourgogne* helped to stimulate a historiographic drive to "depict rather than analyze," as he wrote in his preface to the work.[63] This viewpoint is also evident in Devéria's illustrations for its third edition. In 1825, Ladvocat, Barante's publisher, had been encouraged by the immediate success of the work to bring out a visually elucidating edition, with portraits, topographic maps, architectural views, and so forth. The *Journal des Débats,* an official government newspaper, asserted that Barante's style of narration made such illustrations absolutely necessary for his enthralled readers:

> Everyone who reads this long sequence of vivid scenes, each more interesting and animated than the last, will feel the need to fix the features of the main characters in their memory, to become familiar with their physiognomies, to see them revived and brought out of their tombs, wearing their chivalric costumes. The account of a siege or the description of battle will be easier to imagine after the illustrator has translated the historian, after the pencil has demonstrated the truth of the pen's account. The site's appearance adds an attraction to the most eloquent and precise history, an attraction that the theater, despite all its lofty prestige, is loath to forgo. And if the observer feels equal sorrow at seeing two equally disastrous scenes, he still enjoys the different sights of the fields of Agincourt and the palm trees of Heliopolis.[64]

As this writer makes clear, the images were not so much intended to represent an action as to document an edifice or a terrain; not to repeat scenes from the narration presented by the author, but to present the sites on which the scenes had taken place. Thankfully it was unnecessary,

FIGURE 24

Achille Devéria,
*Public Square of
Bruges in 1740.* In
Barante, *Histoire
des ducs de
Bourgogne de la
maison de Valois,*
3rd ed. (Paris:
Ladvocat, 1825),
vol. 12, p. 366.
(Photo courtesy
Bibliothèque Nation-
ale de France, Paris.)

certainly it was uncomfortable, to show the disastrous Battle of Agin-
court to Frenchmen who had just been defeated by the English; the
terrain on which the battle had been fought would be sufficient for these
modern readers.

Devéria's figural illustrations to Barante's work were frequently anti-
anecdotal, and most often they were not aligned in the volumes so as to
illustrate dramatic points in the narrative but included as documentary
records. In *An Officer Announcing the Death of Charles VI* (Fig. 23), the
figure's downcast eyes and passive stance make him a vehicle for his
costume rather than an actor delivering an important message. The por-
trait of Dunois, which could have been placed in any of six different
volumes as a highlight to such exciting passages as his exploits at the
siege of Orléans, instead illustrated his presence at the conference at
Compiègne. Often vignettes were completely devoid of active figures,
offering the reader monuments, such as the tomb of Jean Sans Peur, or
even those from another era, as in *The Public Square of Bruges in 1740*
(Fig. 24). The purpose of these images was not to illustrate, in the
modern meaning of the term: they were not visual representations of
narrative nor dramatic poses distilled from historical moments. Rather,
they were sites of memory: fragments or terrains into which readers
could project their knowledge and sentiments. In this process, lucid and
passionate observation invests meaning in the objects perceived. Louis-
Antoine-François de Marchangy's historical and fictional texts exem-
plify this sense of history, in which the detailed description of topogra-
phy, mores, and dress is the source of truth and emotion. He urged
artists to turn their attention away from actions on the world stage (wars
or revolutions) toward private mores, visible in concrete objects:

> Observation, as well as taste, and feeling, almost always grasp things
> only through their details; that is how a painting seizes the spectator's
> interest, shows him what the artist has seen and renews memories and

impressions in him. Moreover, the narrator's great power lies in transporting us directly into the midst of times, sites, and people of whom he speaks, and he can only create this illusion by carefully describing customs. The historian who is satisfied with describing common events, such as wars, conspiracies, or revolutions, will not be able to distinguish one culture from another, for all of them resemble each other more or less in such great political developments. But nations are differentiated from one another, which is particularly evident in their citizens' private dwellings, in their labors, their arts, their amusements. That is where the national character and soul develop.[65]

Marchangy announced that his aim in *La Gaule Poétique* was to enable his nation to rediscover its local culture and to love that culture once again. His new form of historiography was not intended to survey historical events, he wrote, but to permit his readers to "interrogate the debris." He had suited his style to its medieval subject matter, making it brilliantly colored and studded with fascinating details. Poets, lawmakers, and archaeologists would be able to recover essential information about institutions, artists would be able to reclaim their cultural patrimony; and the ordinary reader would be gently introduced to his country's heritage by learning about the details of private life in another age.[66]

Marchangy's viewpoint and his narrative approach are directly related to the aesthetic issues evident in the Troubadour paintings that we have seen. In his writing, the concrete illusion of inanimate forms arouses a passionate response from reader-viewers, who invest fragments with their regret that their civilization no longer exists. This view of history, which marked an important stage in historical interpretation and description, could not be permanently satisfying in an optical realm but left an enduring legacy in the expanded role of local color, conveyed most directly in the creation of a new pictorial genre: historical landscape.

"INTERROGATING THE DEBRIS": MARCHANGY'S *LA GAULE POÉTIQUE*

The literary career of Louis-Antoine-François de Marchangy (1782–1826) must be understood in the context of his support of royalism, for which he was named to high legal positions by Louis XVIII and honored throughout Europe.[67] He was born into the family of a notary, attended the Collège de Nevers, studied law at the Faculté de Droit in Paris between 1805 and 1808, and was appointed juge suppléant of the Tribunal de Première Instance in Paris. His support of Napoleon was rewarded by his being named assistant to the attorney of the imperial Tribunal de la Seine in 1811. In 1814, he assumed the same post for the Cour Royale. Louis XVIII appointed him avocat-général of the Cour Royale in Paris, and of the Cour de Cassation. In 1818, the comte d'Artois asked him to be one of his counsellors. In 1822, he was made a

knight of the Legion of Honor. His most notable political prosecutions were those of Béranger, in 1821, and of the Carbonarist La Rochelle conspirators in 1822; his five-hour address to the court at the latter trial was published as a pamphlet, in several editions. He ran successful campaigns to serve as a member of the Chambre des Députés in 1822, 1823, and 1824, supported by Nevers (Département de la Nièvre), Lille (Nord), and Altkirch (Haut-Rhin), but was repeatedly refused entry on the grounds that he had not paid all the taxes necessary for eligibility, a charge he bitterly disputed. In 1823, when he was reelected by the département du Nord, he was able to take his seat. His letters testify to his gratitude to his supporters in the provinces, and to his suspicion that his earlier exclusions had been brought about through the efforts of Parisian political cabals.[68]

He made his literary debut in 1804 with a poem entitled *Le Bonheur de la campagne*.[69] The first segment of *La Gaule Poétique, ou l'Histoire de France considérée dans ses rapports avec la Poésie, l'Eloquence et les Beaux-Arts,* appeared in 1813; there were four editions between 1815 and 1824.[70] *La Gaule Poétique* was favorably reviewed by the *Journal des Débats,* the *Revue encyclopédique,* and the *Minerve Française. Tristan le Voyageur* was written in 1822–4, during his electoral crises. The first four volumes appeared in 1825–6, before Marchangy suddenly died from lung disease; the remaining two volumes were published after his death in 1826, even though they broke off in midsentence. The novel was so popular that a second edition was published in the same year.[71] Both works were written in a literary format that broke apart chronological narrative and rejected explanation. The texts by Marchangy that we shall be examining in detail are imaginative disquisitions that range freely through chronology, wandering through the past, describing the details of certain sites and customs, so as to make them come alive again to the reader, phantasmagorically.

Marchangy had come to adulthood during the chaos of the Revolution. What had been his generation's inheritance?

> The only sustenance its genius will have, to compensate it for all it has suffered, will be political disorder, artistic Romanticism, crime, and, in religion, misty idealism of the *philosophes,* if not outright skepticism . . . The ages that we shall be evoking were very different. Then, a pure and vibrant faith was passed on, sanctifying households in services which commemorated the dead and celebrated the living, eloquent practices that linked present and future, so that the past's radiance adorned every part of one's life.[72]

Marchangy wished to reclaim the beliefs, customs, and fables that were the marks of a national physiognomy. Their concrete presence was eloquent denial of the "misty idealism" of Enlightenment philosophers. This was the justification for his historical lament, *La Gaule Poétique,* and his picaresque novel, *Tristan le Voyageur.*

In both *La Gaule Poétique* and *Tristan*, each moment is visually evident, but it is also truncated. Marchangy's style of writing insisted on the evocative reality of fragments but refused to add experiential increments together to make linear narrative "sense." Members of the audience had to divest themselves of ties to their own time and place. In *Tristan*, a picaresque novel written as a modern version of the medieval *romaunt*, this displacement occurs over and over again. In such successive displacement, the only security is a complete confidence in one's environment, made possible through concrete descriptive detail. The emotional impact is similar to that of Robertson's phantasmagorical theater: repetitive evocation of illusions without narrative connection. In Said's terminology, Marchangy's recognition of loss forced him to make "beginnings" rather than search out "origins" and therefore to choose a picaresque narrative format, one that dispersed interest into the concrete remnants of past experience, since a coherent recovery of the origin of events was impossible.[73] In his historical narration, although there is a chronological sequence, it is only the springboard for extended disquisitions on culture: manorial architecture, monastic discipline, the lives of kings and queens: any and all were possible subjects. In his fictional narration, Tristan wanders as he wishes; each vivid view of the past is lost and replaced by another, equally vivid.

Marchangy's medievalism is a consolation for loss; his advocacy of details and concrete resurrection are intended to encourage a pious revival of sentiment through concentration on material relics. In 1824, in the preface to the fourth edition, Marchangy's editor explained that the author's patriotic and pious program of instruction would console Frenchmen for their recent reverses: "Public mores will benefit even more when the memory of our past times stimulates respect for those customs and beliefs. He brings us back to the tombs of our fathers, and to the monuments of their glory."[74]

The need for such a work was most acute during an era of turmoil, invasion, and defeat. Standing on a devastated landscape covered with the ruins of political and religious beliefs, Marchangy reminded his countrymen that history was not a smooth progression, but disjunction: alternation and individuation in "contrasts," each of which insisted on specific description.[75] The genius of France had showed itself most sublimely during periods of devastation: after the battles of Crécy or Pavia or after the seventeenth century's senseless, ferocious religious wars. Now Marchangy invited his audience to climb out of the tomb that had been the Revolutionary period and revisit the periods of French greatness, from the ages of the Druids and of the Gauls to those of the lords and monarchs of the feudal period:

> After the shameful Revolutionary period, where terror, carnage, famine, and every calamity were digging France's grave, we now see dawn

breaking . . . You, citizen-artists and poets, inspired by love for your country, take up your lyre, chisel, or palette and follow me in the new paths I shall forge for you. You will learn of great deeds, great virtues, great crimes, unusual customs, national tales, and the simple way of life of our ancestors. Then, dazzled by so many poetic splendors, you will spend the rest of your days celebrating that history that has been misunderstood and neglected for too long.[76]

Marchangy transports his readers directly into the midst of those other times, places, and people, by describing them as specifically and vividly as possible. Here is a typical textual example of his phantasmagoria. Marchangy begins with a discussion of terrain:

One would have taken the place for a scene from Hell, if it had not been for the striking contrast with lovely Limagne, which lay nearby, the beautiful fields watered by the Sioult that crown the hills of Or. One sees the double mountain range that extends from Clermont to Riom, as well as the ruins of the castles that were destroyed by Richelieu, enemy of the nobility.

But this cultivated, fertile landscape has softened the somber colors of a barbarous age, for its fortified castles now lie in ruins, overgrown by plants:

But, whatever impression is gained by the sight of these ruins, nevertheless one must return to the age when these sanctuaries were inhabited by their original owners, for today their ferocious appearance has been softened and brightened by nature, which relieves the somber colors and marks of the barbarous century that saw their creation. Birds and shepherds are singing in these ruined precincts where once the only sound was the sentinel's cry . . . ivy, clematis, lilac wind over the slopes and battlements where vassals raised their lances . . . The towers wear a crown of gillyflowers; the doe grazes among the hedges that grow between the broken stones of the arcades and steps. The region, which used to think of these oppressive retreats as their terror, is now inhabited by free and happy men who go gaily to harvest the crops or press the wine. Looking at the debris of these castles, uninhabited for so long a time, open to nature, which has dressed them with mosses, turf, and blossoms, as if nature had made a gift of its innocence and peace, it is difficult to conceive of feudal mores. These ruins resemble a tyrant's tomb laid in a field of flowers. Let us imagine this tyrant opening up his sepulcher and stepping out of it, dressed in his armor, with his proud glance and bloody hands. History can, in evoking the past, create this sort of *phantasmagoria*, and that is what we are going to attempt in the following account of some scenes of feudal life.[77]

Frustrated by his inability to recognize past civilization in architecture broken and softened by time and nature, Marchangy uses his knowledge of the purpose of architectural forms to evoke, phantasmagorically, the mores of the people who had once lived there. The culture of the region is personified: it once considered fortresses terrifying objects. This pas-

sage is immediately followed by "Historical Details. The poetic life of castles of old, and a portrait of country and town under feudalism." Having pointed out that fortified castles were built only in places that were favorable for defense, Marchangy then describes these frightening architectural forms:

> The great towers of fortified castles were separated by crenelated galleries or by various buildings whose ramparts were pierced irregularly by windows, in which the embrasure showed the density of the walls and parapets. These windows were round or square; sometimes they were made in the shape of eyes, ears, or clover leaves. The shutters were of canvas. As for the interiors of these massive structures, a stranger could not enter without fear. Secret openings, holes, gates, girders suspended by iron cables, subterranean doors where the threshold was wet and slippery, cisterns without rims, bridges without parapets, the sound of invisible waters dully rumbling underneath dark, reverberating vaults, all these things made these places frightening and encouraged the people in neighboring hamlets to make up stories. The battlements were covered with screens called *hourdis,* the entrances defended by machicolation, ditches, palisades, and barbicans.[78]

Narrative sequence in these two passages proceeds from the visually specific to the culturally descriptive. The landscape's topographic description (Limousin, the Sioult, mountains from Clermont to Riom), and its flora (ivy, clematis, lilac, towers covered with gillyflowers) give way to architecture that becomes increasingly threatening to the alien invader. We pass through secret passages and "murderous" holes (*meurtrières,* deadly because they permit arrows to pass through) to a subterranean wet and slippery terrain in which one may fall into reservoirs of water or over the edge of a bridge without guardrails (termed *gardesfoux,* "guardians of madmen," because they prevent the insane, oblivious to their surroundings, from falling to their death), moving under lugubrious and sonorous vaults, where we can hear the dull rumbling of invisible water in reservoirs that run toward the moat. Marchangy makes every detail recall actual experience that is distant from us both temporally and geographically. He retains local terms as he stresses visual local color. The vocabulary is defiantly archaic: machicolation, palisades, barbicans. Every effort is made to express the meaning of this lost world in concrete terms that address all of our senses. We see, hear, and feel. The synaesthesia of the writing style evokes an overwhelming illusion of the presence of the past. The pictorial impact of such writing was immediate and significant, particularly after the publication of the third edition, which had colored plates, making his phantasmagoria concrete.

"Do you see these fragments?" he asks the reader and then evokes the lost civilization that had built the original structures. This occurs metaphorically, in some plates, as a combination of architectural periods in

FIGURE 25

*The Precincts of the
Abbey Were Sur-
rounded by Walls,
Trenches, and
Bastions.* Tinted
engraving in
Marchangy, *La
Gaule Poétique*, 3rd
ed. (Paris: C.-F.
Patris, Lecointe, &
Durey, 1819), vol. 4,
facing p. 346.
(Photo courtesy
Bibliothèque Nation-
ale de France, Paris.)

FIGURE 26

*Ancient Cloisters
against Which
Knights Displayed
Their Shields.* Tinted
engraving in
Marchangy, *La
Gaule Poétique*, 3rd
ed. (Paris: C.-F.
Patris, Lecointe, &
Durey, 1819), vol. 2,
facing p. 165.
(Photo courtesy
Bibliothèque
Nationale de France,
Paris.)

one place, a visual layering of history. For example, in *The Precincts of the Abbey* (Fig. 25), eighteenth-century figures in the foreground of an abbey place the time in the recent past, whereas the architecture directly behind them appears to be from the seventeenth century. The medieval towers looming in the background are the subject of the text, the military defenses of monasteries during the feudal period, whose brooding forms embody the brutal monastic discipline that was observed within their walls.[79]

In the plate *Ancient Cloisters against Which Knights Displayed Their Shields* (Fig. 26), the modern ruins serve as the background for a dream-like procession of the departed knights who had originally lived there. We see and hear the site: "Do you see these monasteries of Valdor, Oranfeuille, Kimperlai, Saint-Gildas, ancient cloisters on whose walls knights displayed their shields the day before their tournaments? Do you see these Gothic refuges that look as though they had been built by supernatural beings, set in the roaring sea on rocks that cast shadows on dark pines?"[80]

The same synaesthesia was utilized by Marchangy in his historical novel *Tristan le Voyageur, ou La France au XIVe siècle*, published in 1825. Perhaps it would be more accurate to call it a novel-history: the six-volume work was accompanied by footnotes on each page and an annotated glossary for each volume. Marchangy wrote this fictional work so that he could put into practice the beliefs he had enunciated in the more theoretical *La Gaule Poétique*, where he feared that the overrid-

ing chronological sweep in his survey of French medieval history had subsumed the evocative power of cultural details. In *Tristan le Voyageur*, Marchangy invited his readers to journey through France, so that they, too, could see the details of the national physiognomy more clearly and study them more lovingly.

WANDERING THROUGH THE PAST:
MARCHANGY'S *TRISTAN LE VOYAGEUR*

In his introduction, Marchangy signaled his intention, his method, and his political viewpoint. All three rested on the voyaging of the hero through France, on Tristan's reclaiming his national heritage from a "corrupting capital."[81] Tristan would set off in 1373 from Poitou to explore the feudal institutions that no longer existed.

The reason for their disappearance was modern political centralization, which, by destroying the delicate and differentiated system of local institutions, breaking the natural ties of family, community, and religion, had brought about "political suicide":

> The system of centralization, which has increasingly oriented all France toward its capital, as if bringing it to the edge of a precipice, has robbed our provinces of the physiognomy that had marked them for so long a time. And thanks to the devastation of our forests, the terrible breaking apart of properties, and the crumbling of historical edifices, soon the Salic land, deprived of its signs of glory, will be as devoid of memories as the banks of the Ohio or the Mississippi. This dreadful thought has inspired the author with the idea of seeking the true France in France, of breathing on the traces of our ancient institutions, of brushing the dust from guarantees of public liberty, of lighting the embers in private hearths and showing how different social classes kept each to their own rank in order to better enjoy the results of inheritance and live lives of uninterrupted peace and happiness.[82]

In contrast, Marchangy will describe patriotic provinces like the Vendée, which had remained loyal to Louis XVI:

> Brought up in the Poitou countryside, amidst hereditary traditions and religious beliefs that had not been weakened by the influence of a corrupting capital, those inhabitants were like the ones, four hundred years later, those noble inhabitants of the Vendée, who died in so self-sacrificing a manner in order to raise once again the throne of Saint Louis. Because they had remained on their own territory, the heroic virtues of their ancestors had not suffered any emasculation by the court.[83]

Our hero, preparing to set off on his adventures, is Tristan the "triste." He himself announces it when he bids farewell to the owner of Thouars: "sire, now my name befits my grief; he who leaves you is indeed poor Tristan." His modern amanuensis concurs, in a note: the

name was given to those who had suffered during their birth pangs.[84]

Why so sad? Because Tristan is transparently a surrogate modern: one who travels throughout his nation for three years, only to find that his own hearth rejects him at his return, and that the local institutions which had been his strength have been replaced by a foreign culture.

Tristan bases his patriotism in locality, ordained by God. Climate influences the physical development of a native population, and that, in turn, influences their character. Thus there is an intrinsic harmony between place and mores on a local scale, that is impossible to maintain throughout a nation:

> God has wished to restrict each government to a certain expanse, beyond which the same intelligence and empathy cannot be found. For in truth, love of country is made up only of hereditary traditions, fables learned in the cradle, local customs, sentiments experienced in the shade of trees marking the boundaries of home. And so it is that love of country is inherently love of one's place of birth, and a Norman could never feel it for Burgundy, any more than a Burgundian could feel it for Picardy or Saintonge . . . those who are born in the same place will have the same needs, wishes, hopes, which will certainly not be felt by people scattered by chance across a vast kingdom.[85]

Tristan admires a small manor at Quimper whose customs are in scale with those of the locality and contrasts it to the decadence of the royal court, when Richelieu and Louis XIV deformed aristocracy by making feudal lords become royal courtiers.[86] A tournament at Marsannay, near Dijon, is a celebration of knightly valor and prowess, under banners whose rich colors and emblematic designs are carefully explained to us.

But Paris, capital of corruption, is a nightmare of crime, disease, and death. The cut-throat locale of the Cour Jussienne, for example, is a disgusting nest of animal and human vermin: "thieves' dens, where constables don't dare to enter, where they fear the ambushes, vermin, and putrid miasmas that emanate from such a repulsive place." False beggars and prostitutes, who speak an unintelligible argot, are daily more numerous. Tristan's guide, Oresme, sorrowfully predicts that all society will be infected by these social diseases after a few centuries.[87]

When at last Tristan returns to Thouars, the cold and foggy autumnal weather, in contrast to the verdant spring that had seen his departure, presages his chilly reception. Visiting his beloved lady, Tristan meets her guest, a Greek doctor named Arthésias who had fled Constantinople, settled in England, and come to France with the retinue of the Black Prince. Arthésias is a personification of the late eighteenth-century and early nineteenth-century cultural invasion of France by international neoclassicism and Anglophilia. He contemptuously asks Tristan what he has learned during his voyage "merely in France." Tristan replies with a paraphrase of the comtesse de Die's poem of love, but he is unable to

touch the heart of his lady. After a sleepless, tearful night, Tristan decides to return to his fiefdoms in Aunis.[88]

Throughout the novel, Marchangy, like Tristan, has been attempting to win the heart of the reader by returning not only to a medieval epoch but a medieval narrative framework. Marchangy insisted that national history had to be expressed in a national literary form, that of the medieval *romaunt*. Its themes of love and valor, its fantastic and poetic qualities, its construction out of contrasts and episodes, made it particularly appropriate for French history.[89]

Marchangy celebrated the mosaic of civilizations that had existed in the provinces. He spoke as the representative of provincial conservatism against a corrupt and corrupting capital, and as the advocate of a nobility based on inheritance rather than political expediency. This was the true civilization of the country, one which he hoped to see arise once more, not the new modes and opinions that clashed and replaced each other daily in Parisian newspapers, politics, and art. In the provinces, the brilliant and differentiated tesserae of architectural monuments and cultural mores expressed the diversified and deeply rooted cultures of the French nation; because of their differentiation, they contributed to an indelible and rich cultural tapestry, one far more precious than the "misty idealism" of universally identical classicist abstractions. By moving into the provincial terrain, the French would not only be able to perceive the ruins of once-great monuments, they would be able to discern the stifled expression of mores. Object, costume, physiognomy, and custom had to be seen and appreciated as part of their unique climate and landscape. Once seen, they would be comprehended in all their distinctive glory; once their glory was represented, they would inflame the patriotism of locality once again.

The Restoration government recognized the validity of Marchangy's point of view and commissioned paintings of scenes from *La Gaule Poétique* from Bertin, J. A. Laurent, Rémond, Mongin, and Serrur.[90] These artists helped to create a new pictorial genre, and this is where we find the most permanent and productive visual manifestation of Marchangy's viewpoint. The genre was historical landscape, where subject, site, and meaning were united.

THE LOCALIZATION OF CATASTROPHE: HISTORICAL LANDSCAPE

In 1814, Gault de Saint-Germain subdivided historical landscape painting into four styles: the rustic, the pastoral, the heroic, and the historical. When he spoke of the latter two styles of landscape painting, he contrasted the heroic style of Arcadian classicism with the historical style, one appropriate to European chaos. The former, born of antique order and ideal beauty, had left behind it monuments whose description

FIGURE 27

Alexandre-Louis-
Robert Millin-
Duperreux, *Scene at
the Château de Pau:
Henri IV as a Child
Holding a Flag*
(1814). Pau, Musée
National du Châ-
teau de Pau. Oil, 75
cm × 1.32 m.
(Photo courtesy
Musées Nationaux,
Paris.)

should be recorded with a similarly ordered arrangement. The latter, however, which had developed out of modern political revolutions, required a greater degree of specificity in their pictorial chronicle.[91]

Although they may appear serene, Millin-Duperreux's historical landscapes were produced as a response to Revolutionary chaos. These landscapes were the loyal re-creation of patriotic heritage that had been born on a native place, since devastated. Thus, serenity is the achievement of will and fidelity: by scrupulously representing the terrain and monuments exactly as they had been, the artist dismisses their present ruined form and succeeds in re-creating them and their age.

Millin-Duperreux himself had experienced the chaos of the Revolution, and he described his efforts to help pioneer the genre of historical landscape during the Empire as having been motivated patriotically as well as aesthetically.[92] He was the son of an émigré whose properties were confiscated and who was guillotined after he returned to France in 1794. Millin-Duperreux's brother was a politician during the Restoration.[93] Instead of submitting his *Scene at the Château de Pau: Henri IV as a Child, Holding a Flag* (Fig. 27) to the Salon jury during the fragile period of the first Restoration, before the Hundred Days, the artist wrote directly to the comte de Blacas, minister of Louis XVIII's household, requesting Bourbon support for this work, because of its style as well as its subject: "This painting, which exactly represents the topography of a land that was the cradle of His Majesty's ancestors, a place that has inspired so many dear memories in France, seems, because of its subject,

FIGURE 28

Charles-Louis
Lesaint and
Théodore Géricault,
*The Church of Saint
Nicholas, Rouen*
(1823). Lithograph
by Engelmann, in C.
Nodier, J. Taylor,
and Alph. de
Cailleux, eds.,
*Voyages pittoresques
dans l'ancienne
France: Normandie*
(Paris, 1820–5),
plate 150, vol. 2.
(1825). (Photo
courtesy Biblio-
thèque Nationale de
France, Paris.)

to be a family portrait, which the king would perhaps take pleasure in
seeing."[94] The dearly beloved place demanded the homage of specificity.
In these historical landscapes, visual fidelity to the facts of architecture
and topography testified to spiritual fidelity, adherence to the beliefs that
had first created them. In 1816, the Ecole des Beaux-Arts finally
crowned this genre with its own Prix de Rome.[95] In 1834, the creation of
the Service des Monuments Historiques, as part of Guizot's program of
public instruction, carried this edification through edifices to the next
logical stage: that of direct architectural research and restoration.[96]

In 1820, the Romantic author Charles Nodier described the colossal
enterprise of the *Voyages pittoresques et romantiques dans l'ancienne
France*, whose multivolume publication extended over nearly sixty years,
as a voyage of site sensations. The enormous patrimony, filled with graves,
each clamoring to be preserved in art, set the author and his team of artists
roaming through France in search of meaningful fragments of the past
that possessed the "double charm of sites and souvenirs":

Monuments of ancient France reveal in their ruined forms far more
dreadful ruins to the imagination: the ruins of institutions . . . Not

only temporal catastrophes are written on these neglected ramparts; historical catastrophes are as well. At the sight of them, all the memories of days gone by are aroused once more; entire centuries, with their mores, beliefs, revolutions, the glory of their great kings and great commanders, seem to appear in these deserted places.[97]

Although the visual appeal of the illustrations for the *Voyages pittoresques dans l'ancienne France* resided in evocation through tone, rather than mimesis through trompe l'oeil depiction, they resembled Troubadour pictorial development in their address to the imagination through concrete fragments. Generally, however, they did not restage scenes from the past but offered present-day views of what remained of past civilizations: sculptural fragments, details from manuscripts, column capitals, landscapes, and contemporary interiors of monuments. Thus, they functioned differently from the vignettes Devéria was producing for Barante's *Histoire des ducs de Bourgogne* (Figs. 23, 24) in the same years. Devéria's tombs or facades were immaculate, despite the passage of time; if he included portraits, they were extrapolated figures, not broken busts. But the reader of the *Voyages pittoresques* surveyed architectural capitals, manuscript details, or modern views of historically notable places that had been transformed over time, as in *Church of Saint Nicholas, Rouen* (1823, Fig. 28), a composite view by Bouton's student Charles-Louis Lesaint (architecture) and Géricault (coach and horses).[98] Medieval statues contemplate modern commerce and transportation. Norman architecture and sculpture become melancholy debris from an age that is no longer whole and vibrant, broken shells left on the shore after the tide has ebbed.

Millin-Duperreux's landscape paintings were the faithful representations of ancient sites and monuments. The illustrations in the *Voyages pittoresques* were records of historical effects. In both cases, the places were intended to arouse memories of great heroes, significant events, precious aspects of culture that were tied to localities. The paintings by Bouton, Coupin, Richard, and Révoil that we have seen extended this process, by celebrating objects and architectural monuments as surrogates for historical heroes. Memories were to be aroused by the contemplation of "precious relics."

The Restoration audience for this group of Troubadour paintings and for Marchangy's texts had come to understand history as a consolation for loss. For them, the loss of the institutions so deeply rooted in the nation's medieval past, Catholicism, monarchy, the local institutions that united family and community, was directly related to the political disasters of their nation: their lost king and queen (guillotined), their lost aristocratic privileges (abolished) and properties (confiscated), the destruction of their churches and royal monuments (the Bourbon tombs at Saint-Denis), and, finally, the military invasion and defeat of their country. Piety and patriotism demanded a eulogy.

When we eulogize, we console ourselves for our loss by seeking to integrate the virtues of those who have died and left us behind. To do this, as Willemin had said, we fasten our eyes on "precious relics from the shipwreck of the generations," mute presences consoling us for what has been lost by persisting into our own day. In these examples, Bouton, Richard, Révoil, and Coupin de la Couperie sought a new balance between setting and meaning, in which the specificity of description could honor the spirit and mores of a past age. They hoped to accomplish the traditional aim of historical painting by establishing a new morality of local color, one that would permit concrete reality to illuminate the traditions, the thoughts, the meaning of the past. This lost civilization would be honored by being described as specifically as possible, as medieval pilgrims clarified their piety by concentrating their sight on the precious relics of a lost saint.

We can now understand why Bouton, Coupin de la Couperie, and other Troubadour artists chose to overturn the rules that had governed historical painting, rules that insisted on the visual primacy of the figure, why they gave architectural fragments pride of place, making them the heroic protagonists of the canvas. We can now understand why they decided that the visual impact of each concrete object must be maintained, so that the entire field is filled with brilliantly specific details that demand attention and respect, as in Bayard's crowded convalescent room. Generalized idealism, for this audience, was the dismissal of a dearly beloved civilization, an outrage to their beliefs. Those who wished to establish that civilization once again welcomed the new approach. Bouton's *Saint Louis* and Révoil's *Bayard* were government commissions; Richard's *La Duchesse de Montmorency* and Coupin de la Couperie's *Sully* were bought from the Salon by Louis XVIII.

Whether because of their political partisanship or their expressivist aesthetics, those who were willing to reinvent compositional formulae so that emotion could reside in the object rather than the figure found these Troubadour paintings worthy of acclaim. Classicists, as we have already seen, were bewildered or offended by them. But the royalist critic Kératry prefaced his review of the Salon of 1819 with the statement that human beings cherished their memories, their source of identity, were more affected by them than by their present-day experiences, and wished above all to see them given concrete form.[99] This link between the memories of the Salon audience and this new style encouraged Jouy (whose taste generally ran to Vernet) to be profoundly impressed by Bouton's *Charles-Edward* (Fig. 10). He was so overcome by emotion at the sight of an exile taking refuge in the tombs of his ancestors that he was forced to speak directly to the unfortunate prince and reassure him:

> The great virtue of sentiment is found in the highest degree in the painting of prince *Charles-Edward in Scotland*. Come, men of 1815,

and contemplate an exile's terrors! Here you can see the son of a legitimate king, for whom a bounty is advertised by the sons of a usurper, who have legitimated themselves. The last scion of a great race flees into the hills, takes refuge in ruins, the last palace of outcasts. He listens and trembles at the sound of insects and falling leaves. Isn't that the sound of his pursuers? No, be reassured, unfortunate prince; the sound that frightens you is made by a shy foot, a light garment tossed by the wind; it is a maiden, your deliverer, who approaches you.[100]

Delécluze had thought Coupin de la Couperie's *Sully Showing His Grandson the Monument Containing the Heart of Henri IV* (Fig. 13) flawed by the puerile care with which the artist had depicted the mausoleum. But Gault de Saint-Germain found the work one of the most remarkable of that year's Salon. He wholeheartedly approved of the union of content and form: color, architecture, and theme were equally instructive in their melancholy: "Let kings be instructed by the ruins and debris of a past reign! . . . The lugubrious color of twilight that surrounds the refuge of tombs is heartfelt poetry."[101] The fortunes of the painting were completely in the spirit of its subject and style. It was acquired by the Maison du Roi from the Salon, but in 1820, after the duc de Berry's assassination, it was given by the king to the duc's widow. The duchesse de Berry exhibited it at Rosny, her château, which had been built by Sully himself and visited by Henri IV. During the same month in which she acquired Coupin's painting, she commissioned the construction of a chapel in which the heart of her husband would be enshrined. There the painting would serve as the backdrop to her own instruction of her son, the duc de Bordeaux, who she hoped would ascend the throne in future as Henri V.[102]

The works by Bouton, Richard, Révoil, and Coupin de la Couperie that we have been examining overturned the established rules of composition, which centered on figural emotion and action primarily, because they made architecture and decor the motive elements. The returning Bourbons who responded to their works yearned for this meaningful, moral local color, just as they treasured the mementoes of their own lost families. Descriptions of decor now were not merely objective information or fairy-tale distractions; they were the beads for a visual rosary: by fastening attention on the concrete, the spirit could rise up to contemplate the divine.

But these paintings by Bouton, Coupin, Richard, and Révoil were meaningful only for those spectators who were able to invest them with the emotional weight of memories: Catholic and aristocratic compatriots of those whose virtues and endurance of misfortune were being celebrated. These works demanded the prepared, cultivated, pious attention associated with the medieval viewpoint, which perceived the spiritual meaning inherent in the material, the symbolic affirmation behind

the physical presence. If the Restoration spectator simply scrutinized the object as a material object and nothing more, and was more concerned with the painter's technical polish in representing it than the moral message contained within it, the precious relic became mere bric-a-brac.

In 1822, Delécluze complained that medieval romances had deformed the visual arts, as leprosy deforms the human body. He did not simply criticize the repertory of Troubadour subject matter as one comprised of trivial anecdotes of private life or describe its visual style as flawed by pedantic details and literally minimized by its small scale, where careful technique was an inadequate substitute for elevated expression of thought. These were merely the visual results of a deeper, conceptual flaw. Troubadour artists had denatured history itself by concentrating on transitory episodes and localized mores. Their canvases of accessories were cluttered with cultural records but lacking in meaning. True historical art arose out of poetic literature. The *romanesque,* in contrast, was based on singular and coincidental occurrences, rather than the abiding truth of human nature.[103]

Delécluze's argument went beyond opposing the truth of history to the falsity of fiction. Accepting Aristotle's distinctions, he found the created truth of tragedy superior to the actual, but merely coincidental, facts of history or historical romance. But, as we have seen, historians, readers, artists, and spectators were no longer satisfied with an eternally valid precept, insisting on specific and local details. How were artists to reintegrate the universal human emotions into unique cultural frameworks? Once catastrophe had been comprehended, its meaning needed to be conveyed. That meaning, Delécluze and other classicists argued, could be expressed only by human beings. Dramatized or personified history had its pictorial parallel in Delaroche's dramas. Having contemplated the ruins that historical events had left on their desolate national landscape, the French entered the theater, to witness the re-enactment of history itself.

WITNESSES TO CATASTROPHE
THE DRAMATIZATION OF HISTORY

IN 1841, the poet-critic Heine wrote, he passed by Goupil and Rittner's window, where he saw a print after a painting by Delaroche and was struck by the connections among history, theater, and politics. He recalled the protagonists in earlier works by Delaroche: *Jane Grey* (1833) (Fig. 29), showing the lady readied for the block; *The Children of Edward IV in the Tower* (1830), depicting the princes cowering on their bed as their murderer's shadow steals into the room; *The Death of Elizabeth I of England* (1828); *Cromwell* (1830), showing the Puritan leader raising the lid of Charles I's coffin; or *Strafford* (1835), in which Charles I's friend Strafford is blessed by Bishop Laud as Strafford goes on his way to execution.[1] Heine was forced to conclude that Delaroche's career had been that of a professional mourner at court, who specialized in depicting the defeats, assassinations, or impending deaths of monarchs and their supporters. Delaroche staged brutal or bathetic dramas for Conservative aristocrats to weep over and for smug bourgeois to buy in the form of pendant engravings:

> Delaroche shows a singular bent, if not idiosyncrasy, in his choice of subjects. They always concern eminent people, most frequently kings and queens, who are being executed, or have been executed. M. Delaroche is the court painter of all decapitated monarchs. He is an artist of lugubrious servility, who has dedicated his palette to these high and ultrahigh offenders . . . [these are] the favorite paintings of the bourgeoisie, those honest, worthy citizens . . . who confuse the horrifying with the tragic, and who eagerly seek to be edified by examples of great men brought low, content in the knowledge that they themselves are safe from being threatened by such catastrophes, standing in the back room of a shop in the rue Saint-Denis.[2]

Heine's discussion of Delaroche, both extensive and suggestive, requires close analysis. His first point is thematic: that Delaroche's art

centers on subjects that are brutal or bathetic: executions, deathbeds, and similar situations of monarchs or leaders in peril. This is undeniable, as we shall see when we consider the works he cites, as well as Delaroche's *Joan of Arc in Prison* (1824), *Miss Macdonald Bringing Aid to the Last Pretender* (1827), *The Assassination of the duc de Guise* (1834), and *Charles I Mocked by Cromwell's Soldiers* (1836). Heine's next point is that such themes require a gestural vocabulary that is "stagy" or "theatrical"; these gestures, which he considers not intellectual communication through corporality but strained emotionality, are evident in viscerally directed physicality, titillation at the sight of suffering flesh. Heine connects these gestures with Pixerécourt (a melodramatist) instead of Euripides or Racine. Such enactments convey meaning through pose rather than plot, confusing the merely frightful (the view of a shocking physical plight) with the tragic, in which catharsis promotes understanding. The melodramatic gestural repertory is rooted in moment rather than meaning: tearing out one's hair in despair, twisting another's wrist in retaliation. But how can a gesture that is determined by concrete necessity and coincidence, a gesture such as that of lifting a coffin lid, express both a universal emotion and a unique historical situation? Jane's fumbling for the block, Laud's extending his arms through prison bars to bless Strafford: such gestures are so controlled by concrete demands as to be historically meaningless, unless the arms are attached to identifiable historical characters, in a known situation. Even so, they run the risk of appearing unintentionally humorous; Heine thought Laud's arms resembled those of a traffic semaphore. The critic Planche, who insisted on the visual transmutation of emotion, feared that *Jane Grey* "threatened" to be the star of the Salon of 1834, found her gesture expressive of nothing more than somnambulism. He could not fathom why Delaroche had rejected the actual historical gesture: the executioner's kneeling before Jane Grey to beg her pardon, before he raised his axe for her decapitation.[3]

Heine's third point is political: that this dramatic manner of presenting imperiled monarchs would appeal to Conservatives, the "legitimists" of the "noble faubourg," who shed tears at the sight of Marie-Antoinette in prison.[4] Dramatic personification of historical meaning was understood by Delaroche's contemporaries, from Tom Paine and Edmund Burke to Chateaubriand and Lamartine, to be a politically Conservative rhetorical strategy. Theme, sentiment, and pantomimic lucidity could coalesce in what I shall call "corporal conservatism": the presentation of a political institution as a vulnerable body, exhibited to evoke respect and sympathy. This explains why Delaroche had chosen to depict what Planche considered a banal situation: Jane Grey as beauty at the block.

Heine's fourth point unites politics, class, and the graphic arts. The bourgeois audiences of the July Monarchy delighted in such paintings because they enjoyed edification at one remove: witnessing catastrophes

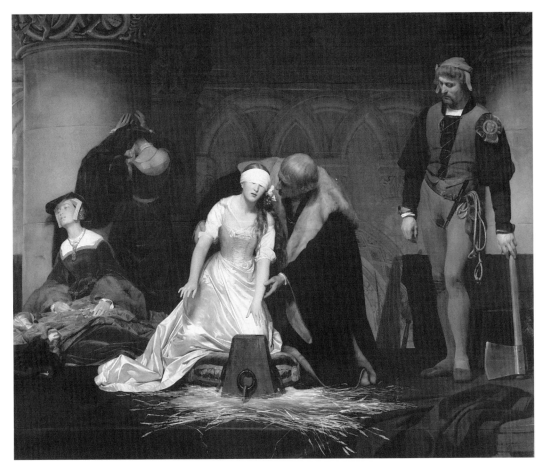

FIGURE 29

Paul Delaroche, *Jane Grey* (1833). London, National Gallery. Oil, 246 × 297 cm. (Reproduced by courtesy of the Trustees, The National Gallery, London.)

enacted by others. To extend their pleasure in witnessing such catastrophes, they sought to own a personal copy of the enactment in a graphic work, savoring the downfall of past monarchs in prints by Goupil and Rittner.

The picture-dramas of Delaroche and his followers could easily be reproduced in graphic form for a wider audience without losing their potency. Printsellers not only catered to the taste for such works, they provided further pleasurable control over the past by commissioning graphic cycles of two or more related themes, so that full comprehension of the situation was dependent on viewing its components. In this "pendant pedantry," paired graphic works further controlled historical chaos by not only personifying the past, but making one such personification function in tandem with another. Thus, the shock of the original event was transformed into a rhythmic repetition of similar events. A rupture, unique and inexplicable, was transformed into a series, one that could be analyzed for comparable motives and effects or supplied with them.

The bourgeois witnesses, pressing their noses against the printseller's window, were seeking the consolation of closure: the assurance that the past was past, and that meaning could be drawn from seeing it once

again. Unlike the aristocratic elite, who mourned the lost civilization of the past by contemplating its remains, the bourgeois audience wished to see the past perform for them, thrilled by a supposed witnessing of a spectacular act of heroism or a poignant resignation to a terrible act of violence. But in order for such violence to yield a message, its arrangement had to be perceptible: it had to be an obviously "staged" view into the past, whether it was acted on a literal stage, or took the appearance of a dramatized moment in a painting or print, or, in a narrative, framed a description of the original event with a commentary relating it to the present day. Witnessing the conscious enactment of a catastrophe, instead of the original and uncontrollable event, meant controlling it by making its arrangement apparent, making an invisible director place its horror behind an implicit proscenium.[5]

In this chapter, we shall be examining the dramatic personification of history in paintings by Delaroche, and corporal conservatism in Chateaubriand's *Les Quatre Stuarts* (1828). This history described the varying fortunes of England's Stuart kings, from James I's accession to the throne in 1603, through the Civil War, republicanism, military despotism, and the restoration of the monarchy and concluded with James II's flight into exile in 1688.[6] The similarity between these events and those that the Bourbons had experienced between 1789 and 1815 were obvious (and were to become even more striking after 1830). Chateaubriand, the Bourbon apologist, described his historical approach as "moral narration." He thought an objective description of the facts would be "callous." Instead, he claimed, his purpose in writing had been to conclude the French "drama of revolution" with the triumphant return of the Bourbons, who could now profit from the lessons they had learned from the unhappy history of the Stuarts, a history that he narrated in almost unbearably concrete, corporal terms.

In this approach to history, anecdotes from the private lives of leaders are presented to the audience so that they may be able to recognize them as conscious enactments of moments, rather than unmediated presentations of the original moments themselves. It is as if, instead of turning a corner to find a robbery in progress, we settle ourselves into our seats at the theater and watch actors "rob" actors on the stage. We are offered a reassuring configuration of meaning, born of later experience and reflection, rather than the original, terrifying situation. In Chateaubriand's words, this approach to history "closes the drama of revolution" by accompanying a catastrophe that occurred in the past with its lesson for the audience in the present day.

Initially it seemed that dramatic personification, whether in drama, painting, or historical narration, would be the ideal method for conveying historical meaning to the entire nation. We can easily understand why this was so. After we plunge beneath the surface of a lake, we immediately seek light and air and the ability to situate ourselves in

space. In the same way, we long to be able to configure meaning out of chaotic experience. We are able to achieve this, in the stage of historical comprehension that Ricoeur termed "historicality," where recollection allows us to emplot the consequences of past actions and so face the future with some security. The ostensible past performs for our benefit, the trauma of past experience is tamed; action is framed; past and present are linked. But in order for the moment to signal its meaning, in order for such dramatic anecdotes to function didactically, time must be doubled back upon itself. We do not see the original "now" but a modern revision of "now," which is crowned by a moral halo.

In the visual arts, dramatic personification, combining the sight of history-in-the-making with its final significance, became both the most institutionally sanctioned visual approach to historical representation and the most commercially successful, culminating in the July Monarchy's booming industry of historical prints and illustrated historical texts and Louis-Philippe's creation of the Musée Historique at Versailles.[7] Delaroche, the leading pictorial dramatist, helped to initiate this approach to historical painting, by far the most popular during the nineteenth century and one that has had extensive influence in our own era in historical films. Not only were his paintings often assessed in terms of their scenic impact and their staging, their deployment of gesture to convey plot to the spectator; his *Death of Elizabeth I* (1827), his *Children of Edward IV* (1830), his *Cromwell* (1830), and his *Jane Grey* (1834) even inspired dramas.[8] But there were problematic consequences to dramatizing history on the canvas: temporal, pictorial, and conceptual.

In dramatized historical painting, the dual temporal sense was manifested in a visual style that was conservative not only politically but pictorially. The material facts of reality, presented in explicit arrangements, were of primary importance for Delaroche; he often began work by constructing sets, and the final appearance of his paintings, like Cicéri's sets for Pixerécourt's melodramas, presented archaeologically exact scenery and costumes. Furthermore, Delaroche made the concrete presence of local color even more prominent by his reticent brushwork. But these were relatively minor issues, in comparison to the fundamental problem: dramatizing history according to a dual temporal sense that presented extraordinary difficulties in painting, tied to one visible moment. Delaroche had to make the canvas not only lucid but transparent: not only did the audience look "through" the space to see the actors (instead of examining the canvas to assess its composition, handling of form, and so on); they were forced to look through the moment to its preparation and denouement. To make this possible, the artist needed to construct the composition from a dramatist's perspective: to make the precipitating motive clear to the viewers of its physical result. Thus, the religious tension between Catholics and Protestants that resulted in Strafford's execution would be shown by Bishop Laud thrusting his arms

through prison bars in blessing. By 1837, one Salon critic promised his audience that they need not worry that he would discuss such pictorial concerns as drawing, brushwork, or color, for that year's Salon was filled with theatrical productions of every genre: "you can find your favorite: the picture-tragedy, the picture-comedy, the picture-drama, the picture-vaudeville, the picture-burlesque."9 Such dramatic scenes were clearly alienated from both "the event as it must have taken place" and the pictorial object itself.10 And, if the dramatic approach failed to satisfy those who sought Romantic colorism and touch, it also failed to satisfy classicist critics, who complained that dramatic anecdotal paintings were presenting only material truth, not its distillation into moral truth through formalist metamorphosis.

Furthermore, such dramatic historical paintings not only lacked pictorial integrity, they lacked historical truth, if history were understood according to a Liberal rather than a Conservative political viewpoint. Liberal historians and critics complained that the dramatic staging of history oversimplified social experience to biographical anecdote and excluded the potent but invisible social forces that had actually influenced those events but that could not be seen on the stage. Liberals complained that Conservatives presented revolution as the martyrdom of monarchs rather than as a conflict between parliamentary and royal authority, between religions, or between classes. The commercial appeal of graphic renditions of such dramatic historical paintings, both as independent prints and as graphic series, helped to complete what Liberal critics complained was a vicious cycle. Just as modern viewers worry that news events are being reduced to that which can be televised or photographed, so these art critics feared that because pictorial values were being subordinated to the goal of graphic communicability, historical reality was being oversimplified, reduced to that which could be personified and dramatized, that which could be summarized in a graphic anecdote.11 Though dramatic historical painting triumphed with the public, that triumph was a pyrrhic victory. By the 1830s, when these dramatic pictorial anecdotes were ubiquitous, many critics condemned such works as neither true paintings nor true history. But at the beginning of the century, these works were hailed by the historian–art critics Guizot and Thiers as the salvation of modern historical art.

"ARRESTING THE PASSING VIEWER": DRAMATIC PAINTING AND PEDAGOGICAL PANTOMIME

In 1810, the historian Guizot (later minister of public instruction for Louis-Philippe) cautioned Troubadour artists that their modern subjects, though well chosen, were presented too pedantically for all Salon viewers to be able to appreciate them:

Paintings are made for those who are experts; fair enough. But even if only those experts judge them, the public should still be able to enjoy them, and their approbation is not as unimportant as people suppose. Artists don't recognize what they lose in neglecting composition; for those who glance by in passing, they take away the desire to stop, and for those who scrutinize the work carefully, the pleasure of contemplating it without irritation, of being immediately delighted.[12]

The ordinary members of the public were neither erudite connoisseurs, primed with full knowledge of the event, nor emigré-aesthetes who piously contemplated relics. Instead, they glanced at paintings in passing. These viewers would be able to understand only those compositions that were absolutely legible, "melodramatic" compositions, in the opinion of many critics. By 1835, Fabien Pillet would describe the Salons as "history courses that impress national events on the minds of the general population, who would not willingly go to libraries for the information."[13] Artists were urged to return to the traditionally sanctioned dicta for historical painting: centralize visual interest, subordinate decorative detail, and, above all, rely on gesture, the "primal language of mankind," in order to literally "incorporate" the subject. Historical painting was turning away from edification, toward pedagogical pantomime, where drama and didacticism could be conflated.[14]

Two proposals for pedagogical galleries were made during the Restoration: one by Jussieu in 1816, the other by Ponce in 1829.[15] They were to contain paintings that would be sufficiently large in scale to permit life-size figures, which would be supplemented by historical lectures or by catalogue. Ponce argued for a gallery of "virtues" of filial respect, fraternal love, and so on; the subjects would be taken from modern national history, which had the advantage of impressing children's memory and imaginations more forcefully. He insisted that viewers should be able to apprehend the situation and its moral lesson at first sight, without the assistance of a printed guide. Keeping that explanation from them as long as possible would ensure that the sight of these actions would be engraved more deeply on their soul.[16] Providing illustrative paintings for an uninformed audience but separating the paintings from their intended texts meant that meaning had to reside in that which could be seen immediately: the gesture, the action of an unfamiliar person, denuded of its context and consequences. But could the sight of that gesture, that action, convey more than a thrilling but generalizable corporal situation? Could it convey the full meaning of a unique event?

The impact of the gestural revolution in theater provides an instructive parallel. There, too, verbal expression of meaning was rejected; instead, dramatists sought the (literal) articulation of moral legibility through corporally expressed emotion.[17] This was not a simple matter, either onstage or on canvas, since gestures are compounded of intellectual significance, emotional expression, and physical reflex. Classicists

stressed the first, moderns investigated the last. Melodramatists, para-doxically, found that they had codified the corporal presentation of passion to pose platitudes.

Although many eighteenth-century authors urged artists to study theatri-cal works, they were cautious about instructing painters to copy theatri-cal gestures in their paintings. Action onstage was limited to a chronologi-cal moment. If artists described the pivotal moment of transition between emotions (Shaftesbury, for example, cited Hercules's hesitation between Minerva and Venus), or the moment of maximum emotional involvement of the protagonists (Hippolytus's rejection of Phaedra before his father Theseus), then they could give a more informative and expressive represen-tation of the event than dramatists would be able to present onstage.[18] Diderot was both a playwright (inventor of the "drame bourgeois") and an art critic; he drew a more subtle distinction. He urged artists to con-sider the structure of the plot, as well as the pose of the actors. If the play were structured expressively, so that the emotional crux was visible on-stage in the groupings and poses adopted by the characters, then the playwright would be offering artists in his audience "tableaux," moments in which the stage action paused so that the audience could respond more completely to the crisis. If, however, the actors posed in order to react to a surprising turn in the plot, this was a mere "coup de théâtre," unworthy of inspiring a great painting.[19]

The classicist Paillot de Montabert insisted that artists should refrain entirely from copying theatrical gestures. The fundamental purpose of art was the expression of intellectual and spiritual significance, not their literal incorporation into gestures. It was the sentiment animating a hero – the sentiment itself – that the artist was to depict, not the transi-tory expression of that sentiment in a pose, an act. If painters copied modern actors' gestures, the result would be visual stridency, "screaming with one's arms as one screams with one's voice."[20]

But some dramatists, seeking to instruct the nation by dramatizing history, were forcing a revolution in dramatic themes, dramaturgical for-mat, and gestural repertory. In 1768, Hénault urged modern French dra-matists to dramatize their nation's history, as Shakespeare had the Wars of the Roses; Hénault himself wrote such a work.[21] In 1769, Mercier re-minded modern French dramatists that the original aim of Greek tragedy was not simply to affect heart and soul, but to foster republicanism. In a theatrical tract of 1773, he demonstrated how modern dramas could correct tyranny: for example, the death of Nero might be staged in the most graphic and unheroic terms, with the emperor screaming in fear and scrabbling on the ground in convulsions as he fought against his approach-ing death.[22] The same points were made by André Chenier in 1789: subjects of modern history, acted out before the nation, would deeply move the audience and thus indelibly instruct them in the moral message as well as the facts.[23] During the Revolution and the Empire, corporal

clarification of a propagandistic message was transmitted through the funerary display of a fallen hero or the unification of the community in a festival; citizens could witness the pose and even adopt it themselves. Such kinetic activity would transform them into enlightened members of the nation, would knit them into the body politic.[24]

The melodrama was developing during this same period, but in a less elevated sphere, profiting from the fluidity of theatrical genres at that time. It grew out of the "dialogue-pantomime," which became popular in the 1780s and 1790s. During the Empire, Napoleon attempted to regulate four major theaters in Paris, each specializing in one of the major genres of tragedy, comedy, and tragic and light opera (the Opéra, the Empereur, the Impératrice, and the Opéra-Comique) and four minor theaters, for melodrama, farce, pantomime, parody, and lesser musical entertainments (the Gaîté, Ambigu-Comique, Variétés, and Vaudeville). After 1815, pantomimic theaters not only multiplied but diversified: dialogue, heroic, historical, and spectacular forms became common. Melodramas flourished in three theaters: the Gaîté, the Ambigu-Comique, and the Porte-Saint-Martin. The Franconi brothers produced historical pageants and animal spectacles at the Cirque Olympique. Scenic effects were not only sumptuous, they were the product of considerable erudition, as we can see in Gué's lithograph showing Cicéri's sets for Pixérécourt's *Le Château de Lochleven*, staged at the Gaîté in 1822 (Fig. 30). Visual effects and gestural insistence were mandatory; in Pixérécourt's words, "I am writing for those who cannot read."[25]

Aristotle had insisted that tragedy had to be based in moral, not physical, action. Emotional catharsis should occur as a result of witnessing causality, or even of hearing about the plot, not of seeing a spectacular display of suffering. An expensively mounted performance in which fear and pity were evoked by the spectacle itself would merely amaze the viewer, not purge his soul. Such a spectacle had nothing in common with tragedy; it was incapable of extracting philosophical meaning from human experience.[26]

But the direction of modern drama was away from the cathartic, toward the spectacular; away from the verbal, toward the gestural. Stage gestures were not simply the accompaniments to the dramatic action, summing up didactic meaning in a gestural pause in the verbal action. Now, physical actions *were* the dramatic action; sentiment was aroused through a series of discontinuous configurations of poses.[27] In order to construct plays where there would be a corporal summation of the psychological conflict, authors had recourse to mutes or others unable to speak. One of the key actors in Pixerécourt's popular melodrama *Le Chien de Montargis* (1814) was the trained dog, who identified the falsely accused hero by licking his hand in Act III.[28]

Melodramatic gestures, though capable of conveying strong emotion in an unambiguous manner, ran the risk of being neither visually beauti-

ful nor uniquely characteristic, descending into clichés that became unin-tentionally ridiculous. The authors of the parodic *Traité du Mélodrame* (1817) scornfully suggested poses for the stock characters of the perse-cuted hero, the despairing heroine, or the fool, that would "render the state of their souls" in a group "tableau" at the end of each act: "grief will place a hand on his forehead; despair will tear out her hair; joy will have one leg in the air. This general view of the cast is designated the 'tableau.' Spectators will be delighted to see at a glance the moral state of each character."[29]

Dramatists who took a more serious approach and who wished to move their audience to more than snickers had to turn away from trite gestures that could render grief, despair, or joy to more brutal actions. Violent acts onstage could not be dismissed as easily, for they rendered the murder or the duel in direct terms: the audience worried that both actor and character were at risk. This direction toward physically reflex-ive drama reached a crisis point on the stage of the Théâtre Français itself, when Alexandre Dumas's *Henri III et sa cour* opened on February 11, 1829.

The climax of the play, seen here in a contemporary lithograph by Achille Devéria (Fig. 31), occurs in Act III, Scene 5.[30] The duchesse de Guise is forced by her jealous husband to write a letter to her lover and so betray him to death. The audience found it almost unbearable to watch the husband wrenching her wrist until she agrees to his demand. Less than a week after Dumas's play opened, classicist dramatists sent a petition to Charles X asking him to prevent the Théâtre-Français from substituting this frighteningly populist genre of melodramatic theater ("Melpomene of the boulevards") for classical tragedy. Its decorative spectacle was ruinously expensive, but that was a minor defect com-pared to its fundamental menace: instead of enlightening, as tragedy did, it simply stunned the audience, destroying any possible address to the soul, the intelligence, and the heart.[31]

This transparently lucid pantomime would be a powerful aid to artists seeking to configure compositional themes. In the Restoration, critics were willing to accept the dangers of such an approach in painting, given the urgent need to depict national history for a wider audience than those who savored the Troubadour style. In this period, almost all critics hailed Delaroche's dramatic historical compositions that explained them-selves to the ordinary viewer at first sight. We can see the reason for their excitement, and the difference between such works and Troubadour paintings, which needed to be savored by an elite before becoming com-prehensible, if we compare two depictions of Joan of Arc, one by Révoil in 1819, the other by Delaroche in 1824.

Révoil's *Joan of Arc Imprisoned at Rouen* (Fig. 32) is a Troubadour work that dramatizes meaning through the figure instead of allowing it to emanate from the decor.[32] Joan's central placement, elevated position,

FIGURE 30

Gué, *Théâtre de la
Gaîté. 1er Acte du
Château de Loch-
leven* (c. 1822).
Lithograph (Paris:
Engelmann, c. 1830).
(Photo courtesy Bib-
liothèque Nationale
de France, Paris.)

illumination, contrapposto movement, and diagonally lifted arm estab-
lish her as the focal point; she dominates the crowded scene that is
literally below her notice. Révoil orchestrated Joan's reactions (coura-
geous patriotism, refusal to negotiate, and controlled dismay at her im-
prisonment and certain death), contrasting them with the anger and pity
felt by her tormentors. Thus, Révoil carefully presents the situation of
Joan's imprisonment and coming martyrdom in a manner that under-
scores the transcendent meaning of her suffering (comparable to Christ's
flagellation) instead of her physical suffering. It is clear why such a
moving yet diplomatically nonphysical description would please the
duchesse de Berry, who immediately acquired the painting.

In *La Gaule Poétique*, Marchangy had refused to describe Joan's
capture, imprisonment, interrogation, illness, or death at the stake. In-
stead, after describing Charles VII's solemn entry into Reims ("where
more than once God has made miracles come to pass in support of our
monarchy"), he had her speak with a disguised archangel and then rise
like a phoenix to eternal peace with the angels and the French queens in
Heaven. Those who insist on a narration of earthly events, Marchangy
noted, should read such authors as Lebrun de Charmettes.[33]

Révoil did just that and cited the text extensively in the 1819 Salon
livret when he exhibited his painting of Joan. Lebrun de Charmettes,
writing about Joan in 1817, had reproduced the archaic spelling and
repetitive phraseology of a medieval chronicle and provided a chronicle's
eyewitness description of physical peril.[34] Just as the text is a feigned
chronicle, a medievalist memento of the past, so Révoil's image isolates
and distances the event from its spectators in the nineteenth century.
Joan's reduced scale invites the audience's recognition of a historical
situation, but their empathy with her psychological situation is achieved,
paradoxically, by denying her visual prominence. Joan gesticulates, as-
serting her defiance, but she does so in such a dark and cavernous space

FIGURE 31

Achille Devéria,
*Henri III. Act III.
Scene V.* Lithograph
(Paris: Gaugain,
1829). (Photo cour-
tesy Bibliothèque
Nationale de France,
Paris.)

that her small figure, only supported by the sturdy column to which she is chained, is visually dwarfed, as well as historically doomed.

In contrast, Delaroche's *The Ailing Joan of Arc Is Interrogated in Her Prison by the Cardinal of Winchester* (Fig. 33) expresses meaning through gesture in three figures placed directly in front of the picture plane, with no distracting space behind or above them.[35] Delaroche avoids Révoil's gestural cacophony by reducing his cast to a heroine, a villain, and a clerk transcribing her testimony (veiled in darkness). A brutal prelate who represents a God of vengeance confronts a trembling girl who represents a God of mercy: two antagonists (a tiger and a gazelle, one critic called them) who almost constitute the scene in its entirety. Winchester's fearful power is evident in the shrieking tones of his crimson and pink robes, his fiercely twisted profile, and his clenched grip on the arm of his chair; his verdict can be read in the downward-pointing finger. Although the humbler brown tones of Joan's costume make her disappear into her prison's wooden planks and stone walls, her tonal range is greater (particularly in the *trompe l'oeil* straw escaping from her pallet), and her pose is more massively three-dimensional, so

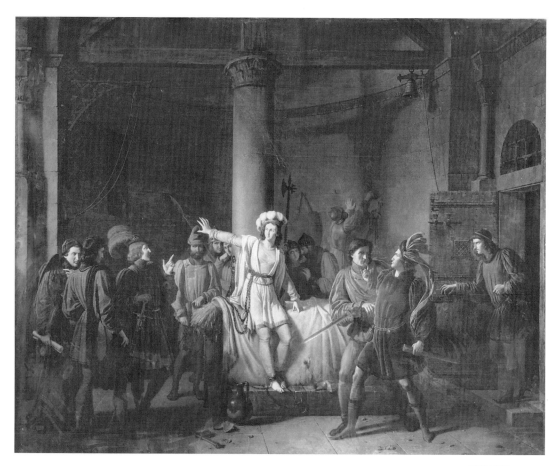

FIGURE 32

Pierre Révoil, *Joan of Arc Imprisoned at Rouen* (1819). Rouen, Musée des Beaux-Arts. Oil, 1.39 × 1.75 m. (Photo courtesy Giraudon/Art Resource, NY.)

that her clasped hands not only summarize her characterization but stabilize the viewer's interest. These gestures are candid, concrete, and characteristic, and they reign supreme. Delaroche's *Joan of Arc* was universally praised for its dramatic, historical, and pictorial achievement. Rabbe and Thiers, two art critics who were also historians and Liberals, were impressed by the way the artist had combined a faithful description of costume and setting with psychological insight into national character, visible in physiognomy and gesture.[36] Thiers hailed Delaroche's satisfaction of the longed-for combination: eternal didactic meaning, imbued with local color, conveyed with heartfelt emotion. This was modern beauty: the new, and true, style of history painting.[37] Delaroche received a medal after this Salon.

In the Salon of 1827, Delaroche exhibited *Miss Macdonald Bringing Aid to the Last Pretender* (Fig. 34).[38] This dramatic scene expanded the cast beyond the two protagonists, but its emotional focus was maintained. One of the Jacobite soldiers looks back to Flora, another kisses her hand; above her hands, Charles's pale face is silhouetted against the dark void of the cave in the background. Once again, the critics were delighted, calling it a masterpiece of truth and sentiment.[39] Despite the work's small scale, it was discussed as a historical painting, even by such

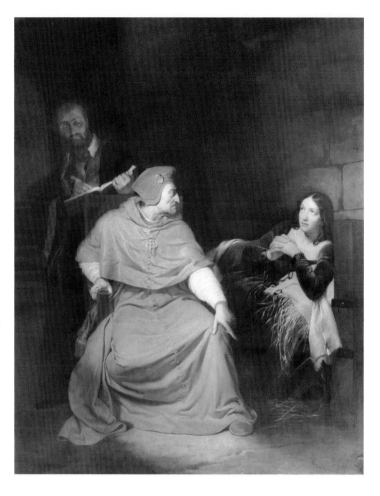

FIGURE 33

Paul Delaroche, *The
Ailing Joan of Arc Is
Interrogated in Her
Prison by the
Cardinal of
Winchester* (1824).
Rouen, Musée des
Beaux-Arts. Oil,
2.77 × 2.175 m.
(Photo courtesy
Musées Nationaux,
Paris.)

stringent critics as Delécluze, who was pleased to see the artist subordinating decor to figure.[40] After this Salon, Delaroche was awarded the Cross of the Legion of Honor.

How far we have come from Bouton's depiction of the same subject, exhibited in the Salon of 1819 (Fig. 10). Landon had been perturbed by Bouton's architectural protagonists and his solicitation of the viewer's interest throughout the canvas's setting, even probing the background. But Delaroche's faggot of sticks, basket of provisions, or plaid kilts remained decorative accents to a figural drama; though local color was accurate, it was unobtrusive. In his dramatic historical paintings, acts such as Joan's prayer or Flora's charity were physically and emotionally gripping and morally and intellectually instructive. Meaning (lasting spiritual and intellectual commentary) and moment (the locally specific details of temporal experience) were reconciled in the body that acted out the pathetic situation.

In Chapter 3, we considered the first response of royalists to their terror and loss during the Revolution, a response that deflected emotion from figure onto inanimate relic. In this chapter, we see the natural

FIGURE 34

Paul Delaroche,
*Miss Macdonald
Bringing Aid to the
Last Pretender*
(c.1825). Engraving
by Sixdeniers after
the original oil
painting, now lost
(Paris: Goupil &
Vibert, 1840).
(Photo courtesy Bib-
liothèque Nationale
de France, Paris.)

sequence to that first horrified denial and defense: a determination to
configure meaning out of catastrophe. Edmund Burke and François-
René Chateaubriand utilized bodily metaphors in their writings that
would induce readers not only to sympathize with suffering monarchs,
but to realize the transcendent meaning of their physical Passion, permit-
ting them to learn from and leave behind the original traumatic event.
Such dramatized anecdotes, in texts or in visual images, were (if carefully
handled) not only exciting but didactic and morally beneficial.

The royalist Horace de Viel-Castel, in his review of the Salon of 1831,
the first Salon after Louis-Philippe d'Orléans had supplanted his cousin
Charles X on the throne of France, praised artists who utilized the
"moral" or "dramatic" approach to "writing" historical painting, mak-
ing it possible for the audience to "look back with them on events":

> Painting, like poetry, has three epochs: first it is lyric, then epic, and it
> is now in its dramatic period . . . history's exalted mission will be given
> over to painting from now on; modern history, the great drama from
> the Middle Ages up to our own age, will be the domain that painters
> will be determined to master. They will find it both aesthetically valu-
> able and socially beneficial to encourage the public to look back with

them on events that took place recently in their land or nearby, and in showing them these actions they will make them feel the drama of the scene and learn an important moral lesson. Charles I stepping onto his scaffold and the massacres of our Terror have made many people and kings reflect. I place in the new school all those artists who devote themselves to writing pictorial history . . . Thus, our painters can be divided into several ranks . . . dramatic or moral painting, genre painting, and landscape painting.[41]

In the same year, under the same impact of the Bourbon fall, Chateaubriand defined the ideal historical narrative as a moral history, one that distinguished vice from virtue, a characteristic lacking in both the "descriptive" and the "fatalistic" schools of French historiography, which refused to recognize tragic catastrophe.[42] But he promised a moral history, one that recognized the facts of Bourbon suffering as a modern Passion, where he would lead the reader "to the foot of the cross of Louis XVI on the scaffold."[43]

Chateaubriand's *Les Quatre Stuarts* (1828) was a Conservative historical text that literally configured historical meaning, presenting it in corporal terms. It was very popular, and frequently the source of historical paintings, including Delaroche's. On a more fundamental level, Chateaubriand's "moral" and dramatic historical approach influenced Delaroche's dramatic historical paintings in two respects: their signaling of two time frames, and their locating historical and political meaning in the body. But before considering his approach in depth, we must first examine the English works that influenced Chateaubriand during his exile in England (1793–1800): Hume's *History of the Stuarts* (1754–6), which provided Chateaubriand's themes; the images illustrating Hume's histories in Robert Bowyer's Historic Gallery during the 1790s, compositional sources for Delaroche and other French artists, as well as for Chateaubriand; and Burke's antirevolutionary polemics, which provided a precedent for the French historians' corporal conservatism, exhibited in a "moral theater."[44]

CORPORAL CONSERVATISM IN THE 1790s: BURKE AND THE BOWYER HISTORIC GALLERY

Edmund Burke's *Reflections on the Revolution in France* (1790) were written as a Conservative dramatization: a polemic in which pathos and personification were the instruments of his argument. Burke argued that Britain's Conservative, balanced government, in which a divinely ordained monarchy was supported by a hereditary aristocracy and enforced by law and religion, was authorized by the natural order of humanity.[45] English liberties were "an entailed inheritance" from "canonized forefathers," meant to be carefully guarded before being passed down to posterity. The constitution was bound together with "our dear-

est domestic ties." Political institutions were as palpable and beloved as family members, or bodily members:

> By a constitutional policy, working after the pattern of nature, we receive, we hold, we transmit, our government and our privileges, in the same manner in which we enjoy and transmit our property and our lives . . . By adhering in this manner and on those principles to our forefathers, we are guided not by the superstition of antiquarians, but by the spirit of philosophic analogy. In this choice of inheritance we have given to our frame of polity the image of a relation in blood; binding up the constitution of our country with our dearest domestic ties; adopting our fundamental laws into the bosom of our family affections.[46]

Burke contrasted modern Britons, who still had "real hearts of flesh and blood," with the French, who had been "drawn and trussed . . . filled, like stuffed birds in a museum, with . . . blurred shreds of paper about the rights of man."[47] This paper parliament, this French "burlesque" of a representative assembly, in seeking to alter a naturally ordained order had made an error as fatal to political efficacy as that of exchanging a theater's audience with its actors:

> The Assembly, their organ, acts before them the farce of deliberation with as little decency as liberty. They act like the comedians of a fair before a riotous audience; they act amidst the tumultuous cries of a mixed mob of ferocious men, and of women lost to shame, who, according to their insolent fancies, direct, control, applaud, explode them; and sometimes mix and take their seats amongst them.[48]

Burke ushered the audience back to their seats, to see his dramatization of the suffering of the Bourbons in the "intricate plot which saddens and perplexes the awful drama of Providence now acting on the moral theater of the world," as he wrote in his last polemic, *Letters on a Regicide Peace* (1796–7).[49] It was necessary to exhibit the pathetic sight of a dethroned king to an alarmed, reflective, and (he hoped) remorseful Assembly:

> when kings are hurl'd from their thrones by the Supreme Director of this great drama, and become the objects of insult to the base, and of pity to the good, we behold such disasters in the moral, as we should behold a miracle in the physical order of things, We are alarmed into reflexion . . . Some tears might be drawn from me, if such a spectacle were exhibited on the stage.[50]

David Hume's intention in writing his history of England had been less polemical and less personalized than Burke's: it was to instruct his contemporaries about British progress from savage tribal licentiousness toward modern, balanced political institutions, those institutions being not personifications but intellectual constructs.[51] He had written his *History of the Stuarts* (1754–6) as a work of political philosophy, balanced between support for the crown and respect for parliamentary

FIGURE 35

Charles Benazech,
*The Last Interview
between Lewis the
Sixteenth and His
Disconsolate Family
in the Temple*
(1793). Engraving
by Schiavonetti
(London: Colnaghi,
1794). (Photo cour-
tesy Bibliothèque
Nationale de France,
Paris.)

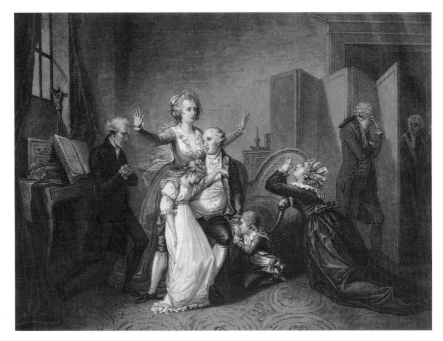

authority.[52] Hume strained to provide an impartial account of the events
from the ascent of James VI of Scotland (Mary Stuart's son) to the
throne of England after the death of the Tudor Elizabeth I, to the coming
of William of Orange. He portrayed the tumultuous events of the Civil
War as the result of both "superstition" (as he termed the mystic dogma
of the divine right of kings) and popular fanaticism.[53] Biographical por-
traits were set into a network of social forces.[54]

But Chateaubriand was reading Hume after the world had seen and
domesticated monarchical agony. The sufferings of the royal family as
family members, their private convulsions, swoons, and screams, de-
scribed to emigrés in London by their former valet-de-chambre Cléry,
were being stressed in royalist prints such as the 1794 engraving after
Charles Benazech's painting *The Last Interview between Lewis the Six-
teenth and His Disconsolate Family in the Temple, On the Twentieth of
January 1793, the Day Previous to His Execution* (Fig. 35).[55]

We can see the impact of this direct experience of royal vulnerability
in Robert Bowyer's Historic Gallery, a collection of more than one hun-
dred paintings commissioned to serve as the models for illustrations to
Hume's history of England from the invasion of Julius Caesar to the
Glorious Revolution of 1688. Bowyer exhibited the paintings in his
house in Pall Mall in 1793 and in 1795, engraved them during the
1790s, and published them in a folio edition in 1806. In images such as
Thomas Stothard's *Charles I Taking Leave of His Children* (1793), en-
graved by Bromley in June 1794 (Fig. 36), we see a sentimental personifi-
cation of history in poignant biographical anecdotes from the private
lives of leaders.[56] No images were provided of the uncomfortably topical

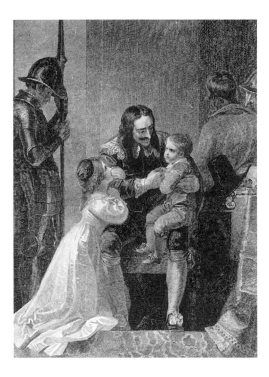

FIGURE 36

Thomas Stothard,
*Charles I Taking
Leave of His
Children.* Engraving
by Bromley after the
original oil painting,
now lost, for the
Bowyer Historic
Gallery (London,
1794). (Photo cour-
tesy Bibliothèque
Nationale de France,
Paris.)

trial and execution of Charles I, public and humiliating moments. In the
same manner, Chateaubriand eliminated Hume's impartial context for
his poignant anecdotes, underscored the physical vulnerability of mon-
archs and their tragic fate, and linked the events directly to recent French
experiences.

The Bowyer illustrations were immediately known to the French and
had a lasting, significant impact on their historical repertory and concep-
tions.[57] When Charles I's farewell to his children was reinterpreted in
France, during and after the Restoration, as an icon of paternal kingship,
paintings and prints of this subject, often virtual repetitions of this com-
position, were produced by Decaisne, Colin, Achille Devéria, Mme
Rude-Frémiet, Alfred Johannot, Somers, and Jacquand.[58] Delaroche's
frequent compositional dependence on Bowyer, which was immediately
noted by his critics, had technical, intellectual, and emotional ramifica-
tions.[59] First, and most directly, it was a suggestive visual precedent in
which minimal figures, without distracting accessories or deep back-
ground spaces, enacted the event. This was an appropriate approach to
depicting history for those whose conception of history was that of
dramatic personification. Second, it demonstrated the artist's intellectual
command of historical documentation, gesturing toward the larger asso-
ciative field of reference: the original event, Hume's history, and the
Bowyer illustrations to Hume.[60] Finally, because of this gesturing toward
a larger archival authority, the artist ensured that his authoritative inter-
pretation was comfortably distant from the original agony of patricide
and orphanhood. The contemporary audience was reassured that they

were seeing history through strata of interpretation: Hume's, Stothard's, the historian presently cited (Chateaubriand), and the French artist who produced the work under examination: a series of frames that imposed distance and resonance at the same time. Chateaubriand, as he repeated Hume's account of the scene virtually word for word, deepened its poignancy by doubling its characters. Narrating the sad history of the Stuart children "in republican hands" inevitably led him to remember that "The young king Louis XVII and his saintly, noble sister, received later on, in the Temple, the blessings of Louis XVI."[61]

We have been seeing how strategies of literary polemics by Burke and Cléry were immediately reflected in the visual arts in the Bowyer illustrations to Hume. The dramatization of private anecdotes that conveyed dynastic and national implications, the corporal configuration of meaning, the temporal doubling to stage a feigned catastrophe in front of a docile audience: all of these rhetorical strategies were utilized by Chateaubriand. It is now time to examine Chateaubriand's career, and the way in which he employed corporal conservatism in his history of the Stuarts, to ensure the triumph of the Bourbons.

CHATEAUBRIAND'S LES QUATRE STUARTS: CLOSING THE DRAMA OF REVOLUTION

François-René, vicomte de Chateaubriand (1768–1848), was a politician-historian whose works in all literary genres were both influential and widely read. A lifelong Bourbon apologist, his royalism was pragmatic as well as lachrymose. During the Restoration, Marchangy eulogized a civilization that had been lost forever. Chateaubriand served his king by addressing royalist propaganda to the general audience, in the hope of achieving a lasting Bourbon restoration for the future.

Chateaubriand had come to Paris in 1788 with a military commission and immediately made friends at court. He fled to America in 1791, an experience that later resulted in his novels *Atala* (1801), *René* (1802), and *Les Natchez* (1826). He returned to France in 1792, and fought in the first corps of the royal army, led by the future Louis XVIII and Charles X. After their defeat at Valmy, he escaped to England, where he supported himself as a translator from 1793 to 1800. During his exile, his brother and sister-in-law were executed and his wife, sister, and mother imprisoned. He returned to France and published *Le Génie du Christianisme* (1799–1801), a poetic work of Christian apologetics, in 1802, just after Napoleon's signing of the Concordat. In 1803, Napoleon appointed him secretary of the French Embassy in Rome, but Chateaubriand resigned the post in 1804, to protest the execution of the duc d'Enghien. From that point on he supported the Bourbons, either overtly or covertly. In 1807 he became editor of the *Mercure de France* (formerly edited by his royalist friend Louis de Fontanes). In 1811 he was elected

to the Académie, but the text of his acceptance speech was so inflamma-tory that he was not permitted to read it.

During the Restoration he was appointed to leading ministerial posi-tions and published numerous political pamphlets and journalistic arti-cles to advance Bourbon constitutional monarchy. His *De Bonaparte et des Bourbons* (published a week after the Allied armies entered Paris in 1814) was, he later claimed, the beginning of his campaign to educate the French in constitutional monarchy. He established the journal *Le Conservateur* (1818–20) as an organ of Ultraroyalist opinion. But his support of the Charter made for a stormy political career, combining direct support of the Bourbon dynasty's members with criticism of the Bourbon government's decisions to censure publications and deny broader suffrage.[62] He insisted that France's only salvation lay in its adherence to the Charter and was proud that he had succeeded in mak-ing the nation comprehend the necessity of a constitutional monarchy, despite the Villèle ministry's efforts to suppress his views.[63]

He was named a minister of state the day after Louis XVIII entered Paris for the second time, on July 8, 1815, became interim minister of the interior and minister of state in 1815, ambassador to Berlin in 1820 and ambassador to London in 1822. As minister of foreign affairs in 1823, he was in great part responsible for the war against Spain, which he thought necessary to quell republican insurgency in Spain as well as in the Caribbean and South America. But in June 1824, after British and American warnings against intervention in the Americas, and the increas-ingly expensive Iberian war, Chateaubriand was dismissed from his post. After that abrupt dismissal, he threw his support to the Liberals and reversed his foreign policy. He joined the Comité Grec and waged a campaign, during 1825 and 1826, in pamphlets and in articles in the *Journal des Débats,* for representative government and Greek indepen-dence, condemning French support of Turkish militarism and of the slave trade in Greek captives.[64] The Villèle ministry succeeded in having him named ambassador to Rome; he left Paris in September 1828, the year *Les Quatre Stuarts* was first published.

The advent of Louis-Philippe d'Orléans meant the end of Chateaubri-and's public career. He refused to swear the oath of loyalty to the new king, gave up his pension as a peer of France, and retired. He made a brief appearance in 1832, when he conspired to aid the duchesse de Berry in her attempt to rouse the Vendée to put her son Henri on the throne; the conspiracy failed, and he was imprisoned for two weeks in June 1832.[65] After this debacle, he retired to complete the writing of his memoirs.

Chateaubriand had written his history of the Stuarts several years earlier (c.1826), as part of his campaign to stabilize the Bourbon restora-tion. Although the work was structured as a biographical sequence, covering the period from James I's ascent of the British throne in 1603 to

James II's departure from the realm during the Glorious Revolution of 1688, Chateaubriand took Hume's political analyses, extracted the biographical anecdotes, and literally configured monarchical vulnerability.

This is evident in the very first passage of Chateaubriand's text. Hume's history of the Stuarts had begun with a celebration of the tranquil passage of the crown from Elizabeth, last of the Tudors, to James VI of Scotland, now to be James I of Great Britain, who ruled in peace for twenty-two years. Chateaubriand, in contrast, found James I's reign devoid of historical meaning, scarcely worth two pages of discussion. On the contrary, this monarch's significance lay in the nascent tragedy of his dynasty. The first sentence announced James I's ascent to the throne and the loss of that throne by his grandson James II, personified in one citizen whose life could encompass these events of eighty-five years.[66]

For Chateaubriand, James I was haunted by violence, and he described that violence with almost unbearable concreteness. The king's mother, Mary Stuart, had been six months pregnant with him when she saw her favorite courtier Rizzio murdered before her eyes. Thus, James trembles before a sword "à la française" while still in his mother's womb, that sword which will later decapitate his mother and his son Charles I. His reign was only a "dark space between the two scaffolds of Fotheringay and Whitehall."[67]

Chateaubriand's personification of the tragic destiny of the Stuarts was made visually explicit in 1853, when an illustrated edition of Les Quatre Stuarts placed vignettes out of chronological sequence, so that they could underscore the message of the text: Stuart martyrdom and apotheosis. The description of Charles I's execution (1649) incorporated an image of Cromwell's dissolution of parliament in 1653: monarchical murder would result in despotism. Cromwell's Republic and the Protectorate (1649–58) were illustrated by Charles II's return as king in 1660: such a government would not endure. The inauguration in 1603 of James I's reign, Chateaubriand's violent text of swords in the womb, had the most far-fetched illustration in terms of meaning and temporality: it depicted the escape of James I's daughter-in-law Queen Henrietta-Maria in 1644 (Fig. 37).[68] The last passage in the text, describing Charles-Edward Stuart's escape into exile after the Battle of Culloden in 1746, could not be the conclusion; visually, that was provided by an illustration of the execution of Charles I in 1649. Here, however, the nadir of the history was inverted to predict a triumphant future: Stuart martyrdoms were the lessons that the Bourbons had learned from history, lessons that would make their own restoration permanent and close the drama of revolution for their happy subjects:

> The Stuarts have disappeared, the Bourbons will remain, because in bringing back to us their glory, they have also adopted recent liberties that were painfully born of our sorrows. Charles II disembarked at

Dover with empty hands; he had brought with him only vengeance and absolute power. Louis XVIII came to Calais holding in one hand the ancient law, in the other the new law that pardoned offenders and gave constitutional powers. He became at one and the same time Charles II and William III, legitimacy disinheriting usurpation. Charles X, loyally imitating his great brother, has neither wished to change the national religion nor to destroy what he has sworn to maintain. Thus the drama of revolution is concluded. All France, with joy, love, and gratitude, reposes under the protection of its monarchs of old.[69]

Chateaubriand's dramatic personification of history, his corporal realization of the vulnerability of the crown, was perfectly adapted to his double aim: to arouse sympathy for the reigning Bourbons through evoking their trials in the past, and to explain why they were destined to remain the ruling dynasty of the present population, which included those who had supported the Revolution. Chateaubriand's goal was to teach the nation as a whole, not only returning emigrés who wished to contemplate their memories. His pedagogy was patent in his narrative style: the events were immediately explained, the act was immediately paired with its moral precept. Revolutionary calamities could serve as "lessons from God."[70] Chateaubriand instructed his readers to weep for the Stuarts and the Bourbons of the past but be comforted that the present-day Bourbons had learned from, and so concluded, catastrophe. We see the benefit of staging these lessons when we compare two Salon paintings of the escape of Henrietta-Maria, the second inspired by *Les Quatre Stuarts.*

Mlle Louise Mauduit's *Henrietta of France, Wife of Charles I, King of England,* a government commission, was exhibited in the Salon of 1819 (Fig. 38).[71] The subject was the queen's landing on the Breton coast in 1644, after escaping Cromwell's army, sailing over a stormy sea, scaling the rocks, and withstanding pursuing cannon fire. Mauduit accepted the daunting challenge of making the entire career of Henrietta-Maria comprehensible in one visual instant. Breton peasants gesture to the retreating English ship and kneel at the feet of the daughter of their late king. The queen stands tranquilly in the center of the work, flanked by a courtier, a lady-in-waiting, and a priest, her vertical stance reinforced by a lushly leaved and firmly rooted tree, signaling the endurance of monarchy. There is no evidence of her physical travails in her serene expression, nor does the balanced grouping of the composition convey a sense of harried escape. The *livret* description stressed the queen's noble character (inherited from her father, Henri IV), her persecution by the English parliamentary rebels, and the fidelity of the French, who welcomed her return to the land of her birth. As in Révoil's *Joan of Arc,* the formal composition distances the protagonists from their spectators and mutes the emotional tenor. Legibility comes at the cost of expressive impact, particularly in the central group of the queen and her court in exile, who

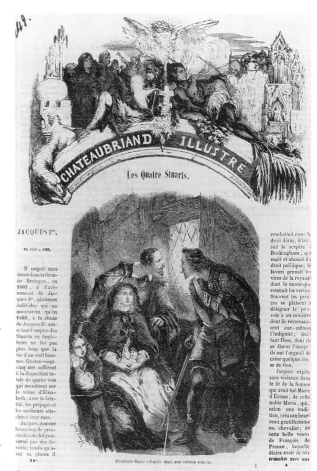

FIGURE 37

Janet-Lange [Ange-
Louis Janet],
Henriette-Marie. In
*Chateaubriand
Illustré* (Paris:
Hippolyte Boissard,
1853), vol. 2, p. 1.
(Photo courtesy Bib-
liothèque Nationale
de France, Paris.)

must demonstrate a greater nobility than their loyal peasant subjects, who are rooted to their physical experience. The queen's impassive expression refuses to mirror excitement, pain, or fear, for she is not in the experience but above it. The spectator's experience would be a parallel one: instead of empathizing with her transient tribulations, he or she would step back to contemplate the event's significance, monarchy's triumph over rebellion. The painting was wholly pleasing to Landon, the supporter of both classical, monumental historical painting and the Bourbon reign. Affirming the obvious modern political analogies inherent in the theme, he advised Mauduit to consider painting a modern pendant: the return of the duchesse d'Angoulême to France in 1815.[72]

A very different image was provided by Desmoulins in 1835, when he depicted Henrietta-Maria's journey into exile in *The Flight of Henrietta-Maria of France, Queen of England* (Fig. 39).[73] Instead of showing her tranquil return to her native soil, he showed her still in danger in England, barely recovered from childbirth, cowering in a hut where she hid for two days, while pursuing soldiers passed by. History was no longer a precept derived from experience: it was now lodged directly in physical

FIGURE 38

Louise-Marie-Jeanne
Mauduit, *Henriette
of France, Wife of
Charles I, King of
England* (1819).
Engraving by Le
Normand, in
Charles-Paul
Landon, *Salon de
1819* (Paris:
Imprimerie Royale,
1819), plates 37–8,
in vol. 2, facing p.
57. (Photo courtesy
Marquand Library,
Department of Rare
Books and Special
Collections, Prince-
ton University
Library.)

vulnerability, which denoted political tragedy. Desmoulins's source was
Chateaubriand's *Les Quatre Stuarts*, which he cited and quoted in his
livret description. In that passage from Chateaubriand, the moment's
poignancy was increased by its contrast to Henrietta-Maria's festive
departure in 1625 to marry the king of England. She had left France in
pomp, as befitted royalty: prisoners had been released at her request, she
had been showered with benedictions and honored by artillery fire. But
now the artillery fire was in earnest, and she herself had been impris-
oned. She had been overtaken by the sad destiny that stalked the Stuarts:

> When the queen of England returned to France in 1644, she returned
> here as a fugitive. No prisons opened at her command; instead, she
> herself escaped from imprisonment. Traveling from one kingdom to
> another, fleeing tempests only to be embroiled in combats, leaving
> combats only for more tempests, Henrietta was struck down by the
> fatal destiny of the Stuarts. This courageous woman was under artil-
> lery attack up to the threshold of the humble dwelling where she took
> shelter; forced to spend the night in a ditch where bullets flew by her,
> showering her with earth ... After other misfortunes, deprived of
> almost every aid in the town of Exeter, to which the count of Essex
> was preparing to lay siege, on June 16, 1644, she gave birth to her last
> daughter. Barely delivered, she was once again forced to flee, only
> supported by her confessor, a nobleman, and one of her waiting
> women, *who could scarcely hold her upright because of her extreme
> weakness.* She had been compelled to abandon her newborn daughter
> at Exeter. This was the princess imprisoned seventeen days after her
> birth, this princess struck down by death at Saint-Cloud in the bloom
> of her youth and beauty, this duchesse d'Orléans, this second Henri-

FIGURE 39

François-
Barthélemy-
Augustin Desmou-
lins, *The Flight of
Henriette-Marie of
France, Queen of
England* (1835).
Engraving by
Desmadryl (1838).
(Photo courtesy Bib-
liothèque Nationale
de France, Paris.)

etta, whose life Bossuet should have been able to celebrate as he had
the first. During her flight, Henrietta-Maria came upon a deserted hut
at the edge of a wood. She remained there in hiding for two days. She
heard the troops of the count of Essex march past, speaking of bring-
ing to London *the head of the queen,* that same head that had had the
sum of 6,000 pounds sterling placed upon it.[74]

The meaning of history was now to be found in concrete experience:
combats, storms, the death of children, and the flight of a frail mother just
risen from her bed of childbirth, phrases that Chateaubriand underlined.
Meaning resides in the price on the head of Henrietta-Maria and, we
assume, in the decapitation of Marie-Antoinette. But because he wishes to
control the violence that threatens this frail queen, Chateaubriand does
not proceed through a sad but comprehensible chronological sequence.
He does not force us to experience unbearable anguish, locking us into a
moment from the past. Instead, he ranges back and forth through time:
the birth, the imprisonment of the baby seventeen days later, and that
daughter's death while still in her youth (in 1670), the immediate conceal-
ment of the queen, and finally the placing of a price on her head, which
had preceded the entire episode. Instead of an "eternal moment" of mean-
ing, or a "frozen moment" of action, Chateaubriand combines both,
describing physical anguish but controlling it temporally.

Whereas Mauduit's decorous painting requires a primed audience,
Desmoulins's gripping work, which is completely in accord with Cha-
teaubriand's text, succeeds even when spectators are unfamiliar with the

subject because of his use of dramatic cues in gestures, facial expressions, and lighting.[75] Inside the hut, the queen and her lady-in-waiting are centrally placed and closest to us, struck by a sudden beam of light from our space. But we cannot settle our gaze on them with confidence; we are forced to experience the fear and uncertainty of her supporters in the hut as we turn our gaze from side to side. We must continually readjust our viewpoint (optically and intellectually), from her enemies (outside at the extreme left background), to her defender on the left (whose sword blade and hand emerge into the light), to her servant on the right (who kneels in prayer in the shadows). It is impossible to see the work as a moment of eternal truth. The shocking alternation between turgid darkness and blazing light interferes with stable compositional orientation. Are we seeing a moment from the past? The absolute fidelity with which Desmoulins depicts fabric or metal could imply that, but the difference between the queen's gesture and those of her supporters argues against that interpretation as well. The queen confidently calms her waiting woman, who is caught in the moment. The queen turns to the light of her witnesses in the future: ourselves. This image is a dramatic reenactment of a moment, not the original moment of confusion and doubt; a recollection after the fact, after reassuring reintegration has been achieved.

But the most inventive and successful pictorial adaptations of Chateaubriand were Delaroche's: his *Cromwell,* in the Salon of 1831, and his *Strafford* and *Charles I Mocked by Cromwell's Soldiers,* in the Salon of 1837.

DELAROCHE'S *CROMWELL* AND
DELACROIX'S CRITIQUE

Delaroche's *Cromwell* (Fig. 40, Pl. 4) was a late arrival to the Salon of 1831.[76] The subject of a republican dictator contemplating the corpse of a decapitated Stuart king was one that had obvious analogies with Bourbon experiences during the French Revolution. Those analogies had been refreshed by the July Revolution; only a few days after Louis-Philippe ascended the throne, *Le Globe* published a chart in which thirty-seven parallels were made between Stuarts and Bourbons, including parallels between Charles I and Louis XVI, Cromwell and Bonaparte, Charles II and Louis XVIII, on and on, until the climax was reached with the parallel between William of Nassau and Louis-Philippe d'Orléans. These last two men had completed peaceful parliamentary revolutions, divesting England and France of their regressive and Catholic factions: England's Glorious Revolution of 1688 had been repeated in France's "révolution glorieuse" of 1830.[77] The subject of Delaroches's painting would expose the work to close political scrutiny; its source in a history by Chateaubriand, the noted Bourbon apologist, would have to be handled diplomatically. The Salon *livret* briefly described the encoun-

ter between the stolid leader and his former monarch (the painting was entitled *Cromwell and Charles I*) and referred the spectator to Chateaubriand's *Les Quatre Stuarts*, though without quoting the relevant passage. By citing a specific text for a familiar historical anecdote Delaroche made it clear that his interpretation was indebted to Chateaubriand's viewpoint as well as his presentation of the physical facts.[78]

Chateaubriand prefaced his discussion of Cromwell's action in 1649 with a description of the discovery in 1813 of the body of Charles I, miraculously preserved from decomposition, which testified to the martyrdom of another saintly king, Louis XVI:

> Clarendon relates that the body of the king, which could be seen *in his room in Whitehall* the night of the execution, could not be found after the restoration of Charles II. However, Herbert had explicitly written that the burial had taken place at Windsor, in the sepulchral vault under the choir of the Saint George chapel, where the remains of Henry VIII and of Jane Seymour were kept. Men at work in this chapel in 1813 opened the vault by mistake. The prince regent, now George IV, ordered them to search, and a lead coffin was discovered. On this coffin was a plaque bearing these words: CHARLES, KING. All of this was completely in accord with Herbert's account. The coffins were cut into, and after a cloth impregnated with a greasy substance was removed, one saw come into view a corpse whose blurred features resembled the portrait of Charles I. According to Sir Henry Halford's eyewitness report, the head of the cadaver, separated from its torso, had half-open eyes, and it was possible for a white handkerchief to touch still-liquid blood. This extraordinary evidence of a return from the grave after the murder of Louis XVI testifies to the faults of kings, the excesses of the people, the march of time, the sequence of events, and the complicity of the crime of 1649 with that of 1793. There is one striking omission in the popular account of Charles's execution: there is no mention of the masked executioner. Ludlow, a regicide, is also silent on this matter. Pamphlets could not be sold on the streets of London until they had passed the *censure* of the men of *liberty*. But executioners under their mask feel either a horrible joy or that they have murdered one whom no mortal creature should touch. In order to come to this fatal execution, Cromwell needed the laughter and tears that, by their alternation, expressed his hypocrisy. After the act, he became sincere once more. He had the coffin opened and assured himself, by touching the head of his king, that it had truly been separated from its body. He remarked that a man as well constituted could have lived for many years. Cromwell the terrible, dark and unknown as destiny, experienced inexorable pride in that moment; he gloated in his victory over a king and over nature.[79]

In Chateaubriand's text, the physical corpse incarnates meaning, resurrection after death. He insists on the "complicity of the crimes of 1649 and 1793." The memoirs of seventeenth-century witness-historians Clarendon and Herbert lead to the modern rediscovery of Charles I by the prince regent, who interprets the information before him in the light of

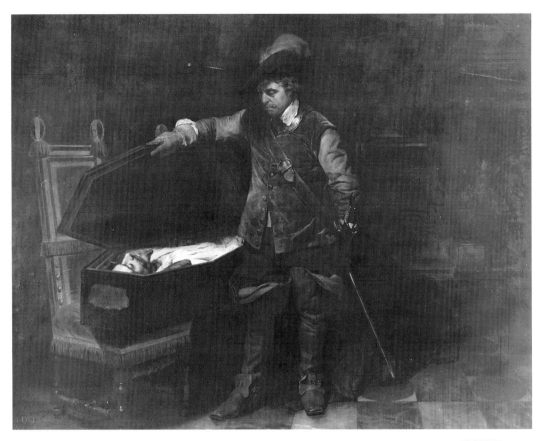

FIGURE 40

Paul Delaroche,
Cromwell (1831).
Nîmes, Musée des
Beaux-Arts. Oil,
2.25 × 2.92 m.
(Photo courtesy
Giraudon/Art
Resource, NY.)

his own experience of the death of kings, the execution ten years before
of Louis XVI.[80] Charles I's physical existence transcends the ordinary
laws that govern biology and temporality. Halford testified that the
corpse's blood remained liquid. Just as Saint Veronica's cloth, passing
over Christ's body, became a "true icon" of Christ, so the handkerchief
dipped in Charles's blood is a holy relic. It is contrasted to the cloth that
shrouds the corpse in the coffin: once that winding cloth is unwrapped,
the features, subject to the processes of disintegration, are merely those
of "a corpse," which Chateaubriand compares to Van Dyck's portrait.
The king was no longer in his corruptible body; his name and station
triumphed, capitalized in Chateaubriand's text.

Chateaubriand insists that the moral meaning will endure whereas the
grim corporal facts, like Cromwell's power, will pass away. In the pas-
sage that intercedes between the description of the rediscovery of the
corpse in 1813 and the moment in 1649 when Cromwell leans over the
coffin, Chateaubriand complains that the words of regicide historians
have masked reality, as the executioner himself wore a mask over his
features. The truth of the moment must be exhumed as the corpse is
exhumed and returned to its original miraculous state. Chateaubriand's
description of Cromwell's actions of lifting the coffin lid and touching

the head of the corpse is "brutal as fact," as Heine said, in reviewing the painting for a German newspaper.[81] But his description of Cromwell's emotions as he stood beside the coffin is far more ambiguous: "dark and unknown as fate," masked by hypocritical and hysterical laughter and tears.

In Delaroche's somber, large-scale painting, in which a life-size figure looms over a foreshortened, sharply lit coffin, we see the contrast not only between two men and two political principles, but between living fact and martyred myth. Cromwell's dark volumes are pressed into one plane of space, whereas the sharply lit angles of the coffin almost pierce the viewer's space, and the thread of blood glistens in the light of historical revelation. But the success of the work rested less on the pictorial presentation than the dramatic confrontation of the two figures, whose drama was offstage and whose meaning was elaborated in Chateaubriand's text. The artist depended on his audience's preparation to make the scene taut with emotion.

The comte Horace de Viel-Castel, who had argued for moral dramatic paintings in an earlier article on the same Salon, wrote a review that was completely sympathetic to both Delaroche's painting and Chateaubriand's text. He praised the artist's portrayal of Cromwell, the populist, as visually uninspiring as well as politically misguided: middle-aged, badly dressed, and betraying a fear of attack. The French, having seen a revolution and a restoration, now sadly brought to a close, needed to be reminded of this tragic moral lesson:

> It is in an epoch like our own, in a century when kings' destinies are unable to outweigh popular interests, that the painting of Cromwell arrives, stirring in all its high morality. We too have had our Charles I, our Whitehall, our Cromwell believing himself obliged to sign his revolutionary pact with the blood of a royal person. Like England, we too have seen a restoration for several years, then our Stuarts exiled from France, seeking unsuccessfully a Louis XIV in England . . . This painting can be counted an important victory of the new dramatic school, for, in truth, never has drama been better understood, more succinctly and more completely. An immobile man, a corpse, and a coffin, and yet these three components, this simple composition, stirs the soul powerfully. Conception and representation, both are perfect. This is a painting from a king's palace, destined to be engraved for the people with this simple caption: *Et nunc intelligite*.[82]

In contrast, Delacroix's reaction, which he expressed to his friend Paul Huet, was bewilderment that a painter could proceed in such an antivisual manner and contempt at Delaroche's lack of historical insight. Apocryphal or not, Cromwell's action could be a valid vehicle. But Delaroche had made a fundamental mistake in concentrating on material facts of the most trivial kind, completely ignoring the visual and the emotional qualities that were the heart of this subject. In Delacroix's words:

Delaroche's painting is meaningless. It is obvious that Cromwell would never have come there on purpose and, impelled by who knows what unhealthy and cynical curiosity, lifted the lid of the coffin of his victim *like the lid of a snuffbox*. One could suppose that . . . Cromwell lifts a drape and suddenly finds himself face to face with the cadaver. He hesitates, worries, involuntarily takes off his hat . . . doesn't know whether to go forward or backward. – The place is still, silent, shrouded in darkness and mystery; the coffin, laid on the ground, is still open; the cadaver in its winding-sheet makes a white flash in the darkness that surrounds it; the head, returned to its body, yet still separated from it by a bloody line and touched by a discreet beam, comes into the light.[83]

For a Romantic artist, the historical action was psychological and therefore internal: the hesitation, anxiety, involuntary respect within the antihero's heart. Like Shaftesbury and Diderot, Delacroix prefers the transitional moment between emotional states to the physical moment of action. The challenge was to make them visible in art, through the glinting light, the mysteriously shrouded space. Delacroix found that Delaroche's pictorial presentation merely repeated physical coincidence without visual transmutation or emotional amplification. The action of phlegmatically opening a coffin as one would a snuffbox was hence aesthetically meaningless, "un non-sens."

Delacroix's own watercolor of *Cromwell before the Coffin of Charles I* (Fig. 41), which Huet recognized was the product of their conversation, shifts the compositional focus away from the concrete act toward the charged space between the protagonists, so that contrasting pictorial elements carry historical meaning. The coffin is flattened into one lateral plane; it presents a brief glimpse of the corpse's profile, washed by a weak light. The three-dimensional figure of Cromwell tensely gripping his cane stands in the compass of a harsh beam that activates the full tonal range. The thin line of shadow underneath the coffin suddenly widens at right until it blots out the light on the wall.

Planche, who had begun his review of the entire Salon of 1831 with the goal of curing the ailments of modern art, returned again and again to Delaroche's faults. He reiterated Delacroix's points, fiercely condemning Delaroche's *Cromwell* as the worst and the least successful of all his works, neither true, meaningful, nor communicative. Cromwell's features were completely devoid of emotion. His gesture of opening the coffin was trivial. The painting's costumes and props were rendered with great skill, but the work was glacially impassive. Since, despite these numerous and severe faults, the artist was undeniably popular and officially honored as well (he would be elected to the Institut de France in 1832), Planche concluded that what pleased the crowd was first-class mediocrity, and that "drama is invading the painting that has been called historical."[84]

Delaroche was following a historical interpretation that could not be

FIGURE 41

Eugène Delacroix,
*Cromwell before the
Coffin of Charles I*
(1831). Watercolor,
now lost. (Photo
courtesy Artists
Rights Society, New
York/SPADEM,
Paris. © 1997
Artists Rights
Society (ARS), New
York/SPADEM,
Paris.)

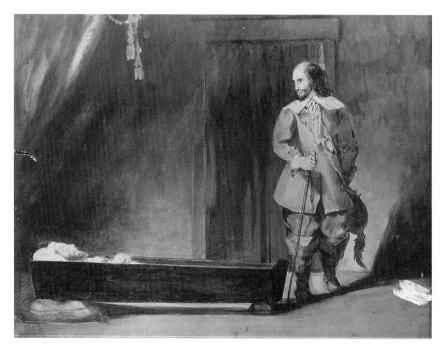

translated into a painting. Chateaubriand's temporal doublings were incompatible with the pictorial moment. His insistently gruesome physicality, triumphantly overturned by the martyred king's resurrection, could not be transposed into an optical arena, where material objects were visually privileged by their massiveness and tactile complexity. A similar challenge, and a similar fate, awaited his depictions of scenes from Chateaubriand in the Salon of 1837, his last Salon.

DELAROCHE'S *STRAFFORD* AND *CHARLES I MOCKED:* SIN AND EXPIATION

Delaroche exhibited two subjects from Charles I's unhappy reign: the march to execution in 1644 of Thomas Wentworth, earl of Strafford, and Charles I's humiliation in the house of Sir Robert Colton during the period of his trial in 1649. Both of them were large in scale, with life-size figures. Both were faithful to Chateaubriand's reinterpretation of Hume. The painter's historical interpretation was made clear in diametrically opposed compositions: truncated moment and enduring meaning.

Charles I Mocked by Cromwell's Soldiers (Fig. 42) cited no text, and needed none: it was a secular mocking of Christ.[85] Hume had mentioned Charles's saintly demeanor at his trial-martyrdom: "The soldiers . . . were permitted to go the utmost length of brutal insolence, and to spit in his face, as he was conveyed along the passage to the court. To excite a sentiment of piety, was the only effect which this inhuman insult was able to operate upon him."[86] Guizot, more impartial than Chateaubriand, described the mocking of the king at considerable length. The de-

FIGURE 42

Paul Delaroche,
*Charles I Mocked
by Cromwell's
Soldiers* (1836).
Engraving by
Martinet (1843).
(Photo courtesy Bib-
liothèque Nationale
de France, Paris.)

scriptive passage occurred immediately after Guizot's description of the
rendering of the verdict at Charles's trial:

> BRADSHAW. – "Guard, withdraw your prisoner."
> THE KING. – "I may speak after the sentence. By your favor, sir, I may
> speak after the sentence . . . By your favor . . . hold . . . The sentence,
> sir . . . I say, sir . . . that . . . I am not permitted to speak; expect what
> justice other people will have."
>
> At this moment some soldiers surrounded him, and dragged him
> violently to the spot where his close chair awaited him. On descend-
> ing the staircase he was insulted; lighted pipes were thrown under his
> feet; tobacco smoke was blown in his face. The same threatening cry
> still resounded in his ears, "Justice! execution!" With these exclama-
> tions, however, the people at times, mingled their own: "God save
> your Majesty! God deliver your Majesty from the hands of your
> enemies!"[87]

Chateaubriand did not quote the king's stammers which Guizot indi-
cated by the ellipses in his text.[88] Instead, Chateaubriand quickly passed
over the transitory physical experience of humiliation, stressing its eter-
nal significance. Charles compared himself, in his abasement, to Christ,
the King of Kings, suffering his Passion: "Religion sustained the mon-
arch. He imagined himself sharing his ignominies with the King of Kings,
and this idea lifted his soul away from the miseries of his life on earth."[89]
Chateaubriand's interpretation of Charles's martyrdom and its reward
occurred a few pages earlier in the text, in the description of his imprison-
ment in Holdenby Castle. Not only would his suffering mean his spiri-
tual triumph; it would result in the miraculous salvation of his country,
just as the Bourbons were to save France. His blood would cure "the

malady of liberty," just as the first saint-king, Louis IX, king of France, had been a thaumaturge of physical ailments:

> Prisoner of the men who would soon destroy him, Charles was brought to Holdenby castle (February 9, 1647). During his journey, he received marks of respect from everyone: crowds ran to see him go by, the ailing were brought to him so that his touch could make them regain their health, a power which he had been given as *King of France,* as the heir of Saint Louis. The more Charles suffered, the more he was believed to be gifted with this power to heal. Extraordinary combination of power and impotence! The royal captive was believed to have supernatural strength, and he couldn't break his fetters, he could cure every evil except his own. It was not by his act, but by his blood that England was delivered from that illness of liberty from which she suffered.[90]

Although Delaroche clearly profited from the information Guizot presented, his painting is conceptually in accord with Chateaubriand's spiritual view of humiliation. The painting juxtaposes two visual ancestries: seventeenth-century Dutch tavern scenes and Van Dyck's elegant portraits of the Stuarts. Charles is held captive in the center of two opposing diagonals, hemmed in on either side by boisterous drinkers and smokers or by people who ostentatiously ignore him. A bare minimum of existence remains to him in the present: a crumpled piece of paper in the foreground, which resembles a crown. But his expression of mild forbearance is illuminated by a supernatural light, unlike that of the fireplace at right or the pale beams that fail to penetrate the smoky room from the window in the left background. He turns toward the future crown of a martyr and the restoration of his son to the throne.

Strafford (Fig. 43) presented the prelude to the king's suffering: it showed his supporter, Thomas Wentworth, Lord Strafford, pausing to kneel on his way to execution to receive the blessing of the imprisoned Bishop Laud.[91] This act was described in similar terms by Hume, Chateaubriand, Guizot, and the comte de Lally-Tolendal. The latter's biography of Strafford was published in London in 1795, just after the execution of Louis XVI, and contains this description:

> Leaving the Tower, he stopped near where the Archbishop of Canterbury was imprisoned. Laud, hearing the noise, remained in the corner of his apartment, until he heard the voice of his unhappy friend, who cried out to him: *Milord, your blessing and your prayers!* . . . he could not resist, and came forward, trembling, toward the window, saw the count who waited, kneeling, held his hands out through the bars of his prison, but in the middle of his prayers, his voice failed him, all strength left him, and the venerable old man fell back in a swoon. Strafford, after having made a few steps, turned back again to the room which held a victim as devoted as he himself, and, kneeling once again, *farewell my lord,* he said; *God protect your innocence,* and he walked off to execution.[92]

The assertively centralized composition of *Charles I Mocked,* in which the hero faced posterity, was countered in *Strafford* by an assertively oblique composition, a sudden plunge into the space and time of the participants. The visual device of reducing the figure of Laud to his arms had been used in a royalist print of 1796 representing *Marie-Antoinette, Late Queen of France, in the Prison of the Conciergerie in Paris* (Fig. 44), where the queen knelt for the blessing of the abbé Emmery, also imprisoned in the Conciergerie.[93] His figure is brutally reduced to his helpless arms, just as he is prevented from seeing and touching her. This presentation of corporal vulnerability to arouse political sympathy is entirely in harmony with Chateaubriand's Conservative personification in *Les Quatre Stuarts.*

Chateaubriand links Strafford's execution and Charles's humiliation both causally and symbolically. Strafford, the king's loyal supporter, had been accused of treason for carrying out the king's orders, yet Charles I had signed the act permitting Strafford's execution, a sin that could be expiated only by the shedding of the king's own blood:

> In shedding the blood of his minister, Charles succeeded in appeasing no one; an act of cowardice never saved anyone. Worldly princes, whose faults or crimes cause them to lose their crowns, would do better to make occasional compromises for religious reasons. Moreover, the unfortunate man did not cease to reproach himself for his weakness; condemned in his own turn, he declared that his death was a just recompense for Strafford's. This public confession, said aloud while on the scaffold, is one of history's greatest lessons. Posterity has not absolved the friend but has pardoned the monarch, because of his sincere penitence and the greatness of his expiation.[94]

Chateaubriand insists on the difference between the events of the Charles I's martyrdom and Strafford's execution. Charles's weakness, a man's fault, was redeemed by the monarch's expiation of his error. If the sacrifice of Strafford was the original sin, the physical fact that would necessitate martyrdom, then the depiction of Strafford would have to make the physical nature of reality unbearably oppressive, would have to shackle the audience to the "now." In contrast, the suffering of a king-martyr takes on symbolic meaning; justified by past actions, it is released from its own time, because its saintly self-abnegation will result in the restoration of divine monarchy. In choosing diametrically opposed compositional formats, Delaroche demonstrated his comprehension of his two textual sources and his ability to translate the levels of their meanings into an optical realm.

Once again, the critics did not grasp the subtleties of his temporal and historical insight. Although the works were discussed together, their differences in compositional orientation were compared without analyzing their purpose. Most of the commentary addressed the idea of presenting Laud as a pair of searching arms, locking him into the moment. This

FIGURE 43

Paul Delaroche,
Strafford (1835).
Engraving by
Henriquel Dupont
(1840). (Photo cour-
tesy Bibliothèque
Nationale de France,
Paris.)

dramatic stage gesture appeared ridiculous to eyes trained to see moral
messages for eternity. The spectators' attention was caught by the trun-
cated arms of the aged prelate instead of by Strafford kneeling for a last
blessing. Thus, instead of being moved by the pathos of the historic
event, they scrutinized the artist's clever arrangement.[95] Delaroche had
attempted to make the tragic ramifications of historical action clear in
visual terms but was accused of denying pictorial meaning so that he
could re-create dramatic spectacle. Worse yet, such dramas were incapa-
ble of representing true history, now understood to be a nexus of mo-
tives, which could not be conveyed in closed actions. Dramatic historical
paintings were neither paintings nor history.

"THE DRAMATIC POWER OF HISTORY ITSELF"

By this time, dramatists had become convinced that history itself could
not be staged, at least not according to conventional theatrical formats.
Stendhal called, in *Racine et Shakespeare* (1823 and 1825), for national
prose tragedies on themes like the death of the duc de Guise at Blois,
even if that meant that Racinian drama had to be supplanted by a new
format which broke the unities of place and time.[96] But the complexity
of historical events, their concurrence, the conflict of popular opinions,
the unlimited range of settings, resisted incorporation into a theatrical
mode. In the preface to his play *Charles Premier* (1820), the comte J. R.
de Gain-Montaignac apologized for the unwieldy work he was offering

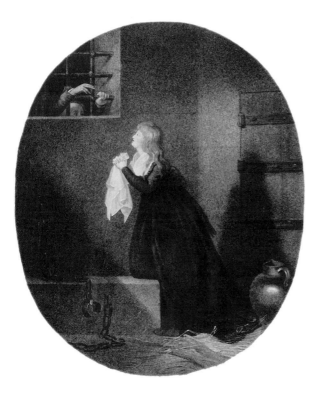

FIGURE 44

Anne-Flore-Millet, marquise de Bréhan, *Marie-Antoinette, Late Queen of France, in the Prison of the Conciergerie in Paris*. Engraving by Keating (London: C. Laurent, 1796). (Photo courtesy Bibliothèque Nationale de France, Paris.)

to an audience accustomed to finely sculpted tragedies but said that his subject could not be contained in such a form:

> Here is a great historical depiction. I have worked to make it accurate. I have dared to call this work a tragedy, although French rules for tragedies have been broken. But, with the best will in the world, how can one depict such a subject in the narrow confines of twenty-four hours? He who would wish to do so could, if he were eloquent, write beautiful speeches, describe several characters and several situations; but would he be representing the truth of this great catastrophe, the clash of opinions and passions, the range of people, the era's colors and mores, and all the subtleties necessary for the description of such a tragic event? Let orators deny, if they wish, the title of tragedy to *Charles the First;* I willingly accept their criticism. But if, after reading this work, the terrible event is clarified and impresses itself on the reader's soul forever, more than would be the case if he had read Hume, Clarendon, and Ludlow, then I will have fulfilled my task and attained my goal.[97]

History had its own dramatic power, but Romantic historical dramatists denied that it could be contained in self-referential explanation, in one meaning expressed in one gesture, in a melodramatic, spectacular production. The inability to stage history was proof that the dramatist was truly confronting the protean nature of historical experience, what Vitet called "the dramatic power of history itself."

In his preface to *Les Barricades* (1826), a play about the day of May 12, 1588, on which Paris rose in revolt against Henri III, Ludovic Vitet

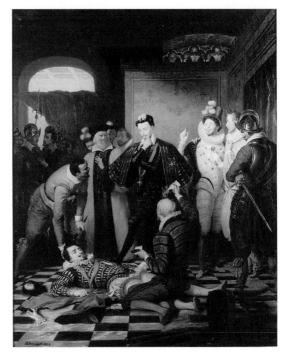

FIGURE 45

Charles-Barthélemy-
Jean Durupt, *The
Assassination of the
duc de Guise*
(1832). Musée du
Château de Blois.
Oil, 91 × 72 cm.
(Photo courtesy
Château de Blois.)

explained that he had written this reading-drama as a historian, and that this had meant completely redefining the dramatic format. Historical events were too multifaceted, too insistently local, too dependent on individual acts and social prejudices to be contained within one unified plot. Instead, Vitet claimed, he had imagined himself as wandering through Paris on that day, entering the Louvre, the Hôtel de Guise, cabarets, and churches, and he had sketched for himself whatever he had seen there, if it appeared visually interesting or sociologically significant. Such "sketches" had the merit of resemblance, if they also had the defect of haste or incompleteness. The author had deliberately forgone dramatic interest, which would have made the plot paramount, and had instead piqued the interest by making certain figures stand out and by eliminating details. If, after all the sacrifices he had made for accuracy, there were still dramatic effects, those effects were the result of the "dramatic power of history itself."[98]

Could this "dramatic power of history" be depicted? We can see the difference between the sort of history that permits edificatory staging and the historical experience that resists such staging if we compare two contemporaneous art works depicting the assassination of the duc de Guise. Both of them were inspired by Vitet, this time by *Les Etats de Blois* (1827), another reading-drama from his trilogy about the French religious wars in the 1580s between the Roman Catholic Henri III (supported by Henri, duc de Guise, the leader of the Holy Catholic League) and the heir to the throne, Henri of Navarre, a Protestant. Durupt shows us pensive conspirators bending over the corpse of the duc de Guise (Fig. 45). Henri III looks

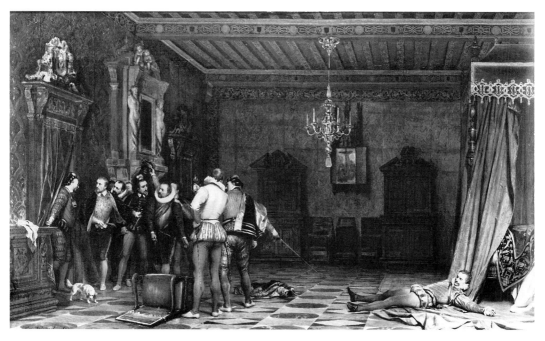

FIGURE 46

Paul Delaroche, *The Assassination of the duc de Guise* (1834). Chantilly, Musée Condé. Oil, 57 × 98 cm. (Photo courtesy Giraudon/ Art Resource, NY.)

down on his dead rival, whose body is neatly extended in one plane; the duc's head is lifted up almost tenderly by one of his assassins. The composition is centralized and stable. But in Delaroche's small-scale painting of 1834 (Fig. 46, Pl. 5), the corpse, splayed on the floor on the right, is ignored by his contemptuous assassins.[99] Delaroche followed Vitet's stage directions: Henri III hesitates in the doorway, asking if the deed has been done; Sainte-Malines replies that His Majesty should look down at the floor, where his enemy lies. Delaroche isolates the duc de Guise at the extreme right, optically balancing him through the dynamic tension of the bed hangings against the rest of the cast of characters, who are forced into a confused clump on the extreme left. Henri III's hesitation and cowardice is projected onto his cringing dog, sniffing the bloodstains on the floor. In the empty center of the room, a light burns in the background, in front of a painted crucifix.

This compositional confusion is very different from the compositions by Delaroche that we have been considering up to this point, which are oriented around gestures of expressive summation: Jane Grey kneeling at the block, Cromwell looking into Charles I's coffin, Joan imploring Heaven to witness her innocence, Laud stretching his arms through prison bars to bless Strafford. Here, in contrast, a corpse on the ground is ignored by those in the same room. The compositional arrangement performs a similar function: the Salon audience is ignored as well. As a result, we are thrilled, because we interpret this exclusion to mean that we are voyeurs at the moment itself, instead of an audience watching a play, after the fact.[100] Delaroche's feigned avoidance of compositional decisions is comparable to Vitet's insistence on trivial actions, without

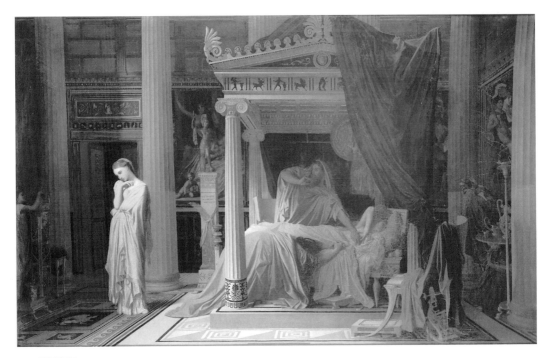

gestures of premonition, dignified composure, or transcendence. In the play, before going to his death, the duc de Guise rummages through an empty bonbon box, asks for a handkerchief to staunch a nosebleed, then accidentally drops the handkerchief and steps on it, and twitches his cape from one shoulder to another. When the deed has been accomplished in a bedroom (offstage), the murderers describe it to Henri III as insignificantly as possible: the force of the blows and the body's weight and momentum threw it against the bed, pulling down the hangings and making a thud that shook the floorboards. The king kicks the corpse's shoulder and fears that he sees a response but is reassured that the eyes have rolled upward in their sockets. In sum, the physical gestures in Vitet's play are described as reflexes rather than significations, and Delaroche maintained this extraordinary strategy, breaching it only in the melodramatic cringing dog, emblem of his master's nature.

Delaroche's painting was stupendously successful with both the patron and the general public. The duc d'Orléans paid 10,000 francs, twice the agreed-upon fee for the commission, for the work, because he was so delighted with it. At the Salon, two guards were stationed near it, to prevent pickpockets from profiting from the crush of spectators. But the critics were shocked by the artist's historical voyeurism, his lack of moral stance.[101] Were the viewers to support the king in a necessary but lamentable action? Were they to grieve for the leader of the Guise faction, unjustly struck down by his rival? Instead of pictorial interpretation of the event, instead of pictorial presence in the formal adjustments and compositional legibility, they were left with an impressively painted

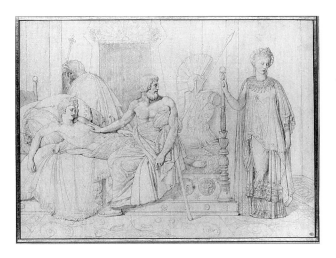

FIGURE 48

Jean-Auguste-
Dominique Ingres,
*Antiochus and
Stratonice* (c.1807).
Paris, Musée de
Louvre. Drawing,
graphite and brown
wash, 29 × 40 cm.
(Photo courtesy
Musées Nationaux,
Paris.)

cadaver. Making many of the same points that Heine would make in 1841, Delacroix's friend Victor Schoelcher compared the painting to the third act of a Franconi melodrama, condemning the artist for his morbid themes, theatrically oriented concerns, and complete lack of pictorial originality in style or conception.[102]

When Ingres was commissioned by the duc d'Orléans to produce a pendant work, he responded in 1840 with a rebuke to Delaroche's melo-dramatic voyeurism: *Antiochus and Stratonice* (Fig. 47).[103] The subject, from Plutarch's *Life of Demetrius*, was supremely corporal yet also capable of rising above momentary bodily situations to express a larger truth. Antiochus's ignoble passion for his stepmother Stratonice had led him to decide to starve himself to death. The cause of his failing health was not identified until the doctor observed that his pulse rose tumultu-ously and he broke into a sweat when his beloved entered his room. And yet these medical symptoms were only the physical expression of the true subject: the passion and the self-abnegation of both Antiochus and his father Seleucus. In contrast to the cowardly and treacherous Henri III, Seleucus was a magnanimous king who gave his wife to his son because his son's life was more precious to him than his own marital happiness.

Ingres had already described this theme several times in drawings, for example, one from about 1807 (Fig. 48). In this earlier version, the subject is presented in a friezelike manner, controlling any sudden move-ment (or shocking emotion) into elegant but static linear rhythms. The physician Erastratus's recognition of the source of his patient's illness is flattened into a lax arm resting on the youth and a profile stare at the placid Stratonice, whose frontal stance echoes his own frontal torso.[104] But forced into competition with Delaroche's dramatics, Ingres altered the poses in his painting of 1840, so that they became betrayals of tense emotion. Stratonice wraps her arms around herself and turns her entire body away from the bed. Antiochus's arm suddenly rises up from his sickbed. Erastratus's torso now has a contrappostal twist; his finger rises

to his lips in surmise. And yet the characters' emotions are conveyed by aesthetically adjusted form, not dramatic cue. Erastratus's face is shadowed; it is the slender, rising arm of Antiochus that is lit, an arm whose mass and direction echoes that of Stratonice.[105] The youthful, slender forms of the lovers rise up, the massive mature forms of father and doctor bow down in grief or solicitude.

Ingres's *Antiochus and Stratonice* fulfills the necessary role of balancing its pendant, Delaroche's *Assassination of the duc de Guise*. The theme of Ingres's painting is that of a magnanimous monarch saving one he loves from self-imposed death; Henri III had ordered the murder of a political rival. The setting in Ingres's work, like the room in Blois, seems an absolutely convincing three-dimensional space, crowded with meticulously rendered historical objects. But Ingres's style of rendering both subject and objects is very different. Ingres refused to allow a sudden shock to unbalance his figures and lock them into the moment. They had to retain their beauty and their character, or the larger message of the story would be lost in the trivial activity of identifying "who." Thus, the composition opposes three linked gestures (a father's prayer, a doctor's diagnosis, a son's involuntary response) to their cause: a woman's beauty, locked away from them. Visually, Ingres forces us to contemplate a canvas instead of plunging into a supposed scenic box. His insistent chorus of accessories and patterns, each soliciting our eye and blocking our view of the background, his expanded cast of characters, which now includes servants at far right and left and a mourning friend who leans against the column: these visual complications retard our scanning of the canvas and insist that we ponder a known subject, rather than looking in on a subject in-the-making. In contrast to Delaroche's staging of a moment from a modern drama for an expanded audience, Ingres offered a precept from Plutarch's history, created for an already informed elite.

But Delaroche's gestural vocabulary (a cringing dog sniffing bloodstains, a blindfolded Jane Grey groping for the executioner's block), which had promised transparent legibility for an untutored audience, was incapable of conveying a historical situation unless it was supplemented by an increasingly complex dramatic presentation, or unless the historical situation dealt with the self-explanatory: cadavers or victims sensing their end. Without previous knowledge of the subject, provided by the artist in increasingly lengthy catalogue entries or by the critics in their reviews, which centered on theme rather than technique, the audience would be locked into a visceral encounter with violence. In order to rise above this undeniably exciting but uninformative encounter, they had to be able to look through the painting to the moments before and after the event depicted there.

The dilemma of dramatic painting was twofold. If it addressed the spectators visually, it locked them into a visceral relationship with suffering flesh: they would thrill to the sight of a woman kneeling at the

executioner's block, but that thrill would be the same, whether the woman was Jane Grey or Marie-Antoinette. If, on the other hand, the painting was composed so that it could address the viewers as a unique historical situation, it would have to be composed as a drama instead of a visual object.

In 1839, Prosper Mérimée complained that the gestures that Delaroche selected, gestures that functioned as dramatic cues instead of visual incarnations, forced viewers to construct their own imaginative recreation of the play and contemplate that mental drama instead of the painting on view:

> Today one calls a subject well chosen if it makes the spectator's imagination travel through the entire series of events that preceded or followed the one before his eyes. This is an entire drama that is related to him, not an individual scene, complete in itself. Under this system, painting, to be frank, is simply transformed literature . . . [Delaroche] represents Cromwell looking at the corpse of Charles I and *saying*, "this man was healthy, and could have lived a long life." But, I ask M. Delaroche, with all his talent, can he make us hear these words? Yet everyone stops in front of this painting, everyone admires it. Yes, after having read the description; and only *then* each spectator can begin to enter into Cromwell's meditation and endeavor to decipher that obscure character. Yes, without a doubt, the spectators remain there, but are they looking at the painting? No, each is contemplating his own thoughts.[106]

Dramatic paintings were not paintings at all; they were transparent windows onto a stage – and that stage was incapable of containing historical truth.

When Burke's *Reflections* was published in 1790, the radical Tom Paine argued that Conservatives distorted history by "staging" it. They could influence their audience to accept their viewpoint only by excluding the populace from the cast of characters, and by exhibiting dramatic consequences without their causes. If the precipitating factors as well as the resulting crises were represented, the audience, instead of commiserating with monarchs in peril, would approve of the assassination of tyrants.[107] In his view, history was actually created by the people. If the participants were forced offstage into the audience, if they were told to ignore their own experiences to witness those of their king, then they were watching a dramatic performance, staged for a political purpose.

This complaint greeted Delaroche's dramatizations as well. In 1837, Piel, a Saint-Simonian, agreed that the fatal flaw of dramatic painting lay in its political viewpoint – its Conservative manipulation of history into the format of suffering monarchs, presented "objectively" as physical fact. For him, *Cromwell, Strafford,* and *Charles I Mocked by Cromwell's Soldiers* all failed as historical interpretations. They were mere waxworks of suffering flesh, automatons instead of actors, because Delaroche had not comprehended their true passions, which arose out of

the conflict between monarchy and parliament. Piel found such dramatic historical paintings "incomprehensible denouements" of dramas that were filled with historical costume, historical furniture, even historical poses, but devoid of historical insight.[108]

Chateaubriand, and other Conservative historians, sought to personify the past, selecting episodes in the lives of protagonists that stood for larger truths. Safely over, closed and codified, the past would be arranged for modern viewers to ponder, as "witnesses." But Liberals worried that this closed and didactically functional past was not history at all. If history lacked fully realized characters, with motivations that linked them to a larger world, than it was merely an exhibition of dramatic consequences without their causes. Instead of containing events as unique but completed acts, they wished to link the social forces of the past to their continuing impact on the present. In the same fashion, Delaroche's dramatic paintings had promised to unite pictorial concerns and historical truth but had resulted in mere anecdotalism. Subjects were selected for their pathos and violence and presented according to literary rather than painterly criteria, in paintings designed to serve as graphic pendants. For Romantics, historical anecdotes did not present historical meaning, and a material replication was devoid of artistic interpretative insight. Romantic artists wished to paint thoughts. But how were artists to depict social forces, rather than personages? How were they to create works whose temporality was a fusion between past and present, instead of a transcendent climax or a pause in action? We shall see the struggle to depict the invisible, the psychic aspects of history in the next chapter.

PAINTING THOUGHTS: ROMANTIC LIBERALISM AND THE CHALLENGE TO HISTORICAL REPRESENTATION

D URING HIS STAY in Great Britain in 1820 and 1821, while taking the *Raft of the Medusa* on tour, Géricault saw a sketch in Wilkie's studio of the painting that would be called, when it was first exhibited in 1822, *Chelsea Pensioners Receiving the London Gazette Extraordinary of Thursday, June 22, 1815, Announcing the Battle of Waterloo* (Fig. 49).[1] He wrote his friend Horace Vernet of Wilkie's ability to touch the spectator's heart without resorting to gesticulation or visual bombast:

> How I wish that I could show, even to some of our ablest artists . . . the touching expressions in Wilkie's work! In one small picture, of a very simple subject, he has brought off an admirable effect. The scene is laid at the Veterans' Hospital; at the news of a victory, these veterans have gathered round to read the *Gazette* and to rejoice. He has varied all these characters with much feeling. I shall mention to you only the one figure that seemed the most perfect to me, and whose pose and expression bring tears to the eyes, however one might resist. It is the wife of a soldier, who, thinking only of her husband, scans the list of the dead with an unquiet, haggard eye . . . Your imagination will tell you what her distraught face expresses. There are no signs of mourning; on the contrary, the wine flows at every table, nor are the skies rent by ominous lightning. Yet Wilkie achieves the last degree of pathos, like nature itself. I am not afraid that you will accuse me of Anglomania; you know as well as I what is good in us, and what we lack.[2]

Géricault's praise of this figure of the anxious wife demonstrates his close study of the entire composition, for although she is in the center, she is shaded, and the newspaper itself blocks the lower half of her face. Her pose is one that could be unintentionally ludicrous; in her tense concentration, she clutches her baby so closely that it howls in distress. And she is only one of the sixty characters whom we see cheering and waving handkerchiefs, raising their children or their glasses aloft in exul-

tation or, less heroically, momentarily ceasing to eat oysters or comb hair. Both Géricault and Vernet, who was painting the Battle of Jemappes in 1821 for the duc d'Orléans, were seeking a modern manner of rendering history as popular experience, on and off the battlefield.[3]

Géricault's praise of Wilkie to Vernet is well known, but its significance has not been examined in the depth that it deserves, nor has the significance of his conveying this enthusiasm to Delacroix. When Delacroix visited London in 1825, he wrote that Wilkie's "sketches and rough drafts are beyond all praise"; he maintained that opinion thirty years later, when his visit to Wilkie's studio was still a vivid memory. This excitement was due to more than an inventive combination of anecdotes or a fluent brush.[4] Géricault and Delacroix appreciated, as Romantics and as liberals, Wilkie's portrayal of aspects of historical truth that hitherto had been excluded from painting. They recognized that Wilkie was a pioneer in visualizing history as experience rather than as action. This sense of the past was socially and nationally oriented and sought the imaginative resurrection of a populace's sentiments instead of the concrete representation of a hero's act. The visual implications of this shift would affect composition, temporal allusion, and the viewer's role. In Wilkie's *Chelsea Pensioners* we see the other side of historical experience, which had been excluded from dramatic enactments of the execution of monarchs: the nation, not as a chorus but as a community of individuals who contribute toward and respond to world events. Avoiding the glacial denotation of significance in theatrical climax, rejecting stale and exaggerated natural symbols of disaster, Wilkie had successfully evoked a moment of the past, so that the present-day spectators now became the modern surrogates of the scene's participants. Instead of placidly witnessing the catastrophes of others, they suffered along with them. The past flooded into the present.

In 1829, when he reviewed Casimir Delavigne's *Marino Faliero*, Charles Nodier linked Romantic aesthetics and Liberal politics. He urged dramatists to break apart the unities of time, place, and action, so that "the people could see themselves." They had learned that they could influence historical events and political institutions; henceforth this would have to be acknowledged in aesthetic creations:

> the change in our political ideas has necessarily produced, if not a complete change, at least many modifications in dramatic construction. For the last forty years in France, it has been evident that there is a real, live, palpable, passably dramatic being, and yet one who, until our day, has been completely ignored by dramatists: that is, the people. The people are entering everywhere, whether by invitation or by force, throughout the government, in political movements, in all institutions, and particularly in history. It has been only natural that this new being, by its nature restless, active, acquisitive, has entered tragedy . . . Today you would make a man laugh if you showed him conspiracies plotted

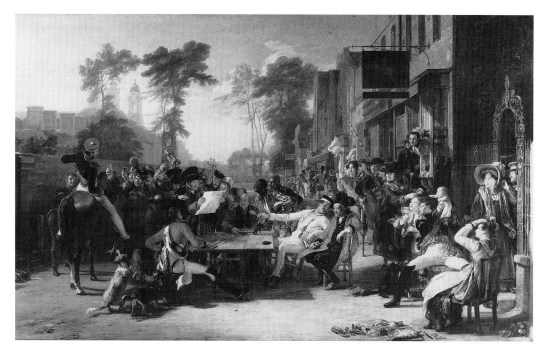

FIGURE 49

Sir David Wilkie,
*Chelsea Pensioners
Reading the Gazette
of the Battle of
Waterloo* (1822).
London, Victoria &
Albert Museum,
Apsley House,
Wellington Mu-
seum. Oil on panel,
97 × 158 cm.
(Photo courtesy of
the Board of
Trustees of the
Victoria & Albert
Museum.)

in a council chamber, revolutions *intra-muros* that alter an empire's destiny, in which the only participants were two tyrants, two confidants, two traitors, and two lovers, accompanied by at most six walk-ons with halberds. It would seem as ridiculous as a Roman uprising without a forum or a Neapolitan revolt without *lazzaroni*. I repeat, the people wish to see themselves where they are, and you will no longer be able to persuade them that they stayed home the day of Coriolanus's disgrace or Caesar's assassination.[5]

But what would it mean for the "people to see themselves" in paintings instead of onstage? Was such a historical approach possible in the visual arts?

The Ultra-royalist and Conservative political viewpoints were easily translated into the visual arts by means of object-relics or corporal gestures. But the Liberal viewpoint that was adopted during the Restoration by Augustin Thierry and the Saint-Simonians, a viewpoint that was allied with Romantic aesthetics, opposed the concrete representation of history.[6] For Marchangy and Chateaubriand, linear narratives were appropriate vehicles for conveying meaning, because the events of history had already taken place. Their duty as historians was to enlighten their audience and engage them emotionally by conveying their own explanations. But Liberal historians could not express themselves through such narratives, for history had a completely different meaning for them, just as their own political actions were diametrically opposed. Marchangy prosecuted conspirators after the revolt of the Belfort garrison, one of the attempted military uprisings against the government by disaffected Bonapartists and Carbonarists that occurred during 1821–2. Thierry

participated in this conspiracy, along with the Liberal historians in his circle: Bodin, Carrel, and Arnold Scheffer and his painter brothers.

For the Liberals, history was not over at all: it was an incomplete revolution. History had not been made at one unique place and time by "them": it was being made by all of us. Liberals were determined to awaken their audience to the persistence of history in their own daily lives, so that the nation itself would participate in this experience of cultural resurrection. For them, historical meaning could not be conveyed in closed linear narratives or edifying enactments of historical anecdotes, because history was not to be found in the actions of a ruler. Instead, popular experience demanded resurrection in open-ended, multivocal texts, inspired by historical fiction. We see this conception of history in Wilkie's *Chelsea Pensioners*.

This painting had originally been commissioned in 1816 by the duke of Wellington as a simple scene of soldiers relaxing outside a pub. Wilkie, however, had felt the need for "some story . . . to connect the figures together." Wellington suggested a game of skittles, but Wilkie preferred the reading aloud of a newspaper report, which could promote additional "incidents" in the varied responses. He had already used this device in *Village Politicians* (1806), where Scots peasants, debating radical politics, destroy their own domestic happiness.[7] But when he described the nation's response to the news of victory at Waterloo, Wilkie's intentions were very different, and Wellington's payment of 1,200 guineas for the painting, far greater than the usual fee for a work by a modern British artist, acknowledged it to be more than a genre scene of veterans enjoying their well-earned repose. In *Chelsea Pensioners Reading the Gazette of the Battle of Waterloo*, Wilkie opened up the visual moment and aggrandized its intellectual content. He did not provide a casual view of soldiers relaxing and reminiscing or a humorous commentary on the folly of the lower classes attempting to understand and sway world events. Nor did he describe the battle itself, an action set in a particular time and place. Instead, he presented British war veterans and their families and neighbors responding to the news that peace had at last been achieved.

The cast of characters is larger than in his other paintings, and the evolution of the work was far more complex; more than eighty preparatory drawings survive. From the painting's inception, Wilkie studied the subject of veterans responding to the news of peace with consummate sympathy for their past experience (evident in their disabilities) as well as their present emotion. We see veterans who had survived warfare against the French through every decade from 1759 and the taking of Quebec (the veteran reading the *Gazette* aloud) to the Peninsular Battle of Vittoria in 1813 (the young corporal at right, exultantly lifting up his child). Even a canine veteran is included: the black dog named "Old Duke," in honor of Wellington himself. Each figure who hears the an-

nouncement also contributes memories to this corporate celebration; they respond as individuals whose personality and response have been conditioned by past experience. We see the lives of actual people, not a theatrical chorus: ourselves, our comrades in arms, our compatriots.

We see these individuals incrementally, as glittering touches of color, horizontally ordered in scarlet and white. The sharply foreshortened light horseman from the Seventh Lancers, on the left (welcomed by excited dogs), is one of the four scarlet and white color anchors of the work. The angle of his leg draws our eye to the scarlet and white figure seated at the foreground left of the table with his back to us. To the right of the table, an Irishman of the Twelfth Dragoons, in white foraging dress, explains the news to an old (possibly deaf) pensioner in a paler red coat. Finally our eye comes to rest on the happy family group at right: the sergeant of the Oxford Blues, in black and yellow, and his wife, in a brilliantly embroidered red and yellow jacket. Their domestic happiness is the result of the sudden military incursion at left, and their joy reassures the spectator who has been moved by the agonized mother who searches the newspaper's death notices.

The work defies summary in one mood and is composed additively instead of climactically. Instead of a central, pyramidal group, we see a scintillating optical field. Instead of universal celebration, we see reactions that range across the entire emotional gamut, from patriotic joy, through gluttony and boredom, to terrified concern for those missing in action. Furthermore, the work resonates outward to include us. The viewer is invited to participate as another witness, another celebrant. This was indeed the result: *Chelsea Pensioners* was the first painting at the Royal Academy to require a protective guardrail, since spectators surged forward to enter into the painting imaginatively, if not physically.

Victor Hugo, in his preface to *Cromwell* (1827), a reading-drama that he had written as a contribution to historical studies, insisted that historical truth lay more in character and mores than it did in facts. He called for modern history and historical drama to describe completely human beings, their body and their soul, their inner life as well as their external features. In antiquity, poets had sung of humanity's dreams; in the medieval period, they had narrated its deeds. Now authors and artists were to resurrect a culture by painting its thoughts.[8] By 1830, Hugo could make a terse equation: Romanticism was literary Liberalism.[9]

During these years, Delacroix was also seeking a way to describe scenes of historical significance without sentimental or melodramatic exterior cues, through pictorial means alone. As we shall see in his novels (written c.1814–16), his style of writing became less representational as he sought to express the essence of culture in its impact on temperament and behavior. In 1819, Delacroix reiterated Géricault's praise of Wilkie when he lauded English historical drama: "None of those inflated words, deliberately introduced to convey images," unlike Chateaubri-

and's overly refined vulgarity, which underscored emotion with exaggerated expressions and sinister omens.[10] Delacroix did not merely wish to see conspirators' gesticulations; he wished to understand their thoughts, and to depict them, for art addressed the intelligence as well as the senses. Delacroix wrote in his journal in 1822:

> When I have painted a fine picture, I haven't given expression to a thought. That is what they say. What fools people are! They would strip painting of all its advantages. The writer has to say almost everything in order to make himself understood, but in painting it is as if some mysterious bridge were set up between the spirit of the persons in the picture and the beholder. The beholder sees figures, the external appearance of nature, but inwardly he meditates; the true thinking that is common to all men. Some give substance to it in writing, but in so doing they lose the subtle essence. Hence, grosser minds are more easily moved by writers than by painters or musicians.[11]

Although painting was optically oriented, it was not fettered to objective representation. That was why it could be more evocative, expressive, and persuasive than a linear literary narrative.

It was precisely this approach that Thierry was urging on historians during these years. Thierry wished to evoke the inner history of conquered populations, their resistance and integration, in a history of cultural clashes and revolutions.[12] His own *Histoire de la Conquête de l'Angleterre par les Normands* (1825), inspired by Walter Scott's *Ivanhoe* (1819), was a history of the four cultures that had formed Great Britain, each traced through six centuries to the end of the eighteenth century. The panoramic scope of the work was unusual, but even more so his address to the reader, whom he wished to take an active role:

> The task is to find a way across the distance of centuries to men, to represent them before us alive, and acting upon the country in which even the dust of their bones could not be found today, and that is why many local facts, many unknown names have been included in this account. Let the reader's imagination seek to repeople the land of old England, with its victors and vanquished of the eleventh century. Let him imagine their situation, their concerns, their different languages, the glee and insolence of the former, the wretchedness and terror of the latter, everything that accompanies two great populations engaged in a war to the death. These men have been dead for fully seven hundred years, their hearts stopped beating with pride or anguish seven hundred years ago; but what is that to the imagination? For the imagination there is no past, and the future itself is in the present.[13]

The resurrection of an entire people meant the active construction by modern readers and spectators of a sympathetic bridge from soul to soul. Instead of lamenting the truncation of the past, or witnessing the reenactment of the past, experiential history revealed the past as still active in the psyche of the present.[14] Barante had spoken of "depicting," of "representing" an event that had occurred in the past. But Thierry wished the

modern reader not only to recognize the fact of the past event but to perceive its simultaneous presence in the present day, perceptible in titles, idioms, racial traits. This history would be truly of the people and for the people and would make it possible to educate the people for their ultimate liberation.[15]

How were narrators to convey all the psychic and concrete density of popular life? The appropriate manner in which to write such revolutionary history was a subjective, evocative, even cacophonous one. Only that style of writing could implicate readers in participatory experience, instead of forcing them to become docile witnesses to descriptive representation. Liberal historiography was inspired neither by archaeological relics nor by melodramas, but by historical novels. The novel's format permitted the author to travel backward and forward through time, to enter into the psyche of protagonists, to speak in many voices, each with its own idiom, to perceive multiple events almost simultaneously, and to render them through description, soliloquy, or dialogue. The mentor of French liberal historians was actually a Scots historical novelist: Sir Walter Scott.

In painting, comparable strategies were being employed for a comparable goal. Romantic subjectivism often employed an optical field that offered multiple focal points, in an approach whose impact was subtly different from the scintillating Troubadour works that we have examined. Troubadour artists had elided the impact of the canvas, soliciting the viewer's eye to engage the viewer's memory with a multitude of crisply defined objects, all of them rendered in a similarly illusionistic manner. The audience was encouraged to look at a scene or a monument, rather than a painting. But Romantic artists varied their handling of paint and color across the canvas in autobiographical testimony, and in correspondance with the diversified experiences of the protagonists. Such a visual strategy was adopted during the Restoration by Géricault, Delacroix, Ary Scheffer, and others to open a bridge to the imaginative resurrection of the past, without confining history to the representation of an anecdote. Romantics such as Hugo and Vitet, and Liberals like Thiers, immediately recognized that using such visual strategies to express historical meaning enlisted these artists alongside Liberal historians: describing mores rather than representing heroic action, evoking social forces rather than focusing on a protagonist, invoking an empathetic response by the spectator to the psychic moment, a moment that fused past and present.

This was the core of the Romantic pictorial challenge: just as Liberal historiography was opposed to conventional historical representation, so was Romantic painting opposed to "historical" representation, in the sense of repeating concrete forms. Just as Liberal historiography sought new narrative frameworks to achieve a more valid rendition of historical truth and a more effective address to the modern reader, so Romantic

painting wished to provide a less material, more experiential sense of history. Scott pioneered a dynamic sense of the past in which individual action and national destiny were interwoven, in which temperament was the expression of culture and caste, in which those of the past spoke directly to the readers of the present day. Many critics agreed that Scott's novels were more truthful historical texts than many "objective" histo-riographic narratives. Would it be possible to utilize the same approach in the visual arts? Let us first consider how this literary manner functioned in the hands of Delacroix, Scott, Thierry, and Monteil, before turning to examine pictorial works by Géricault, Ary Scheffer, and Delacroix.

DELACROIX'S HISTORICAL FICTION

Delacroix had been searching for a new way to convey the experience of a historical moment since his schooldays. He left the Lycée Impérial/ Louis-le-Grand in June 1815, became a student of Guérin's in October of that year, and entered the Ecole des Beaux-Arts in March 1816. The caricatures he produced during the period between his student days and his Salon debut in 1822 have been meticulously studied as documents of his intellectual maturation in politics and aesthetics, but almost no attention has been given to the historical novels that Delacroix wrote during the same years of his late adolescence, *Alfred* (c.1814) and *Les Dangers de la Cour* (c.1816).[16] They provide precious insight into Delacroix's developing conception of history and his search for a way in which to convey the meaning, rather than the appearance, of a cultural milieu by describing its impact on belief and behavior.

Delacroix was inspired to write *Alfred* after his visit in 1813 to the house of his cousin Augustin Bataille at Valmont, a former Benedictine convent, "which, as you may well imagine, was in no small degree romantic." In January 1814, after the vacation was over, he wrote of the pleasure he had taken in wandering through this place, with its passages, vaults, narrow staircases, Gothic windows; he also noted that the wind whistled through ill-fitting casements, and that the hooting of owls had awakened him in the night.[17] Delacroix was fully aware that although ruined Gothic architecture could arouse poignant and sublime emotions, those external objects were not infallible conduits to historical meaning. By this period, fifty years after Horace Walpole's *Castle of Otranto* (1765) had inaugurated the rage for "Gothick" novels, gloomy Gothic ruins had become so banal that they could appear unintentionally comic to a person of Delacroix's taste and intelligence. His mischievous recognition of this aspect of the situation was more explicit in another letter, this one written while still at Valmont: "There are huge interminable passages. At the end of one of them, *right at the very end*, there is my room. Beside my door there is a little winding stair . . . (beware, this is

becoming like a novel) you go down that winding stair . . . (I can see you trembling) and you find a little, very low door."[18] And so on, to monks in lead coffins in a crypt and a female spirit who haunts the abbey at midnight, rushing about and pinching feet. His phrase "beware, this is becoming like a novel," warns us that he is alert to the flaws as well as charms of "Gothick" literature.[19] The plot would be rich in dreadful actions, the speeches would be declamations of passion, the architectural background would assert itself. This is exactly what we find in *Alfred*, Delacroix's blood-and-thunder novelette of love, insanity, and parricide, set at the time of the Norman Conquest, with a character named "Hastings." But despite its brevity and its rhetorical platitudes, it demonstrates Delacroix's early recognition that culture explains temperament and motivates action.

The comte de Burtmann, fearing his battle wounds are fatal, asks his ambitious and unscrupulous chaplain to administer the last sacrament. The chaplain, Harold, who wishes to take over Burtmann's estates, asks him to swear to give his son Alfred (aged eighteen) to monastic life if he is cured. Burtmann agrees to this, swayed by his culture's superstitious credence in religion instead of his innate paternal love. When he recovers, he realizes that because of this decision, made in a moment of weakness, he does not deserve to live. He makes his confession to his chaplain and prepares to commit suicide, to ensure his son's happiness. But the suicide attempt is foiled by Alfred and the baron de Hastings (father of Amélie, Alfred's beloved), who have overheard his confession. Later, Alfred, increasingly agitated, loses touch with reality. The perfidious Harold works on Burtmann's superstitious fears and then decides to proceed directly against Alfred, telling his cohorts to arrest him. Burtmann regrets the oath he has sworn and runs, sobbing, to embrace his son. But the deranged Alfred does not recognize him and deals him a mortal blow. Burtmann expires, acknowledging that he deserved this end. As dawn breaks, Alfred, conscious for the first time that he has committed parricide, stabs himself and falls dead on the bloody corpse of his father.

Delacroix's visual sensitivity is marked in *Alfred*. This is more than a question of his representing physical actions: the sacramental rites, the overheard confession, the tearful father running to embrace his implacable son, the duel, the collapse of two corpses. Accessories and setting also take a role in the dramatic mood and action. The hero recognizes portents of disaster in the black crows that seek refuge in the turrets against a coming storm and asks them: "Sinister omens of nature's gloom, what do you portend?" When Hastings and Alfred, hiding behind an enormous pillar, overhear Burtmann's confession, they are overshadowed by "pale statues that decorate the tombs underneath Gothic arches and that seem to be ghosts." Phrases represent action in concrete visual terms, in sentences such as "he crossed the threshold of the Gothic

doorway, and, more swiftly than the wind, flew toward Burtmann's castle." But the most important aspect of *Alfred*, which will be retained when Delacroix has sacrificed these descriptive exterior images and rhetorical flourishes, is the fundamental assumption that culture is a motive force. Medieval superstitious credulity makes it possible for Harold to gain his hold over a decent and loving father. This insight is the definitive characteristic of *Les Dangers de la Cour*, a far more ambitious eighty-page novella written two years later.

If Walpole inspired *Alfred*, Rousseau inspired *Les Dangers de la Cour*. The anonymous hero-narrator, the son of a Swiss pastor, begins his tale by describing a mountain at sunset in September. The pure air, the vista over the valley, symbolize his virtuous heart and uncomplicated happiness and explain how they are possible: he is isolated from European civilization, or, should one say, vice. Here, he saves the life of a Frenchman, the Comte de C***. This man is a rarity: an aristocrat who is noble by nature as well as by birth. The youth, offered a post at the French court, refuses, but this experience has awakened in him a longing to see more of the world. He accepts the next offer, from the marquis Antonio de Tortinelli, who lives in Piedmont, at the court of the king of Sardinia.

Once the Swiss youth arrives at court, he realizes that his patron is not as securely situated as he had claimed. During a boar hunt, the youth saves the life of an unknown man, who turns out to be the prince: "a good-hearted man who would have been virtuous, if he had been lucky enough to be born in my station."[20] The marquis recognizes that his protégé's star is rising and asks him to intercede with the prince so that he may obtain a position at court, offering the young man some gold as a bribe. Furious at this insult, the youth decides to seek revenge by supporting the prince's suit of Hortense, whom the marquis had been courting. He gives his garments to the prince, so that, dressed as a commoner in the train of the marquis, he may woo Hortense. While the prince is attempting to seduce Hortense, her father enters. The prince, humiliated, immediately blames the instigator of the ill-fated plan. Since the youth has offended both prince and marquis, his career at court has ended in disgrace. Suddenly the new French ambassador arrives: the Comte de C***! The entire court of Piedmont, which had been threatening to deport this "vile peasant," now, fearing to insult the king of France, treats the youth respectfully once again. The Comte de C*** even offers him a good position, but he is determined to return to Switzerland, where he will be safe from the dangers of the court.

Court life is intrinsically corrupt because it is based on inherited rank, despotic tyranny, and libertine indulgence. Delacroix structures his novel on the corruption of innocence, revealed in the hero's three helpful acts. The first demonstrates true virtue: he rescues the unknown Comte de C*** in Switzerland prompted solely by the desire to assist a human

being in need. The second, the rescue of the prince from the wild boar, is innocent in its initial motive, but our hero later calculates how to make use of this act to advance his own position. The third act is completely callous and duplicitous: aiding the prince to seduce an innocent girl, so that the youth may destroy the hopes of his former patron, the marquis. The meaning of a cultural milieu is expressed directly through its impact on the protagonist's character and behavior.

In this novel, Delacroix's style is severely pruned of descriptive details and gestural anecdotes. It is astonishing that the author of this antivisual novel was pursuing art studies and producing caricatures in these years. In *Alfred,* the arches and the tomb sculptures were vividly present; here, the Swiss setting is glossed over with platitudes about "rustic villages." When the youth prepares to leave his Swiss home, "the least important object drew my attention, as if to keep me there," but not one of them is described. The depravity of the court is obvious to him at first glance; for example, on his arrival, he sees a woman with a child who resembles the marquis, presumably his bastard. But the reader is not allowed to see his features; the identification of the bastard is followed by a disquisition on courtiers who wish to be distinguished through their vices instead of adhering to the insipidity of a virtue that can be attained by any commoner. Local color is flattened and material description erased, so that nothing will distract us from our perception of how court life warps the hero's psyche. We enter directly into the thoughts of those who live in another milieu. This is precisely what Delacroix, and the other French Romantics, praised in Scott's novels.

In 1825, Stendhal, hailing Guizot's latest volume of French archival documents, found it both amusing and reassuring that Chateaubriand's planned history of France, which was to describe "the eight hundred years of felicity that France enjoyed after Clovis's conquest," a work that would have been a great success if it had been published in 1816, would now be hard pressed to find one hundred readers. Historical texts that the French would have found too difficult to understand in 1820 were now deemed superficial. Stendhal credited Scott's novels, *Ivanhoe* in particular, with the immense progress in French historical studies since 1816, progress away from Chateaubriand's sentimental eulogy of feudalism and Bourbon monarchism toward Thierry's social insight.[21]

Thierry had been seeking a historian of nations rather than monarchs. In 1820, Thierry wrote that Scott's *Ivanhoe* opened a new age in historical studies, because it described the persisting conflicts between Norman and Saxon, centuries after William the Conqueror's victory at Hastings:

> A man of genius, Walter Scott, has revealed the truth of these events, so disfigured by modern phraseology, for the first time. Oddly, but this will not surprise anyone who has read his previous works, he has clarified this great historical point in a novel. He has made the Norman Conquest come to life, the same subject that the philosophical

school of the last century, more in error than the illiterate medieval chroniclers, had elegantly shrouded in the banal formulae of succession . . . Where the historian Hume could only speak of a *king* and of *England,* without explaining what "king" meant, nor what he understood by the term "England," Walter Scott, probing deeply into the actual situation, shows us the whole population, their opinions, their separate existences, two cultures, two languages, a conflict of mores, on one side tyranny and insolence, on the other misery and hatred; the real developments of the drama of the Norman Conquest, for which the Battle of Hastings was merely the prelude to the first act . . . This is the real, truly historical scene in which the story of *Ivanhoe* is laid, in which the fictional characters make the truth of the political setting in which the author has placed them even more apparent.[22]

"FOR THE IMAGINATION, THERE IS NO PAST": SCOTT'S IMPACT ON THE HISTORIANS THIERRY AND MONTEIL

Sir Walter Scott was born in 1771. His earliest memories were of a dying culture, and his subsequent training in law, his antiquarian studies, and his creative expression in poetry, fiction, and historiography all sprang from the same insight: local mores were the mirror of history. He was called to the bar in 1792 and served as advocate from 1795, as sheriff-depute of Selkirkshire from 1799, and as principal clerk of the Court of Session in Edinburgh (1806–30). After publishing translations of Bürger and Goethe, he made his own literary debut in 1802 with *Minstrelsy of the Scottish Border,* a collection of ballads that he had heard in his childhood, extended by his own critical essays and historical notes. This was an immediate hit, which Scott consolidated by publishing his own narrative poems, such as *The Lay of the Last Minstrel* (1805), *Marmion* (1808), and *The Lady of the Lake* (1810). So successful were these poems that the post of Poet Laureate was offered to Scott in 1813; he declined it. In 1814, he wrote articles on chivalry and romance for the Encyclopaedia Britannica. After 1812, when Byron's successful debut with *Childe Harold* challenged his career in poetry, Scott turned to prose, publishing (at first anonymously) twenty-six historical novels, a nine-volume life of Napoleon (1827), two histories for children entitled *Tales of a Grandfather* (one completed for Scotland [1828–31], the other begun for France [1831]), historical short stories, historical dramas, editions of historical memoirs, and many other works. In 1820, he was created baronet by King George IV; the king's ceremonial visit to Scotland two years later was stage-managed by Scott. Scott's later life was overshadowed by the impact of his publishers' bankruptcy in 1826; by his own heroic efforts, he paid off his creditors (a debt of 117,000 pounds) by 1831. He died in 1832.[23]

His first novel, begun in 1805 and published in 1814, was signifi-

cantly titled *Waverley; or 'Tis Sixty Years Since*. Scott announced that his purpose in writing it was to preserve the culture of his grandparents' generation:

> It was my accidental lot, though not born a Highlander . . . , to reside during my childhood and youth among persons of the above description ["folks of the old leaven"]; – and now, for the purpose of preserving some idea of the ancient manners of which I have witnessed the almost total extinction, I have embodied in imaginary scenes, and ascribed to fictitious characters, a part of the incidents which I then received from those who were actors in them . . . It has been my object to describe these persons, not by a caricatured and exaggerated use of the national dialect, but by their habits, manners, and feelings . . . To elder persons it will recall scenes and characters familiar to their youth; and to the rising generation the tale may present some idea of the manners of their forefathers.[24]

Ancestral manners were the expression of human emotion, which was motivated by local, social, and political circumstances. The novel describes the formation of Edward Waverley as a naïve, enthusiastic, but irresponsible youth, who is induced to fight with the Jacobites for Prince Charles Edward Stuart under the influence of the picturesque Highlands, the arguments of the fierce Fergus Mac-Ivor, and the charms of Flora Mac-Ivor. After the first five chapters, Scott apologized:

> I beg pardon, once and for all, of those readers who take up novels merely for amusement, for plaguing them so long with old-fashioned politics, and Whig and Tory, and Hanoverians and Jacobites. The truth is, I cannot promise them that this story shall be intelligible, not to say probable, without it. My plan requires that I should explain the motives on which its action proceeded, and these motives necessarily arose from the feelings, prejudices, and parties of the times.[25]

Waverley was a spectacular success. Scott's audience responded to his vivid descriptions of sites, costumes, characters, and above all to his interrelating of psychological and cultural development.

Scott's novels present a dynamic view of history, as the result of crises of conscience as well as of collective evolution and cultural conflict. Whether in the England of Richard the Lion-heart (*Ivanhoe*) or of Cromwell (*Woodstock*), the Scotland of the Covenanters (*Old Mortality*) or the Jacobites (*Rob Roy*), France under Louis XI (*Quentin Durward*) or the court of Byzantium facing eleventh-century Crusaders (*Count Robert of Paris*), we are who we are because of our race, our class, our heritage. The impact is also reciprocal: in forging our identity, we also influence the course of history.

Today, his best-known novel is *Ivanhoe*, one of his most popular and influential novels in the nineteenth century and, as we have seen, a direct inspiration for Thierry's *Histoire de la Conquête de l'Angleterre par les Normands*. The novel is set in twelfth-century England, four

generations after the Norman Conquest, and its theme is the coming of the nation-state to a land torn by feudal factions and racial conflicts. Richard the Lionheart (disguised as the Black Knight) has returned from Palestine to find that his younger brother, Prince John, has usurped his place on the throne and is plotting his murder. A Saxon, Wilfrid of Ivanhoe, helps Richard the Lionheart to become "Richard of England," ready to preside over the harmonious union of all cultures. There are three climaxes: the joust at Ashby-de-la-Souche, the siege of Torquilstone, and the trial by combat at Templestowe, where Knights Templar threaten to burn the Jewess Rebecca at the stake. All three climaxes extend over many chapters, with precinematic flashbacks and cross-cuts between different confrontations in the same locale.

The age's ferocity, fanaticism, racial genocide, and brutal anti-Semitism are revealed through a cast of characters that includes swine-herd and king, Jew and Knight Templar, each presented both as a unique individual and as the personification of an age's opinion, as Thierry noted in his review.[26] Each character's language is vividly diversified, as is costume, to make class, religion, and political partisanship evident to the reader. The most celebrated example is the first character whom we meet, the Saxon swine-herd Gurth, who wears his class around his neck: a brass collar, inscribed "Gurth, the son of Beowulph, is the born thrall of Cedric of Rotherwood." Gurth's Anglo-Saxon phrases ("the curse of St. Withold upon these infernal porkers!") and Cedric of Ivanhoe's resentment of Norman hunt vocabulary ("I can flay and quarter the animal when it is brought down, without using the newfangled jargon of *curée, arbor, nombles,* and all the babble of the fabulous Sir Tristem") are linguistic expressions of cultural identity, as French critics recognized.[27]

Each of these historical personifications voices his or her viewpoint, and thus the novel makes a very different impact from that of a text written by an omniscient author (as in Marchangy's works) or even one like Chateaubriand's *Les Quatre Stuarts,* in which the author allowed people from the past to interrupt his disquisition and speak directly to the reader. Instead of accepting a single view of events, verified by direct quotation, Scott presents us with a refracted view that we must assemble for ourselves. In such multivocal novels, we understand the inner lives of all the characters, from swine-herd and fool to Templar and king, because they speak directly to us, and because we are offered their motives and desires as well as their declamations.[28] And, to further enrich the reader's understanding of past civilizations, the characters' opinions are at times undercut by Scott, the modern ironic narrator, as in his conclusion to the description of the joust at Ashby-de-la-Souche:

> Thus ended the memorable field of Ashby-de-la-Souche, for although only four knights, including one who was smothered by the heat of his armour, had died upon the field, yet upwards of thirty were desperately wounded, four or five of whom never recovered. Several more

were disabled for life; and those who escaped best carried the marks of the conflict to the grave with them. Hence it is always mentioned in the old records as the "gentle and joyous passage of arms of Ashby."[29]

It is not surprising that Thierry himself considered writing a historical novel in 1824.[30]

Wilkie had depicted the responses to peace instead of the Battle of Waterloo. In the same fashion, Scott, a friend and admirer of Wilkie's, did not set himself the task of retelling known events but that of describing what it was like to live at a particular place and time, to be a member of a particular race and class. As Thierry pointed out in his review, whereas historians had considered the Norman Conquest a unique act, succeeded by a change of dynasty (history as the achievement of rulers), Scott described the ongoing experience of invasion from the point of view of the conquered population; this is what made his historical novel not only a work of genius, but far more truthful than the works of the eighteenth-century philosophers, which had buried this living truth under banal formulae of "succession."[31] Scott's readers, instead of watching distant figures enact known events once again, for incomprehensible reasons, were drawn directly into another age, which became nonetheless understandable through concrete description and through empathy. Local color and dialect were not a masquerade costume, temporary dress for eternally similar human nature, but the direct expression of the impact of historical forces on a point of view. History was expressed from the inside out, for readers who, reentering the past, transcended time. And this conception of history, subjectivity made visible, was precisely what Delacroix was seeking in the visual arts when he wrote that he wished to "paint thoughts."

In *Ivanhoe*, Scott describes the siege of Torquilstone in nine chapters, in a precinematic montage of simultaneous confrontations in different places. In chapter 29, those besieging the castle (who include the disguised Richard the Lionheart) begin their attack. Wilfrid of Ivanhoe, imprisoned in the castle, is almost mad with frustration, for his wounds prevent his aiding his friends. The Jewess Rebecca, imprisoned with Ivanhoe, has been nursing the man whom she secretly loves. Ivanhoe begs her to tell him what is happening outside their window. Scott chose to have Rebecca, the alien Jewess, narrate the action to Ivanhoe and the reader. He realized that if an omniscient narrator described the siege directly to the reader, it would be too thrilling a sight: axes smashing barriers, a hail of arrows and missiles, gore and corpses. Intelligent, honorable, and generous, Rebecca is horrified by warfare's brutality and finds chivalric glory, which the man she loves celebrates, to be merely "a life spent miserably that ye may make others miserable." Ivanhoe recoils from such sentiments in disgust, saying, "Thou art no Christian, Rebecca."[32] The chapter presents a cultural debate as an unspoken subtext and an unseen battle.

This verbal description of temperament and culture, this epitome of the antivisual, attracted several Romantic artists. Delacroix depicted the scene in 1823 (Fig. 50) and again more than twenty years later. Lithographs of the scene were published by Achille Devéria in 1829 (Fig. 51), as part of a suite of lithographs relating to Scott's novels to which Delacroix contributed two images of Ivanhoe, and by Nicolas Maurin in 1836 (Fig. 52).[33] In these works, we are not meant to view the enactment of an action, the battering down of the barriers at Torquilstone, but to enter into the characters' thoughts as they seek refuge from their situation and to consider how those thoughts indict an age, race, caste, religion. The lurid flames of the torches held by those outside the castle are barely present, so that our concentration will be held by the contrast between Rebecca's gentle curves, lapped by richly patterned fabrics of mauve and red, and Ivanhoe's heavy, brutish masses, covered in a white sheet. Delacroix and Maurin rupture the unified compositional effect, for the purpose of such a theme, and such a depiction of it, is to evoke a fragment of experience, which flashes backward and forward between prison and release, between chivalric enthusiasm and pacifist repudiation. By deciding to portray such a subject, Delacroix validates Scott's historical insight into culture as determining temperament and motivating behavior, an insight that Delacroix had demonstrated in his own fiction years before. In words and in images, Delacroix was determined to make this psychic and dynamic cultural sense evident without distracting the audience with concrete descriptive details. He was aided in this difficult endeavor by the universal popularity of Scott's works: spectators of this scene would be able to supplement the visual information with the unseen actions, the cultural background, the passionate emotions that could not be acknowledged.

Scott's novels popularized this historical viewpoint for the entire French nation. He was ubiquitous: in 1830, of the 111 novels by British authors published in France, 82 were by Scott.[34] Not only were they sensationally popular, they were recognized as having opened up a new era in historical studies, particularly by the Liberal historians in Thierry's circle. Mignet called Scott a genius, and *Ivanhoe* more historically true than any scholarly historiographic work.[35] Bodin agreed, in his review of Scott's *Quentin Durward* in 1823:

> history does not only consist of certain facts, certain dates. Certainly, general matters such as social class, mores, beliefs, acquired ideas, have a far greater importance; that is precisely what he reproduces so accurately . . . there is more history in the novels of Walter Scott than in half of the historians, and above all the historiographers.[36]

Jouffroy (another Carbonarist) pointed out that because the French had vivid memories of making history themselves, they, even more than the British, could appreciate Scott's insights.[37]

FIGURE 50

Eugène Delacroix,
*Rebecca and the
Wounded Ivanhoe*
(1823). Private
collection, New
York. Oil, 64.7 ×
54.2 cm. (Photo
courtesy of the
owner and the
Metropolitan
Museum of Art,
New York.)

In "Sur l'histoire d'Ecosse, et sur le caractère national des Ecossais" (1824), Thierry praised Scott as possessing more historical insight than any historian into the motive forces of history, cultural clashes, and the inevitability of political and religious revolutions.[38] Carrel's *Résumé de l'Histoire d'Ecosse* (1825) (for which Thierry wrote an introduction) repeated Thierry's praise of Scott, and Carrel cited Scott's poems and novels in his notes as historical sources.[39] In 1826, the Saint-Simonian journal *Le Producteur* credited Scott with having established a new historical school by relating individual and collective passions to political events:

> this writer, in associating individual and social passions, in localizing them, in giving them the character of the physical circumstances, political events, and mores in which they appear, has given them a new life. His works have been immensely successful. One of the main reasons for this success has been the minutely detailed description of mores, beliefs, preferences of another age, which was unknown to authors as well as readers. It was as if a frequent traveler described a new world's

FIGURE 51

Achille Devéria,
*Ivanhoe. Chap.
XXIX*. Lithograph
in suite entitled
*Illustrations de
Walter Scott* (Paris:
Gaugain, 1829).
(Photo courtesy Bib-
liothèque Nationale
de France, Paris.)

customs to us. And that interest grew even more when we realized how
many reference points there were between that world and our own.
From that day on, the public has shown its interest in historical works,
and writers have copied his approach . . . the novelist Walter Scott
should therefore be considered the founder, and leader, of the most
celebrated and numerous group of modern historians.[40]

It is now time for us to examine historical texts written by Thierry and
consider why Scott's narrative approach would be so influential for him.

Jacques-Nicolas-Augustin Thierry (1795–1856) began his career in
1814 as the secretary and collaborator of Claude Henri de Rouvroy,
comte de Saint-Simon (1760–1825), and Saint-Simon's politics perme-
ated his own historical approach in its subject matter and its style of
narration.[41] Thierry's articles for the *Censeur Européen* during 1817–19
stress his interest in tracing national evolution. As early as 1817, he main-
tained that "Cromwell was not the hero of his own history." It was not a
question of replacing a king with a republican dictator; rather, all citizens
should recognize that *they* were the hero of their nation's history. Histori-
cal insight was to be found in popular movements, not personal machina-
tions.[42] In 1818, Thierry urged his compatriots, newly freed slaves, to seek
out their own history, not that of their masters. Their ancestors had cre-
ated Gaul long before there had been a Frankish dynasty.[43]

The assassination of the duc de Berry, the heir to the throne, on Febru-
ary 13, 1820, was followed by a wave of hysterical anti-Liberalism. The
feared extinction of the Bourbon dynasty (though a posthumous son

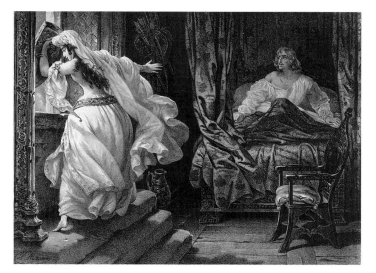

FIGURE 52

Nicholas-Eustache
Maurin, *Rebecca
and the Wounded
Ivanhoe.* Lithograph
in suite entitled
Ivanhoe (Paris:
Bulla, 1836). (Photo
courtesy Biblio-
thèque Nationale de
France, Paris.)

termed "l'enfant du miracle" was born in September 1820) resulted in the
fall of Decazes's liberal ministry. The duc de Richelieu returned; after the
Ultra-Royalists won the elections of November 1820 and October 1821, a
repressive ministry under the comte de Villèle came to power. Liberals
went underground, in the secret society of the Charbonnerie (modeled on
the Neapolitan Carbonaria).[44] It soon had fifty thousand members, includ-
ing Thierry, the marquis de Lafayette, and the three Scheffer brothers.
Thierry's historiographic activities during the 1820s, and the establish-
ment of the Saint-Simonian journal *Le Globe* in 1824 as a forum of
Liberal opinion on the arts as well as politics, must be set into the context
of Carbonarist opposition. In 1820, Thierry published "Première lettre
sur l'histoire de France, adressé au rédacteur du *Courrier Français*," one
of a series of salvos in the battle for a truly national history that would
endow collective populations with a soul. The history of the people of
France, which remained to be written, had to be written so that modern
readers would engage with their ancestors:

> we lack the history of citizens, the history of subjects, the history of the
> people. That history would offer us both deeds worthy of note and
> that sympathetic interest which we seek in vain when we read of the
> exploits of a few privileged people who occupy the historical arena by
> themselves. Our souls are captivated by the destiny of ordinary people
> who lived and felt as we do, far more than by the fortune of nobles or
> princes, which is the only history that we hear about . . . the progress
> of the masses toward liberty and happiness is more important to us
> than tracing the route of invasion, and their miseries more poignant
> than those of dethroned kings. In this truly national history, if some-
> one is capable of writing it, France's cities and cultures will appear as
> active collective agents, endowed with free will.[45]

Thierry not only wished to describe the actions of these citizens, he
wished to have the modern reader's soul touch their souls, to endow

communities with intelligence and a will to action. Until now, history had been written by and for those in power. The people's role in history had been hidden by a biographical-heroic approach to history, chronicled by monks whose abbeys were supported by lords:

> It is interesting how obstinately historians refuse to attribute any spontaneity or originality to a group of people. To read the annalists and poets, if an entire population emigrates and settles in a new place, it is because some hero has decided to establish an empire in order to honor his name. If new customs become established, it is because some legislator has thought them up and imposed them. If a city develops, it is because someone has decided that it should. In every case, the people, the citizens are only raw materials to be used by an individual.[46]

Thierry declared war against history that ignored the people, a war waged in *Histoire de la Conquête* (1825) and *Lettres sur l'histoire de France, pour servir d'introduction à l'étude de cette histoire* (1827):

> The vocation I embraced from then on with all the ardor of youth was not that of casting a solitary light on some little-known corner of the Middle Ages but of planting for nineteenth-century France the standard of historiographic reform. Reform of the study of history, reform of the way history is written, war on the writers without learning who failed to see, and on the writers without imagination who failed to depict ... war on the most acclaimed writers of the philosophical school, because of their calculated dryness and their disdainful ignorance of our national origins.[47]

The syntheses written by Enlightenment historians were incapable of describing a history of persisting cultural forces in such a way that the modern reader would be endowed with divine insight into the souls of those who had gone before. Instead, Thierry proposed the direct recapitulation of locality and nationality, in a chorus of voices from the past, in dialect and in bardic poetry: a literature that would "protest for us, lament with us, speak to us of France and its destiny, the destiny of our ancestors and our descendants."[48]

Liberal historians did not believe in a unique "meaning" of the past, nor in its encapsulation away from the present, nor that it should be framed according to a single viewpoint. Instead, Thierry planned to publish a "great chronicle" mosaic of texts with his brother, Amédée Thierry, and François-Augustse Mignet. The prospectus, published in 1824, promised the most complete and satisfying historiographic work in the modern period: one that would reject narrative synthesis for the direct recapitulation of the original chronicles and memoirs. The original witnesses of the past would speak directly to the modern reader who had been created by them:

> This long succession of testimonies, uninterrupted by any modern addition, any philosophical reflection, which will unfold without a break, as if unaware of the reader, will be the immediate representa-

tion of that past which has produced us, we ourselves, our habits, our mores, and our civilization. A work of this sort seems almost obligatory, given the new direction in France, as in neighboring countries, in all forms of literature, and even in the fine arts. On the stage, in novels, in pictorial works, we are seeking, we are demanding subjects taken from our own national history, or that of other nations, because we are assured of finding both a more direct instruction and a more profound impact on our emotions.[49]

Thierry and his coauthors saw that political beliefs, subject matter, and stylistic strategies were intrinsically linked.

Narrative would have to be extraordinarily flexible if it were to satisfy the demands of complete descriptive fidelity and modern insight into causation. Narration would have to be empathic as well as descriptive.[50] If it were, it would not flatten the multiplicitous experience of the past into one viewpoint, looking back. Instead, it would resurrect all the suffering populations of the past. Thierry explained in his introduction to *Histoire de la Conquête*:

if I will more frequently be narrating than analyzing, even in describing actions and their impact, it is so that I can somehow make the larger population appear, as it were, a living individual. By doing this, the political destiny of nations can offer something of that human interest which is aroused, automatically, by the detailed description of one man's achievements and misfortunes.[51]

Multivocal and multifocal, this sort of narrative's temporal sense would be fully three-dimensional, extending the past forward into an eternal present:

These men have been dead for fully seven hundred years, their hearts stopped beating with pride or anguish seven hundred years ago; but what is that to the imagination? For the imagination there is no past, and the future itself is in the present.[52]

Thierry's *Histoire de la Conquête de l'Angleterre par les Normands* (1825) took up where Scott's *Ivanhoe* left off. It depicted the persisting consequences of the Norman Conquest for all of Great Britain, with a chronological span extending from the ninth century (the establishment of the Picts, Scots, and Saxons in Brittany) to the modern period, successively describing England (until 1477), Wales (until 1790), Scotland (until 1688), and Ireland (until 1802). The past permeated the present; the question was whether the narrator ever could, or should, stop. Thierry raised this point as a moral and philosophical one. The purpose of history was not merely to describe what had happened, but to awaken sympathy for entire populations. Once this was accomplished, the modern reader would realize the debt that was owed to those who had taken part in actions whose consequences were still present in our own time. History would not be a peep show of vulnerable monarchs; it would

come alive, an endless chain of eternally living ancestors and humble compatriots, still suffering for the sympathetic modern reader:

> the main aim of this history is to consider the collective destiny of populations, not certain famous or infamous men; to narrate the events of society's life, not one individual life. Human sympathy can extend to entire populations, as if they were living beings, whose lifespans are longer than our own but whose lives are filled with the same joys and sorrows, the same depression and hope. Seen in this way, the history of the past obtains some of the interest that we take in the present. The collective entities it describes never ceased to live and breathe: they are the very same people who now suffer and hope before our eyes.[53]

Liberal historians during the Restoration insisted that history should be truly national, not only in its themes but in its presentation. Rather than tracing the biography of a hero (isolated and temporally closed), they worked to awaken empathy with suffering peoples, whose descendants suffered still. To achieve this empathy, they broke apart narrative's linear clarity into a scintillating, simultaneous address, so that the protagonists expressed themselves directly, in their own voices. One such work, Amans-Alexis Monteil's *Histoire des Français des Divers Etats aux Cinq Derniers Siècles* (1828–44), was reviewed as "a literary 1789."[54]

Monteil's history employed a novel's temporal breadth and narrative fluidity to "avenge the nation," as Monteil said in his prospectus, since the history of France was the history of all the French people, not only those in power.[55] Such a history should be about people of every station, written from their own experience, in their ordinary manner of speaking, from accounts in vernacular documents: fables, police records, sermons. And it should be written so that they would read it for themselves. We cannot claim our identity by accepting its enunciation by another. We must express who we are in our own words.

In Monteil's conclusion ("La Décade des Adieux"), when midnight sounds the end of the eighteenth and the beginning of the nineteenth century, the dying century speaks to its son of the need to write history in a new style that will include the entire nation. The old style wore a crown of lances and bayonets; it sparkled; it resounded with the clash of arms. The new style, generally peaceful, would be unadorned, and the only sound heard would be that of labor. But this new style of historical narration would have the consummate merit of including everyone:

> Do you hear me, my son? Whatever is done, whatever is said, in whatever government you choose, men are always placed in a pyramid, one over another. The old form of history never showed that and doubtless will never describe anything but the summit of the pyramid. But the new history, in contrast, describes both summit and base, and begins with the base.[56]

Monteil adjusted his narrative format throughout his work, faithfully describing the differing "physiognomies" of these periods and cultures, to enable the people of the past to speak directly to his readers.[57] Their phraseology, even their stammering, convey their experience in an unmediated manner. Here is the storming of the Bastille:

> But lo! on July 14 of the year '89 a great voice, the voice of the entire nation, suddenly made itself heard: People – stop everything! everything must disappear! no more taxes, no more lords! It continued: No more privileges, no more hereditary distinctions! Equality before the law! Equality, equality! Liberty, liberty! Liberty to work, liberty to earn, liberty! Liberty of conscience, liberty of opinion, liberty of speech, liberty of the press! Legal liberty, social liberty! Liberty, equality, liberty, liberty![58]

Monteil's work was twice awarded a prize by the Institut de France and was given serious attention even by historians as conservative as Chateaubriand.[59]

The prospectus that Thierry and his coauthors issued in 1824 for a history of France that would "be the immediate representation of that past which has produced us, we ourselves," had insisted that this conception of history was being demanded in painting as in literature. Although the paintings that we shall be examining in this chapter did not depict themes from the texts which we considered, as Delaroche depicted themes from Chateaubriand's *Les Quatre Stuarts*, nevertheless the link between painters and historians was an even closer one: in some cases, political collaboration and blood relationship.

The three Scheffer brothers, who had emigrated from Holland with their widowed mother, consisted of Arnold, a journalist and historian, and Ary and Henry, two painters. Ary Scheffer came to Guérin's studio in 1811, where he soon came into contact with first Géricault, then Delacroix. During these years, the family was frequently in economic difficulties; Saint-Simonian charity saved them from starvation. In 1815, Arnold Scheffer, secretary to the marquis de Lafayette, was editor first of *L'Indépendant,* then later of *Le Constitutionnel.*[60] He introduced his brothers to the Thierry brothers and to Carrel and Thiers. Like Thierry, Arnold Scheffer wrote historical texts that expanded the significance of monarchical actions to consider their impact on the populace, a point of view he expressed in his political journalism as well.[61] Arnold Scheffer was expelled from France in 1818 after publishing a critique of the Bourbon government. In 1821, he became a Carbonarist agent responsible for organizing the Midi; all three Scheffer brothers participated in the Belfort garrison uprising in 1822. That same year, Ary Scheffer became drawing master to the duc d'Orléans' children. The Société Philanthropique en Faveur des Grecs, or Comité Grec, was founded in February 1825; its patron was the duc d'Orléans, its mem-

bers included Ary Scheffer, as well as Claude-Charles Fauriel and Benjamin Constant. During the July days in 1830, Ary Scheffer accompanied Thiers to Neuilly, entrusted with the mission of requesting the duc d'Orléans to support the Parisian uprising.

Géricault's friend and neighbor Horace Vernet was a Carbonarist and a Mason; it is possible that Géricault himself was inducted into the Masonic order in 1815. His friendship with Corréard brought him into abolitionist circles; one of his last projects dealt with the slave trade. Arnold Scheffer mentioned this work, unfortunately left incomplete, when he traced the history of Romanticism in his review of the Salon of 1827.[62] Delacroix, a Bonapartist like Géricault, was in close contact with the Scheffers during the 1820s. During the spring of 1824, when he was at work on the *Massacres at Chios,* he saw Henry and Ary Scheffer almost daily.[63] As we shall see, the paintings that these artists exhibited in the Salons from 1819 to 1827 were immediately recognized by critics (who were sometimes sympathetic historians, like Thiers) as expressing the same view of history as texts by Liberal historians.

Romantic painters who were drawn to the Liberal manner of conceiving history were faced with a profound challenge. Seeing historical meaning in an entire population's ongoing experience rather than an individual hero's unique action, the Liberals learned from Scott to express historical truth as a succession of individual viewpoints that provided an additive description rather than a hierarchically ordered depiction. But Scott's novels and Thierry's or Monteil's historical texts were imaginative rather than transparently lucid: multivocal, multifocal voyages through time and space, and into the psyche.

Nevertheless, Scheffer, Géricault, and Delacroix accepted the challenge of depicting this conception of history. The historical paintings that they exhibited in the Salons of 1819, 1824, and 1827 presented subject matter empathetically rather than descriptively. Their subjects were more easily found in texts that were written in new formats (such as Byron's reading-dramas), or events already in contemporary experience. Romantic aesthetics expressed Liberal politics and historical insights. The visual consequence of Thierry's insight and empathy was the "assemblage" composition, which replaced the hierarchical arrangement predicated on a closed action. Artists could incorporate popular experience into the present place and moment; they could separate a unified figural grouping and individualize the members of a multitude. They could employ luminous scintillation, evident touches of the brush, strident colors, groups that fled the center of the canvas or hid the action in the middle ground. But if they did, they would have to sacrifice a unified meaning and fragment the composition. In these subjects, historical truth could not be contained in dramatic literature. Depicting true history would mean the redefinition of historical painting.

Scheffer's *Patriotic Devotion of Six Burghers of Calais* (Fig. 53), which
he exhibited in the Salon of 1819, was an attempt to visualize corporate
heroism as a compound of individual experience.[64] After his victory at
the battle of Crécy, Edward III of England besieged the city of Calais.
The city surrendered after nearly a year's siege. Edward promised to
spare Calais's inhabitants if six of its most prominent citizens sacrificed
themselves. When these hostages appeared before him, he ordered their
execution, but their lives were saved because of the pleas of his wife,
Queen Philippa. The *livret* description stressed that it had been the suffer-
ing of the entire city (famine, looting, massacres, and executions) that
had induced Eustache de Saint-Pierre and his supporters to sacrifice
themselves. Scheffer's innovative corporate conception of historical ac-
tion becomes clear when we compare it to François-Anne David's illus-
tration of the same event in Caillot's *Histoire de France, représentée par
les figures*, entitled "Devotion of Six Inhabitants of Calais. 1347" (Fig.
54), published in the same year.[65] Despite the plate's title, despite the
textual appellation "martyrs of patriotism," David's illustration focuses
on Queen Philippa's action; her tears and arguments succeed in soften-
ing Edward's heart. The citizens await their fate, which is decided by the
actions of their rulers.

Scheffer's interpretation was very different. Not only did he depict
popular heroes, he depicted them taking heroic action as a group,
through their choice of starvation and death. As Thierry would write the
next year, in the first of his letters on French history, Scheffer was at-
tempting to fasten the soul of the spectator to the destiny of the group of
people who had lived and suffered as we do in our own time. Thus,
instead of the tearful pleading of a lovely queen, viewers saw the death
march of the citizens of Calais. There is no physically impressive action.
Weakened by famine, the group steps mildly out into the darkness.[66]
Rather than making the climax of the composition the decisive move-
ment of the group toward the left, Scheffer tore apart the center to
render the grief of leavetaking: arms are restrained and extended in a
wave of emotion through the group of wives and children who have
come to the gates. The stalwart band gazes in three directions: toward
the destination pointed out by the soldier on the left; outward toward
us; and back at the soldiers on the right. Visual unity was sacrificed to
the truth of this patriotic self-sacrifice: a multilayered, emotionally com-
plex truth that could not be summed up in one action.

The critics were torn between admiration of the subject of a work that
"breathed love of country" and concern that its dark patriotism would
alienate more viewers than it would inspire. The Liberal Jouy mentioned

FIGURE 53

Ary Scheffer,
*Patriotic Devotion
of Six Burghers of
Calais* (1819).
Calais, Musée des
Beaux-Arts. Oil, 347
× 456 cm. (Photo
courtesy Musées
Nationaux, Paris.)

Arnold's expulsion from France for sedition in his review of Ary's Salon painting about bourgeois self-sacrifice and praised the conception, expression, and execution.[67] The classicist Landon and pro-Romantic Jal agreed on more than the relatively minor flaw of an overly dark visual tone. They were perplexed, even repulsed, by the realistic figures and fragmented composition. Landon approved of the moral message of the subject but disliked the crude figural types; he thought that the work was one of the Salon's best, but that Eustache de Saint-Pierre looked more like a criminal than a hero.[68] Jal, more perceptively, worried that it was only too successful in arousing an empathetic response: how were patriotic emotions to be inspired by the sight of despairing victims?[69]

Emeric-David saw many similarities between Ary Scheffer's *Calais* and Géricault's *Raft of the Medusa* (Fig. 55, Pl. 6).[70] Not only were the themes and dark tonality comparable, as were the compositional choices: both of these scenes presented collective agony in multiple pathetic "episodes."[71] Both Scheffer and Géricault had chosen to depict an extended emotional experience without a physical conclusion, instead of a visual instant of decisive physical action. Paradoxically, their compositional innovation should be seen as mandated by the traditional exhortation to history painters to depict truth rather than fact. Géricault believed that truth resided in suffering.[72] His *Raft of the Medusa*, titled for this Salon *Scene of Shipwreck*, released an event from a particular moment and from the closure of comprehension of a "message," a "meaning," a "moral." Instead, Géricault presented agonized existence: endless suffering, without localization, explanation, or consolation.

Instead of centrally framing an action, Géricault's composition pre-

FIGURE 54

François-Anne
David, *Devotion of
Six Inhabitants of
Calais. 1347*. In
Caillot, *Histoire de
France représentée
par les figures*
(Paris: Fr.-A. David,
1817–19), plate 42,
in vol. 2, p. 115.
(Photo courtesy Bib-
liothèque Nationale
de France, Paris.)

sented a visual dynamic, straining outward in two opposing directions. One of the raft's sufferers, cropped by the frame, dangles into the viewer's space, as Delacroix noted.[73] Others ignore the *Argus* on the horizon or strain with impotent energy toward it. In earlier studies, the *Argus* had been a clear salvation; here it was reduced to a faint possibility of rescue or even a delusion. Spectators were forced to question rather than witness, to identify with the experience of those on the raft. The inner lives of those sufferers are made manifest in their bodies, which do not seem "arranged" or "posed." Limbs in the water give evidence of the surrender to despair and death, clutching arms reached up to support those signaling for recognition and rescue. But winds and storms, visible in the billowing sail and taut ropes, drag the raft toward the left. Surrounding the spectator with the dead and dying, exploding compositional closure to ensure a continual, dynamic tension based on the visual and emotional strain of actors and spectators alike, cropping the foreground, extending a figure past the frame: all these compositional choices drew the viewer directly into empathetic experience, without permitting the intellectual distance of comprehension.[74]

The critical reception, surprisingly, did not entirely follow political lines.[75] Certainly, those who were impressed naturally approved of the theme (transparently an attack on government incompetence, which had already resulted in the removal of the minister of the marine), but even more fundamentally, they approved of a composition that was expressively ordered, one that rendered suffering instead of action. Jouy, who had admired Scheffer's *Calais*, recognized that this particular shipwreck,

a recent and well-known example of unparalleled suffering, justified the artist's composition.[76] Critics in the opposing camp, those who supported the traditional distinction between the roles of history painting and genre painting, thought that a journalistic theme should not have been described in a monumental manner. Landon's extremely hostile and lengthy review detailed the artist's errors in subject, style, scale, solicitation of an audience. In his view, Géricault would have had a greater impact on his audience's emotions if he had opted for naturalistic documentation localized in time and space, expressing his vision in a small-scale, compositionally centered work. Instead, by using the colossal proportions of a history painting to describe such a terrible event, he had made a tactical error, for where could such an enormous painting hang except in a royal and civic venue, and who would wish to acquire this work? He had also made a conceptual error: history painting was designed to perpetuate the memory of elevating events that were of general interest (such as a coronation) or emotions whose description would be of general benefit (patriotism or piety). This subject – starvation and despair – was neither instructive nor elevating and was therefore absolutely unsuitable for history painting.[77]

Géricault's projects after the *Medusa* demonstrate a continued interest in utilizing an empathetic, experiential viewpoint for the presentation of subjects of suffering and social injustice. His chalk drawing *Opening of the Doors of the Inquisition* (Fig. 56), describing the release of republican prisoners during the Spanish uprising in January 1820 against the Bourbon King Ferdinand VII, visually breaks apart the prison world, plunging into the background with the *repoussoir* kneeling figure who hails his liberators with joyfully upraised arms.[78] The foreground figures form an arc, which rises from the figure on the left, who kneels and listens with timid hope, passes through the slumping prisoner supported by two figures, who exhibits stolid self-control, and curves downward to the woman on the right, whose depression and disbelief have not yet been surmounted and who barely has the strength to embrace her children. As in the *Medusa*, we see a chain of emotional energy, which reveals the full resonance of the preceding history before this momentary physical conclusion, and which allows the figures to address the audience successively and empathetically.

Géricault died on January 26, 1824. Ary Scheffer painted him on his deathbed. Two leitmotifs appear in Delacroix's journal during the period when he was creating his seminal *Massacres at Chios* (Fig. 57, Pl. 7): grief for the deaths of Géricault and Byron (who died at Missolonghi on April 9, 1824), and his own struggle to realize a form of painting in which visual language would be liberated from objective representation. Delacroix rejected the Aristotelian unities for poetic evocation. He wished to paint the thoughts of the suffering Greeks who had been defeated at Chios. In this new language, soul would speak to soul.[79]

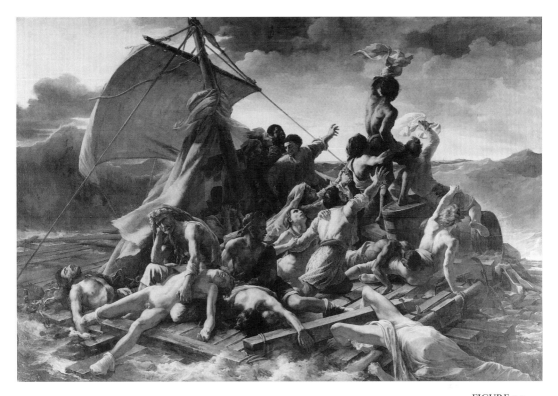

PAINTING THOUGHTS: DELACROIX'S AND SCHEFFER'S SUFFERING GREEKS

FIGURE 55

Théodore Géricault, *The Raft of the Medusa* (1819). Paris, Musée du Louvre. Oil, 4.91 × 7.16 cm. (Photo courtesy Musées Nationaux, Paris.)

In the Salon *livret* for 1824, Delacroix described the subject of his painting as *Scenes from the Massacres at Chios; Greek Families Awaiting Death or Slavery, etc. (See the various reports and newspaper accounts).*[80] This description was a clear signal that this historical painting was the expression of immediate and ongoing experience, that it would be conveyed in the visual equivalent of journalistic prose, and that spectators should read it interactively and individually, compounding their knowledge gained from one account with their tears after reading another.[81] The *Chios* was a monumental work that expressed passionate concern for the suffering of the Greeks by evoking their continuing psychic and emotional experience (terror, despair, resignation) as well as the actions that had affected them (rape and massacre), in a composition that exploded outward from the center, and that masked action in the middle ground. Delacroix was fully aware that he was putting compositional clarity at risk by adopting this manner of painting historical experience so that he could address the imagination of the viewer and achieve direct empathy. He wrote on May 7, 1824:

> My picture is beginning to develop a rhythm, a powerful spiral momentum. I must make the most of it . . . If only it hangs together! O! the smile of the dying man! The look in the mother's eyes! Embraces of despair! Precious realm of painting! That silent power that speaks at

FIGURE 56

Théodore Géricault,
*The Opening of the
Doors of the
Inquisition* (1823).
Paris, Musée du
Louvre. Drawing in
black and red chalk,
419 × 581 cm.
(Photo courtesy
Musées Nationaux,
Paris.)

first only to the eyes and then seizes and captivates every faculty of the soul![82]

Many of the criticisms that had greeted Scheffer's *Calais* and Géricault's *Medusa* were reiterated for Delacroix's *Chios*. Its composition was confused, and its subject was visually unsuitable, since it centered on horrifying and disgusting sights: naked or rag-covered, wounded, bloody victims with coarse, ugly features.[83] Landon saw the work as a flagrant destruction of every pictorial rule. The drawing was incorrect and trivial, and the coloring lacking in liaison and harmony, so that even passages in the nude that were well painted were lost in a chaos of raw and discordant tones. The arrangement was a confused collage of figures, and the space was obstructed so that the middle ground was blocked from view. Yet even Landon admitted that his heart had been touched: "Strange composition, which seems to have been produced expressly in order to afflict the sight, rend the heart, and outrage decorum."[84]

The author of "L'amateur sans prétention," during the course of three visits to the Salon, was able to overcome his initial horror at seeing rawly painted, plague-stricken cadavers and to recognize the expressive sublimity of certain figures: the father, in a stupor caused by despair, or the woman whose harsh, unblended colors and sharp relief made her appear to break through the canvas. But he did complain, as did several other critics, that the work was a variety of scenes rather than one thought. Since we can only feel deeply about one thing at a time, he continued, this undercut the expressive force of the work:

> M. Delacroix . . . has neglected to create a central scene of interest, or
> at least a few major scenes, if it seemed to him that it was impossible to
> establish unity in his composition. Here he has ignored one of the
> essential principles of art, a law of reason deriving from the weakness
> of our senses, of our spirit, of our heart, which are unable to embrace,
> comprehend, and deeply feel several things at the same time.[85]

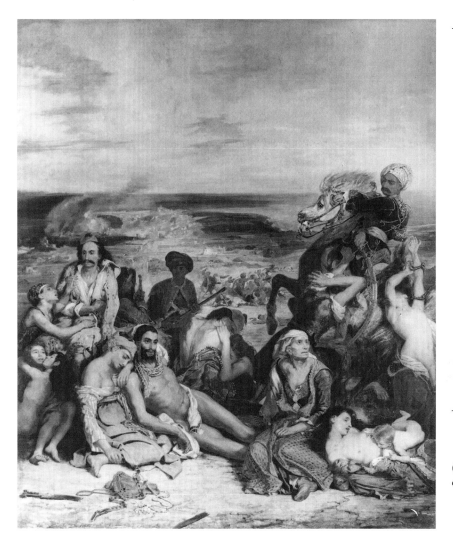

FIGURE 57

Eugène Delacroix,
*Scenes from the
Massacres at Chios*
(1824). Paris, Musée
du Louvre. Oil, 4.17
× 3.54 m. (Photo
courtesy Musées
Nationaux, Paris.)

The Royalist *Oriflamme*'s critic was shocked by the artist's dry and strident painting and the compositional solutions necessary to render extended emotional experience. Using unmixed colors at the highest intensity under the strongest light made flesh appear to be in an early stage of putrefaction. Scattering a few feeble sufferers across the canvas ruined a work intended to raise sympathetic interest in the cause of Greek independence. Instead of suffering after the Chios massacres, the critic helpfully proposed a dramatic action, more suitable for historical painting: the heroic vengeance of a group of Greek survivors.[86] Throughout his review, he insisted on dramatic unity, on poetry's dramatic scenes, on the lack of drama in the artist's conception and composition. Clearly, the choice of a subject from the chaotic events in the real world, a subject that had been described by journalists, was completely unsuited to the fine arts, both drama and painting.

But the Liberal and Romantic faction eagerly welcomed the expres-

sive force of such a subject and were willing to accept compositional collage as appropriate historical interpretation. Even they, however, could not accept art that broke apart the visual instant. An anonymous critic in *Le Globe* (probably the historian Thiers) wrote the most interesting assessment, because it linked temporal extension, subjective persuasion, and compositional fragmentation. The critic praised the artist's choice of subject precisely because it was *not* an action but the extended experience of horror, fear, and uncertainty. The work's composition, its "systematic disorder," was necessitated by the subject:

> M. Delacroix has not chosen the moment of the massacre, he has set himself a greater challenge. He has chosen to describe their exhaustion after they have been wandering for several days, when they are still uncertain of their fate, not knowing whether they will be massacred or sold into slavery. In his view, this subject was much more piteous, and he thought he would be able to render it more forcefully and more heartrendingly. He has not wished to compose a scene, not at all, because he despises all arrangement, and so he has scattered the figures of his painting here and there, in a sort of systematic disorder . . . Here is the result of all his planning: everyone without exception has confused the massacre for a scene of the plague. M. Delacroix has repelled, he has horrified, and yet, for all those people who judge painting according to linear schema, he has only succeeded in distracting the spectator's eye, without even escaping the reproach of being too symmetrical, for there is no lack of order in his painting, there is a systematic disorder.[87]

But such a subject could not succeed in painting; although the dramatic unities of place and time were "paltry conventions," unity of action was obligatory in the visual arts, because "one cannot be present at twenty tragedies simultaneously nor interest oneself in the fate of twenty heroes and heroines." And yet the work showed genius in its characterization of a variety of emotional states and the drawing of certain figures (he noted, as did many other critics, the woman tied to the horse); the color and the execution were impressive. In conclusion, Delacroix's talent, although not yet fully mature, was undeniably great. Although Delacroix's sacrifice of visual unity was a flaw, it had been made in the service of truth, and his imagination was full of beauties that he would be able to describe in a purer and more complete manner in the future. Delacroix was awarded a second-class medal, and his painting was acquired by the government, for display in the Musée du Luxembourg.

Flocon and Aycard showered Delacroix with praise, precisely because he had dared to break aesthetic rules in rendering this terrible subject without deforming it by constricting its focus to one moment or making its physical and emotional torments bearable. They began their eight-page review of the work with a direct link between aesthetics and politics: those who found the subject repugnant and the treatment horrifying were literally closing their eyes to the truth. Suppose a painter were told

of a peaceful populace that had been invaded by barbarians who burned
villages, murdered unarmed citizens, and enslaved women and children.
Would he still employ harmonious colors, careful studies, and all those
technical tricks? Well, yes he would – if he were an ordinary painter:

> But if his soul is ardent and sensitive; if, forgetting the pedantic, hol-
> low precepts of his teachers, he only heeds his own heart and his
> imagination, he will find himself transported in his thoughts into the
> middle of this place of horrors; he will see every agony: bloodstained
> corpses, the murderer's crude and insolent figure, slavery, death, and
> abandonment to despair; he will see these things, and his brush will
> faithfully render them so that the spectator can see them as well.[88]

They admitted that such truth was not attractive, but what was elegant
style when compared to national honor? Once you looked at the paint-
ing, you could not tear your eyes away, the harsh colors were no longer
distracting, and the subject absorbed you completely:

> It is impossible to remain impassive in the middle of the host of emo-
> tions aroused by this painting. Everything here is so natural, the disor-
> dered clothing, the facial expressions, the dark despondency of the
> people, that you forget art and the artist and feel as though you are
> really there at the site of this terrible event. Then you find yourself
> tormented by your thoughts. A barbarous war, dishonoring all human-
> ity, . . . is taking place in the heart of Europe, near civilized nations,
> and they remain neutral. What sort of neutrality is this, which allows
> thousands to be massacred, annihilating entire populations? His paint-
> ing is both a beautiful art work and a beautiful polemic.[89]

The audience could not distance itself from this terrible sight, which was
history itself, but a history in which time past and time present were
fused. There on the plains with the suffering Greeks, the French specta-
tors were beset by reflections of their own culpability, their dishonorable
neutrality. This historical painting was no longer a static object.

In the last Salon of the Restoration, that of 1827, Ary Scheffer's *The
Souliot Women* (Fig. 58) consolidated the advances made by Romantic
liberals. It was acquired by the state, and he was made a knight of the
Legion of Honor.[90] Scheffer's women of Souli, like his citizens of Ca-
lais, were martyr-patriots. He took his subject from Fauriel's *Chants
populaires de la Grèce moderne* (1824–5), which described how sixty
women, seeing the Turks' victory imminent, decided to commit mass
suicide by throwing first their children and then themselves over a cliff,
one by one.[91] Scheffer rejected the text's two possible poignant and
horrifying physical actions and dismissed its description of these brave
women's brief deliberation and unanimous decision. Instead of conclu-
sive action, he depicted emotional agony.[92]

However, instead of deliberately overturning compositional rules, as in
Delacroix's *Chios*, Scheffer forced his composition to express emotional
flux and physical precariousness in a coherent manner. He arranged his

figures into a mass that builds diagonally to the right, the ominous precipice. This thrust is repeatedly countered by gestures toward the upper left, whose diagonals are reinforced by the backs of the woman in the left foreground and the girl crouching in her mother's lap. In the very center of the group, one woman's arms are raised in hopeful solicitation of the heavens; other moods are evoked: confusion, horror, and blank despair. Scheffer suddenly juxtaposes foreground and deep space, on the left, with a view of the ongoing battles and daringly allows the cliff to break off in our own space at the picture plane on the right. Although Scheffer's *Souliot Women* is comparable to Delacroix's *Chios* in its expressive variety and its denial of release in a physical act, its visual arrangement is conservative. Scheffer contained the debris and disorder of raw emotion, whereas Delacroix opened a central void, a wound, in his composition. Conservative critics, though they noted the problems with thematic clarity, the lack of figural idealism, the dark tones veiling the group, nevertheless praised the *Souliot Women*. The classicist Coupin reported that some thought the painting one of the best in that year's Salon, though he himself felt that the subject would have been clearer if one of the women had been shown plunging to her death.[93] The conservative *Journal des Artistes* admitted that it was difficult to understand the subject without reading the *livret* but praised Scheffer's compositional arrangement as touching, clear, and tactful.[94] Jal, supporting the Liberals and the Romantics, gave Scheffer a very favorable review, calling him the most distinguished of the Romantic independents and a "judicious writer," and found his greatest quality to be his sentimental expressiveness, subtly indicated in the oblique composition.[95]

We have seen a campaign waged in the Restoration Salons, by Géricault and Scheffer in 1819, Delacroix in 1824, and Scheffer in 1827. By 1827, even conservative critics had become persuaded of the validity of compositional variants that could convey popular experience as well as heroic action. In making visible extended emotion, continued suffering, these artists had rejected moments of action. They had broken apart dominant groups to scatter their figures in what was recognized, and even accepted, as "systematic disorder." In his *Marino Faliero,* Delacroix attempted to go a step farther. Instead of depicting the actions and reactions of the participants during a dramatic climax, he portrayed the invisible social forces that had motivated them: the interrelationship that Scott and Thierry had described among actions, prejudices, and class politics.

BREAKING DOWN THE PROSCENIUM:
MARINO FALIERO

Marino Faliero (Fig. 59) was one of Delacroix's favorite works throughout his life.[96] He exhibited it to help raise money for the Greek cause in the Galerie Lebrun in 1826, in the Salon of 1827, and at the British

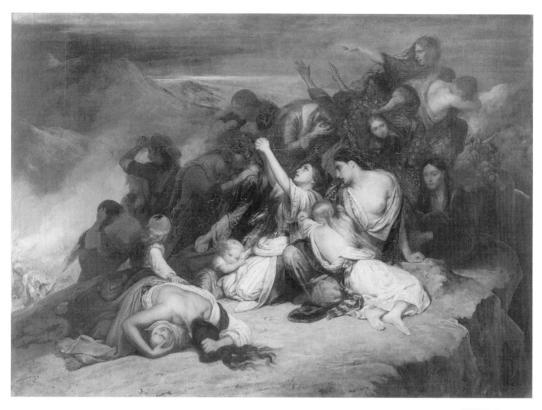

FIGURE 58

Ary Scheffer, *The Souliot Women* (1827). Paris, Musée du Louvre. Oil, 261.5 × 359.5 cm. (Photo courtesy Musées Nationaux, Paris.)

Institution in 1828; each time it was acclaimed for its color and effect.[97] It is also a perplexing work, both visually and expressively. The doge Marino Faliero's decapitated corpse lies in the foreground at the bottom of a staircase to the Doge's Palace. Guards on either side of the corpse look off to the right, where the people are beginning to ascend from a lower staircase. The chief of the Council of Ten, who raises the executioner's sword aloft, stands on a landing in the right middle ground. Since he is forced into depth, dwarfed by his own soldiers, his gesture is denied visual impact.[98] The populace's threatened insurrection is pressed downward and to the right until it is practically pushed off the canvas. The composition is dominated by the staircase, its white tones vibrating without contradiction. There is almost no visible emotion: the patricians are implacable, the guards offensively nonchalant, the grumbling plebeians barely visible. It is difficult to reconcile these impassive figures with the rearing horse and writhing woman that so many critics admired in the *Chios*. Why was the *Marino Faliero* so dear to Delacroix?

Byron's *Marino Faliero, Doge of Venice: An Historical Tragedy in Five Acts* (1820) was a reading-drama based on a real event in 1355.[99] Faliero, a soldier, became the doge of Venice; after a nobleman insulted his wife, he conspired with the plebeians and was executed as a traitor to the state. Byron presented this plot, however, in an emphatically anti-Aristotelian fashion. The decapitation is successively described from dif-

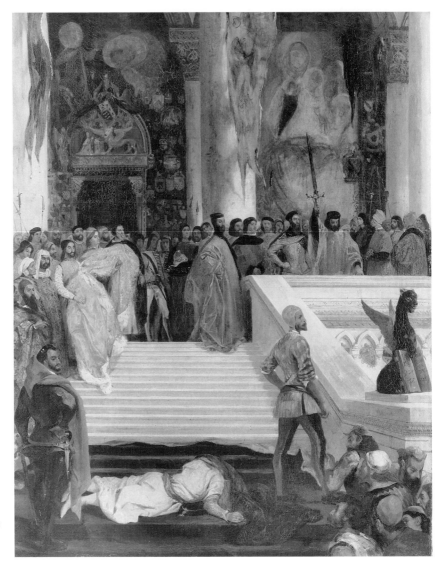

FIGURE 59

Eugène Delacroix,
Marino Faliero
(1826). London,
Wallace Collection.
Oil, 1.464 × 1.143
m. (Photo courtesy
of the Wallace Col-
lection. Reproduced
by permission of the
Trustees of the
Wallace Collection.)

fering points of view. In Act 5, Scene 3, as the hero prepares for his death, the stage directions read:

> The Court of the Ducal Palace: the other gates are shut against the people – The Doge enters in his ducal robes, in procession with the Council of Ten and other Patricians, attended by the Guards, till they arrive at the top of the "Giants' Staircase," (where the doges took the oaths). The Executioner is stationed there with his sword.[100]

Faliero's monologue concludes with his exhortation to the executioner:

> – Slave, do thine office,
> Strike as I struck the foe! Strike as I would
> Have struck those tyrants! Strike deep as my curse!
> Strike – and but once! (The Doge throws himself upon his knees, and
> as the Executioner raises his sword the scene closes.)

But this is not the end of the drama, as it could have been in a French tragedy. The scene immediately shifts outside to the Piazza San Marco, where the same moment is being experienced quite differently by the common people, who are losing their champion. These excluded commoners strain to understand what is happening. One citizen complains bitterly: "Let us hear at least, since sight is thus prohibited unto the people." They are denied the opportunity to hear the doge's three-page monologue: "his lips move . . . 'Twas but a murmur." A companion reports to the populace:

> Now – now – he kneels – and now they form a circle
> Round him and all is hidden – but I see
> The lifted sword in air – Ah! Hark! it falls!

The people grumble that they would have stormed the palace with weapons had they known that this would be the Council of Ten's decision. One, still unwilling to believe the truth, asks plaintively: "Are you sure he's dead?" and is told:

> I saw the sword fall – Lo! what have we here?
> Enter on the Balcony of the Palace which fronts Saint Mark's Place a
> Chief of the Ten, with a bloody sword. He waves it thrice before
> the People, and exclaims "Justice has dealt upon the mighty
> Traitor!"

> The gates are opened; the populace rush in toward the "Giants'
> Staircase," where the execution has taken place. The foremost of
> them exclaims to those behind: "The gory head rolls down the
> Giants' Steps!" The curtain falls.[101]

Delacroix's staircase symbolized the gulf between classes in conflict: the aloof aristocracy, protected by military force, and the populace, threatening to burst into their realm. Between these two worlds lies the corpse of the man who attempted to integrate them, wrapped in a shroud whose color absorbs his blood, as its volumes cover his severed head. Delacroix's painting is antagonistic to Delaroche's dramatic personification of history. Instead of a hero who faces death courageously, it depicts class arrogance, power, resentment. This is the resurrection of opinions that Thierry had praised in Scott and that he wished to see in modern French historiography.

When Delacroix's *Marino Faliero* was first exhibited in 1826, Hugo praised it as both history and drama.[102] In his preface to *Cromwell* the next year, Hugo insisted that the site was not only a background to history, it was a witness, an actor:

> It is only now that we are beginning to understand that one of the
> primary components of reality is the locale. Speaking or active figures
> are not the only ones who impress the spectator with the truth of events.
> The place where a certain catastrophe occurred becomes a terrible,

inseparable witness, and the omission of this sort of mute actor from the great scenes of history will result in their being incomplete.[103]

Thus, he would have supported Delacroix's daring choice to make the staircase, a white retreat into space, play a major compositional role. Delécluze thought that this factor destroyed compositional coherence, proof of either the artist's incompetence or his error; he complained that the composition was not properly historical, or rather, he corrected himself, not poetic.[104] By 1827, it was clear even to classicists that Romantic historical painting, unlike traditional history painting, was related to historiographic, not poetic, literature.

Romantically oriented critics, however, praised Delacroix's compositional innovations as historical insights. *Le Figaro* remarked that the current joke was that "the staircase plays the principal part," but the newspaper defended its prominence as expressively and visually potent, as well as historically accurate.[105] The *Visite au Musée du Louvre* placidly noted the void at the heart of the composition and praised its effect on the senses and spirit of the spectator, who would easily return to the original event, and the artist's successful resurrection of Venetian history.[106]

But Romantic and Liberal critics also worried about the compatibility of historical insight and visual coherence. Jal began his discussion of Delacroix and his "Anglo-Venetian" school of Romanticism ("The Gospel according to Saint Effect") with a general summary of the need for truth in modern tragedy and historical painting, describing themes from modern European history in a style adopted from the "positivism" of chronicles.[107] However, he continued, though the desire for truth in modern historical description affected all the arts, the Romantic revolution in painting could not go as far as it had in literature. Painting was a language of the visible world: the positivism of history would have to be expressed in concrete palpability.[108] All the poses, all the figural placement, had been mandated by the historical event, from the corpse at the bottom of the staircase to the member of the Council of Ten displaying the sword to the executioner studying the impact of his action on the crowd of plebeians. In sum, both the painting's virtues and its flaws resulted from its historical fidelity. This was historical painting as eyewitness report:

> The composition of the *Marino Faliero* has been strongly criticized, but I cannot concur with that opinion. M. Delacroix has not wished to represent in visual terms a historian's narrative, he has made a pictorial chronicle. This painting simply is an eyewitness report in oils . . . The entire arrangement of his work is good, because it is true, and if it does not obey the rules of pictorial composition, M. Delacroix is not to blame for that.[109]

Vitet came to the same conclusion. Delacroix, heroically, had set out as a historian, intending to depict this fascinating subject in a way that

would make its social conflicts visually explicit. Unfortunately, accomplishing this meant that he had to violate the rules governing pictorial comprehensibility, decorum, and variety. The prominent staircase, a visual lacuna, was absolutely necessary for this historical moment, for the painter had to show us two classes: aristocrats above, executioner and people below. Academic compositional rules counseled the painter to include "episodes" of complementary reactions, wives and mothers grieving or fathers showing the dead body to their sons. But history insisted on repetitive physiognomy and a uniform lack of pity, so that the patricians became mannequins. Instead of retreating, the setting solicited the eye, with a colossal madonna and bewildering patterns of shields, livery, banners. Thus historical fidelity denied this historical painting its emotional interest, its unity, its figural climax. The work was a brilliant historical interpretation, but as a painting it could not succeed:

> Who would dare to paint such a work? M. Delacroix. He accepts all these difficulties, he is faithful to every historical detail. If he thought he was going to be able to produce an attractive painting, he has been strangely mistaken, but I am convinced that he only sought to write a page of history with his brush. And there, I must say, he has succeeded wonderfully well. If he wishes praise, then he must admit that his intention had been to put his art at the service of history, that he forgot that he was a painter . . . For some works, we say that the design is beautiful, the composition admirable, and yet make our qualified praise evident in the additional comment: but it's not a painting. Follow M. Delacroix onto the terrain he has chosen and judge him as a historian. Well, I repeat, as a portrait of history, his painting has impressed me tremendously. He evokes, he resurrects the past, he demonstrates great insight, great imagination, a profound understanding of what we call historical art; and according to this viewpoint, despite all its faults and all the criticisms that have greeted it, this painting must be regarded as one of the most remarkable of this exhibition.[110]

The success of the work lay in its fidelity to historical experience, but that very success had destroyed its pictorial cohesiveness. It had resurrected the past itself: class hatreds, cool brutality, Venetian glamour. Delacroix had taken dictation, he had written with his brush, but he had not produced a painting. As Vitet said of his own dramatic trilogy on the League, historical truth broke apart aesthetic coherence.[111]

Jal and Vitet recognized that Delacroix was not simply taking a different approach to historical representation. They saw that Delacroix's historical viewpoint was antagonistic to cogent but static representation. Their praise stressed the lack of distance between the event, as it continued to take place, and the modern spectator. Whereas ordinary historical paintings were analyses and assessments of a closed event, Delacroix was transporting the viewer directly into the heart of the ongoing experience. He was "taking dictation," he was "an eyewitness," he was writing a "chronicle." This is the same view of history that Thierry had been

urging throughout the Restoration, a view that could be conveyed only in narratives that quoted past voices directly and invented new, flexible forms: a "succession of testimonies, uninterrupted by . . . philosophical reflection . . . the immediate representation of that past which has produced us, we ourselves." In this view of history, insight establishes an empathetic link between the suffering populations of the past and the modern reader-viewer, and so transcends time.

THE CRISIS IN HISTORICAL REPRESENTATION

In the preceding chapters, we have seen how the lost and lamented past, recaptured and mourned in the guise of precious relics, rendered history as object rather than action. Delaroche's dramatic restaging of catastrophe attempted to distill a moral message out of an emotional crisis by concentrating on physical vulnerability, physical act. But dramatic personification followed the actions of one leader, ignoring cultural identity as a historical force. Rejecting Chateaubriand's moral narratives of action, Thierry urged the resurrection of the past instead of its dramatization. This meant evoking a people's thoughts, its soul, from which both objects and actions arose.

Liberal Romanticism during the Restoration attempted to make this new view of history accessible in every discipline, an ambitious attempt that was fraught with both aesthetic and political difficulties. Politically, a view of history as the creation of the masses, a view in which revolution was the inevitable response to despotic government, was a frightening prospect to those in power. Aesthetically, the recognition of a temporally fluid and culturally experiential sense of history meant that historians had to renounce the coherent but solitary viewpoint of modern objectivity. Instead of Chateaubriand retelling "God's lessons of revolution," Thierry listened to the voices of cities and races, and Monteil made the centuries speak out. Heine had spoken sarcastically of the comfortable reassurance of knowing that a catastrophe was being staged for one's benefit. In Byron's drama, there was no such comfortable distance. Instead, the modern audience was thrust directly into what appeared to be the ongoing, original experience.

During the Restoration, Romantic historical painters attempted to equal this historical conception in canvases that functioned neither as object nor anecdote but as insight: insight not only into the emotional experience of the protagonists, but into the political decisions and class conflicts that had made their experience inevitable. Such compositions were complex eccentric or spiral organizations of forms and focal points, fragmented, scintillating, which encouraged an incremental and resonating response instead of immediate recognition. Delacroix's subtle and complex comprehension of culture was ahead of his time and could not be accepted by his contemporaries. Historical depiction was being torn

apart by the contradictory imperatives of insight, communication, and visual coherence. But Delacroix's *Liberty* demonstrated that a supremely gifted artist could create a true historical painting that was not a closed representation, one that was both historically valid and pictorially sublime, as we shall see when we consider the legacy of the Restoration's historiographic revolution for the visual arts.

RESTORATION
HISTORIOGRAPHY'S LEGACY
IN THE VISUAL ARTS

CHARLES X'S REIGN was doomed on July 25, 1830, when he
signed the four decrees that broke with the constitutional Charter
of 1814. They suppressed freedom of the press, dissolved the newly
elected Assembly, scheduled new elections, and reorganized the electoral
system to favor those with landed estates over urban voters. The decrees
were published in the *Moniteur universel* on July 26. Fighting broke out
on July 27 and reached its height on July 28; by the next day royalist
troops were forced to leave Paris. On July 31, the king's cousin, Louis-
Philippe, duc d'Orléans, was acclaimed by the people of Paris when he
appeared on the balcony of the Hôtel-de-Ville side by side with the hero
of earlier Revolutions, Lafayette. Two days later Charles X abdicated.
On August 7 Louis-Philippe was formally invited by the Chambers of
Peers and Deputies to accept the crown as king, not of France, but of the
French. Now the time was ripe for the sense of history that had been
sought in 1824 by the Thierry brothers and Mignet, both in historical
literature and historical art: "the immediate representation of the past
that has produced us, we ourselves." The time was ripe for historical
resurrection, for psychic fusion of the past with present-day experience.

Delacroix's *The Twenty-eighth of July; Liberty Leading the People*
(Fig. 60) was the visual corollary of Thierry's sense of history, a resurrec-
tion liberated from the direct reproduction of one site and moment.[1]
Thierry had insisted that collectivities should be endowed with a force
and a soul, so that every citizen would realize that the political evolution
of their nation had the same urgency and fascination as their own life.
Once they recognized this, the imagination of present-day citizens would
revivify those of the past and transcend the barriers of time.

In his *Liberty*, Delacroix combined, without coalescing, allegorical
ideality and genre mimesis, in a composition that was both monumen-
tally ordered as a pyramid and episodically diversified. We see the tri-

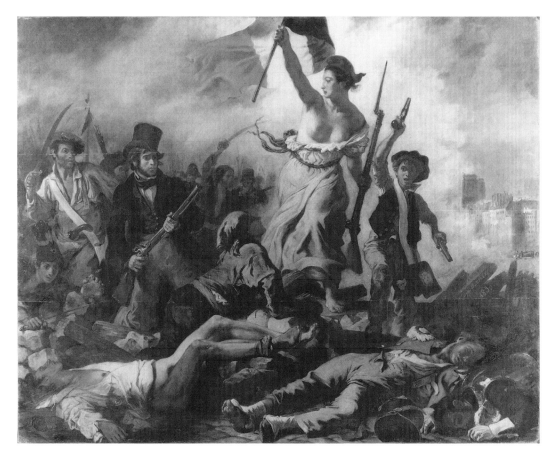

FIGURE 60

Eugène Delacroix,
*The Twenty-eighth
of July. Liberty
Leading the People*
(1831). Paris, Musée
du Louvre. Oil, 2.60
× 3.50 m. (Photo
courtesy Musées
Nationaux, Paris.)

color float from the towers of Notre-Dame in the background, the dead bodies of a worker and a soldier of the royal guard lying in the foreground, but these indications of time and place are overwhelmed by the beautiful personification of Liberty. She is both rooted in the people and their inspiring genius, and she visually lifts those contemporaries who fight by her side from their ordinarily subordinate position in the middle ground, making them larger than life.[2] Delacroix's intention was not to represent a heroic action from the July days, but to imply both its motivation and its enduring importance. He based his figure of Liberty on the Nike of Samothrace and described the suffering, coarsened, alienated human beings who had been excluded from participation in their nation, and so conveyed the full historical meaning of the July Revolution.[3]

Although his rationale was understood, Delacroix's decision to retain the truth of popular insurrection was perceived as both pictorially misguided and politically dangerous, even at this moment of Liberal triumph. Ambroise Tardieu, completely sympathetic to the "patriotic" conception of the work, which he described as "liberty helping the nation to win its rights, after that nation had been humiliated for sixteen years by being crushed by stupidity, bigotry, and fanatical hypocrisy," still thought that it had been a mistake to depict brutes in rags, "the populace and not the

people."[4] This criticism was made several times by others, in even more vehement terms.

But Delacroix's historical conception mandated this aesthetic amalgam of truth and poetry. It was necessary to root allegorical ideality in genre specificity, just as it was necessary to balance Liberty's appearance between a recognizable classical Victory and an agonized, contemporary woman, so that both immediate events and their eternal significance would be revealed. By acknowledging the harsh experiences that had led to insurrection, that insurrection would become comprehensible, even justifiable. Similarly, it was necessary to break apart a unified figure canon, to refuse to give a coherent retreat into space, in order for the viewer to see shards of reality, each true, instead of an enactment of reality, which would have to be false. This was the "désordre intelligent" that Casimir Delavigne lauded in his poetic celebration of the July Revolution, which voiced popular resentment, determination, and triumph in irregular, colloquial stanzas.[5] Poem and painting held up a lens to reality, so that the concentrated rays of the July sun would set it aflame.

Many critics realized that Delacroix had taken this approach to achieve historical resurrection, and praised him for doing so. Victor Schoelcher, a republican and Delacroix's friend, thought that the painting was the most remarkable of all the works that commemorated the July Revolution, precisely because it was not a mere representation of an actual event. The personification of Liberty herself would inspire the people and their descendants.[6] Lenormant affirmed the artist's evocation of site and people without tying them to "topographical exactitude" and was thrilled by the vitality, the reality, of this allegory of "Liberty of the people," which was so true to its subject and summarized it so poetically.[7] Yet critics admitted that they were disconcerted by Delacroix's compositional strategies. Planche, for example, was disturbed by the indecisive spatial location, finding that the background "danced" forward and backward. And the moment was not precisely indicated: Was the battle over, beginning, or still being fought? But Planche admitted, despite these concerns and despite his rejection in principle of the mixing of allegory and reality, that once he had seen Delacroix's work all his preconceived ideas faded away, and that allegorical personification added history's majesty to yesterday's memories.

Planche also believed, however, that the full significance of Delacroix's work was not being recognized. In his conclusion to his review of the Salon as a whole, he warned that as long as the general public sought "first-class mediocrity" in Delaroche's Cromwell, Delacroix's Liberty, the Salon's most beautiful work and one that would endure, would not have the success it deserved.[8] In 1831, two schools of historical painting faced each other: one that sought historical resurrection, and another that succeeded in historical representation.

Heine, a Romantic and a liberal who considered Delaroche the "ring-

leader" of the school of artists who preferred representation to "the past itself," wrote the most insightful of all the reviews of Delacroix's *Liberty*.[9] He couched his praise of Delacroix in a commentary that in itself was a homage to the work: it exploded linear time, making the work come alive in an interactive review of the art work's impact on his soul. His language, like Delacroix's figural vocabulary, was compiled of metaphor, prose, and slang. He described Delacroix's color as muted, lacking varnish and brilliance, dusty, sun-dried, qualities that gave his picture the real physiognomy of the July days. Delacroix's Liberty, her features expressing "insolent pain," was "Phryne, fishwife, and goddess." And if she appeared to be a common prostitute, if the urchin at her side was filthy, if the hero charging forward holding a gun looked like a criminal: "that is just the point, a great idea has ennobled these common people, these blackguards, sanctified them and awakened the slumbering dignity within their souls." Heine realized, however, that Delacroix's resurrection of popular power would be welcomed only briefly:

> Sacred July days of Paris! ... Whoever experienced you no longer whines at the old graves but believes instead, joyfully, in the resurrection of the peoples. Sacred July days! how beautiful was the sun and how great were the people of Paris. The gods in heaven who watched the great struggle ... gladly would they have come down to earth to become citizens of Paris! But envious, anxious as they are, they feared that in the end people might blossom up too high and too splendidly, and through their priests they sought to "blacken what shone and drag what was lofty through the dust," and they started the Belgian rebellion, de Potter's beastly oeuvre. Precautions have been taken that the tree of liberty not grow up into the sky.[10]

Heine and Planche were prescient. Such a passionate resurrection of struggle would not be welcome, once the government that had come to power because of that struggle was firmly in place. Then historical representation would be required: a clear description of the meaning of the recent events, a representation of their actions. Delacroix's *Liberty*, which the government acquired from the Salon and exhibited in the Musée de Luxembourg in 1832, was soon put into storage, and his competition entries for the Salle des Séances in the Chamber of Deputies at the Palais-Bourbon were not selected.

There were conceptual as well as aesthetic reasons for their rejection. Guizot had announced the subjects for these paintings to be Mirabeau's refusal to dismiss the Constitutional Assembly and Boissy d'Anglas's calm salute to Féraud's head on a pike, thrust towards him by rioters who had burst into the chamber. These events symbolized the legislature's resistance to both despotism and sedition during the French Revolution. The third subject, Louis-Philippe's oath to the legislature on August 9, "closed in a fitting fashion the series of events to which we owe our political security."[11] The Revolution had reached its culmination; its

depiction of revolutionary resistance would have to convey closed meaning, not ongoing experience. The July Monarchy's support of historical painting was guided toward clarified representations, not visual recreations of the inner life of the past.

We have now reached a point at which it is possible not to conclude, but to take stock: to consider the issues that have become evident and their implications for art during the July Monarchy and thereafter. In writing this study of art and historiography during the Restoration, I wished to make it clear that there was a direct relationship between these disciplines, not simply as a matter of textual inspiration for art works, or in the more general form of intellectual influence, but on a basic level of artistic reevaluation. Given the redefinition of historical meaning, and the consequent development of various literary forms of conveying that meaning (historiographic narrative, reading-drama, and historical fiction) it was inevitable that visual forms of conveying historical meaning would have to redefine themselves as well.

In this study, I isolated three historians, representing three political views of history that were expressed through three different narrative strategies, so that three different visual interpretations of history could be examined: history perceived through object and site, through physical action, and through the voicing of psychic states that were not only individual, but national and racial. Marchangy's passages were studded with anachronistic locutions, hallucinations of past existence. Chateaubriand provided lessons by making material situations take on moral meaning. Thierry prepared textual mosaics or modern constructions that resurrected past experience and fused it to that of the modern reader. Artists became aware of the daunting complexity of historical truth, and at the same time of the urgent need to convey its protean meaning to the entire nation. Historical paintings were subjected to dual, and potentially divergent, criteria: those of pictorial aesthetics and those of modern historiography. Aesthetic debates regarding the role of local color, the inclusion of theatrical or prosaic gesture, and the stress on the canvas's actual optical field in contrast to its supposed stage space behind the picture plane were debates on the possibility of expressing historical meaning in painting, not simply acknowledgments of its impact on the pictorial object.

Paradoxically, as historical narrative became more descriptively vivid, historical representations became more problematic, particularly for Romantics and Liberals. Artists and critics soon recognized that the emotive possibilities of historically significant monuments and objects depended on an erudite audience primed with personal memories. They learned that coherent visual representations in figural anecdotes could be accused, on both political and pictorial grounds, of ignoring the motivations for popular uprisings to concentrate on the dramatic gesticulation of monarchs. They realized that canvases that evoked social forces and

functioned empathetically, instead of mimetically, could mystify an audience that wished to receive a message from the work instead of entering into its experience, and could undermine the stability of the government's presentation of historical meaning. Naturally, the contemporary political implications of medieval communal revolts were not lost on Salon juries, as Barbier noted after the rejection of Clément Boulanger's *Episode of the Enfranchisement of the Communes* (1835, Bourges), inspired by Thierry's *Lettres sur l'histoire de France*.[12] Thus, although we may not find exhibitions or museums crowded with paintings directly inspired by texts written by Thierry, Monteil, Michelet, or Carlyle, both because of their style, which resisted visual representation, and their view of history as communal and experiential, nevertheless we should recognize that these historians had a profound influence on the visual arts, not only through their conceptual viewpoint and their themes, but also through art reviews written by their disciples.

The creation of modern historiographic texts, whose readers would proceed actively, even interactively, and so constitute themselves truly informed members of the nation, aroused increasingly onerous expectations for historical paintings. As we have seen, Delaroche's dramatic paintings of events were frequently condemned by Salon critics (particularly by Saint-Simonians, such as Louis Piel) as both pictorially flawed and historically naïve. How were artists to communicate the new definition of historical meaning as "the spirit of an age" to all of the nation's citizens without merely representing appearances and events?[13] Did this mean the end of historical art? In 1835, in his dissertation on contemporary French historiographic studies, Sarrazin (who frequently cited Thierry), insisted both on the invisible aspects of history and on the necessity of visualizing history. History was a series of distinctly different, complex, and interactive social ecologies; they would be deformed and falsified if they were examined by a unique and rigid analytical methodology. This swiftly changing, dynamic existence demanded a picturesque and animated narrative, and it needed to be conveyed in paintings and images, which Sarrazin thought were the best means of making history come alive for ordinary people: "Give people history in visual forms, for this is the only place where history comes alive for them, where it impresses and moves them."[14]

This sense of history as the "spirit of an age," which created a crisis in representational canvases, was ideally suited to textual vignettes. To understand the development of historical painting during the Restoration and thereafter, we must take into account the complementary and competitive role of illustration in histories. As early as 1826, Michelet noted that illustrations could contribute to the intellectual value of a history of sixteenth-century France's political and literary events by providing insight into the age's way of life and aesthetic preferences as well as the appearance of its major figures or monuments.[15]

Illustrated histories were published constantly during the July Monarchy, and their popularity had a powerful impact on Salon viewers' expectations for unique and monumental historical paintings.[16] Like historical paintings, these illustrated histories were visually informative and expressively effective, documenting site and costume and presenting dramatic anecdotes. Furthermore, illustrators could avoid the pitfalls that awaited painters: they could break apart the visual instant into multiple images, and they had the support of textual commentary, which could explain action. The painter's rupture of a unified pictorial field had been criticized, but this rupture was acceptable, even praiseworthy, in sumptuously illustrated texts, where an encyclopedic visual range of typographic and graphic approaches was considered both intellectually appropriate and visually attractive.

In 1833, in his prospectus to his *Histoire Pittoresque de la Révolution Française*, Béraud supported Sarrazin's views when he argued that illustrative documentation was a primary instructive method for conveying the modern sense of history. No longer was it a question of teaching princes or ministers what had happened in the past, while excluding the rest of the nation from such an education. Now all of the citizens of the nation would be able to learn for themselves from his animated and vivid narrative, in which illustrations would not simply accompany the text but supplement its didactic ability. The prospectus for this *Histoire Pittoresque* (several *livraisons* were published) promised images of battles, festivals, parliamentary sessions, caricatures, and fashions. Béraud wrote that he wished to see the Federalist's green jacket with steel buttons, the Montagnard's unpowdered hair, the Jacobin's red bonnet, for "in times of popular upheaval, a hairdo is a profound thought, the cut of a coat a treasured symbol."[17] Given this promise of a direct reentry into the past, through the reproduction not only of details of local color but even of period documents, we can understand the cool reception that greeted modern depictions of dramatized scenes from lives of the celebrated.

Finally, vignettes could act associatively as well as representationally. In 1828, Ludovic Vitet, the Romantic supporter of Delacroix's historical painting and the author of the League's trilogy of reading-dramas, urged artists to avoid the "false, literal vignette," the mere restaging of actions, and to utilize the free play of purely visual elements to address the reader's and viewer's imagination.[18] Barthes called this associative manner of reading a text pleasurable "abrasion," in contrast to a linear pursuit of its content.[19] We have seen this sort of "abrasive" approach taken in the antichronological placement of Janet-Lange's vignettes in Chateaubriand's *Les Quatre Stuarts*, where Henriette's cowering in a hut and Charles I's preparation for execution framed the history of that doomed dynasty. Readers of this edition of Chateaubriand's work relished this subjective and interactive manner of learning history, the "reading" of text and image through their orientation to each other as well as

their independent representation of an action. Text and image were not only parallel or supplementary representations; they were contrapuntal commentaries on the meaning of the event. This, I propose, is what Sarrazin had in mind when he stated that visual images could render the dynamism of historical existence, where conventionally ordered and analytical narratives could not.

The development of historical literature from a corpus of moral precepts to an evocation of an age's spirit made it possible for the French to arrive at increasingly rich and subtle judgments of what comprised historical meaning, and how that meaning could be conveyed in visual form. It was inevitable that the revolution in historiography would create a crisis in pictorial representation. We have seen how artists struggled heroically to create works that could express meaning without its being flattened into representations of physical events or exploded into scintillating compositional fragments. But the crisis in historical representation did not mean the death of historical painting, as we saw in Delacroix's *Liberty*. Artists could rise to the challenge of conceiving and composing works that were both pictorially sublime and historically insightful, according to the rigorous standards of modern historiography. When Courbet described his *Burial at Ornans* (1850, Musée du Louvre), his "declaration of principles," in the Salon entry list as "painting with human figures, the history of a burial at Ornans," he stressed that his work presented a subject that was conceived historically, in contrast to a traditional "history painting," conceived according to pictorial criteria based on tragic or poetic literature.[20] Masterpieces such as Courbet's *Burial at Ornans*, or Delacroix's *Abduction of Rebecca* (1846, Metropolitan Museum of Art) from Scott's *Ivanhoe*, a whirlpool of action and passion rooted in racial conflict, or Manet's versions of *The Execution of Maximilian* (1866–9), were true historical paintings in both senses of the term. The crisis in historical representation was a productive one for painting in general, for it demanded and justified such pictorial innovations as incrementally rather than hierarchically constructed compositions, multiple viewpoints, and diversified quotations from past pictorial works, because they could activate associative responses from the viewer. The readers of Thierry and Michelet were prepared to see history, past or present, as conceived by Delacroix, Courbet, Manet.

In 1833, Henri Martin, introducing his illustrated history of France, insisted that history was not a painting, organized according to a unique perspective system, nor a text written according to one myopic author's point of view, but a faceted mirror in which not only all the people of the past but every present-day reader's point of view would be reflected, and which every reader could break and reconstitute according to his own convictions.[21] This radical refusal to consign authority to another proved that the French nation was no longer "abandoned by the past, without memory or hope," as Benjamin Constant had lamented only a

few years before. Then they had been lost in a traumatic present, their past wrenched away from them and rendered meaningless, their future impossible to predict. They could save themselves only by recovering their nation's memory, to be found in the facts, protagonists, passions that had existed, and that demanded commemoration, comprehension, and integration. Now they could move into the future, wholly themselves, because they had arrived at an understanding, however partial or evanescent, of that which had occurred before them, and so resulted in them: "the immediate representation of the past that has produced us, we ourselves."

NOTES

I have retained the original spelling in French quotations; translations are my own, unless otherwise noted. All dimensions of paintings are given with height preceding width.

CHAPTER ONE. IMAGINING THE PAST IN 1827

1. Paris, Musée du Louvre, Inv. 5417, 386 × 515 cm. Commissioned in 1826 as a ceiling decoration for the Salle Clarac, one of the nine rooms in the Musée Charles X. See Daniel Ternois and E. Camesasca, *Tout l'oeuvre peint d'Ingres* (Paris: Flammarion, 1971), no. 121, 103; *In Pursuit of Perfection: The Art of J.-A.-D. Ingres* (Louisville, KY: J. B. Speed Museum/Indiana University Press, 1983), exhibition catalogue by Patricia Condon et al., 110–15; Georges Vigne, *Ingres* (New York: Abbeville, 1995), 170, 175–80. Ingres derived the subject of Homer's dream of his apotheosis in front of a "temple of memory" erected by Jupiter from Népomucène Lemercier's *Homère, Alexandre* (Paris, 1800); see Jon Whiteley, "Homer Abandoned: A French Neo-Classical Theme," in *The Artist and the Writer in France: Essays in Honor of Jean Seznec,* ed. Francis Haskell, Anthony Levi, and Robert Shackleton (Oxford: Clarendon Press, 1974), 40–51. See Claude Allemand-Cosneau, "Le Salon à Paris de 1815 à 1850," in *Les Années romantiques. La Peinture française de 1815 à 1850* (Paris: Réunion des Musées Nationaux, 1995), exhibition catalogue by Claude Allemand-Cosneau et al., 106–29. On Ingres's resistance to aesthetic eclecticism, see Adrian Rifkin, "Ingres and the Academic Dictionary: An Essay on Ideology and Stupefaction in the Social Formation of the 'Artist,' " *Art History* 6, no. 2 (June 1983): 153–70.
2. See Michael Paul Driskel, "Icon and Narrative in the Art of Ingres," *Arts Magazine* 56, no. 4 (December 1981): 100–7. Both Ingres's *Apotheosis of Homer* and his *Apotheosis of Napoleon I* (1854, Paris, Hôtel de Ville, destroyed in 1871) were removed from their ceilings for inclusion in his retrospective in the Exposition Universelle of 1855, despite the artist's objections; see Marilyn Brown, "Ingres, Gautier, and the Ideology of the Cameo Style of the Second Empire," *Arts Magazine* 56, no. 4 (December 1981): 94–9; Patricia Mainardi, *Art and Politics of the Second Empire: The Universal Expositions of 1855 and 1867* (New Haven: Yale University Press, 1987), 49–51, 73–7.
3. "It is impossible, in fact, not to place him on art's summit, on that throne of gold with ivory steps on which are seated, crowned with laurel, the artists who have accomplished their glory and are ready for immortality." Théophile Gautier, *Les Beaux-Arts en Europe,* 2 vols. (Paris, 1855), 1:142. In gratitude, Ingres gave

Gautier his preparatory oil sketch for the Greek tragedians (Angers) and portrayed him in *Jesus among the Doctors* (1842–62; Montauban, Musée Ingres); see Vigne, *Ingres*, 304.

4. Vicomte Henri Delaborde, *Ingres: Sa Vie, ses travaux, sa doctrine d'après les notes, manuscrites et les lettres du maître* (Paris: Plon, 1870), cited in Joshua C. Taylor, ed., *Nineteenth-Century Theories of Art* (Berkeley and Los Angeles: University of California Press, 1987), 118.

5. Henri-Benjamin Constant de Rebecque, *De la religion considérée dans sa source, ses formes et ses développements*, 5 vols. (Paris, 1824–30), 1:46. See Lionel Gossman, "History as (Auto)Biography: A Revolution in Historiography," in *Autobiography, Historiography, Rhetoric: A Festschrift in Honor of Frank Paul Bowman*, ed. Mary Donaldson-Evans et al. (Atlanta: Rodopi, 1994), 103–29.

6. Gautier, *Les Beaux-Arts en Europe*, 142, cited in Lorenz Eitner, *Neoclassicism and Romanticism, 1750–1850: An Anthology of Sources and Documents* (New York: Harper & Row [Icon], 1989), 297–8. *Note:* I shall be using the term "history painting" to refer to traditional *peinture d'histoire*, and "historical painting" to refer to *peinture de genre historique*, which developed during this period as a pictorial compromise between *peinture d'histoire* and smaller-scale *genre* painting's detailed description of local color. The aesthetic implications of these distinctions are discussed in Chapter 2.

7. On Charles-Claude de Flahaut, comte de la Billarderie d'Angiviller, see Francis H. Dowley, "D'Angiviller's *Grands Hommes* and the Significant Moment," *Art Bulletin* 39, no. 4 (1957): 259–77; Robert Rosenblum, *Transformations in Late Eighteenth-Century Art* (Princeton: Princeton University Press, 1967), 32–4; Stefan Germer and Hubertus Kohl, "From the Theatrical to the Aesthetic Hero: On the Privatization of the Idea of Virtue in David's *Brutus* and *Sabines*," *Art History* 9, no. 2 (June 1986): 168–84; Andrew McClellan, "D'Angiviller's 'Great Men' of France and the Politics of the Parlements," *Art History* 13, no. 2 (1990): 175–92; Andrew McClellan, *Inventing the Louvre: Art, Politics, and the Origins of the Modern Museum in Eighteenth-Century Paris* (Cambridge: Cambridge University Press, 1994), 77–90.

8. See Dorothy Johnson, *Jacques-Louis David: Art in Metamorphosis* (Princeton: Princeton University Press, 1993); James H. Rubin's description of "performative" representation as a hieroglyphic or emblematic political projection in "Disorder/Order: Revolutionary Art as Performative Representation," in "The French Revolution, 1789–1989," a special issue, edited by Sandy Petrey, of *Eighteenth-Century* (1989): 83–111; Stefan Germer, "In Search of the Beholder: On the Relation between Art, Audiences and Social Spheres in Post-Thermidor France," *Art Bulletin* 74, no. 1 (March 1992): 19–36; Michael Marrinan, "Literal/ Literary/ 'Lexie': History, Text, and Authority in Napoleonic Painting," *Word & Image* 7, no. 3 (July–September 1991): 177–200; Susan Locke Siegfried, "Naked History: The Rhetoric of Military Painting in Postrevolutionary France," *Art Bulletin* 75, no. 2 (June 1993): 235–58; Michael Marrinan, "Historical Vision and the Writing of History at Louis-Philippe's Versailles," in *The Popularization of Images: Visual Culture under the July Monarchy*, ed. Petra ten-Doesschate Chu and Gabriel P. Weisberg (Princeton: Princeton University Press, 1994), 113–43; Thomas Crow, *Emulation: Making Artists for Revolutionary France* (New Haven: Yale University Press, 1995).

9. Rensselaer W. Lee, " 'Ut pictura poesis': The Humanistic Theory of Painting," *Art Bulletin* 22, no. 4 (1940): 197–269; revised as book of same title (New York: Norton, 1967); Meyer Schapiro, "On Some Problems in the Semiotics of Visual Art: Field and Vehicle in Image-Signs," *Semiotica* 1 (1969): 223–42; Schapiro, *Words and Pictures: On the Literal and Symbolic in the Illustration of a Text* (The Hague: Mouton, 1973); Martin Meisel, *Realizations. Narrative, Pictorial, and Theatrical Arts in Nineteenth-Century England* (Princeton: Princeton University Press, 1983); Richard Brilliant, *Visual Narratives: Storytelling in Etruscan and Roman Art* (Ithaca, NY: Cornell University Press, 1984); Sixten

Ringbom, "Action and Report: The Problem of Indirect Narration in the Academic Theory of Painting," *Journal of the Warburg and Courtauld Institutes* 52 (1989): 34–51; James Elkins, "On the Impossibility of Stories: The Anti-narrative and Non-narrative Impulse in Modern Painting," *Word & Image* 7, no. 4 (October–December 1991): 348–64.

10. See Gérard Genette, *Narrative Discourse. An Essay in Method*, trans. Jane E. Lewin (Ithaca, NY: Cornell University Press, 1980); Paul Ricoeur, *Temps et récit*, 3 vols. (Paris: Seuil, 1983–5); trans. as *Time and Narrative* by Kathleen McLaughlin and David Pellauer, 3 vols. (Chicago: University of Chicago Press, 1984–8).

11. Horace Vernet (1789–1863), *Julius II Commissioning the Projects for the Vatican and Saint Peter's from Bramante, Michelangelo and Raphael* (1827; Paris, Musée du Louvre Inv. 8564). Ceiling decoration in Salle B, dedicated to Egyptian Antiquities. See the exhibition catalogue *Horace Vernet* (Paris: École Nationale Supérieure des Beaux-Arts 1980); Robert N. Beetem, "Horace Vernet's Mural in the Palais Bourbon: Contemporary Imagery, Modern Technology, and Classical Allegory during the July Monarchy," *Art Bulletin* 66, no. 2 (June 1984): 254–69; Marie-Claude Chaudonneret, "Historicism and 'Heritage' in the Louvre 1820–1840," *Art History* 14, no. 4 (December 1991): 488–520. Coupin lauded Vernet after criticizing allegory as cold and boring; Vitet praised the work's historical merit, evident not only in its accurate costumes, but its dramatic insight. See "P. A." [Philippe-Alexandre Coupin], "Exposition des tableaux en 1827," *Revue encyclopédique* 37 (1828): 302–16, 303; L. V. [Louis Vitet], "Salon de peinture. IIIe article," *Le Globe* (February 6, 1828), 181.

12. Marie-Claude Chaudonneret pointed out in her review of the 1989–90 exhibition "The Art of the July Monarchy" (Columbia, MO: Museum of Art and Archeology, University of Missouri-Columbia, 1990) that the development of historical genre painting was directly related to historiographic developments after 1814. See "La Peinture en France de 1830 à 1848. Chronique bibliographique et critique," *Revue de l'art* 91 (1991): 71–80.

13. Eugène Delacroix (1798–1863). Salon of 1827–8, no. 1630 (2nd supp.):

> *Mort de Sardanapale*. Les révoltés l'assiegèrent dans son palais . . . Couché sur un lit superbe, au sommet d'un immense bûcher, Sardanapale donne l'ordre à ses eunuques et aux officiers du palais, d'égorger ses femmes, ses pages, jusqu'à ses chevaux et ses chiens favoris; aucun des objets qui avaient servi à ses plaisirs ne devait lui survivre . . . *Aïscheh*, femme bactrienne, ne voulut pas souffrir qu'un esclave lui donnât la mort, et se pendit elle-même aux colonnes qui supportaient la voûte . . . *Baleah*, échanson de Sardanapale, mit enfin le feu au bûcher et s'y précipita lui-même.

1827; Paris, Musée du Louvre, RF 2346; 3.95 × 4.95 m. See Lee Johnson, *The Paintings of Eugène Delacroix. A Critical Catalogue, 1816–1831*, 2 vols. (Oxford: Clarendon Press, 1981), J 125, 1:114–21.

14. In Act IV, Scene 1, lines 66–7, Myrrha encourages Sardanapalus to relate his nightmare to her to "lighten [his] dimmed mind"; Richard Lansdown calls the dream classically neurotic, since it incorporates oedipal-like apparitions of his ancestors: Nimrod accuses him, and Semiramis attempts to seduce him; see *Byron's Historical Dramas* (Oxford: Clarendon Press, 1992), 161–2.

15. *Sardanapalus* was written as a reading-drama (also called "closet drama") in 1821, and published in that year in London and Paris, in English and in French translation respectively. Byron did not wish it to be staged; Macready was responsible for its world première at Drury Lane in the 1833–4 season. See Edmond Estève, "Appendice bibliographique," in *Byron et le romantisme français. Essai sur la fortune et l'influence de l'oeuvre de Byron en France de 1812 à 1850*, 2nd ed. (Paris: Boivin, 1929), 525–9; David V. Erdman, "Byron's Stage Fright: The History of His Ambition and Fear of Writing for the Stage," *ELH* 6 (September 1939): 219–43; Boleslaw Taborski, *Byron and the Theatre*, University of Salzburg, Institut für Englische Sprache und Literatur, Salzburger

Studien zur Englische Literatur, no. 1, ed. James Hogg (Salzburg: Institut für Englische Sprache und Literatur, 1972): 118–24, 152–7, 183–207; Elizabeth Porges Watson, "Mental Theatre: Some Aspects of Byron's Dramatic Imagination," *Renaissance and Modern Studies* 32 (1988): 24–44; special issue of *Studies in Romanticism* 31 (1992) related to the conference "Byron and the Drama of Romanticism."

16. Lewis B. Namier, *Conflict: Studies in Contemporary History* (London: Macmillan, 1942), 70.

17. See Jacques Barzun, "Romantic Historiography as a Political Force in France," *Journal of the History of Ideas* 2 (1941): 318–29; Stanley Mellon, *The Political Uses of History: A Study of Historians in the French Restoration* (Stanford: Stanford University Press, 1958); Friedrich Engel-Janosi, *Four Studies in French Romantic Historical Writing (Chateaubriand, Barante, Thierry, Tocqueville)* (Baltimore: Johns Hopkins University Press, 1955); *Romantisme et politique, 1815–1851: Colloque de l'Ecole Normale Supérieure de Saint-Cloud* [1966] (Paris: Colin, 1969); Lionel Gossman, "Augustin Thierry and Liberal Historiography," *History and Theory,* supp. 15, no. 4 (1976): 3–83, reprinted in Gossman, *Between History and Literature* (Cambridge, MA: Harvard University Press, 1990), 83–151; Gossman, "History and Literature: Reproduction or Signification?" in *The Writing of History: Literary Form and Historical Understanding,* ed. Robert Canary and Henry Kozicki (Madison: University of Wisconsin Press, 1978), 3–29, reprinted in *Between History and Literature,* 227–56; Gossman, "History as Decipherment: Romantic Historiography and the Discovery of the Other," *New Literary History* 18, no. 1 (Autumn 1986): 23–57, reprinted in *Between History and Literature,* 257–84; Alan Spitzer, *The French Generation of 1820* (Princeton: Princeton University Press, 1987); Ceri Crossley, *French Historians and Romanticism. Thierry, Guizot, the Saint-Simonians, Quinet, Michelet* (London: Routledge, 1993).

18. "Le Salon est aussi politique que les élections; le pinceau et l'ébauchoir sont des instrumens de partis aussi bien que la plume . . . Le romantisme en peinture est aussi politique, car c'est la révolution." Auguste Jal, *Esquisses, croquis, pochades, ou Tout ce qu'on voudra sur le Salon de 1827* (Paris: Ambroise Dupont, 1828), iv. His discussion of Delacroix's *Justinian* (443–5) and Ary Scheffer's *Charlemagne* (442–3) for the Conseil d'Etat included a lengthy description of Delacroix's purported wish to depict Spartacus's revolt, denied by an administration unwilling to countenance such a dramatic scene of revolutionary sedition by torchlight, as they had denied Scheffer his desired subject of Athenian democratic elections, ordering him to depict Charlemagne writing his capitularies.

19. See Lloyd Kramer, "Literature, Criticism, and Historical Imagination: The Literary Challenge of Hayden White and Dominick LaCapra," in *The New Cultural History,* ed. Lynn Hunt (Berkeley and Los Angeles: University of California Press, 1989), 97–128; Bernadette Fort, "The French Revolution and the Making of Fictions," in *Fictions of the French Revolution,* ed. Bernadette Fort (Evanston, IL: Northwestern University Press, 1991), 3–32.

20. See Roland Barthes, "Introduction to the Structural Analysis of Narratives" (1966), in *Image, Music, Text,* trans. Stephen Heath (New York: Hill & Wang, 1977); Roland Barthes, "Le Discours de l'histoire," first published in *Information sur les sciences sociales* 6, no. 4 (August 1967): 65–75; trans. as "The Discourse of History" and introduced by Stephen Bann, *Comparative Criticism* 3 (1981): 3–20. The impact of Barthes's Structuralist linguistic and rhetorical analysis of historiography, both in abstract terms and with concrete reference to Michelet, has influenced Paul Veyne, *Comment on écrit l'histoire* (Paris: Seuil, 1971); Michel de Certeau, *L'Ecriture de l'histoire,* 2nd ed. (Paris: Gallimard, 1975); Linda Orr, *Jules Michelet: Nature, History, Language* (Ithaca, NY: Cornell University Press, 1976); John D. Rosenberg, *Carlyle and the Burden of History* (Cambridge, MA: Harvard University Press, 1985); Ann Rigney, *The Rhetoric of Historical Representation: Three Narrative Histories of the French*

Revolution (Cambridge: Cambridge University Press, 1990); Linda Orr, *Headless History: Nineteenth-Century French Historiography of the Revolution* (Ithaca, NY: Cornell University Press, 1990).

21. Barthes discusses photography's "certificate of presence" and abolition of temporal duration in memory in *La Chambre claire–Note sur la photographie* (Paris: Seuil, 1980), and in "The Reality Effect," in which the additive, useless detail signifies the "real." "L'Effet de réel," *Communications* 11 (1968): 84–90; trans. as "The Reality Effect" and reprinted in Tzvetan Todorov, *French Literary Theory Today* (Cambridge: Cambridge University Press, 1982), 11–17. See also the special issue of The *American Historical Review* 93 (1988) on representing history in photography and film, particularly the essays by David Herlihy ("Am I a Camera? Other Reflections on Film and History," 1186–92) and Hayden White ("Historiography and Historiophoty," 1193–99).

22. Stephen Bann, "Image, Text, and Object in the Formation of Historical Consciousness," in *The New Historicism,* ed. H. Aram Veeser (New York: Routledge, 1989), 102–15. See Wolfgang Ernst, "Frames at Work: Museological Imagination and Historical Discourse in Neoclassical Britain," *Art Bulletin* 75, no. 3 (September 1993): 481–98; *Saloni, gallerie, musei e loro influenza sulla sviluppo dell'arte dei secoli XIX e XX,* Acts of the Twenty-Fourth Congress of the CIHA in Bologna (September 10–18, 1979) (Bologna: CLUEB [Cooperativa Librarie Universitaria Editrice Bologna], 1981); Andrew McClellan, "The Politics and Aesthetics of Display: Museums in Paris, 1750–1800," *Art History* 7, no. 4 (1984): 438–64; Thomas W. Gaehtgens, *Versailles: de la résidence royale au Musée historique. La Galerie des Batailles dans le Musée historique de Louis-Philippe* (Paris: Albin Michel, 1984).

23. See in particular Stephen Bann, *The Clothing of Clio: A Study of the Representation of History in Nineteenth-century Britain and France* (Cambridge: Cambridge University Press, 1984), a work that has been of critical importance for my own research. On Delaroche, citing Barthes's "reality effect," Bann wrote: "the crucial relevance of photography to historical representation lies in the fact that it gradually converts the otherness of *space* . . . into an otherness of *time* . . . making manifest to the spectator what Roland Barthes has called the 'having-been-there . . . the always stupefying evidence of *this is how it was*' " (134). Bann, perceiving in Delaroche "archaeologically accurate details which are the basic safeguard of the genre" (72), excludes Delacroix, whose attention is devoted to his visual idiom:

> By 1830, Delacroix has visibly committed himself to renewing the medium of painting, through a reversion to the broad colour effects and vigorous brushwork of the Baroque, and an ever more conscious exploitation of the phenomenon of complementaries. This applies as much, of course, to his great historical compositions of later years, like the "Prise de Constantinople" (1840) as to his exotic, biblical and mythological pieces. It makes little sense to single out from this undivided stream the current of Delacroix the historical painter. (72)

Recently, in *The Inventions of History: Essays on the Representation of the Past* (New York: Manchester University Press, 1990), and *Romanticism and the Rise of History* (New York: Twayne, 1995), Bann has widened his focus on "the productive crisis in historical representation, which is especially strong in Restoration France" (74), incorporating visual works by Victor Hugo, Bonington, and Eugène Devéria into his discussion of the adoption of a subjective relationship to the past: "living the past," as opposed to "staging the past."

24. Hayden White, "The Historical Text as Literary Artifact," *Clio* 3, no. 3 (1974): 277–303; reprinted in White, *Tropics of Discourse: Essays in Cultural Criticism* (Baltimore: Johns Hopkins University Press, 1978), 81–100, 91. See also White, *Metahistory. The Historical Imagination in Nineteenth-Century Europe* (Baltimore: Johns Hopkins University Press, 1973), particularly "Introduction: The Poetics of History," 1–42; White, "Interpretation in History," *New Literary*

History 4, no. 2 (Winter 1973): 281–314, reprinted in *Tropics of Discourse,* 51–80; White, "The Question of Narrative in Contemporary Historical Theory," *History and Theory,* Beiheft 23, no. 1 (1984): 1–33, reprinted in White, *The Content of the Form: Narrative Discourse and Historical Representation* (Baltimore: Johns Hopkins University Press, 1987), 26–57; Rigney, *The Rhetoric of Historical Representation.* White's tropological modes (metonymy, metaphor, synecdoche, irony) are adapted from Roman Jakobson and Kenneth Burke; see Roman Jakobson and Morris Halle, *Fundamentals of Language* (The Hague: Mouton, 1956); Burke, *A Grammar of Motives* (University of California: Berkeley and Los Angeles, 1969).

25. Hayden White, "The Burden of History," *History and Theory,* Beiheft 5, no. 2 (1966): 111–34, reprinted in *Tropics of Discourse,* 27–50, 46–7.

26. White has recommended that historians be more alert to visual rhetoric in historical paintings, suggesting that they exploit "the possibilities of using images as a principal medium of *discursive* representation, using verbal commentary only diacritically, that is to say, to direct attention to, specify, and emphasize a meaning conveyable by visual means alone." White, "Historiography and Historiophoty," 1194. In his review of Francis Haskell's *History and Its Images: Art and the Interpretation of the Past* (New Haven: Yale University Press, 1993), Stephen Bann argued for the parallel analysis of visual and verbal modes of historical representation; see "The Road to Roscommon," *Oxford Art Journal* 17, no. 1 (1994): 98–102.

27. See Baudelaire's second article reviewing the Exposition Universelle (*Le Pays,* June 3, 1855), reprinted in *Art in Paris, 1845–1862: Salons and Other Exhibitions Reviewed by Charles Baudelaire,* ed. and trans. Jonathan Mayne (New York: Phaidon, 1965), 141.

28. Léon Rosenthal, *La Peinture romantique. Essai sur l'évolution de la peinture française de 1815 à 1830* (Paris: L. H. May, 1900), and *Du romantisme au réalisme. Essai sur l'évolution de la peinture en France de 1830 à 1848* (Paris, Renouard & Laurens, 1914). The modern edition (Paris: Macula, 1987) has a preface by Michael Marrinan; see Rosenthal's discussion of Romantic literary painting (169–77) and the relationship between Romantic art and literature (278–98). Rosenthal distinguished "illustrative" Romantic painting (Louis Boulanger, Achille Devéria, the Johannot brothers) from "expressive" Romantic painting, asserting that Delacroix and Hugo had only had a "diplomatic alliance." Rosenthal, *La Peinture romantique,* 279. But during the Restoration, Delacroix and Hugo were in close contact; Delacroix designed the costumes for Hugo's *Amy Robsart* in 1828 (a play based on Scott's *Kenilworth*) and offered to do the same for his *Cromwell.* Their relationship cooled only after *Hernani* in 1830.

29. See Geneviève Lacambre and Jean Lacambre, "La Politique d'acquisition sous la Restauration: Les Tableaux d'histoire," *Bulletin de la Société de l'histoire de l'art français* (1972): 331–44; Francis Haskell, "The Manufacture of the Past in Nineteenth-Century Painting," *Past and Present* 53 (November 1971): 109–20; reprinted in Haskell, *Past & Present in Art & Taste. Selected Essays* (New Haven: Yale University Press, 1987), 75–89; Ruth Kaufmann, "François Gérard's 'Entry of Henry IV into Paris': The Iconography of Constitutional Monarchy," *Burlington Magazine* 117 (December 1975): 790–802; Carol Duncan, "Ingres's *Vow of Louis XIII* and the Politics of the Restoration," in *Art and Architecture in the Service of Politics,* ed. Henry A. Millon and Linda Nochlin (Cambridge, MA: MIT Press, 1978), 80–91; reprinted in Carol Duncan, *The Aesthetics of Power: Essays in Critical Art History* (Cambridge: Cambridge University Press, 1993), 57–78; Michael Marrinan, *Painting Politics for Louis Philippe: Art and Ideology in Orléanist France, 1830–1848* (New Haven: Yale University Press, 1988); Nina M. Athanassoglou-Kallmyer, *French Images from the Greek War of Independence, 1821–1830: Art and Politics under the Restoration* (New Haven: Yale University Press, 1989); Nina Maria Athanassoglou-

Kallmyer, *Eugène Delacroix: Prints, Politics and Satire, 1814–1822* (New Haven: Yale University Press, 1991); Pierre Nora's magisterial edition of *Les Lieux de mémoire* (Paris: Gallimard, 1984–93): *tome* 1: "La République"; *tome* 2: "La Nation" (3 vols.); *tome* 3: "Les France" (3 vols.).

30. In his *Scienza Nuova* (1725; rev. eds. 1730, 1744), known in France through Michelet's adaptations (1827; see n. 32 to this chapter), Giambattista Vico (1668–1744) analyzed the relationship between language, thought, and the cyclic rise and fall of cultures. Collective memory gave rise in each culture to poetic linguistic images corresponding to knowledge of the concrete world, according to the four ages of its evolution: the ages of gods, heroes, men, and decline. Vico described three successive forms of language: averbal (mimical gestures), "heroic" (similes, metaphors, images), and "conventional" (abstract expressions). See *The New Science*, trans. Thomas Goddard Bergin and Max Harold Fisch (Ithaca, NY: Cornell University Press, 1968), particularly nos. 400–10, 127–32, and nos. 443–6, 147–50; Alain Pons, "Vico and French Thought," in *Giambattista Vico: An International Symposium*, ed. Giorgio Tagliacozzo and Hayden V. White (Baltimore: Johns Hopkins University Press, 1969), 165–85; Hayden White, "The Tropics of History: The Deep Structure of the *New Science*," in *Giambattista Vico's Science of Humanity*, ed. Giorgio Tagliacozzo and Donald Phillip Verene (Baltimore: Johns Hopkins University Press, 1976), 65–85; Donald Phillip Verene, *Vico's Science of Imagination* (Ithaca, NY: Cornell University Press, 1981). Hersey and Boime argued that Vico's study of the universal historical cycles of rise and decline influenced Delacroix's Palais Bourbon murals, but this has been disputed by Ribner; see George L. Hersey, "Delacroix's Imagery in the Palais Bourbon Library," *Journal of the Warburg and Courtauld Institutes* 31 (1968): 383–403; Albert Boime, *Thomas Couture and the Eclectic Vision* (New Haven: Yale University Press, 1980), 29; Jonathan P. Ribner, *Broken Tablets: The Cult of the Law in French Art from David to Delacroix* (Berkeley and Los Angeles: University of California Press, 1993), 100–28.

Victor Cousin (1792–1867) taught at the Ecole Normale in 1817–18 and at the Sorbonne in 1815–20 and 1827–30. In Cousin's view, since the human mind grasped reality successively through the stages of sensationalism, idealism, skepticism, and mysticism, the purpose of historical literature was to reveal the divine ideas that endowed external events and actions with true meaning. See *De la philosophie de l'histoire* (1823) and *Cours de philosophie: Introduction à l'histoire de la philosophie* (Paris: Pichon & Didier, 1828–9). Cousin's aesthetics (influenced by Winckelmann and Quatremère de Quincy), most fully expressed in *Du vrai, du beau, et du bien* (1836; rev. ed. 1853), were first published during the Restoration in "Du Beau Réel et du Beau Idéal," in *Premiers Essais de Philosophie* (1816) and in *Fragments Philosophiques* (1826).

31. François Guizot (1787–1874) was professor of modern history at the Sorbonne (1812–30); ousted from his professorship in 1822, he returned in 1828. During the Restoration, he published histories of French and European civilization, political pamphlets, and collections of archival material. After the July Revolution, the post of minister of public instruction was created in 1832 for him, where he remained, except for a seven-month interval, until 1837. In 1834, he founded the Comité des Travaux Historiques, under whose aegis the Société de l'Histoire de France and the Service des Monuments Historiques were established. He was prime minister from 1840 to the fall of the July Monarchy in 1848. For his publications during the Restoration, see Chapter 2, note 54, of the present volume. On Guizot's career, see Charles-Henri Pouthas, *Guizot pendant la Restauration, préparation de l'homme d'Etat* (Paris: Plon, 1923); Douglas Johnson, *Guizot: Aspects of French History, 1787–1874* (London: Routledge & Kegan Paul, 1963); *Actes du Colloque François Guizot 22–25 octobre 1974* (Paris: Société de l'Histoire du Protestantisme Français, 1976); Pierre Rosenvallon, *Le Moment Guizot* (Paris: Gallimard, 1985); Laurent Theis, "Guizot et

les institutions de mémoire," in Nora, ed., *Les Lieux de mémoire, tome* 2 "La Nation," (3 vols.) (Paris: Gallimard, 1986), 2:568–92; Dominique Poulot, "The Birth of Heritage: 'Le Moment Guizot,' " *Oxford Art Journal* 11, no. 2 (1988): 40–56; Crossley, *French Historians and Romanticism*, 71–104. Adolphe Thiers (1797–1877), author of *Histoire de la Revolution française* (1823–7) and *Histoire du Consulat et de l'Empire* (1845–62), reviewed the Salons of 1822 and 1824. He held several key positions in the July Monarchy, forming a cabinet for Louis-Philippe in 1840, and became president of the Third Republic in 1871.

32. Jules Michelet (1798–1874) is most celebrated for the first six volumes of his *Histoire de France* (1833–43) and *Histoire de la révolution française* (1847–53). During the Restoration, he published *Tableaux chronologiques des temps modernes* (1825), *Tableaux synchroniques des temps modernes* (1826), *Discours sur le système et la vie de Vico* (1827), and a translation-adaptation of Vico's *Scienza Nuova, Principes de la philosophie de l'histoire* (1827). Michelet's *Précis de l'histoire moderne* (1827–8) was the standard school survey of history for more than twenty years. In 1828, he became the tutor of Louise-Marie-Thérèse de Berry, granddaughter of Charles X, and professor of history and philosophy at the Ecole Normale Supérieur (1828–9). In 1830, after the July Revolution, he was appointed tutor to the fifth child of Louis-Philippe, Clémentine, and taught her until 1843. In October 1830, he was also named head of the historical section of the Archives Royales (later the Archives Nationales). On Michelet, see the works by Orr, Rigney, and Crossley cited earlier in these notes, and *Mother Death: The Journal of Jules Michelet, 1815–1850,* ed. and trans. Edward K. Kaplan (Amherst: University of Massachusetts Press, 1984); Arthur Mitzman, *Michelet, Historian: Rebirth and Romanticism in Nineteenth-Century France* (New Haven: Yale University Press, 1990).

33. I first presented some ideas from this material in meetings of the American Society for Eighteenth-Century Studies (Charleston, SC, 1994, and Tucson, AZ, 1995) and the International Society for Eighteenth-Century Studies (Münster, 1995). See Beth S. Wright, " 'Interrogating the Debris': Revolutionary Vandalism and Marchangy's Phantasmagoric History," in "Transactions of the Ninth International Congress on the Enlightenment," *Studies on Voltaire and the Eighteenth Century* (in press).

CHAPTER TWO. "EVERYTHING IS OPTICAL"

1. E. J. D. [Etienne-Jean Delécluze], "Septième Lettre au Rédacteur du Lycée Français sur l'exposition des ouvrages de peinture, sculpture, etc. des Artistes vivans," *Le Lycée Français* 2 (1819): 182–92, 186–7.

2. "the historian relates what happened, the poet what might happen. That is why poetry is more akin to philosophy and is a better thing than history; poetry deals with general truths, history with specific events." Aristotle, *The Poetics,* in Aristotle, *On Poetry and Style,* trans. G. M. A. Grube (Indianapolis: Bobbs-Merrill, 1958), IX, 18. See Lionel Gossman, "History and Literature: Reproduction or Signification?" in Gossman, *Between History and Literature* (Cambridge, MA: Harvard University Press, 1990), particularly his comparison of neoclassical historiography with *peinture d'histoire,* 231–8.

3. Aristotle, *Poetics,* IX and X, 20–1. The six elements of tragedy are plot, character, thought, diction, spectacle, and music.

4. Félibien's hierarchy proceeded from the reproductive to the interpretative; he placed genre scenes below history painting, since the latter was not simply a "grouping of several human figures" but a visual embodiment of an intellectual construct: "il faut traiter l'histoire et la fable; il faut représenter de grandes actions comme les Historiens, ou des sujets agréables comme les Poétes; et montant encore plus haut, il faut par des compositions allégoriques, sçavoir couvrir sous la voile de la fable les vertus des grands hommes, et les mystères les plus relevez." André Félibien, "Préface," in *Conférences de l'Académie*

Royale de Peinture et de Sculpture (Paris, 1669), reprinted in André Félibien, *Entretiens sur les vies et sur les ouvrages des plus excellens peintres,* 5 vols. (Trévoux, 1725), 5:310. Thomas Puttfarken, *Roger de Piles' Theory of Art* (New Haven: Yale University Press, 1985), 6–16, relates Aristotle's "organic" unity of action to Félibien's views: "not narrative continuity but logical consequentiality" (14).

5. Millin, in 1800, warned artists not to paint history "materially," replicating the original event's concrete conditions so that viewers could "see" the act, but to encourage viewers to feel what they would have felt if they had been witnesses, to make the moral impulse behind the gestures and emotions of the expressive figures apparent, and so "activate" the sentiments. See Aubin-Louis Millin, "Histoire," in *Dictionnaire des Beaux-Arts,* 3 vols. (Paris: Crapelet-Desray, 1806), 2:57–67.

6. On désigne en peinture, par le mot *histoire,* ou genre *historique,* l'art d'exprimer avec élévation & avec choix les actions des Dieux, & celles des hommes que leur célébrité a placés au-dessus des hommes ordinaires. Tous les genres de peinture, même les plus communs, doivent parler aux yeux. Il en est d'un style bas qui savent récréer, instruire & quelquefois émouvoir; mais en ne nous offrant que la représentation de scènes, dont les modèles peuvent se montrer à nos yeux. Cette dernière distinction est ce qui caractérise spécialement ce qu'on appelle *les genres* proprement dits, & ce qui les fait différer de ce qu'on nomme l'*histoire* . . . parce que la composition n'en est pas poétique, que dans l'exécution tout y est fait d'après des objets communs, & que le résultat en est de rendre simplement la nature. Le devoir du peintre d'*histoire,* est d'élever l'âme par la noblesse du sujet, & par la grandeur du style, & de présenter à notre esprit tout ce qu'il peut concevoir au de-là de ce qui est possible. Ainsi point de tableaux d'*histoire* sans poésie . . . Ainsi bien loin d'astreindre le peintre d'*histoire* à la fidélité d'un biographe ou d'un historien, on doit exiger qu'il traite les sujets à la manière d'Homère, ou d'Euripide.

Robin, "Histoire," in Claude-Henri Watelet and Pierre-Charles Levesque, *Dictionnaire de Peinture, Sculpture, et Gravure,* 5 vols. (Paris, 1792), 3:36–45, 36–7.

7. Baron Gottfried Wilhelm von Leibnitz (1646–1716) wrote: "The chief end of history, like that of poetry, is to teach prudence and virtue by examples, and to exhibit vice in such a way as to arouse aversion and lead to its avoidance." *Die Philosophische Schriften,* ed. K. Gerhardt, 7 vols. (Berlin: Weidmann, 1875–90), 6:198. Viscount Henry St John Bolingbroke's *Letters on the Study and Use of History* (1735–8, first published London: A. Millar, 1752) reiterated this precept, which derived from Dionysus of Halicarnassus (*Ars rhetorica,* XI, 2). Cited in A. Dwight Culler, *The Victorian Mirror of History* (New Haven: Yale University Press, 1985), 4.

8. Voltaire, letter no. 4163 (August 1, 1752), cited by Gossman in "History and Literature," in Gossman, *Between History and Literature,* 235. See also Gossman, "Voltaire's *Charles XII*: History into Art," *Studies on Voltaire and the Eighteenth Century* 25 (1963): 691–720.

9. Jean-Jacques Garnier, ed., "Editor's Foreword," in *Histoire de France, par M. L'abbé Velly* (Paris, 1770), 1:xxi–xxv, cited by Gossman in "History and Literature," 238. Garnier's revision and continuation of Velly's history was published 1770–8.

10. HISTOIRE Cicéron l'a défini: Le témoin des temps, la lumière de la vérité, la vie de la mémoire, l'école de la vie, la messagère de l'antiquité . . . On peut distinguer, dans l'*Histoire,* un intérêt d'instruction & un intérêt d'affection. Quant à l'instruction, il n'est pas difficile, soit dans les faits, soit dans les hommes, de discerner ce que l'*Histoire* doit prendre soin de recueillir; il suffit de se demander quels sont, parmi les événements et les exemples du passé, ceux qui peuvent être pour l'avenir des avis salutaires, ou de sages leçons.

Jean-François Marmontel, "Histoire," in *Elemens de littérature*, vols. 5–10 in *Oeuvres Completes de M. Marmontel* (Paris: Née de la Rochelle, 1787), 8:70–128; 70, 94–5.

11. "tragedy is an imitation, not of men but of action and life, of happiness and misfortune." Aristotle, *Poetics*, VI,13.

12. David Hume, *An Enquiry concerning Human Understanding* (1748), in *Enquiries*, ed. L. A. Selby-Bigge, 3rd ed. (Oxford: Clarendon Press, 1975), 83 [sec. 8], cited in Culler, *Victorian Mirror of History*, 4.

13. François-René, vicomte de Chateaubriand, *Essai sur la littérature anglaise suivi de la Traduction du Paradis Perdu de Milton*, in *Oeuvres Complètes de Chateaubriand*, 10 vols. (Paris: Eugène and Victor Penaud frères, 1849–50), 10:282. During his exile in England (1793–1800), Chateaubriand supported himself by translating English literature. In *Mémoires d'Outre-Tombe*, he describes preparing the *Essai sur la littérature anglaise* in 1822, but it was first published in 1836 by Furne and Gosselin.

14. Edgar Quinet, *Histoire de mes Idées* (1858), in *Oeuvres Complètes d'Edgar Quinet*, 11 vols. (Paris, 1857–70), 10:233.

15. Nous avons vécu depuis plus de trente années dans un monde agité par tant d'événemens prodigieux et divers; les peuples, les lois, les trônes ont tellement roulés sous nos yeux . . . Comme l'existence de chacun, tel grand ou tel petit qu'il soit, est venu se rattacher immédiatement aux vicissitudes de la destinée commune; comme la vie, la fortune, l'honneur, la vanité, l'emploi de soi-même, les opinions peut-être, en un mot la situation toute entière du citoyen a dépendu, et dépend encore, des événemens généraux de son pays, ou même du monde, l'observation a dû prendre pour but presque unique l'histoire des nations.

Amable-Guillaume-Prosper Brugière, baron de Barante, "Préface," in *Histoire des ducs de Bourgogne de la maison de Valois, 1364–1477* reprinted from the first edition (Paris: Ladvocat, 1824) in the sixth edition, 12 vols. (Paris: Delloye, 1839), 1:1–88, 31–2.

16. Amable-Guillaume-Prosper Brugière, baron de Barante, "De l'Histoire," in Eustache-Marie-Pierre-Marc-Antoine Courtin, ed., *Encyclopédie Moderne, ou Dictionnaire Abrégé des Sciences, des Lettres et des Arts*, 26 vols. (Paris, 1824–32); 14 (1828): 124–59; separately printed as a pamphlet entitled "Histoire, article extrait du 14ᵉ volume de l'*Encyclopédie Moderne*" (1828), 3–37, 36–7.

17. Augustin Thierry, "Avertissement," in *Lettres sur l'Histoire de France*, in *Oeuvres Complètes* (Paris: Furne, 1851), 1–3. Ten of the letters had been published in the *Courrier français* in 1820; the first publication of them in book form, with fifteen more, occurred in 1827, with a second edition in 1828.

18. In the Faculté des Arts of Lyon, in 1840, there were 200 students of philosophy, 800 of foreign literature (50 of ancient literature, 80 of French literature), and 1,880 of history. "Paris Letter," *Literary Gazette* (March 7, 1840), 154–5.

19. See Patrick H. Hutton's description of paradigmatic memory, which reconstructs the past as a coherent structure of present-day cultural practice; this structure is "localized" in particular images of space and time that serve as concrete reference points for the group's understanding of its values. Patrick H. Hutton, "Collective Memory and Collective Mentalities: The Halbwachs-Ariès Connection," *Historical Reflections/Réflexions historiques* 15, no. 2 (1988): 311–22. On catastrophe, rhetorical mnemonics, and the construction of memorials, see Frances A. Yates, *The Art of Memory* (Chicago: University of Chicago Press, 1966); Patrick H. Hutton, "The Art of Memory Reconceived: From Rhetoric to Psychoanalysis," *Journal of the History of Ideas* 48, no. 3 (July–September 1987): 371–92; Hutton, *History as an Art of Memory* (Hanover, NH: University Press of New England for University of Vermont, 1993); Bettina Bergmann, "The Roman House as Memory Theater: The House of the Tragic Poet in Pompeii," *Art Bulletin* 76, no. 2 (June 1994): 225–56. See also *Representations* 26 (Spring 1989), an issue devoted to memory and countermemory, especially

Natalie Zemon Davis and Randolph Starn, "Introduction," 1–6; Pierre Nora, "Entre mémoire et histoire. La Problématique des lieux," in Nora, ed., *Les Lieux de mémoire, tome* 1: "La République" (Paris: Gallimard, 1984): xvii–xlii; trans. Marc Roudebush as "Between Memory and History," *Representations* 26 (Spring 1989): 7–25.

20. In 1833, a new edition of Amédée Pichot's *Histoire de Charles-Edouard, dernier prince de la maison de Stuart* (1830) appeared, with a new preface dedicated "au prétendant français" (Henri, duc de Bordeaux, son of the duchesse de Berry). The duchesse de Berry had fomented an abortive revolt in the Vendée, she was now imprisoned. A reviewer was struck by the fact that events in France exactly repeated events in Britain: "Qu'est-ce donc que cette histoire? est-ce celle de Jacques II ou celle de Charles X? est-ce l'Angleterre ou la France, 1688 ou 1830?" A. Mazure, review of Pichot's *Charles Edouard, La Revue Anglo-Française* 1 (1833): 71–2. Pichot thought all Frenchmen, whether or not they observed the "fatal parallel," could profit from reading the history of the Stuarts between 1688 and 1745; see his nonpaginated preface to *Histoire de Charles-Edouard, dernier prince de la maison de Stuart; précédée d'une histoire de la rivalité de l'Angleterre et de l'Ecosse. Nouvelle édition,* 2 vols. (Paris: Charles Gosselin, 1833).

21. "dans un sujet qui, traite de nos jours, semble trop favoriser le puéril intérêt des allusions contemporaines, l'écrivain impartial était naturellement conduit . . . à déconcentrer les souvenirs par ces grandes diversités de religion, de moeurs . . . qui font que les mêmes événements, reproduits à une autre époque, ne sont pas la même chose. Ces conformités extérieures, que paraissent offrir les faits principaux, s'évanouissent dans la foule des circonstances particulières et locales; ou si quelquefois une certaine force de ressemblance dans les événements et dans les passions, prédomine sur tous ces accidents de moeurs, de pays, de religion soigneusement conservé, il en résulte alors un intérêt purement historique, qu'il n'eût pas été plus permis de supprimer que de chercher avec effort. Ainsi, une bienséance nécessaire exigeait avant tout, dans le sujet que je traite, le soin curieux des détails et la scrupuleuse copie des moeurs; et pour être toujours fidèle, il a fallu souvent que le récit devînt trop exact et presque minutieux.

Abel-François Villemain, "Observations préliminaires," in *Histoire de Cromwell, d'après les mémoires du temps et les recueils parlementaires,* 2 vols. (Paris: Maradan, 1819), 1:i–xv, vii.

22. Thomas Babington, Lord Macaulay, "History," reviewing *The Romance of History: England* by Henry Neele, *Edinburgh Review* (May 1828); reprinted in *The Miscellaneous Writings of Lord Macaulay* 2 vols. (London: Longman, Green, Longman, & Roberts, 1860), 1:270–309, 309.

23. Louis-Sébastien Mercier, "TOUT EST OPTIQUE," chap. 227 of *Le Nouveau Paris,* 2nd ed. 6 vols. (Genoa, an III [sic; c.1798]), 5:215–24, 218–22. See Johnson on David's rendition of cacophony in his *Serment du Jeu de Paume,* in *Jacques-Louis David: Art in Metamorphosis,* 83–6.

24. Thomas Carlyle, "On History," *Fraser's Magazine,* no. 10 (1830); reprinted in *Critical and Miscellaneous Essays,* 2nd ed., 2 vols. (London: James Fraser, 1840), 2:378–93, 384–5.

25. See Paul Ricoeur, *Time and Narrative,* particularly "Time and Narrative: Threefold Mimesis," 2:52–87, and "Between Lived Time and Universal Time: Historical Time," 3:104–26; Hayden White, "The Metaphysics of Narrativity: Time and Symbol in Ricoeur's Philosophy of History," in *The Content of the Form,* 169–84.

26. For Ricoeur, recollection is essential to emplotment; "we learn to read time itself backward, as the recapitulating of the initial conditions of an action in its terminal consequences." "Narrative Time," *Critical Inquiry* 7, no. 1 (Autumn 1980), 169–90, 180.

27. A. Jubé de la Perrelle, *Quelques Mots sur la proclamation de M. le comte de*

Chateaubriand (Paris, 1818), cited in Mellon, *The Political Uses of History,* 6. Jubé de la Perrelle had been a Napoleonic general and served as a historian in the Ministry of War. Thierry wrote: "In 1817, preoccupied with a strong desire to contribute to the triumph of constitutional opinions, I began to look into works of history for proofs and arguments that would support my political beliefs." *Lettres sur l'Histoire de France,* cited in Mellon, 5. See also Gossman, "Augustin Thierry and Liberal Historiography"; Mitzman, *Michelet, Historian,* "Part 1. Prelude, 1789–1831," 3–26; Susan Dunn, *The Deaths of Louis XVI: Regicide and the French Political Imagination* (Princeton: Princeton University Press, 1994).

28. The term "fantasmagorie," the art of using of optical illusions to make phantoms appear, was introduced into the French language about 1787; see Oscar Bloch and Walter von Wartburg, *Dictionnaire étymologique de la langue française,* 6th ed. (Paris: PUF, 1975), 651. It became popular through Etienne-Gaspard Robertson's "phantasmagoric" theater, presented in the Capuchin Convent in Paris during the Revolution; see Chapter 3 of the present volume.

29. De même qu'on observe dans ses détails, dans ses mouvements ce grand drame dont nous sommes tous acteurs et témoins, de même on veut connaître ce qu'était avant nous l'existence des peuples et des individus. On exige qu'ils soient évoqués et ramenés vivans sous nos yeux: chacun en tirera ensuite tel jugement qu'il lui plaira, ou même ne songera point à en faire résulter aucune opinion précise. Car il n'y a rien de si impartial que l'imagination: elle n'a nul besoin de conclure; il lui suffit qu'un tableau de la vérité soit venu se retracer devant elle. Telle est le plan que j'ai essayé de suivre en écrivant l'*Histoire des Ducs de Bourgogne de la maison de Valois.*

 Barante, "Préface," 1:35–6.

30. "Sans parler de la révolution que tant de chutes et de catastrophes ont récemment signalée, et qui, couvrant notre sol des ruines de tant d'édifices politiques et religieux, prépara l'imagination de longues rêveries et de profondes méditations." Louis-Antoine-François de Marchangy, *La Gaule Poétique, ou l'Histoire de France considérée dans ses rapports avec la Poésie, l'Eloquence et les Beaux-Arts,* 8 vols. (Paris: C. F. Patris, 1813–17), 4:6.

31. Ibid., 3rd ed., 4 vols. (Paris: C.-F. Patris, Lecointe, & Chaumerot, 1819), 2: 265–7.

32. Qui n'a éprouvé le charme et la curiosité qu'inspirent ces débris et ces témoignages où nous pouvons lire les habitudes du passé? . . . Ils [young students] songeraient aux temps passés, à ce qu'était jadis la société; les souvenirs des époques diverses de la France et de ses grands hommes se graveraient dans leur esprit par la voie des sens . . . Ils ne regarderaient pas les miniatures du roi René, l'éperon de François Ier, le miroir de Diane de Poitiers, sans vouloir connaître les événements et les personnages de ces temps, qui semblent se montrer encore vivants.

 Amable-Guillaume-Prosper Brugière, baron de Barante, "Sur l'acquisition du Musée du Sommerand. Rapport fait à la Chambre des pairs, le 15 juillet 1843," in *Etudes Littéraires et Historiques,* 2 vols. (Paris: Didier, 1858), 2:417–26, 420–3. On the career of Alexandre du Sommerand (1779–1842) whose collection became the nucleus of the Musée de Cluny, see Fabienne Joubert, "Alexandre du Sommerand et les origines du Musée de Cluny," in *Le "Gothique" retrouvé avant Viollet-le-Duc* (Paris: Hôtel de Sully/Caisse Nationale des Monuments et des Sites, 1979), exhibition catalogue by Louis Grodecki et al., 99–104.

33. On ne lui demande plus tant de charmer, par ses récits, des imaginations facilement émues, ou de satisfaire, par ses méditations, des esprits qui ne s'exercent que sur des idées. On y cherche surtout les travaux et les passions de l'homme dans la condition sociale; on veut connaître la nature et le jeu des institutions, pénétrer dans l'intérieur des partis, démêler les secrets de ces influences si compliquées, de ces mouvemens tantôt si orageux, tantôt si cachés, qui font le sort des nations . . . Il faut qu'elle

émeuve et instruise à la fois, qu'elle rouvre l'arène où se sont débattus les opinions, les intérêts, les passions, et y fasse rentrer et revivre des acteurs . . . Alors les faits y tiennent plus de place que les idées, les hommes plus de place que les faits.

"De l'état actuel des sciences historiques en France," *Revue Européenne* 1 (June 1824): 1–17, 2.

34. "Les Stuarts ont passé, les Bourbons resteront, parce qu'en nous rapportant leur gloire, ils ont adopté les libertés récentes, douloureusement enfantées par nos malheurs . . . Alors le drame de la révolution s'est terminé; la France entière s'est reposée avec joie, amour et reconnaissance sous la protection de ses anciens monarques." François-René Chateaubriand, *Les Quatre Stuarts* (1828), reprinted in *Oeuvres Complètes,* 10 vols. (Paris: Eugène & Victor Penaud frères, 1849–50), 3 (1850): 155–272, 267–8.

35. Lamartine's prospectus to *Le Civilisateur* defined the personified approach to history:

La vie du genre humain est tout entière en effet dans la vie des hommes supérieurs de toutes les époques et de toutes les contrées, qui ont illustré, dominé, éclairé leur siècle, et en qui le genre humain se personnifie aux yeux de l'avenir. Les annales de l'univers n'ont intérêt que par les acteurs. Les événemens sont froids et morts.

His selections had been chosen for their poignant anecdotes as well as their cultural significance:

on doit les choisir surtout à l'intérêt épique ou dramatique de leur vie. A ce titre même, plus un de ces grands acteurs du drame humain est méconnu, plus il est malheureuse, plus il est victime, plus il y a des sueurs, de vicissitudes, de larmes et de sang dans son histoire, plus aussi il y a d'intérêt, d'amour, de passion et de culte dans le sentiment de la postérité pour lui, plus il se grave dans l'imagination.

Alphonse-Marie-Louis de Prat de Lamartine, prospectus and "Introduction," in *Le Civilisateur ou Les Hommes Illustres. Histoires de Jeanne d'Arc, Homère, Bernard de Palissy, Christophe Colombe, Cicéron, Gutenberg,* 3 vols. (Paris: Gennequin Aîné, 1852–4), 1:16.

36. J.-P. P. [Jean-Pierre Pagès], "REVOLUTION (*Politique*)," in *Encyclopédie Moderne* 20 (1830): 198–215, 200–1.

37. Augustin Thierry, *Histoire de la Conquête de l'Angleterre par les Normands; de ses causes, et de ses suites jusqu'à nos jours, en Angleterre, en Ecosse, en Irlande et sur le continent,* 3 vols. (Paris: Firmin Didot, 1825), 1:429–30.

38. "Let it be my part in the future to have not attained, but marked, the aim of history, to have called it by a name that nobody had given it. Thierry called it *narration,* and M. Guizot *analysis.* I have named it *resurrection,* and this name will remain." Jules Michelet, *Le Peuple* (1846), cited by Hayden White in "Michelet: Historical Realism as Romance," *Metahistory,* 135–62, 152. See also White's discussion of Michelet in "Interpretation in History," in *Tropics of Discourse,* 51–80.

39. *Mother Death: The Journal of Jules Michelet, 1815–1850,* entry for January 30, 1842, 120–3.

40. Jules Michelet, *Histoire de la révolution française* (1847–53), ed. Gordon Wright, trans. George Cocks (Chicago: University of Chicago Press, 1967), 444–5; cited by White in *Metahistory,* 151.

41. Carlyle, "On History," 382.

42. "les hommes auront toujours besoin d'être rappelée à leurs devoirs par la Voye du Sentiment." This anonymous writer suggested that a public Temple of Virtue be constructed in each town; separate galleries would be devoted to love of country, spouse, father, son, and so on. Archives de l'Académie des Beaux-Arts, Paris, ms. 2D1 (concours, pièces manuscrits, an 4–8), anon., response no. 3, nonpaginated.

43. "pendant longtemps, la peinture ayant abandonné les riantes et hautes régions

de la poésie et de l'histoire, se vit contrainte comme par enrôlement forcé, de promener ses pinceaux à la suite des armées, de se traîner sur tous les champs de batailles, de parcourir les bivouacs et les camps." Antoine Chrysostome Quatremère de Quincy, "Eloge historique de M. Girodet, peintre. Lue à la séance publique de l'Académie Royale des Beaux-Arts, le 1er octobre 1825," in *Recueil des Notices Historiques lues dans les séances publiques de l'Académie Royale des Beaux-Arts,* 2 vols. (Paris, 1834 and 1837), 1:317. Quatremère de Quincy (1755–1849) advocated Neoplatonic idealism in *Essai sur l'Idéal dans ses applications pratiques aux oeuvres de l'imitation propre aux arts du dessin* (Paris: Adrien Leclerc, 1837), much of it written in 1805, and *Essai sur la nature, le but et les moyens de l'imitation dans les beaux-arts* (Paris: J. Didot l'aîné, 1823). See René Schneider, *L'Esthétique classique chez Quatremère de Quincy* (Paris: Hachette, 1910).

44. "N'allons donc point favoriser ce mouvement de l'instinct vulgaire d'une multitude ignorante, dont on ne doit étudier les penchants que pour y mieux savoir resister. Gardons nous aussi d'écouter les conseils ou les pretension d'une sort de mode, qu'une vanité ridicule voudrait décorer du titre de patriotisme." Antoine Chrysostome Quatremère de Quincy, "De l'emploi des sujets moderne dans la poésie et de leur abus dans la peinture," April 24, 1825, Archives de l'Institut de France, Paris, ms. AA 34A, *tome* 5, no. 2; published in *Recueil des discours prononcés dans la séance publique annuelle* (Paris: Firmin Didot, 1825), 51–65, 64.

45. Le peintre doit parler aux yeux en même temps qu'à l'esprit, et il arrive souvent que tel fait de nos annales, qui frappe en récit, ne produit plus en tableau le même effet. A Dieu ne plaise que je veuille détourner nos artistes de ces annales sacrées! La meilleure manière d'écrire l'histoire de France, pour la graver dans la mémoire et dans le coeur des Français, est de la peindre. Mais ces représentations nationales n'exerceront toute leur influence que lorsqu'elles seront réellement monumentales, c'est-a-dire lorsqu'elles décorent les lieux où les événemens se sont passés. Les administrateurs chargés de la direction des beaux-arts apprécieront cette idée." M*** [Edmé-François-Antoine-Marie Miel], *Essai sur le Salon de 1817, ou Examen critique des principaux ouvrages dont l'exposition se compose, accompagné de gravures au trait* (Paris: Delauray & Pélicier, 1817), 269–70. Edmé-François-Antoine-Marie Miel (1775–1842) was a division chief in the Prefecture of the Seine, Paris. He was an amateur of the arts, and his taste ranged freely from classical antiquity to Troubadour medievalism. His advice on acquisitions was taken by the government. In 1820, the Département des Vosges acquired Jeanne d'Arc's hut, which was restored as a national shrine. The Troubadour artist Laurent's painting of Jeanne dedicating herself to the salvation of France before a statue of Saint Michael (Salon of 1817, no. 484; lost) was displayed inside the hut by order of Louis XVIII. See Norman Ziff, "Jeanne d'Arc and French Restoration Art," *Gazette des beaux-arts,* 6th ser., 93 (January 1979): 37–48, 37–8.

46. The duc de Berry collected Dutch and Flemish Old Masters. The duchesse preferred modern French artists: Boilly, Drolling, the école de Lyon. She bought 19 paintings from the Salon of 1819, 22 paintings from the Salon of 1824. The curator of her collection, the chevalier Féréol de Bonnemaison, published an illustrated guide: *Galerie de S. A. R. la Duchesse de Berry. Ecole française; peintres modernes,* 3 folio vols. (Paris: J. Didot l'aîné, 1822–4). See Barbara Scott, "The Duchess of Berry as a Patron of the Arts," *Apollo* 124, no. 296 (October 1986): 345–53.

47. Of the more than 1,300 works in the Salon of 1819, 65 were commissioned by the Maison du Roi, 37 by the Ministry of the Interior, 20 by the City of Paris's prefect of the Seine, and 23 (10 by Horace Vernet) by the duc d'Orléans. Lorenz E. A. Eitner, *Géricault: His Life and Work* (London: Orbis, 1983), 345, n. 144. Two guides to the collection were published by Jean Vatout and J. P. Quénot: *Catalogue historique et descriptif des tableaux appartenans à S. A. R.*

Mgr le duc d'Orléans, 4 vols. (Paris: Gaultier-Laguionie, 1823–6), and an illustrated, abbreviated guide, *Galerie lithographiée de S. A. R. Mgr le Duc d'Orléans,* 2 folio vols. (Paris: Charles Motte, 1824–9). For his son Ferdinand-Philippe's patronage of the arts, see *Le Mécénat du duc d'Orléans, 1830–1842,* (Paris: Délégation à l'Action Artistique de la Ville de Paris, 1993), exhibition catalogue by Hervé Robert et al., particularly Robert, "Une Prestigieuse Galerie de tableaux," 88–109.

48. Etienne-Jean Delécluze, in his *Précis d'un traité de peinture* (Paris: Bureau de l'Encyclopédie Portative, 1828), implacably separated the beautiful truth of historical painting, whose main goal was "la représentation de l'homme considérée dans l'ensemble de ses facultés" (mental as well as physical), from the ugly realism of genre painting, which presented "l'homme sous le point de vue de la vérité, du comique, du ridicule, du grotesque, et enfin de la caricature" (237).

49. Alphonse Giroux, a restorer, formerly a pupil of David, bought works by the Troubadour artists Révoil, Granet, and Ducis, and later Bonington and Constable, particularly scenes of Gothic architecture (40 works by Renoux, who worked for Daguerre's Diorama). Giroux organized an exhibition in 1809 in his studio; and in 1816, he announced an exhibition of "tableaux anciens et modernes." He published an album of engravings after works in stock in 1819. John Arrowsmith was particularly interested in scenes from British history and literature; Delaroche's *Jeanne d'Arc* (see Chap. 4 of the present volume) belonged to him when it was exhibited in the Salon of 1824, and he bought a second version of the same subject from the artist. Schroth bought Delaroche's *Miss Macdonald* (see Chap. 4). Charles Paillet, commissaire expert des musées royaux, organized exhibitions in the Galerie Lebrun, the most famous of them the 1826 exhibition in support of Greek independence, which included more than 200 works (by David, Gros, Horace Vernet, Delacroix, and Ingres, among others) and one "au profit de l'extinction de la mendicité" in 1829. In 1827, Henri Rittner opened his establishment in partnership with Osterwald; Rittner would begin his celebrated partnership with Adolphe Goupil in 1829. The latter two were noted for their engravings after Delaroche, Ingres, and Léopold Robert. In 1827 Binant organized an exhibition at the Salle Lebrun of works refused by the Salon jury. In 1829 he announced a permanent exhibition. Fleury-Chavant claimed an exhibition of more than 1,000 paintings in the same year. Gaugain's Musée Colbert also opened in 1829; he intended to open branches of his house in London and Berlin. See Linda Whiteley, "Art et commerce d'art en France," *Romantisme* 4 (1983): 65–75; Patricia Mainardi, "The Double Exhibition in Nineteenth-Century France," *Art Journal* 48, no. 1 (Spring 1989): 23–8; Athanassoglou-Kallmyer, *French Images from the Greek War of Independence, 1821–1830,* 39–41 and appendix 1, 159–65; Beth S. Wright, "Henri Gaugain et le musée Colbert: l'entreprise d'un directeur de galerie et d'un éditeur d'art à l'époque romantique," *Nouvelles de l'estampe,* no. 114 (December 1990): 24–30.

50. au moment où les artistes vivants étaient sur le point de se voir fermer le véritable musée national, il n'était pas hors de propos de leur offrir, même sous le rapport de la dénomination [the term "Musée Colbert"], un petit dédommagement . . . Les fondateurs ont eu le bon esprit de ne point se montrer exclusifs à l'égard de telle ou telle école, et de ne proscrire que les tableaux que proscriraient les bien séances. Du reste, on y voit face à face Girodet et Gericault, MM. Guillemot, Court, Steube, et MM. Sigalon, Delacroix, Roqueplan, Collin, Deveria, Johannot, voire même M. Boullanger. C'est au public à choisir, et à décerner les couronnes.

"F." [Charles Farcy], "MUSEE COLBERT. Exhibition permanente et publique de tableaux, statues, bronzes, etc., des artistes modernes, français et étrangers," *Journal des Artistes,* no. 20 (November 15, 1829), 307–8, 308; errors in spelling in the original text. See also "F.," "Musée du Louvre. – Musée Colbert," *Journal des Artistes,* no. 25 (December 20, 1829), 385–7. In 1835, Farcy lamented the current crisis, which he had predicted since 1827: the challenging of the official

Parisian Salon by provincial exhibitions organized by societies of artists and private dealers. "F.," "Situation actuelle des Beaux-Arts. Le Salon, le Musée Colbert, les Expositions départementales," *Journal des Artistes*, no. 14 (April 5, 1835), 209–14.

51. Between 1828 and 1841, the number of daily newspapers in Paris doubled (from 14 to 28); the number of weekly and monthly newspapers almost tripled (from 132 to 312). See Neil McWilliam, "Opinions professionnelles: Critique d'art et économie de la culture sous la Monarchie de Juillet," *Romantisme* 71 (1991): 19–30. He lists thirty reviews of the Salon of 1817 and more than seventy of the Salon of 1827. See Neil McWilliam et al., eds., *A Bibliography of Salon Criticism in Paris from the Ancien Régime to the Restoration, 1699–1827* (Cambridge: Cambridge University Press, 1991), and Appendix 3 "Production of Salon Pamphlets and Press Reviews," in Richard Wrigley, *The Origins of French Art Criticism from the Ancien Régime to the Restoration* (Oxford: Clarendon Press, 1993), 358–9, an indispensable guide to art criticism for this period. On the Restoration press and its censorship, see E. Hatin, *Histoire politique et littéraire de la presse en France*, 8 vols. (Paris, 1859–61); Charles-Marie Des Granges, *La Press littéraire sous la Restauration, 1815–1830. Le Romantisme et la critique* (Paris: Société du Mercure de France, 1907); Edmond Eggli and Pierre Martino, *Le Débat romantique en France (1813–1830). Pamphlets. Manifestes. Polémiques de presse, vol. 1: 1813–1816* (Paris: Belles Lettres, 1933); Irene Collins, *The Government and the Newspaper Press in France 1814–1881* (Oxford: Oxford University Press, 1959); Athanassoglou-Kallmyer, *Delacroix: Prints, Politics and Satire, 1814–1822*. On Restoration art criticism, see Pontus Grate, *Deux critiques d'art de l'époque romantique: Gustave Planche et Théophile Thoré* (Stockholm: Almquist & Wiksell, 1959); Grate, "La Critique d'art et la bataille romantique," *Gazette des beaux-arts*, 6th ser., 54 (1959): 129–48; Francis Haskell, "Art and the Language of Politics," *Journal of European Studies* 4 (1974): 215–32, reprinted in *Past & Present in Art & Taste*, 65–74; Marguerite Iknayan, *The Concave Mirror: From Imitation to Expression in French Esthetic Theory, 1800–1830*, Stanford University, French and Italian Studies, no. 30 (Palo Alto, CA: ANMA Libri, 1983); Susan L. Siegfried, "The Politicisation of Art Criticism in the post-Revolutionary Press," in *Art Criticism and Its Institutions in Nineteenth-century France*, ed. Michael R. Orwicz (New York: Manchester University Press, 1994), 9–28; Marijke Jonker, "Diderot's Shade; The Discussion on 'Ut pictura poesis' and Expression in French Art Criticism, 1819–1840," dissertation for Amsterdam University, 1994; Lynne Ambrosini, "Genre Painting under the Restoration and July Monarchy: The Critics Confront Popular Art," *Gazette des beaux-arts*, 6th ser., 135 (January 1995): 41–52.

52. See Jal's memoirs, *Souvenirs d'un homme de lettres, 1795–1873* (Paris: Léon Techener, 1877). Jal signed his reviews "ex-officier de marine"; Vergnaud had been an officer in the artillery.

53. E. Jouy and A. Jay, *Salon d'Horace Vernet. Analyse historique et pittoresque de quarante-cinq tableaux exposés chez lui en 1822* (Paris, 1822). Victor-Joseph-Etienne Jouy (b. 1764) had served in the army until he was suspended in 1793 for political reasons, returning to service in 1810. Wrigley describes him as "an exponent of *encyclopédiste* secularism" (*Origins of French Art Criticism,* 15) and stresses his search for art directed to the general public's concerns and taste. On Vernet and Bonapartist radicalism in this period, see Nina Maria Athanassoglou-Kallmyer, "*Imago Belli*: Horace Vernet's *L'Atelier* as an Image of Radical Militarism under the Restoration," *Art Bulletin* 68, no. 2 (June 1986): 268–80.

54. Adolphe Thiers (1797–1877), author of *Histoire de la Revolution française* (1823–7), reviewed the Salons of 1822 and 1824 for *Le Globe, Le Constitutionnel* (where he became one of the editors in 1825, with Jay), and *La Revue Européenne*. In a letter of 1822, while in a circle that included the baron Gérard,

Girodet, Carle and Horace Vernet, Delacroix, David d'Angers, and Ingres, Thiers wrote that his influence on artists was even greater through his conversations than through his reviews of their work. See Henri Malo, "M. Thiers et les artistes de son temps," *Revue de Paris* (July 1, 1924), 141–59. In 1830, Thiers and Armand Carrel founded *Le National.* Ludovic Vitet (1802–73) succeeded Thiers as art critic for *Le Globe.* Vitet was a historian and dramatist; his plays are discussed in Chapter 4 of the present volume. He was one of the editors of *Le Globe,* 1824–30. In October 1830, after the July Revolution, the position of inspecteur général des monuments historiques was created for him by Guizot; he held it until 1834. Thereafter he was general secretary in the Ministry of Commerce and deputy for the département Seine-Inférieur from 1834 to 1848. See François Guizot (1787–1874), *De l'état des beaux-arts en France et du Salon de 1810* (Paris, 1810), reprinted in Guizot, *Etudes sur les Beaux-Arts en général* 2nd ed. (Paris: Didier, 1852), with his *Essai sur les limites qui séparent et les liens qui unissent les Beaux-Arts* (1816) and his introduction to Henri Laurent's *Le Musée Royal,* engravings after the historical paintings in the Louvre with descriptive texts by E. Q. Visconti, C. O. F. J. B. de Clarac, and F. P. Guizot, 2 vols. (Paris: P. Didot l'aîné, 1816–18). During the Restoration, Guizot taught modern history at the Sorbonne (1812–22, returning in 1828) and published *Essais sur l'histoire de France . . . pour servir de complément aux "Observations sur l'histoire de France" de l'abbé de Mably* (1823), *Histoire générale de la civilisation en Europe depuis la chute de l'Empire romain jusqu'à la Revolution française,* and *Histoire de la civilisation en France depuis la chute de l'Empire romain jusqu'en 1789* (1828–30) (the latter two contained in his *Cours d'histoire moderne* [1829–32]). He also published political pamphlets and archival collections, such as the *Collection des mémoires relatifs à l'histoire de France depuis la fondation de la monarchie française jusqu'au XIIIe siècle,* 30 vols. (1823–35), and *Collection des Mémoires relatifs de la Révolution d'Angleterre,* which began publication in 1823 and had already reached 25 volumes by 1827. The publication of *Histoire de la Révolution d'Angleterre* (1826–8) was interrupted when Guizot was restored to his university post; it was completed in 1856. See Pouthas, *Guizot pendant la Restauration;* Rosenvallon, *Le Moment Guizot;* Theis, "Guizot et les institutions de mémoire"; Poulot, "The Birth of Heritage. 'Le Moment Guizot' "; and Crossley, *French Historians and Romanticism.*

55. Paul Dubois, a former Carbonarist, led *Le Globe*'s editorial board. Another former Carbonarist reviewing Salon exhibitions was Théodore Jouffroy (1798–1843), a philosopher who espoused Victor Cousin's doctrine of eclecticism. See Jean-Jacques Goblot, *Le Globe, 1824–1830. Documents pour servir à l'histoire de la presse littéraire* (Paris: Honoré Champion, 1993); Patrice Vermeren, "Les Têtes rondes du *Globe* et la nouvelle philosophie de Paris. (Jouffroy et Damiron)," *Romantisme* 88 (1995): 23–34.

56. Charles-Paul Landon (1760–1826) was curator of the Louvre and of the duchesse de Berry's collection and painter to the duc de Berry. Landon had studied with Regnault, Vincent, and Taillaisson. He had won the prix de Rome in 1792 but remained in Paris, where he wrote articles and pamphlets and became one of the owners of the conservative journal *Gazette de France.* He launched several art journals during the Empire, including *Nouvelles des arts* (1802–5), and his *Annales du Musée et de l'école moderne des beaux-arts* (1801–) became the official journal of government aesthetics as they applied to the Salon.

57. Quant à moi, qui depuis 1830, observe la marée toujours montante de l'océan démocratique, je n'ai pas encore pu me rendre compte de ce qui peut avoir causé le mélange monstrueux des opinions républicaines avec le retour du goût pour les ouvrages de Watteau et de Boucher . . . En 1789 jusqu'en 1797, au moins fut-on conséquent et l'on vit le goût qui régnait dans les arts s'accorder avec les idées politiques que l'on professait alors . . . Or, par un contre-sens inexplicable, je le répète, ce sont nos plus

fiers républicains de la veille qui, depuis vingt ans tout à l'heure, ont préconisé avec une espèce de fureur le goût et les ouvrages de Watteau, de Lancret et de Boucher.

Delécluze, *Journal des Débats* (July 31, 1849), cited by Haskell in "Art and the Language of Politics," in *Past & Present,* 69–70. Etienne-Jean Delécluze (1781–1863), unwilling to accept commissions for Napoleonic subjects, lived on a small income as a *rentier* and taught drawing until he began to review art in 1819. His political opinions were Liberal, but the newspaper that published his reviews was the conservative *Journal des Débats.* See Etienne Delécluze, *Louis David, son école et son temps. Souvenirs* (Paris: Didier, 1855); Delécluze, *Souvenirs de soixante ans* (Paris: Michel Lévy frères, 1862). See also Robert Baschet, *E.J. Delécluze, témoin de son temps 1781–1863* (Paris: Boivin, 1942); *Journal de Delécluze, 1824–1828,* ed. Robert Baschet, (Paris: Grasset, 1948).

58. Pierre-Alexandre Coupin became editor of the *Revue encyclopédique* in 1825. He published *Essai sur J.-L. David* (Paris, 1827), and *Oeuvres posthumes de Girodet-Trioson, peintre d'histoire, suivies de sa correspondance, précédées d'une Notice historique, et mises en ordre par P.-A. Coupin,* 2 vols. (Paris, 1829). On Coupin as the biographer of the Davidian school, see Crow, *Emulation,* 273–5.

59. François-Charles Farcy (1792–1869). He directed the *Journal des Artistes* until 1841 and intended it to be an informational conduit (publishing competition guidelines, artists' obituaries, and the like) as well as providing a conservative aesthetic critical voice. One of his aesthetic victories was the reintroduction in 1827 at the Ecole des Beaux-Arts of compulsory examinations in perspective. See Nancy Ann Roth, "*L'Artiste* and *L'Art pour L'Art*: The New Cultural Journalism in the July Monarchy," *Art Journal* 48, no. 1 (Spring 1989): 35–9.

60. Auguste-Hilarion, comte de Kératry (1767–1859), published *Du Beau dans les arts d'imitation,* 2 vols. (Paris: P. Audot, 1822), and *Guide de l'artiste et de l'amateur, contenant le poème de la peinture de Dufresnoy . . . notes de Reynolds; de l'Essai sur la peinture, de Diderot; d'une lettre sur le paysage de Gessner* (Paris, 1824). See Pierre Angrand, *Le Comte de Forbin et le Louvre en 1819* (Paris: Bibliothèque des Arts, 1972), 168, 173.

61. Jacques-Nicolas Paillot de Montabert, "De la beauté intellectuelle et morale du sujet," chap. 141 of *Traité de la Peinture,* 9 vols. (Paris: Bossange, 1829), 4:456. Paillot de Montabert (1771–1849) also wrote *Théorie du geste dans l'art de la peinture renfermant plusieurs préceptes applicables à l'art du théâtre* (Paris: Magimel, 1813). The seminal role of these works has been noted by George Levitine in *The Dawn of Bohemianism. The "Barbu" Rebellion and Primitivism in Neoclassical France* (University Park: Pennsylvania State University Press, 1978), and Dorothy Johnson, in "Corporality and Communication: The Gestural Revolution of Diderot, David, and *The Oath of the Horatii,*" *Art Bulletin* 71, no. 1 (March 1989): 92–113.

CHAPTER THREE. "PRECIOUS RELICS FROM THE SHIPWRECK OF GENERATIONS"

1. Jean-Auguste-Dominique Ingres (1780–1867); listed Salon of 1822, no. 719; exhibited Salon of 1824; Galerie des Arts, Blvd. Bonne-Nouvelle 1846, no. 51; Exposition Universelle 1855, no. 3355. Oil/panel; 47 × 56 cm; $18\frac{1}{2}$ × 22 in., signed and dated 1821. Commissioned by comte Amédée de Pastoret; sold by the marquise du Plessis-Bellière (his daughter) at Hôtel Drouot, Paris, May 10–11, 1897, lot no. 86, to M. Haro; Frappier collection in Paris; Bessonneau d'Angers sale in Paris, June 15, 1954; gift by Paul Rosenberg & Co. to the Wadsworth Atheneum, Hartford, CT, in 1959 (catalogue no. 37). See Edward A. Bryant, "Notes of J. A. D. Ingres' *Entry into Paris of the Dauphin, future Charles V.,*" *Wadsworth Atheneum Bulletin,* 5th ser., 3 (1959): 16–21; Robert Rosenblum, *Jean-Auguste-Dominique Ingres* (London: Thames and Hudson,

tionaux, 1967), exhibition organized by Michel Laclotte et al., Daniel Ternois's entry no. 121, 174–5; Condon et al., *In Pursuit of Perfection*, 102; *Richard Parkes Bonington. "On the Pleasures of Painting"* (New Haven: Yale Center for British Art/Yale University Press, 1991), exhibition catalogue by Patrick Noon, no. 144, 276; Vigne, *Ingres*, 154, 254–5.

2. The comte de Pastoret was the author of a book on Henri IV and a pamphlet on the duc de Berry, whom Ingres portrayed in 1826 (Art Institute of Chicago). See *French Painting 1774–1830: The Age of Revolution* (Paris, Grand Palais, November 16, 1974–February 3, 1975; Detroit Institute of Arts, March 5–May 4, 1975; New York, Metropolitan Museum of Art, June 12–September 7, 1975), exhibition catalogue by Frederick J. Cummings, Pierre Rosenberg, and Robert Rosenblum; Jacques Foucart's entry no. 111, 514–16; Albert Boime, "Declassicizing the Academic: A Realist View of Ingres," *Art History* 8, no. 1 (March 1985): 49–65.

3. Ternois, Rosenblum, and Condon have pointed out the influence of Jean Fouquet's illustrations (the dauphin's entry and a reception for Charles IV) in the *Grandes Chroniques de France* (c.1460–70) and of Ingres's two tracings (Montauban, Musée Ingres, 867.4179 and 867.4180) after medieval vignettes in Montfaucon's *Les Monuments de la Monarchie française* (Paris, 1729–33), as well as compositional similarities to Franz Pforr's *Entry of the Emperor Rudolph of Hapsburg into Basel in 1273* (1808–10). Bryant also suggested the influence of Benozzo Gozzoli and Gentile da Fabriano.

4. "I am convinced that the early history of France, of the time of Louis and others, would be a new source to exploit; that the costumes of those days are very beautiful . . . The love of religion which inspired those warlike old times gives to the paintings an atmosphere that is mystical, simple and grand." Bryant, "Notes of Ingres' *Entry into Paris*," 19, citing Jean Cassou, *Ingres* (Bruxelles: Connaissance, 1947), 42.

5. De nos preux chevaliers peint les faits romanesques.
Les seigneurs chevaliers sont encore pittoresques.
Armés de noirs créneaux, leurs gothiques donjons
Leurs longs appartements tapissés de blasons
Et de portraits du temps des héros des croisades,
De vieux pavois, cloués à de sombres arcades,
Rappellent à l'esprit et présentent aux yeux
Le touchant souvenir de nos braves aïeux.
Dans leurs ameublemens se peint leur caractère:
Là, tout parle d'amour, et d'honneur et de guerre,
De leur religion, de leur fervente foi,
De leur fidélité pour leur dame et leur roi.

Anne-Louis Girodet-Trioson, "Veillées. Essai poétique sur l'école française," published posthumously by Coupin in *Oeuvres Posthumes de Girodet-Trioson*, 1:387–8.

6. Bann associates Troubadour painting with Bouton and Daguerre's theatrical panoramas and identifies such illusionism with Barthes's "reality effect," when it is considered as an emotionally neutral "technical surprise"; see *The Clothing of Clio*, 56–9, following a discussion of Daguerre's *Ruins of the Chapel of Holyrood* (1824), and *Romanticism and the Rise of History*, 122–4, where he says that the same work presages photography's "enunciatory role of perspective and the coding of luminosity with regard to surface" (125). I disagree, for two reasons. First, illusionism's impact on the spectator's senses and emotions differs radically for a small-scale painting and a panorama; an anonymous critic contrasted the comparative pleasure of seeing a small-scale painting in a frame, on a wall, accompanied by other paintings, with the pleasure of surrendering the ability to establish such qualifying or distancing measures. "Peinture. Des illusions de la Peinture au Diorama," *L'Observateur des Beaux-Arts*, no. 17 (June

5, 1828), 66–7. Second, Bann stresses that Barthes's reality effect depends on the obsessive inclusion of the "useless detail": that which convinces us that we are seeing "concrete reality" because it is unmotivated, insignificant, redundant, casual, transitory. He relates such an effect to the historiography of Thiers, who vowed to be objective: "To be simply true, to be as things themselves are, to be nothing more than them, to be nothing other than by them, like them, as much as them." Barthes, "The Reality Effect," 17, n. 11. Thiers's historiographic view is very different from Marchangy's emotionally committed medievalism. I see the optical illusion of Troubadour works as functioning according to Barthes's explanation of the classical rhetorical figure of hypotyposis, "whose function was to 'place things before the hearer's eyes,' not in a neutral manner, merely reporting, but by giving to the scene all the radiance of desire (this was a division of vividly illumined discourse, with prismatic outlines: the *illustris oratio*)." "The reality effect," 14.

7. "As for the spectacle, it stirs the emotions, but it is less a matter of art than the others [the elements of tragedy], and has least to do with poetry, for a tragedy can achieve its effect even apart from the performance and the actors. Indeed, spectacular effects belong to the craft of the property man rather than to that of the poet." Aristotle, *The Poetics*, VI, 15. See also XIV, 26–7.

8. "L'archéologie étant signalée maintenant comme l'une des sources les plus pures de l'histoire, il n'est plus permis de méconnaître l'importance des recherches et des méditations de l'antiquaire; aussi est-on convaincu généralement de l'utilité réelle qu'on peut retirer de l'examen attentif des moindres débris qu'épargna le torrent des âges. Ces restes précieux sont des témoins muets, mais irrécusables, du naufrage successif des générations." Nicolas-Xavier Willemin, "Préface," in *Monumens Français Inédits . . . dessinés, coloriés et gravés d'après les originaux pour servir à l'histoire des arts depuis le VIe siècle jusqu'au commencement du XVIIe* (Paris: Leblanc, 1825), 3. The engraver Willemin (1763–1833), a pupil of Taillasson and Lagrénée *fils*, was a friend of Alexandre Lenoir. He guided Révoil and other artists in forming their collections. In 1806, he began to publish this work's 302 plates, most of which he designed and engraved himself, representing architectural fragments, ivories, figures, or entire pages from stained-glass windows and illuminated manuscripts, primarily from the Middle Ages. Financial difficulties delayed publication at several points. After his death, André Pottier, curator of Rouen's library, wrote and published the final notices. The complete work was published in 1839 by Willemin's daughter in two volumes (Paris: Crapelet, London, and Mannheim).

9. *Mort de Marie Stuart, Reine d'Ecosse, décapitée par l'Ordre d'Elisabeth*, in Pierre Le Tourneur, *Histoire d'Angleterre représentée par figures, accompagnées d'un Précis historique* (Paris: David, 1784), 2 *tomes* in 1 vol., 105–9. The figures were engraved by François-Anne David, primarily after Lejeune. The work was dedicated to the comte d'Artois; 425 copies were printed.

10. Willoughby Bertie, fourth earl of Abingdon, commissioned the works from John Francis Rigaud (1742–1810) in 1789. They were engraved by William Nelson Gardiner in 1790 and 1791; the paintings were exhibited at the Royal Academy in 1791–2. Rigaud, born to French Protestant parents in Turin, was trained in Italy and settled in England in 1771. He became a full member of the Royal Academy and participated in Boydell's Shakespeare Gallery, Macklin's Poet's Gallery, and Bowyer's Historic Gallery. See William L. Pressly, "*Facts and Recollections of the XVIIIth Century in a Memoir of John Francis Rigaud Esq., R.A., by Stephen Francis Dutilh Rigaud, Abridged and Edited with an Introduction and Notes*," *Journal of the Walpole Society* 50 (1984): 1–164, 84 and figs. 45–51: *Mary Queen of Scots Going to the Place of Execution* (Royal Academy 1791, no. 568); *Mary Queen of Scots at Prayers on the Scaffold* (Royal Academy 1791, no. 569); *Mary Queen of Scots at the Block* (Royal Academy 1791, no. 570); *Mary Queen of Scots Beheaded* (Royal Academy 1791, no. 571); *The Sheriff Entering the Chapel of Mary Queen of Scots the Morning of her Execu-*

tion (Royal Academy 1792 no. 466); *The Funeral Procession of Mary Queen of Scots* (Royal Academy 1792 no. 467); *The Entombing of Mary Queen of Scots* (Royal Academy 1792 no. 468).

11. C. P. Landon, *Nouvelles des Arts. Peinture, Sculpture, Architecture, Gravure* (Paris, 1804), 281–2.

12. Jean-Baptiste Vermay (c.1786–1832); *Marie Stuart recevant sa sentence de mort* (Arenenberg, Napoleon Museum; 1.60 × 1.27 m); possibly exhibited Salon of 1814, no. 934. This work is a replica of one exhibited in the Salon of 1808, no. 616 (lost). Collection of the Empress Joséphine (S. Grandjean, *L'Inventaire après décès de l'Impératrice Joséphine à Malmaison* [Paris: Réunion des Musées Nationaux, 1964], no. 1139), and of Queen Hortense. See Marie-Claude Chaudonneret, *Fleury Richard et Pierre Révoil. La Peinture Troubadour* (Paris: Arthena, 1980), 28–9 and 44; Alain Pougetoux, "Peinture 'troubadour,' histoire et littérature; autour de deux tableaux des collections de l'impératrice Joséphine," *Revue du Louvre* 44, no. 2 (April 1994): 51–60, 51–2. He notes a third, variant example (Hôtel Drouot, sales of December 20, 1989, no. 5, and January 30, 1991, no. 145; 129 × 162 cm; New York, private collection), which Nadia Tscherny believes is more likely to have been the one sent to the 1814 Salon. See Tscherny, "A Fascination with the Enemy: Subjects from British History," in Nadia Tscherny and Guy Stair Sainty, *Romance & Chivalry: History and Literature Reflected in Early Nineteenth-Century French Painting* (New York: Stair Sainty Mattiesen, 1996; exhibition catalogue by Nadia Tscherny and Guy Stair Sainty et al., 1996, 106–23 and entry no. 55. In 1808, Vermay's Salon debut, Landon praised the painting, and Vermay received a medal. C. P. Landon, *Annales du Musée et de l'école moderne des Beaux-Arts. Salon de 1808*, 2 vols. (Paris, 1808), 1:62–3. In 1815, Vermay went into exile in Havana, where he founded a school of drawing and painting. Delécluze noted this when he commented on paintings in the Salon of 1827 and recalled Vermay's *Mary Stuart*, its ease, simplicity, and effect, in contrast to the art of Richard, Révoil, and Laurent (*Journal,* ed. Baschet, 481).

13. The pendants were issued by F. Janet. See Beth S. Wright, "The Auld Alliance in Nineteenth-Century French Painting: The Changing Concept of Mary Stuart, 1814–1833," *Arts Magazine* 58, no. 87 (March 1984): 97–107. F. J. Garneray, Salon of 1819, no. 479: "*Marie Stuart reine d'Ecosse*. Cette malheureuse Princesse, enfermée au château de Lochleven, presse avec ferveur un crucifix contre son coeur, implorant le secours du Ciel contre ses persécuteurs qui, après l'avoir détenue en diverses prisons pendant plus de dix-huit ans, lui firent trancher la tête." The print, entitled *Marie-Antoinette au Temple*, is discussed in Marcel Aubert and Marcel Roux, *Inventaire Analytique de la Collection de Vinck*. Vol. 3: *La Législative et la Convention* (Paris: Imprimerie Nationale, 1921), 206–7, *tome* 29, no. 4949, folio 46. My attention was first drawn to this print by François Pupil, whose assistance I gratefully acknowledge. I would also like to express my appreciation to the entire staff of the Cabinet des Estampes of the Bibliothèque Nationale, whose expertise and generosity matches the superb collection of historical prints that were donated by de Vinck and by Hennin.

14. Alphonse L***, *Réflexions sur l'art de la peinture et son état actuel en France* (Paris: Gillé, 1815), 17–20.

15. M. Richard aurait mieux fait de nous présenter son sujet sous ce titre plus modeste: *Vue d'une prison, où l'on aperçoit Marie Stuart, reine d'Ecosse, s'administrant elle-même le sacrement de l'Eucharistie.* En effet, cette figure placée dans l'éloignement, n'est ici qu'un accessoire, et quoi qu'elle soit posée avec assez de goût et de sentiment, on ne peut nier que ces murs et ces voûtes éclairées par la lumière qui s'échappe d'une croisée au-dessus de sa tête, ne soient la partie principale du tableau . . . Je ne crois pas inutile de faire remarquer dans quel principe différent un peintre d'histoire aurait conçu ce sujet vraiment pathétique. Son premier soin eût été de placer sa figure sur le premier plan, et de sacrifier tous les accessoires qui auraient pu

distraire le spectateur . . . il aurait déployé toutes les ressources de son art, pour rendre avec énergie, et en même temps avec grâce, sa confiance sans bournes dans la divinité, et sa resignation sublime. C'est ainsi qu'il serait parvenu à émouvoir le spectateur, et à exciter la compassion dans son âme. M. Richard n'a travaillé que pour le plaisir des yeux.

François-Séraphin Delpech, *Examen raisonné des ouvrages de peinture, sculpture et gravure exposés au Salon du Louvre en 1814* (Paris, 1814), 148–9. Richard's lost *Marie Stuart, reine d'Ecosse, s'administrant elle-même le sacrement de l'Eucharistie* was exhibited in the Salon of 1808, no. 496 (acquired by Mme de Mortefontaine de Saint-Fargeau for 6,000 francs) and the Salon of 1814, no. 787; dimensions of 36 × 30 *pouces* (97 × 81 cm); see Chaudonneret, *Richard et Révoil*, catalogue no. 21, 73.

16. "Comment se fait-il qu'un peintre comme M. Coupin de la Couperie . . . tombe dans une erreur aussi forte que celle qui l'a entraîné à détailler minutieusement une énorme chapelle où il ne se trouve qu'une seule figure vivante? . . . tout cet appareil architectural . . . brouille la vue et disperse l'attention . . . Dans tout tems n'a-t-on pas subordonner les détails au sujet principal? Et n'est-il pas incroyable que l'on me force de regarder du marbre et des pierres de préférence à une belle femme éplorée? Dans la nature tout est également visible, dira-t-on: oui, pour le spectateur qui reste froid, et le peintre qui ne cherche pas à me toucher; mais dès qu'il y a passion tout s'efface, tout disparait autour de l'objet qui m'émeut; que dans un cercle brillant où tous les objets attirent également mon oeil observateur, je voye tous-à-coup quelqu'un pâlir et tomber de son siège, à l'instant même un brouillard semble dérober tous les assistans à ma vue, et je n'ai plus d'yeux et d'attention que pour celui qui souffre.

E. J. D. [Etienne-Jean Delécluze], "Beaux-Arts. Exposition. Salon de 1822. 8e article," *Le Moniteur universel*, no. 156 (June 5, 1822), 802.

17. Charles-Marie Bouton (1781–1853). Salon of 1819, no. 164, "*Charles Edouard*. Après avoir fait de vaines tentatives pour remonter au trône de ses aïeux, le malheureux Charles-Edouard Stuart, dont la tête était mise à prix, fut contraint de se réfugier dans les montagnes d'Ecosse, caché sous les habits d'un montagnard. Le moment du sujet est celui où Mademoiselle Makdonall découvre sa retraite et lui apporte du secours."

18. James II died in exile in 1701. The first Jacobite rebellion occurred in 1715 in the name of his son, James Edward, the "Old Pretender." The supporters of the Stuarts were known as Jacobites, after the Latin name for James, "Jacobus." Alexandre Duval's play *Edouard en Ecosse* (1802) was banned soon after its première but was revived with great success during the Restoration, when it was interpreted by Royalists as a Jacobite parallel to Bourbon experiences. It was performed thirty-three times between 1814 and 1820, and thirty-seven times between 1821 and 1830. See A. Joannidès, *La Comédie Française de 1680 à 1900* (Paris: Plon-Nourrit, 1921), 40.

19. Charles-Paul Landon, *Annales du Musée et de l'Ecole Moderne des Beaux-Arts. Salon de 1819. Recueil de morceaux choisis parmi les ouvrages de peinture et de sculpture exposés au Louvre le 25 août 1819*, 2 vols. (Paris: Imprimerie Royale, 1819), 2:55–6.

20. "il est probable que M. Bouton n'a pas eu d'autre but que de peindre l'intérieur d'un souterrain en ruine, et qu'ensuite il y a placé la figure de S. Louis, comme il y eût fait entrer tout autre sujet. Ici, comme nous l'avons fait remarquer ailleurs, le trait historique qui sert à donner un titre au tableau n'en est encore qu'un partie accidentelle . . . Cette grosse colonne que l'on voit placée en avant, et qui reçoit la plus grande lumière, est peinte à faire illusion. L'artiste en a reçu de grandes félicitations: nous ne pouvons y joindre les nôtres; cette partie morte du tableau écrase ce qui devait en être la vie . . . c'est la colonne qui frappe principalement la vue, et dont l'effet lumineux et plein de relief oblige le spectateur à reporter

sans cesse ses regards sur le même objet. Ce genre de beauté, qui aurait son mérite dans un tableau d'architecture, est un défaut capital dans un sujet que l'on décore du titre le plus relevé.

Landon, *Annales du Musée . . . Salon de 1819*, 2:38–9. Bouton, Salon of 1819, no. 165, *Saint Louis en méditation au tombeau de sa mère*. Commissioned for the Galerie de Diane, Château de Fontainebleau, in 1818. January 6, 1818. Ms. Archives Nationales (hereafter abbreviated Arch. Nat.), O³ 1400 LL 3623. It was completed the same year and still in place, Inv. 2834; 2.10 × 1.12 m. A replica is at Le Puy, in the Musée Crozatier, Inv. 838.3. See Chaudonneret, *Richard et Révoil*, 39; François Pupil, *Le Style troubadour ou la nostalgie du bon vieux temps* (Nancy: Presses Universitaires de Nancy, 1985), 447–8.

21. "Cherchant quelque monument qui put servir de fond à un tableau . . . je m'établis dans une des cryptes de Saint-Irénée, j'y plaçai un sujet en rapport avec ce monument, et faisant poser mes modèles dans le lieu même, peignant tout d'après nature, j'obtins un effet général qui réussit assez bien." "Peintres Lyonnais contemporains. Autobiographie de Fleury Richard," *Revue du Lyonnais*, n.s. 3 (1851), 244–55, 247. This was Richard's frequent practice: "Je peignais aussi un petit cloître que j'appelai l'*Hermitage de Vaucouleurs*, en y plaçant *Jeanne d'Arc consultant l'hermite sur la mission qu'elle doit accomplir*" (252). Chaudonneret discusses Richard's annotation of Lenoir's catalogue for the Musée des Monuments Français and his copies after Gaignères's collection and the illustrations in Millin's *Antiquités nationales* and Willemin's *Monuments français inédits*. See Marie-Claude Chaudonneret, "Fleury Richard et le passé national. ses sources à travers quelques carnets de croquis," *Actes du colloque international Ingres et le Néo-classicisme*, Montauban, October 1975, in *Bulletin spécial des Amis du Musée Ingres* [1977], 11–19.

22. Fleury-François Richard (1777–1852). Salon of 1817, no. 650,
 La duchesse de Montmorency. Après la fin tragique de Henri, duc de Montmorency, décapité à Toulouse en 1632, Marie-Félicie des Ursins, sa veuve, se retira dans la monastère de la Visitation à Moulins; elle y fit élever le riche mausolée qui subsiste encore. Depuis ces événements, le cardinal de Richelieu, traversant la même ville, crut devoir envoyer un de ses pages auprès de la duchesse, pour la saluer de sa part. "*Dites à Son Eminence*, répondit-elle au page, *que vous avez trouvé la veuve du maréchal de Montmorency pleurant encore après dix ans sur le tombeau de son époux.*"
 Bought after the Salon by Louis XVIII (Inv. 7480), passing into the collection at Saint-Cloud; probably destroyed in 1871. See Chaudonneret, *Richard et Révoil*, catalogue no. 33, 79. Richard had first seen the tomb in 1810: "trouvant le sujet d'un tableau dans les souvenirs que me rappela ce monument, je revins à Moulins, quelques temps après, pour faire un dessin de ce célèbre tombeau." *Mes Souvenirs*, 1847–50, manuscript in private archives, cited by Chaudonneret, *Richard et Révoil*.

23. "Je lui en garantis de succès, surtout s'il se résout à faire quelques sacrifices aux parties qui doivent occuper, par leur importance et leur place dans la composition, toute l'attention des spectateurs." Gustave J*** [Auguste Jal], *Mes Visites au Musée Royal du Luxembourg, ou Coup d'oeil critique de la Galerie des Peintres Vivans* (Paris: Ladvocat, 1818), 116.

24. Marie-Philippe Coupin de la Couperie (1773–1851). Salon of 1819, no. 247, "*Vue du monument qui renferme le coeur de Henri IV*. Sully, accablé d'une extrême vieillesse, et sentant sa fin prochaine, vient, accompagné d'un de ses petit-fils, visiter ce coeur généraux dans lequel il avoit occupé une si belle place." The setting was the choir of the chapel of the Jesuit school at the military school of La Flèche, where the artist had served as drawing master in 1815–16. The title in the catalogue description provided by the Musée du Luxembourg was *Vue du monument qui renferme le coeur de Henri IV, dans l'église de l'école militaire de La Flèche* (*Explication des oeuvres . . . du Luxembourg*) (Paris,

1820), no. 17, 15–16. Musée National du Château de Pau, Inv. P 82-8-1; 2.11 × 1.78 m. Bought by Louis XVIII for 8,000 francs after the Salon (ms. Arch. Nat. O³ 1400). In 1820, the king offered it to the duchesse de Berry, owner of the Château de Rosny (former residence of Sully); sold from the collection of the duchesse de Berry, April 19, 1865, no. 253 for 660 francs; acquired from the sale by Léonce de Vogüe; in the collection of the comtesse de La Panouse (née Vogüe), Château de Thoiry; acquired from the sale at the Hôtel Drouot, April 29, 1982. See Chaudonneret, *Richard et Révoil*, 44; Philippe Bouton, "Un Tableau du Mausolée du coeur d'Henri IV à la Flèche," *Mémoires de la Société des Sciences et Arts de la Sarthe* (1982), 31–2; *Henri IV et son ministre* exhibition at Sully-sur-Loire: Château de Sully, August–October 1984, 52; Jacques Perot, *Musée national du château de Pau. Quinze ans d'acquisition, 1970–1984* (Paris: Réunion des Musées Nationaux, 1985), no. 15, 51–2; Bann, *Romanticism and the Rise of History*, 68–71; entry no. 47 by Marie-Claude Chaudonneret in *Les Années romantiques*, 355.

25. "Sa manière, bien que *rapetissée*, rappelle encore la belle école de M. Girodet dont il fut l'élève. La figure de Sully est conçue, composée, et exécutée historiquement: peut-être feroit-elle plus d'effet, si le fond d'une architecture trop compliquée, ne l'écrasoit un peu." Le comte O'Mahoney, "Exposition des tableaux (Ve et dernière article. Tableaux de genre)," *Le Conservateur* 5 (1819): 371–83, 375. Jal agreed: "son architecture trop terminée, et par cela trop rapprochée de l'oeil du spectateur, nuit à l'effet général." Auguste Jal, *L'Ombre de Diderot et le bossu du Marais, dialogue critique sur le Salon de 1819* (Paris: Corréard, 1819), 87.

26. E. J. D. [Etienne-Jean Delécluze], "Cinquième lettre au Rédacteur du Lycée Français sur l'exposition des ouvrages de peinture, sculpture, etc. des Artistes vivans," *Le Lycée Français* 2 (1819): 74–86, 85–6.

27. Pierre Révoil (1776–1842), Salon of 1817, no. 642,
 Convalescence de Bayard. Le bon chevalier a suivi Nemours à la prise de Brescia. Blessé pendant l'assaut d'un coup de lance à la cuisse, il s'est fait transporter par deux archers dans une maison voisine du rempart. Sa protection a préservé la maîtresse du logis et ses deux filles des horreurs du sac de la ville. Ramenées chaque jour par la reconnoissance auprès du lit de leur défenseur, les jeunes personnes y font de la musique afin de charmer l'ennui de sa convalescence. Leur mère a suspendu ses travaux pour les entendre chanter et jouer de luth; le *loyal serviteur*, l'historien de Bayard, tenant un éventail de plumes de paon, a les yeux fixés sur son héros. A droite, sont les armes du chevalier sans peur et sans reproche; à gauche, sa lance, et un étendard qu'il a pris sur les Vénitiens; un écriteau y est attaché; on y lit ces mots: *Conquesté en l'amour du Roi notre sire, Loys le douzième du nom.*
 Paris, Musée du Louvre, Inv. 7473; 1.35 × 1.78 m. The painting was included in "Tableaux qui ont eu le plus de succès au Salon de 1817" (ms. Arch. Nat. O³ 1394) and "Note des tableaux proposés à Son Altesse Royale Mgr le Duc de Berry" (ms. Arch. Nat. O³ 1395 and ms. Arch. Louvre, X. Salons). Musée du Luxembourg, 1818–49; between the Louvre and the Tuileries, 1851–3, then lost until 1976, when it returned to the Musée du Louvre. The subject was to have been "Bayard blessé à mort disant au connétable de Bourbon qui lui adresse ses regrets, ce n'est pas moi qu'il faut plaindre, mais vous qui, malgré votre serment, portez les armes contre votre Roi et votre patrie." "Etat des ouvrages à commander aux artistes, peintres et sculpteurs, pour le budget de 1814," 1813; ms. Arch. Nat. O³ 1389. Although Révoil changed the subject matter, he was paid 6,000 francs, the agreed-upon price. An engraving after the work by Rubierre appeared in *Histoire de Pierre Terrail, seigneur de Bayard de Terrebasse* (Paris, 1828). See Chaudonneret, *Richard et Révoil*, catalogue no. 12, 133–4. Révoil's student, Génod, emphasized his royalist political sympathies: "royaliste par in-

stinct, par tempérament, par nature, par réaction contre la terreur"; see Michel-Philibert Génod, "Eloge de Pierre Révoil, discours de réception de M. Génod lu à l'Académie impériale des sciences, belles-lettres et arts de Lyon dans la séance du 15 juillet 1862," *Revue du Lyonnais*, n.s. 25 (Lyon and Paris, 1862): 171–89, 180, in Hans Naef, *Die Bildniszeichnungen von J.-A.-D. Ingres*, 5 vols. (Bern: Ventelli, 1977–81), 1:79.

28. M*** [Edmé-François-Antoine-Marie Miel], *Essai sur le Salon de 1817*, 94–8, 97. Landon and Jal made the same complaint: "cette multitude d'armes, de meubles et de riche accessoires de toutes espèces semblent disputer au personnages mêmes l'attention du spectateur, et partager l'intérêt de la scène." Charles-Paul Landon, *Salon de 1817. Recueil de morceaux choisis parmi les ouvrages de peinture et de sculpture exposés au Louvre le 24 avril 1817* (Paris: Imprimerie Royale, 1817), 82–3; "M. Révoil semble avoir préféré à l'effet général de son tableau, l'effet de chaque objet en particulier." J*** [Jal], *Mes Visites au Musée Royal du Luxembourg* (1818), 106–7.

29. See J. W. Hovenkamp, *Mérimée et la Couleur locale. Contribution à l'étude de la couleur locale* (Paris: Belles Lettres, 1928). Pougetoux described Henriette Lorimier's *Jeanne de Navarre* (1806; Musée National du Château de Malmaison), where the tomb of Jean IV played a prominent compositional role, as having "un sujet d'un hermétisme presque total, voire même une absence réelle de sujet sur le plan historique. Il n'est pas indifférent de constater que c'est un tel tableau qui remporta un succès aussi éclatant; saisis par le charme du décor médiéval, les spectateurs ne pouvaient que lire dans cette oeuvre les vagues échos d'une situation contemporaine." Alain Pougetoux, "Peinture 'troubadour' . . . collections de l'impératrice Joséphine," 56.

30. Antoine Coypel, "Sur l'excellence de la peinture," address delivered December 7, 1720, to the Académie de Peinture et de Sculpture, in *Conférences de l'Académie Royale de Peinture*, ed. Henri Jouin (Paris, 1883), 216–18.

31. "Le costume est une chose que l'habile peintre ne néglige jamais dans son tableau; c'est l'exacte observation des moeurs, des caractères, des modes, des usages, des habits, des armes, des bâtiments, des plantes et des animaux du pays dans lequel s'est passée l'action qu'il veut représenter." Antoine-Joseph Dézallier d'Argenville, *Discours sur la connaissance des tableaux*, in *Abrégé de la Vie des plus fameux Peintres*, 3 vols. (Paris: DeBuve l'aîné, 1745–52), 1:xxxvi. See also abbé Marc-Antoine Laugier, *Manière de bien juger les ouvrages de peinture* (Paris, 1771).

32. Le costume est l'art de traiter un sujet dans toute la vérité historique; c'est donc . . . l'observation exacte de ce qui, suivant le temps, fait reconnoître le génie, les moeurs, les loix, le goût, les richesses, le caractère & les habitudes du pays où l'on place la scène d'un tableau. Le *costume* renferme encore tout ce qui constitue la chronologie, & la vérité de certains faits connus de tout le monde; enfin tout ce qui concerne la qualité, la nature & la propriété essentielle des objects qu'on représente.

Watelet, "Costume," with commentary by Levesque, in *Dictionnaire de Peinture, Sculpture et Gravure*, 1:498–509, 506.

33. See Hans Eichner, ed., *"Romantic" and Its Cognates: The European History of a Word* (Toronto: University of Toronto Press, 1972), particularly Raymond Immerwahr, " 'Romantic' and Its Cognates in England, Germany, and France before 1790," 17–97, and Maurice Z. Schroder, "France/*Roman – Romanesque – Romantique – Romantisme*," 263–92.

34. Campenon stressed the escapist nature of chivalric romances:

Les romans de moeurs . . . nous laissent dans le monde où nous vivons; c'est à notre époque même qu'ils nous placent, c'est de nos intérêts qu'ils nous entretiennent, de nos contemporains qu'ils nous environnent . . . Les romans de chevalerie, au contraire, nous transportent dans un monde tout fantastique, puisque la vertu seule y règne, ou du moins y triomphe;

puisque la lâche félonie ne s'y montre jamais que pour être terrassée par la loyauté valeureuse; puisque l'innocence ou la faiblesse opprimée y trouve toujours, à point nommé, son vengeur.

François-Nicolas-Vincent Campenon, "Sur M. de Tressan et ses Ouvrages," in Louis-Elisabeth de La Vergne, comte de Tressan, *Oeuvres du comte de Tressan,* 10 vols. (Paris: Nepveu & Aimé-André, 1823), 1:iii–xxxiv, xxxii–xxxiii. By 1861, however, it was recognized that the medieval *romaunt* had originated in the ferocious mores of "ce chaos de l'anarchie féodale . . . Voilà l'origine de la chevalerie, qui était la police des temps barbares." Louis-Nicolas and Albert Bescherelle, *Dictionnaire National, ou Dictionnaire Universel de la langue française,* 2 vols. (Paris, 1861), 2:216–17.

35. Pierre Révoil assembled a collection of medieval antiquities that was acquired by the Direction royale des Beaux-Arts in 1828 for 60,000 francs (ms. Arch. Nat. O³ 1426 and O³ 1428). He also wrote medievalist romances; "Bertrand d'Alkamanon, troubadour de provence" was included in a letter of 1809 to Roquefort, who helped him with his glossary of old Lyonnais dialects. See Marie-Claude Chaudonneret, "Lyon. De la Révolution à l'Empire," in *Les Muses de Messidor. Peintres et sculpteurs Lyonnais de la Révolution à l'Empire* (Lyon: Musée des Beaux-Arts, 1989), 26–41; this is the catalogue of an exhibition held at the Musée des Beaux-Arts de Lyon from November 22, 1989, to February 11, 1990.

36. Outre les défauts matériels résultant de cette affectation, on en a introduit un plus grave qui habituellement dénature les événements de l'histoire et change la physionomie réelle des personnages mis en scène. C'est le choix des aventures et des sentiments *romanesques* pour ces compositions . . . il était difficile d'éviter cet écueil . . . prenant ces sujets à une *époque toute romanesque* . . . où les sentiments d'amour et d'attachement de toute espèce étaient singulièrement exaltés. Il ne s'agit pas ici d'apprécier le bon et le mauvais de l'institution de la chevalerie, que l'on peut et que l'on doit même considérer historiquement comme une transition nécessaire et heureuse des tems de barbarie à des moeurs plus policées; mais il faut l'envisager simplement comme un ordre d'idées, de sentimens, de passions et de moeurs, enfin comme une civilisation toute entière dans laquelle on va puiser des scènes que l'on veut reproduire sur la toile. Or, il me semble que les usages et les opinions en vogue en tems de la chevalerie formaient autant les élans naturels du coeur et de l'esprit que les cuirasses de fer génaient et défiguraient le corps de ceux qui eu étaient revêtus. . . . alors il y avait une cohérence parfaite entre les préjugés moraux et les habitudes physiques et j'avoue que ce triste rapport est loin de me paraître propre à un développement heureux dans un art qui ne vit que de formes et qui doit parler aux sens avant tout.

E. J. D. [Delécluze], "Salon de 1822," *Le Moniteur universel,* no. 156 (June 5, 1822), 801–2.

37. *Oeuvres du comte de Tressan,* 10 vols. (Paris: Nepveu & Aimé-André, 1823); Bibliothèque Nationale, Réserve des Imprimés p.Z.637. The illustrations repeated plates that Clément-Pierre Marillier (1740–1808) had produced for *Oeuvres choisies du comte de Tressan,* 12 vols. (Paris: Basan, 1787–9), and paired them with new watercolors after designs by Colin. See Henri Cohen, *Guide de l'amateur des livres à gravures du XVIIIe siècle* (Paris: Rouquette, 1912), 997–8; Pupil, *Le Style troubadour,* 62–8 and 321–5. The comte de Tressan (1705–83) published *Nouvelle Bibliothèque bleue* (1770), *Bibliothèque des romans* (1777), *Romans de la chevalerie* (1780), *Corps d'extraits de romans de chevalerie* (1782). See Henri Jacoubet, *Le Comte de Tressan et les origines du genre troubadour* (Paris: PUF, 1923); René Lanson, *Le Goût du Moyen Age en France au XVIIIe siècle* (Paris: Architecture et Arts Décoratifs, 1926); Henri Jacoubet, *Le Genre troubadour et les origines françaises du romantisme* (Paris: Belles Lettres, 1928); Lionel Gossman, *Medievalism and the Ideologies of the*

Enlightenment: The World and Work of La Curne de Saint-Pelaye (Baltimore: Johns Hopkins University Press, 1968).

38. It resembles Révoil's pen and wash drawing *Saintré et la Dame des belles Cousines* (1810; Avignon, Musée Calvet, Inv. 624/90–1); see Chaudonneret, *Richard et Révoil,* catalogue no. 76, 152.

39. See Nora's discussion of the modern transformation of hierarchies of meaning into hallucinatory fragments: "the old ideal of resurrecting the past . . . implied a hierarchy of memory, ordering the perspective of the past beneath the gaze of a static present . . . But the loss of a single explanatory principle . . . has promoted every object – even the most humble, the most improbable, the most inaccessible – to the dignity of a historical mystery." "Between Memory and History," 17.

40. See Elizabeth A. Brett and Robert Ostroff, "Imagery and Post–Traumatic Stress Disorder: An Overview," *American Journal of Psychiatry* 142, no. 4 (April 1985): 417–24; Judith Lewis Herman, "Terror," in *Trauma and Recovery* (New York: HarperCollins [Basic Books], 1992), 34–44.

41. Collection Hennin, *tome* 136, no. 11974. The text of the plate reads:
 Une femme désolée, représentant la France assis près d'un monument funèbre élevé à l'auguste Famille de Louis XVI, sur lequel est placée l'urne mystérieuse dont les deux côtés et ledes sua [?] figurent au naturel les profils du Roi, de la Reine et de Madame Elisabeth, Ceux du Dauphin et de Madame de France se remarquent dans le tronc du Saule pleurer, dont les rameaux tristement penchés couronnent ces ruines précieuses. L'hydre de tous les vices est foudroyé. Le Soleil levant désigne l'espérance.

42. Other memorial images with fugitive profiles of the royal family appeared in the exhibition *La Famille royale à Paris. De l'histoire à la légende* (Paris: Musée Carnavalet/Paris-Musées, 1993): see catalogue no. 101, a sheet of vignettes (Evreux: Ancelle fils, c. 1815), in which the hidden profiles of all five members of the royal family are visible (Musée Carnavalet Hist. GC.88); catalogue no. 110, *Tombeau de Louis XVI Roi de France et de Sa Famille,* aquatint by Morinet after C. L. Desrais (Paris: Genty, n.d.); de Vinck, no. 5931 (Coll. Liesville; Musée Carnavalet Hist. PC.27D); catalogue no. 114, *21 janvier 1793* (a female figure leans on a sarcophagus that holds an urn; to the right of the urn the profile of the king is visible), de Vinck, no. 5222 (Musée Carnavalet Hist. PC. 27D); catalogue no. 115, *Urnes et saules pleureurs* (designs for the bottoms of boxes), de Vinck, nos. 5924–6 (Coll. Liesville; Musée Carnavalet Hist. PC.27D).

43. Etienne-Gaspard Robert, called "Robertson" (1763–1837); seminary student, painter, magician, physicist, and aeronaut. See *Mémoires récréatifs, scientifiques et anecdotiques du physicien-aéronaute E.-G. Robertson,* 2 vols. (Paris: Wurtz, 1831–3). His phantasmagorical performances occurred in Paris, January 20–April 26, 1798, at the Pavillon de l'Echiquier; January 10, 1799–October 8, 1802 at the former Couvent des Capucines; November 1814–1818 at 12, boulevard Montmartre; May 1826–1830 at the Nouveau Tivoli, on property that had belonged to Labouxière in the Batignolles quarter. See Max Milner, *La Fantasmagorie. Essai sur l'optique fantastique* (Paris: PUF, 1982), 9–22; Terry Castle, "Phantasmagoria: Spectral Technology and the Metaphorics of Modern Reverie," *Critical Inquiry* 15 (Autumn 1988): 26–61, reprinted in *The Female Thermometer: Eighteenth-Century Culture and the Invention of the Uncanny* (New York: Oxford University Press, 1995), 140–67; Françoise Levie, *Etienne-Gaspard Robertson. La Vie d'un fantasmagore* (Quebec: Préambule, 1990); Barbara Maria Stafford, *Body Criticism. Imaging the Unseen in Enlightenment Art and Medicine* (Cambridge, MA: MIT Press, 1991), 437–50; Barbara Maria Stafford, *Artful Science: Enlightenment Entertainment and the Eclipse of Visual Education* (Cambridge, MA: MIT Press, 1994), 14–16 and 74–6.

44. Robertson's amanuensis acknowledged this in the preface to the memoirs: "C'est sous le règne d'une *terreur* trop réelle qu'il s'était efforcé de détruire pour jamais, par des expériences de fantasmagorie, la terreur imaginaire des spectres et des

visions." Eugène Roch, "Avant-Propos," in Robertson, *Mémoires récréatifs*, 1: i–viii, iii. Robertson quoted a contemporary review: "Robespierre, disait le *Courrier des Spectacles,* sort de son tombeau, veut se relever . . . la foudre tombe et met en poudre le monstre et son tombeau. Des ombres chéries viennent adoucir le tableau: Voltaire, Lavoisier, J.J. Rousseau, paraissent tout à tour . . . Tels sont les effets de l'optique, que chacun croit toucher avec la main ces objets qui s'approchent." Robertson, *Mémoires récréatifs*, 1:282–3. He described his thematic repertory (1:294–302). Claude Roberjot, a member of the Convention, took part in the Congress of Rastatt. He was killed there on April 28, 1799, when Austrian hussars attacked the carriages of the French diplomats leaving the city after peace negotiations had broken down. Two weeks later, Robertson called up Roberjot's ghost, who cried for vengeance. Général Desaix de Veygoux was killed at the Battle of Marengo on June 14, 1800; he first appeared in the show on July 10. Levie describes Robertson's repertory as not only reflecting events during the Revolution and Directory, but offering a blank screen on which injustice could be remedied (*Robertson, La Vie d'un fantasmagore,* 137); she points to his denunciation of Robespierre, rehabilitation of Lavoisier and Condorcet, and homage to Roberjot and Desaix.

45. Armand Poultier's commentary was published in *L'Ami des Lois* on March 28, 1798 (8 germinal, an VI). See Robertson, *Mémoires récréatifs,* 1:215–20. As Castle pointed out, Robertson complained that Poultier's account was false and inflammatory. Castle, "Phantasmagoria," 31–8.

46. Jan Goldstein, *Console and Classify: The French Psychiatric Profession in the Nineteenth Century* (Cambridge: Cambridge University Press, 1987), 84–93. Pinel's phrase was "ébranler fortement l'imagination." Philippe Pinel (1745–1840) performed experiments at the Bicêtre and the Salpêtrière during the Revolution and the Empire; see his "Mémoire sur la manie périodique ou intermittente," in *Mémoires de la Société médicale d'émulation de Paris* 1 (1798): 94–119, and *Traité médico-philosophique sur l'aliénation mentale, ou la manie* (1801) 2nd (expanded) ed., 1809.

47. Ces revenans, ces spectres qu'on evoque sur les théâtres, et qu'on se plait à contempler, sont le reflet des journées révolutionnaires: le peuple se plait, dans la *fantasmagorie,* à voir l'ombre de Robespierre; elle s'avance: un cri d'horreur s'élève, tout-à-coup sa tête est détachée de son corps, un terrible coup de tonnerre écrase le monstre; et des acclamations de joie accompagnent la détonnante fulmination.
 Mercier, "C'EST LE DIABLE &C.," chap. 182 of *Le Nouveau Paris,* 5:30–4, 31–2.

48. On August 6, workmen began excavations in the subterranean chapel dedicated to the Virgin that had become the site of Bourbon tombs in 1683; the royal tombs themselves were destroyed October 12–25. See Alexandre Lenoir, "Notes historiques sur les exhumations faites en 1793 dans l'abbaye de Saint-Denis," in *Musée des Monumens Français ou Description historique et chronologique des Statues en marbre et en bronze, Bas-reliefs et Tombeaux des Hommes et des Femmes célèbres, pour servir à l'Histoire de France et à celle de l'Art,* 8 vols. (Paris: Guilleminet or Nepveu, 1800–21), 2:cvi–cxxxii.

49. The abbé Henri Grégoire coined the term "vandalism" on 21 Nivôse, an II [January 10, 1794], in his report on public monuments. On iconoclastic vandalism, see his three reports to the Convention on behalf of the Committee on Public Instruction (8 Brumaire, an II [October 28, 1793]; 14 Fructidor, an II [August 31, 1794]; 24 Frimaire, an III [December 18, 1794]). Stanley J. Idzerda, "Iconoclasm during the French Revolution," *American Historical Review* 60 (1954): 13–26; Bronislaw Baczko, *Comment sortir de la terreur* (Paris: Gallimard, 1989), trans. as *Ending the Terror: The French Revolution after Robespierre* (Cambridge: Cambridge University Press, Maison des Sciences de l'Homme, 1994); Marie-Hélène Huet, "Performing Arts: Theatricality and the Terror," in *Representing the French Revolution: Literature, Historiography, and Art,* ed. James A. W.

Heffernan (Hanover, NH: University Press of New England for Dartmouth College, 1992), 135–49; Simone Bernard-Griffiths, Marie Claude Chemin, and Jean Ehrard, eds., *Révolution française et "Vandalisme révolutionnaire": Actes du colloque international de Clermont-Ferrand, 15–17 décembre 1988* (Paris: Universitas, 1992).

50. The print (Bibliothèque Nationale Qb1 septembre–octobre 1793 M 102264) was conceived by Langlois, designed by T. de Jolimont, and aquatinted by Chataignier & de Bovinet. It was sold by Bance in 1817. The legend reads:

 Henri IV exhumé. Dédié au Roi. En 1793, lorsque les mains sacrilèges profanèrent les tombeaux de l'abbaye de St Denis, on découvre un caveau d'où l'on tira d'abord le cercueil d'Henri-quatre, mort le 14 mai 1610, âgé de 57 ans, en y trouva les restes glacés de ce bon prince dont tous les traits parfaitement conservés pénètrent les spectateurs d'admiration et de respect, on eût dit qu'il n'était qu'endormi; il parait avoir du embaumé à la manière des anciennes momies et entouré de bandelettes; ce cercueil placé entre les pilliers de l'Eglise souterraine fut exposé pendant quelques temps à la curiosité publique, et chacun s'empresse de venir contempler ces précieuses reliques qui rappellaient de si touchants souvenirs. C'est à cette occasion que l'on a moulé, sur la matière même, le plâtre d'après lequel les artistes multiplient aujourd'hui le portrait de ce bon Roi. Le dessin de cette gravure fut inventé dans le temps par un témoin oculaire, et offre avec exactitude l'état de conservation presque miraculeux ou fût trouver le corps de cet illustre ayeul des Bourbons. Il existe un décret de la Convention Nationale qu'ordonna de conserver cette précieuse momie mais il parvint trop tard.

51. On the reconstruction and reconsecration of the abbey and its new pictorial program, see Pamela Z. Blum, *Early Gothic Saint-Denis: Restorations and Survivals* (Berkeley and Los Angeles: University of California Press, 1992); Josette Bottineau, "Le Décor de tableaux à la sacristie de l'ancienne abbatiale de Saint-Denis (1811–23)," *Bulletin de la Société de l'histoire de l'art français* (1973): 255–81; Pupil, *Le Style troubadour*, 140–3, 331–3. Richard's *Le Corps de Henri IV exposé à Saint-Denis* is discussed by Chaudonneret in *Richard et Révoil*, catalogue no. 14, 69.

52. "Tremble, on a mutilé tous ces grands monumens ... Une nouvelle mort a frappé le tombeau ... Aux pieds du grand Henri je réclame un asile. Dieu! cet asile saint lui-même est violé; Le marbre, sous les coups de leur fer parricide, Se brise, & de Henri le corps est dévoilé." Mme de Vannoz, née Silvry, *Profanation des tombes royales de Saint-Denis en 1793* (Paris: Giguet & Michaud, 1806); an elegiac poem, reviewed by *Le Publiciste* (June 17, 1806), 3–4. The second quotation is from Treneuil's poem *Les tombeaux de l'abbaye royale de Saint-Denis* (Paris: Giguet & Michaud, 1806), reviewed by *Le Publiciste* (June 1, 1806), 3–4. See *Poëmes élégiaques de feu Jos. Treneuil. Nouvelle édition, augmentée d'une notice sur l'auteur, et de plusieurs pièces inédites* (Paris: Firmin Didot, 1824), containing a biography of Joseph Treneuil (1763–1818), ix–xxiv. During the Restoration, he was named Chevalier de la Légion d'Honneur, and given the position of "bibliothécaire de S. A. R. Monsieur" at the Arsenal.

53. Alexandre Lenoir published eleven editions of the museum's catalogue between 1794 and 1815; I have consulted the most extensive description (see n. 48 to this chapter). During the Restoration, two illustrated works maintained the museum's imaginative hold: *Vues pittoresques et perspectives des salles du Musée des monuments français ... gravées par MM. Réville de Lavallée d'après les dessins de M. Vauzelle* (Paris: Didot, 1816), and Jean-Pierre Brès, *Souvenirs du musée des monuments français* (Paris: Brès & Carilian Goeury, 1821), text accompanied by engravings after forty drawings by Biet. Niquevert reviewed Brès's work in *Journal des Artistes* 1, no. 6 (February 11, 1827): 82–6. See Louis Courajod, *Alexandre Lenoir et le Musée des Monuments Français* (which contains Lenoir's journal), 3 vols. (Paris, 1878–87); Alain Erlande-Brandenburg,

"Alexandre Lenoir et le Musée des Monuments Français," in *Le "Gothique" retrouvé,* 75–84; Christopher M. Greene, "Alexandre Lenoir and the Musée des Monuments Français during the French Revolution," *French Historical Studies* 12 (1981): 200–22; Dominique Poulot, "Alexandre Lenoir et les Musées des Monuments Français," in Nora, ed., *Les Lieux de mémoire, tome* 2: "La Nation" (3 vols.) (Paris: Gallimard, 1986), 2:496–531; Haskell, *History and Its Images,* 236–52; McClellan, *Inventing the Louvre,* 155–95.

54. Une masse aussi importante de monumens de tous les siècles me fit naître l'idée d'en former un Musée particulier, historique et chronologique, où l'on retrouvera les âges de la sculpture française dans des salles particulières, en donnant à chacune de ces salles le caractère, la physionomie exacte du siècle qu'elle doit représenter . . . Une salle d'introduction m'a paru indispensable pour servir d'ouverture à ce Musée. Cette pièce contiendra des monumens de tous les siècles, chronologiquement placés; l'artiste et l'amateur verront d'un coup d'oeil l'enfance de l'art chez les Goths, ses progrès sous Louis XII, et sa perfection sous François Ier; l'origine de sa décadence sous Louis XIV, époque remarquable dans les arts dépendus du dessin, par la fuite du célèbre Poussin. Enfin on suivra pas à pas, sur les monumens de notre âge, le style antique restauré dans nos contrées par les leçons publiques de Joseph-Marie Vien.
Lenoir, "Avant-Propos," *Musée des Monumens français,* 1:1–20, 6–8.

55. Mercier wrote in 1797: "Saints and mythological gods, heroes, virgins, antiquities, cardinals, Etruscan vases, holy water basins, medallions, columns, colossal statues of Charlemagne and Saint Louis . . . all have been collected with care . . . and lend this museum a peculiar but striking sensation of the centuries confused. It was the true mirror of our revolution: what contrasts, what bizarre juxtapositions, what twists of fate! What extraordinary chaos!" Mercier, "Sur le dépôt des Petits-Augustins, dit: Le Musée des Monuments Français," chap. 139 of *Le Nouveau Paris,* 5:473–5; cited in McClellan, *Inventing the Louvre,* 166.

56. Jean Lubin Vauzelle (1776–1837), *La salle d'Introduction du Musée des Monuments Français,* 1812 (Paris, Musée Carnavalet P 2074; 60 × 74 cm). Entered in Olivier Le Fuel's collection 1968. See Jacques Vanuxem, "Aperçus sur quelques tableaux représentant le Musée des Monuments français de Lenoir," *Bulletin de la Société de l'histoire de l'art français* (1971): 145–51. Bouton exhibited similar views in the Salon of 1811, no. 148, *Vue intérieure de la salle du XVe siècle au Musée des monuments français;* Salon of 1812, no. 143, *Le Philosophe en méditation près des tombeaux de la salle du XIIIe siècle au Musée des Petits Augustins;* Salon of 1817, no. 113, *Vue de la salle du XIVe siècle au Musée des Monuments français; le sujet représente Charles VI près du tombeau de son père et Valentine de Milan faisant signe aux seigneurs de la cour de ne pas le troubler* (Musée de Brou). On the last, see Marie-Claude Chaudonneret, "Le Goût 'troubadour.' Les Quatre Dernières Acquisitions du Musée de Brou," *Revue du Louvre* 44, no. 2 (April 1994): 61–4.

57. "Je n'étais pas sûr qu'ils ne vécussent point, tous ces dormeurs de marbre, étendus sur leur tombes." Jules Michelet, "Préface," in *Le Peuple* (1846), cited by Douglas Johnson, in "Historians," in *The French Romantics,* ed. D. G. Charlton, 2 vols. (Cambridge: Cambridge University Press, 1984), 2:274–307, 281–2.

58. Lenoir, *Musée des Monumens Français,* 4:25–7.

59. Marchangy, "Dix-Huitième Récit. Siège de Paris par les Normands. Paix conclue entr'eux et la France – Leur établissement dans la Neustrie," *La Gaule Poétique,* 3rd ed., 4:164–6. Marchangy cited *Journal des Arts,* no. 307 (no year), 67; the article was published July 15, 1814, 64. Comte was a ventriloquist, prestidigitator, and professor of physics who assisted Robertson in 1813–14 and produced his own phantasmagoria during the Restoration; see Levie, *Robertson, La Vie d'un fantasmagore,* 241–4, 249.

60. François-Joseph Heim (1787–1865); Sceaux, Musée de l'Ile-de-France, Inv.

37.1.23; 665 × 445 cm. Painted by the artist for Gessard as a reduced replica of the painting that Heim had begun in the hope (which was realized) that it would be acquired by the government for the sacristy at Saint-Denis; the original was exhibited at the Salon of 1822, no. 684,

> *Rétablissement des sépultres royales, à St-Denis, en 1817.* Le Roi, par l'ordonnance du 24 avril 1816, avait ordonné que les sépultres royales, violées en 1793, fussent rendues à leurs tombeaux. Le premier plan représente le moment de l'exhumation des ossemens dans le cimetière de l'Abbaye-Royale de St.-Denis, en présence du Mgr. le chancelier de France, de M. le marquis de Dreux-Brézé, grand-maître des cérémonies; de M. le comte de Pradel, directeur général de la Maison du Roi; de MM. de Laporte-Lalamme et de Blaire, conseillers d'Etat, et de MM. Sallier et A. de Pastoret, maîtres de requêtes, commissaires du Roi, à l'exhumation. Sur le second plan, des gardes-du-corps transportent un cercueil renfermant une partie des dépouilles royales; ce cercueil, précédé du maître et des aides de cérémoniés, est reçu par le Clergé du Chapitre de St.-Denis, à l'entrée d'une chapelle provisoire, d'où s'est faite ensuite la translation dans les tombeaux de St.-Denis (M. I.).

This replica was given by Gessard in 1910 to the Musée Carnavalet; acquired by the Musée de l'Ile-de-France, Sceaux, in 1937.

61. "HISTOIRE, du grec . . . qui sait, qui connait, qui recherche, qui s'informe, qui observe; témoin, juge; annales, chroniques, mémoires, etc." Barante, "De l'Histoire," in *Encyclopédie Moderne* 14 (1828), 124–59; separately printed as 3–37; 3.

62. Barante, "Préface," in *Histoire des Ducs de Bourgogne,* reprinting the original preface (Paris: Ladvocat, 1824); 6th ed., 1:1–88, 23–4.

63. la plupart des écrivains historiques . . . ont voulu atteindre à la fois des mérites contradictoires: conserver l'attrait du drame et de la peinture, et décomposer la narration par l'analyse, l'examen et la discussion . . . Il faut, au contraire, que l'historien se complaise à peindre plus qu'à analyser; sans cela les faits se dessèchent sous sa plume; il semble les dédaigner, tant il est pressé d'entirer la conclusion et de les classer sous un point de vue général.

Barante, "Préface," in *Histoire des Ducs de Bourgogne,* 1:11, 14.

64. "Atlas pour l'histoire des ducs de Bourgogne, par M. de Barante, composé de 20 portraits et 24 plans de batailles, vues, cartes, etc., dessinés et gravés par nos meilleurs artistes," in *Catalogue de la librairie de Ladvocat, Palais-Royal, Galeries de Bois, nᵒˢ 195 et 196* (Janvier 1825) (Paris: H. Fournier, 1825), 5–6, citing *Journal des Débats,* December 7, 1824. Two illustrated editions were published by Ladvocat in 1824–6, in 12 volumes, both available at the Bibliothèque de l'Arsenal. One (8° H 13808) has several portrait illustrations, the other (from Saint-Cloud, 8° H 13809) has numerous and varied vignettes, from which I have chosen my examples. Achille Devéria exhibited two of its vignettes in the Salon of 1827.

65. Marchangy, "Dixième Récit. Détails historiques et poétiques sur les Moeurs, les Coutumes, la Vie privée, le Commerce et les Lettres durant la première race," in *La Gaule Poétique,* 3rd ed., 2:265–7.

66. Le principal objet de la Gaule Poétique est de répandre un jour moins douteux sur les antiquités de notre histoire; d'explorer dans ses nombreux détails la vie privée de nos devanciers, d'interroger le débris de leurs législations primitives et barbares, de leurs cultes sauvages et de leurs institutions féodales, guerrières, superstitieuses, chevaleresques et galantes; d'extraire enfin du moyen âge, comme d'une mine féconde et trop peu connue, des trésors qu'apprécieront également le poète, l'annaliste, le législateur et l'archéologue. Cet ouvrage n'est point une Histoire de France, mais on y trouvera des recherches sur les parties intéressantes de cette histoire. Si parfois le style y paraît revêtu de couleurs plus brillantes que ne l'exigent de

simples dissertations, faudra-t-il blâmer l'innocent artifice de l'écrivain, qui souhaite rendre l'érudition moins rebutante pour la plupart des lecteurs, et par-là faciliter aux Français la culture de leurs propres domaines? Marchangy, "La Gaule Poétique. Première epoque. Premier récit," *La Gaule Poétique,* 4th ed., 6 *tomes* in 3 vols. (Paris; Baudouin frères & F.-M. Maurice, 1824), 1:1–2.

67. On Marchangy's career, see the unpublished thesis by Francine Hamm, "Etude sur Louis-Antoine-François de Marchangy. Contribution à l'histoire des idées en France sous la Restauration," Faculté des Lettres, Université de Strasbourg, 1962, and Archives Nationales 233 AP 1–4. His speech at the trial of the sergeants of La Rochelle was published as *Les Carbonari dévoilés, ou Discours que M. de Marchangy . . . a prononcé pour soutenir l'accusation dans l'affaire dite de la Rochelle, à l'audience de la Cour d'assises, du 29 août 1822* (Montpellier: A. Seguin, 1822).

68. Hearing of Marchangy's nomination, Casimir Périer commented: "je suis bien aisé de rappeler en cette circumstances que nous habitons la France constitutionnelle et non la 'Gaule Poétique.'" Hamm, 24, citing *Le Moniteur universel,* January 31, 1823. In Stendhal's opinion, the success of *Tristan le Voyageur* ("roman loyaliste de M. de Marchangy, qui a prétendu peindre les moeurs du XIVe siècle et susciter notre regret de les avoir perdues") was the result of journalists' reluctance to arouse the enmity of one of the most powerful men in the government. Stendhal (Henri Beyle), *Lettres de Paris par le petit-fils de Grimm. Chroniques 1825–1829,* ed. José-Luis Diaz and Henri Martineau, 2 vols. (Paris: Sycomore, 1983), letter no. 8 (written July 11, published in August 1825), 1:188–201, 194, and letter no. 10 (written September 16), 237. These letters were published as articles in the *London Magazine.*

69. Another early poem, by Marchangy, *Le Siège de Dantzig* (1813), was published anonymously. In 1816 he edited *Mémoires historiques pour l'ordre souverain de Saint Jean de Jerusalem,* published by the Commission des Langues Françaises, for which he was honored with the Order of Malta.

70. There were significant textual variations among the editions. The first edition of *La Gaule Poétique* (Paris: Chaumerot & C.-F. Patris) appeared in 1813–17, in 8 volumes; the second, revised edition (1819) was issued by the same publishers. The third edition (Paris: C.-F. Patris, Lecointe & Durey, and Chamerot jeune) appeared in July 1819 in 9 volumes; this was the first illustrated edition. The colored plates, anonymous for the most part, appear to have been done by several different hands. This edition was dedicated to the conseiller d'etat of the comte d'Artois, baron de Balainvilliers. The fourth edition, 6 *tomes* in 3 volumes (1824), was published by Baudouin frères and F.-M. Maurice. A fifth, posthumous edition in 8 volumes, with illustrations by Camille Rogier, was published by Mme de Marchangy (Paris: L. F. Hivert, 1834–5).

71. Louis-Antoine-François de Marchangy, *Tristan le Voyageur, ou la France au XIVe siècle,* 6 vols. (Paris: F.-M. Maurice & Urbain Canel, 1825–6); 2nd ed., 6 vols. (Paris: Urbain Canel, 1826). The Fonds Marchangy at the Archives Nationales also contains his notes for a dictionary of French mythology and a manuscript history of the French Revolution, from the convocation of the Estates General to the death of Marie-Antoinette.

72. Marchangy, "Introduction," in *Tristan le Voyageur,* 1:xxiv–xxvi. Earlier (1:iii), Marchangy praised foreign authors for collecting "comme de précieux débris sauvés du naufrage des temps" evidences of ancient customs and convictions.

73. Said distinguished between "origins," which dominate their derivatives, and "beginnings," whose "circumstances include a sense of loss," where "the continuities and methods developing from it are generally *orders of dispersion, of adjacency,* and of *complementarity.*" Such beginnings encourage nonlinear development in a "multileveled coherence of dispersion." Edward Said, *Beginnings: Intentions and Method* (New York: Basic Books, 1975), 372–3.

74. "Avis des éditeurs," in *La Gaule Poétique,* 4th ed., 1:ii–iv. The editors stressed

the topicality of his reclaiming the French heritage, inventing editions during the late Empire:

> Trois éditions se sont écoulées au milieu des événemens les moins favorables aux lettres, car ces trois éditions parurent, l'une lors de la retraite de Moscou, l'autre pendant la campagne de 1814, et la troisième durant les cent jours. Si l'attention, quoique distraite par ces grands spectacles politiques, a cependant accueilli vivement cet ouvrage, on doit espérer qu'elle saura mieux le goûter encore maintenant qu'une paix profonde favorise les études historiques et littéraires.

75. Marchangy, "La Gaule poétique. Second Epoque. Seizième Récit. Louis-Le-Débonnaire. Beautés des contrastes historiques. – Sujet d'une tragédie," in *La Gaule Poétique,* 3rd ed., 4:1–3, 6–7.

76. Ibid., 4th ed., 1:9–13.

77. Ibid., 3rd ed., 4:288–90.

78. Ibid., 4:290, 294–6. Kératry recognized the same anthropomorphic architecture in Joly's *Vue d'Ecosse* (1819), accompanied by broken statuary and a hyena devouring a corpse. Auguste-Hilarion, comte de Kératry, *Annuaire de l'école française de peinture, ou Lettres sur le Salon de 1819* (Paris, 1820), 172–3.

79. Quoique leurs bâtiments n'eussent point, comme les autres manoirs féodaux, la position formidable, et si l'on peut s'exprimer ainsi, l'architecture hostile, qui faisant surnommer leurs habitants *des batailleurs et des conquérans,* l'enceinte des abbayes était néanmoins environnée de murs, de fossés, et même de bastions. Dans la première cour était la maison, ou plutôt le palais de l'abbé, qui avait, pour ainsi dire, droit de vie et de mort sur ses religieux, puisqu'au lieu de leur infliger les peines canoniques, il avait droit de leur mutiler les membres ou de leur crever les yeux. Si un moine osait porter des plaintes contre son supérieur, un capitulaire autorisait ce dernier a lui infliger la bastonnade.

Marchangy, "Vingtième Récit. Détails Historiques. Vie poétiques des anciens châteaux. – Tableau des campagnes et des villes sous la féodalité. – Etat des lettres, des sciences et des arts à cette époque. – Détails sur l'ancienne magistrature," *La Gaule Poétique,* 3rd ed., 4:345–6.

80. Marchangy, "Septième Récit. Frédégonde et Brunehaut. Sujets de plusieurs tragédies," in *La Gaule Poétique,* 3rd ed., 2:164–5.

81. Marchangy, "Introduction," in *Tristan le Voyageur,* 1:i–xliv, x.

82. Ibid., 1:ii–iii. The term "political suicide" occurs on xxiii.

83. Ibid., 1:x–xi.

84. Marchangy, "Glossaire et Annotations," in *Tristan le Voyageur,* 1:356, n. to 108. Tristan was the son of Queen Marguerite, who gave birth while imprisoned in Dampierre.

85. Marchangy, *Tristan le Voyageur,* 2:247–8.

86. Ibid., 2:104–5.

87. Ibid., 3:313–323 and 446–7n. To document the rise of poverty in France, Marchangy provided statistics from the manuscript register of parlement, no. 96 on November 12, 1552, from Duclos's *Memoirs,* and from the *Etats statistiques* of the préfet of the département de la Seine: 3,000–4,000 poor in this département in the fourteenth century; 9,000 in the sixteenth century; 12,300 in the seventeenth century; 28,000 in the eighteenth century; 86,936 in 1804; 102,806 in 1813. He later used the same metaphor of epidemic disease when he prosecuted the Carbonari sergeants of La Rochelle.

88. Marchangy, *Tristan le Voyageur,* 6:447.

89. On a déjà remarqué plus d'une fois, dans ce qui précède, que les grands éléments de la poésie, tels que le merveilleux, les passions et les combats, constituaient particulièrement l'histoire de France. Outre ces avantages, elle en possède un autre, non moins précieux, c'est celui des contrastes, sans lesquels un sujet ne peut long-temps attacher. Le sentiment que nous font éprouver les contrastes, loin d'être idéal et chimérique, est l'effet

d'une de ces lois générales et positives de la création, qui embrassent à la fois tout le système physique et moral.

Marchangy, "La Gaule Poétique. Seconde Epoque. Seizième Récit. Louis-Le-Débonnaire. Beautés des contrastes historiques. – Sujet d'une tragédie," *La Gaule Poétique,* 1st ed., 4:1.

90. Bertin, Salon of 1819, no. 87,

Paysage éclairé par le soleil de matin. Le sujet représente Chérebert, un des fils de Clotaire. Un jour, le prince égaré à la chasse, s'arrêta près d'une fontaine. La simple Théodegilde, fille d'un pauvre chévrier, s'approche pour priser de l'eau. Le roi lève les yeux sur cette fleur des champs; quelqu'obscure que fut la naissance de cette bergère, Chérebert, en la voyant si belle, la crut digne d'être reine et bientôt il l'épousa. Histoire des Francs, Marchangi, *tome* 2, page 27. (Mais. d. R.)

Commissioned for the Galerie de Diane at Fontainebleau in 1817 (mss. Arch. Nat. O³ 1400, 1401, 1407); 1876, entered the Musée des Beaux-Arts, Béziers (Inv. 2549). See Suzanne Gutwirth, "Jean-Victor Bertin, un paysagiste néo-classique (1767–1842)," *Gazette des Beaux-Arts,* 6th ser. 83 (May 1974): 337–58, catalogue no. 96. J. A. Laurent exhibited the same subject of Chérebert offering a ring to Teudegilde in the same Salon of 1819 (no. 698), without citing Marchangy; the work was commissioned by the ministre de l'intérieur and was sent to the Musée d'Auch.

Antoine-Pierre Mongin, Salon of 1819, no. 845,

Jeanne d'Arc fait prendre l'épée de Charles Martel dans la forêt de Fier-Bois. Dans une forêt que sa sauvage horreur a fait nommer *Fier-Bois*, et dont les vieux ombrages abritaient l'autel et le tombeau de Sainte Cathérine, l'épée de Charles Martel, cette épée qui délivra la France des Sarrasins était cachée aux yeux des profanes, suspendue dans les rameaux épais d'un chêne. Ce fut là que, conduite par un songe envoyé de Dieu, Jeanne d'Arc fit prendre ce glaive, qui, dans ses mains, devait être si fatal aux Anglais (*Gaule poétique* de M. Marchangy) (Mais. d. R.).

Commissioned for the Galerie de Diane at the Château de Fontainebleau; now in Privas.

Jean-Charles Rémond, Salon of 1822, no. 1068,

Carloman blessé à mort dans la forêt d'Yveline. Le roi, chassant à Yveline, fut atteint d'une flèche qu'imprudent veneur avait lancée à un sanglier. Le prince, pour sauver un serviteur malheureux, persuada à sa cour éplorée qu'il avait été blessé par la bête furieuse, et il expira. (*Gaule poétique,* de M. Marchangy) (M. d. R.)

Paris, Musée du Louvre, Inv. 7409; 1.9 × 2.8 m. Commissioned in 1820 for the Galerie de Diane at the Château de Fontainebleau (ms. Arch. Nat. O³ 1404); sent to the Musée de Soissons in 1876, returned to the Louvre in 1978. See Suzanne Gutwirth, "Jean-Charles-Joseph Rémond (1795–1875), premier grand prix de Rome du paysage historique," *Bulletin de la Société de l'histoire de l'art français* 1981 (année 1983): 189–218, catalogue no. 10.

Henri-Auguste-Calixte-César Serrur, Salon of 1827, no. 960,

Brunehaut. Haïr et commander deviennent de si fortes habitudes pour le coeur de Brunehaut, que le cour de Théodebert, où elle résidait, ne peut souffrir ses injustices et ses excès. Un matin, les seigneurs austrasiens la surprennent dans son palais, lui commandent de quitter sa parure et de se couvrir de vêtemens grossiers; en cet état, ils la conduisent sur les bords de l'Aube; là, ils l'abandonnent seul au declin du jour. Un jeune pâtre descendant du côteau s'arrête, à la vue de Brunehaut; il lui donne l'hospitalité, et elle l'appelle dès l'aube du matin, pour le prier de la conduire à Châlons, où son fils, Thierry, roi de Bourgogne, la reçoit en mère et en reine (Gaule poétique, par Marchangy).

Also exhibited, with a similar *livret* description, in the Musée Colbert between November 1829 (no. 148) and December 1833, (no. 34); now at the Musée des

Beaux-Arts, Arras. On the Galerie de Diane, see Marie-Claude Chaudonneret, " 'Musées' des origines. De Montfaucon au Musée de Versailles," *Romantisme* 84 (1994): 11–35. See also Isabelle Julia and Jean Lacambre, "Répertoire des oeuvres. Essai de répertoire des tableaux français peints entre 1815 et 1850, conservés dans les collections publiques de France," in *Les Années romantiques*, 445–85.

91. L'héroïque n'aît de l'ordre, du choix, de la majesté des arbres, des plans, des monumens réguliers de l'antique; tels que les temples, les autels, les sépultres, les palais, les status, qui font l'ornément des sites idéals ou composés . . . L'historien paysagiste se promène parmi les ruines des ouvrages de l'homme, cherche le théâtre des grandes révolutions politiques, et semble s'attacher à saisir la nature abandonnée, pour lier ses événemens aux annales des peuples et des nations.

Gault de Saint-Germain, "Observations sur l'état des arts au dix-neuvième siècle dans le Salon de 1814," *Le Spectateur*, no. 29, 3 (1815): 442–57, 443. Pierre Marie Gault de Saint-Germain (1754–1842), Parisian art dealer and restorer, directed a school of drawing in Clermont-Ferrand between 1792 and 1797, after he fled the capital. He reviewed the Salons of 1814, 1817, and 1819 and wrote *Des passions et de leur expression générale et particulière sous le rapport des Beaux-arts* (Paris, 1804) and *Les trois siècles de peinture en France* (Paris, 1808). See C. Jeannerat, "De Gault et Gault de Saint-Germain," *Bulletin de la Société de l'histoire de l'art français* (1935), 221–35.

92. When he asked Louis XVIII to allow him to serve on the Conseil de la nouvelle Direction des Arts, Millin Duperreux stressed his aesthetic royalism:

fidel à son souverain légitime, ses pinceaux interprète de ses sentiments et de ses voeux n'ont jamais transmis sur la toile que des sujets de la monarchie qui rappellent les nobles faits des ayeux de Votre Majesté lui ont acquis aux expositions publiques l'honorable estime de tous les bons français. Il a été assez heureux pour créer ce nouveau genre historique et national en l'unissant au Paysage.

Letter of November 14, 1815; ms. Arch. Nat. O³ 1438.

93. The artist, Alexandre-Louis-Robert Millin-Duperreux [or du Perreux] (1764–1843), had studied with Huet and Valenciennes. His father, Jérôme-Robert Millin, had owned the Château du Perreux, near Nogent-sur-Marne, but was forced to emigrate in 1792 and had his properties confiscated. Millin-Duperreux's younger brother, Georges-Marie-Jérôme Millin-Duperreux (1766–1852), was elected deputy from the Bas-Rhin in 1825. See Pierre C. Lamicq, "Henri IV et le château de Pau dans l'oeuvre de Millin Du Perreux. Les peintures de la Galerie de Diane à Fontainebleau," *Bulletin de la Société des amis du Château de Pau*, n.s. 72 (1977): 25–40.

94. Letter of Millin-Duperreux to the comte de Blacas, December 12, 1814 (ms. Arch. Nat. O³ 1876). Salon 1814, no. 373, "*Vue du château de Pau, prise du grand parc. Henri IV enfant, saisit, entre plusieurs drapeaux que Jeanne d'Albret, sa mère, fit porter en sa présence pour connoître ses dispositions, celui qui portoit pour devise Aut vincere aut mori.*" Musée du Château de Pau, P526; Louvre Inv. 6706; 75 cm × 1.32 m. Acquired from the Salon for Louis XVIII's collection for 3,000 francs, passing through the Château des Maisons Laffitte (MR 346), entering the Musée National du Château de Pau in 1930. Millin-Duperreux used the same composition in two other works: *Le Château de Pau vu du parc* (n.d.), Paris, private collection, and Salon of 1822, no. 423, *Vue du Château de Pau prise du parc. Le jeune Henri IV dans les bras de Jeanne-Albret* (1820–2); Musée des Beaux-Art de Pau 876.4.1; Louvre Inv. 6705.

95. See Albert Boime, *The Academy and French Painting in the Nineteenth Century* (New York: Phaidon, 1971), 140–6; Philippe Grunchec, *Le Grand Prix de peinture. Les Concours des Prix de Rome de 1797 à 1863* (Paris: Ecole Nationale Supérieure des Beaux-Arts, 1983), 96–100, 163–202.

96. See Guizot's *Rapport présenté au Roi pour instituer un inspecteur général des*

monuments historiques en France (October 21, 1830); Poulot, "The Birth of Heritage. 'Le Moment Guizot,' " 47–48. In *L'Histoire de la Civilisation en France* (1828–30), Guizot's description of fortified castles, linking their physical isolation with feudalism's ferocity (a method that Poulot calls "philosophical archaeology") is reminiscent of Marchangy's passage cited in notes 77–8 to this chapter.

97. Charles Nodier, "Introduction," in *Voyages Pittoresques et Romantiques dans l'Ancienne France: Ancienne Normandie*, 3 vols. (Paris, 1820–5), 1:1–15, 1–2, 4–5, 10. The entire project was published as *Voyages Pittoresques et Romantiques dans l'Ancienne France Par MM. Ch. Nodier, J. Taylor et Alph. de Cailleux*, 21 vols. (Paris: Gide fils, 1820–78). See Anita Louise Spadafore, "Baron Taylor's *Voyages pittoresques*," Ph.D. diss., Northwestern University, 1973, and Eliane Vergnolle, "*Les Voyages Pittoresques*," in *Le "Gothique" retrouvé*, 105–19.

98. Charles-Louis Lesaint (b. 1795), a student of Bouton, and Jean-Louis-André-Théodore Géricault (1791–1824); a lithograph of 1823 by G. Engelmann for *Ancienne Normandie*, 2 (1825), in which it occupied a full page. There were 328 lithographs in *Ancienne Normandie*, 2 vols. (1820–5). Rouen was Géricault's birthplace. See Loys Delteil, *Le Peintre-Graveur Illustré. Géricault* (Paris: Delteil, 1924), no. 93; Paul Joannides, "Toward the Dating of Géricault's Lithographs," *Burlington Magazine* 115, no. 847 (October 1973): 666–71, who reports that the lithograph was submitted for publication as part of a *livraison* in 1824; W. McAllister Johnson, *French Lithography: The Restoration Salons, 1817–1824* (Kingston, Canada: Agnes Etherington Art Centre, 1977), appendix 6, "Voyages Pittoresques et Romantiques dans l'Ancienne France: Ancienne Normandie," 195–208; *Géricault. Tout l'oeuvre gravé et pièces en rapport* (Rouen: Musée des Beaux-Arts, 1981), exhibition catalogue by François Bergot, no. 46; *Géricault* (Paris: Galeries Nationales du Grand Palais/Réunion des Musées Nationaux, 1991), exhibition catalogue by Sylvain Laveissière et al., 302.

99. Kératry connected his culture's desire to see memories evoked in concrete form with the rigorous truth of local color in the arts, particularly theater, where "la sévérité du costume, la couleur locale du site . . . le maintain exact de leurs intérêts et de leurs habitudes connues, enfin le respect des traditions, sont des conditions rigoureuses de succès." "Avant-Propos," in *Lettres sur le Salon de 1819*, v–vii.

100. "E. J." [Victor Etienne, known as "Jouy"], "Beaux-Arts. Salon de 1819, tableaux de genre," *La Minerve Française* 7 (August 1819): 450–61, 459–60. Jal also approved of the column: "Vous avez loué cette colonne qui supporte la voûte du caveau sépulchral; ici j'en vois les débris qui me frappent par la vérité de leurs formes, et la liberté du pinceau, qui les a pour ainsi dire animés." Jal, *Salon de 1819*, 82.

101. P. M. Gault de Saint-Germain, *Choix des productions de l'art les plus remarquables exposées dans le Salon de 1819* (Paris, 1819), 36–8.

102. See Marie-Claude Chaudonneret and Alain Pougetoux, "Les Collections princières sous la Restauration," *Revue de la Société d'histoire de la restauration et de la monarchie constitutionnelle* 3 (1989): 33–49, 39, citing Th. Delabare, *La duchesse de Berry au château de Rosny dans les premiers jours de 1820* (Paris, 1820).

103. Depuis nombre d'années, on entretient dans les lettres, et par suite dans les arts, une erreur facheuse: c'est de confondre le *romanesque* avec le *poétique*, et de vouloir allier ces deux choses qui sont nées ennemies irréconciliables. Entre toutes les qualités qui constituent la poésie, la vérité est au premier rang; le romanesque doit son existence à l'erreur . . . Rien n'est plus conforme à la nature de l'homme que l'exaltation des sentimens ou des idées; mais ces efforts de l'humanité sont courts et passagers, ils rompent l'uniformité de la vie, sans en changer le cours

ordinaires . . . ce sont des accidens enfin. La poésie s'en empare et les reproduit comme tels. Le *romancier* veut faire de la vie une chose continuellement extraordinaire . . . Le ROMAN, cette lèpre des tems modernes obstrue toutes nos idées, fausse tous nos jugemens.

E. J. D. [Etienne-Jean Delécluze], "Salon de 1822. 10e article," *Le Moniteur universel,* no. 169 (June 18, 1822), 859–60.

CHAPTER FOUR. WITNESSES TO CATASTROPHE

1. Hippolyte (known as Paul) Delaroche (1797–1856). Salon of 1834, no. 503: *Jane Grey.* Jane Grey, qu'Edouard VI avait, par son testament, instituée héritière du trône d'Angleterre, fut, après un règne de neuf jours, emprisonnée par ordre de Marie, sa cousine, qui, six mois après, lui fit trancher la tête. Jane Grey fut exécutée dans une salle basse de la tour de Londres, à l'âge de 17 ans, le 12 février 1554. "La noble dame, arrivée au lieu de supplice, se tourna vers deux siennes nobles servantes, et se laissa desuestir par icelles. Sur cela le bourreau, se mettant à genoux, luy requit humblement luy vouloir pardonner, ce qu'elle fit de bon coeur. Les choses accoustrées, la jeune princesse s'étant jetée à genoux, et ayant la face couverte, s'écria pitieusement: que feray-ci maintenant? Où est le bloqueau? Sur cela Sir Bruge, qui ne l'avait pas quittée, luy mit la main descus. Seigneur, dit-elle, je recommande mon esprit entre tes mains. Comme elle proférait ces paroles, le bourreau, ayant pris sa hache, luy coupa la tête." (*Martyrologie des Protestans,* publiée en 1588.)
 National Gallery, London, 1909; 246 × 297 cm, 97 × 117 in. In the collection of Prince Anatole Demidoff when it was exhibited in the Salon of 1834; H. W. Eaton and his son, the second Lord Cheylesmore, who bequeathed it to the National Gallery in 1902, where it sustained water damage in 1928 and was restored in 1973. See Norman Ziff, *Paul Delaroche: A Study in Nineteenth-Century French History Painting.* Ph.D. diss., New York University, 1974; published (New York: Garland, 1977), catalogue no. 58, 126–34; Cecil Gould, *Delaroche and Gautier: Gautier's views on the "Execution of Lady Jane Grey" and on Other Compositions by Delaroche* (London: National Gallery, 1975), exhibition catalogue; Roy Strong, *Recreating the Past: British History and the Victorian Painter* (New York: Thames & Hudson/Pierpont Morgan Library, 1978), 40, 120–2, 139–40; Haskell, "The Manufacture of the Past in Nineteenth-Century Painting"; Francis Haskell, "The Death of Kings," *Franco Maria Ricci,* no. 5 (London ed., October 1981): 115–32; Meisel, *Realizations,* 230–40; Bann, *The Clothing of Clio,* 71–6.
2. Heinrich Heine, *Lutèce. Lettres sur la vie politique, artistique et sociale de la France* (Paris, 1861; reprint, Geneva: Slatkine, 1979), letter 37 (December 19, 1841), 224–7. The letters were originally published in the *Gazette d'Augsbourg;* first book edition, Paris, 1855. See *Paintings on the Move: Heinrich Heine and the Visual Arts,* ed. Susanne Zantop (Lincoln: University of Nebraska Press, 1989), essays from the October 1985 Dartmouth colloquium on Heine, and David Ward's translation of an uncensored version of "Französische Maler," Heine's review of the Salon of 1831 for the *Morgenblatt für gebildete Stände* (October–November 1831), as *French Painters,* 121–72.
3. Gustave Planche, "Histoire et philosophique de l'Art. IV. De l'Ecole Française au Salon de 1834," *Revue des Deux Mondes,* 3rd ser., *tome* 2 (April 1, 1834): 47–84, 51–4. On Gustave Planche (1808–57), see Maurice Regard, *L'Adversaire des romantiques. Gustave Planche, 1808–1857* (Paris: Nouvelles Editions Latines, 1955); Grate, *Gustave Planche et Théophile Thoré*; Jonker, *Diderot's Shade,* 154–82.
4. "Actuellement ils [Goupil and Rittner] font graver une peinture de Delaroche qui représente *Marie-Antoinette dans la prison du Temple*; la malheureuse reine est vêtue sur ce tableau d'une façon extrêmement indigente, presque comme une

pauvre femme du peuple, ce qui arrachera sans doute au noble faubourg les pleurs les plus légitimes."

5. Heine, "we tremble before a catastrophe which has already taken place," discussing Alexander Gardner's photographic *Portrait of Lewis Payne* (1865); Barthes, *La Chambre claire*, 150. Bann cites this passage when he describes Delaroche as the "poet of impending catastrophe" (*The Clothing of Clio*, 75).

6. James VI of Scotland (1566–1625) became James I of England, ruling 1603–25. He was succeeded by his son Charles I (1600–49). Increasing tension in 1638 resulted in open civil war in 1641, and Charles I's trial and execution. Cromwell became Protector in 1653. He died in 1658, succeeded by his son Richard. In 1660 Charles II (1630–85) was restored to the throne. His brother James II (1633–1701) reigned 1685–8. The Glorious Revolution of 1688 placed William III (1650–1702), James II's nephew, on the throne with his wife Mary II (1662–94), James II's daughter.

7. See Petra ten-Doesschate Chu, "Pop Culture in the Making: The Romantic Craze for History," in *The Popularization of Images,* ed. ten-Doesschate Chu and Weisberg, 166–88.

8. François Ancelot's *Elisabeth* (1829), which inspired Eugène Nos and Alphonse Brot's *Le testament d'Elisabeth* (1865); Casimir Delavigne's *Les Enfants d'Edouard* (1833) (dedicated to Delaroche); Cordellier-Delanoue's *Cromwell et Charles I* (1835); Alexandre Soumet's and Mme Gabrielle Daltemheyn's *Jane Grey* (1844); and Nos and Brot's *Jane Grey* (1856). On Delaroche and the theater, see Beth S. Wright, "Scott and Shakespeare in Nineteenth-Century France: Achille Devéria's Pendant Lithographs of 'Minna et Brenda' and 'Les Enfans d'Edouard,' " *Arts Magazine* 55, no. 6 (February 1981): 129–33; Michael Fried, *Courbet's Realism* (Chicago: University of Chicago Press, 1990), 32–5.

9. Antony Béraud, "Salon de 1837," *Le Monde Dramatique* 4 (1837): 204–7, 205.

10. The socialist, pro-Romantic art critic Maurice-Alexandre Decamps (1806–52) distinguished between Delaroche's theatrical calculation of pose, gesture, glance, and the actual event: "les esprits les plus ordinaires puissent comprendre qu'il y a là une scène dramatique; mais il en résulte une distance immense entre le fait tel qu'il a dû se passer et l'exposition qu'en offre M. Delaroche." But this was the popular taste, and Delaroche addressed it masterfully: "c'est sur elle, sur son intelligence, sur son jugement qu'il agit." Alexandre Decamps, *Le Musée. Revue du Salon de 1834* (Paris, 1834), 36.

11. I would like to thank an anonymous reader of this manuscript for Cambridge University Press for suggesting this modern equivalent.

12. Guizot, *Salon de 1810,* 104–5.

13. F. P. [Fabien Pillet], "Salon de 1835. 3e article," *Le Moniteur universel,* no. 75 (March 16, 1835), 532.

14. See J. R. Knowlson, "The Idea of Gesture as a Universal Language in the Seventeenth and Eighteenth Centuries," *Journal of the History of Ideas* 26 (1965): 495–508; Kirsten Gram Holmström, *Monodrama, Attitudes, Tableaux Vivants: Studies on Some Trends of Theatrical Fashion, 1770–1815* (Stockholm: Almquist & Wiksell, 1967); D. Johnson, "Corporality and Communication: The Gestural Revolution of Diderot, David, and *The Oath of the Horatii*"; D. Johnson, *Jacques-Louis David. Art in Metamorphosis,* 11–69.

15. See Gaehtgens, "La Galerie Historique ou Cours d'Histoire générale par tableaux de Jussieu, Dusaulchoy et Alliez," in *Versailles: De la résidence royale au Musée historique,* 65–85, and its prospectus, 381–2. Ponce's gallery was proposed at a meeting of the Société Philotechnique; an excerpt from his plan was published in "Nouveau moyen d'augmenter l'utilité, l'influence et l'illustration des beaux-arts," *Journal des Artistes* 1, no. 5 (February 1, 1829): 71–4. On pedagogical use of visual images (interactive games, explication of allegorical images, and so on), see L. S. Colart, *Histoire de France représenté par des tableaux synoptiques et par soixante-dix gravures, dédiée aux enfans de France*

et employé pour leur education (Paris: Paul Renouard, 1825). Colart, tutor to the Bourbon heirs Henri and Louise, children of the duchesse de Berry, was continuing the methods of his mentor, abbé Louis-Edouard-Camille Gaultier, whose instructive games were published during the ancien régime and reprinted in numerous editions during the Restoration and July Monarchy.

16. "On pourrait aussi, par suite, faire imprimer la description de ces tableaux avec un commentaire; mais il serait utile de le faire desirer longtems aux enfans, afin de laisser completter l'effet qu'ils auraient produit sur eux par l'organe de vue." Ponce, "Nouveau moyen d'augmenter l'utilité," 73.

17. See the *Encyclopédie* articles "Geste" (1757), adapted by Louis de Cahusac from his *La danse ancienne et moderne, ou traité historique de la danse* (1754), and "Pantomime" (1777), where Marmontel maintains pantomime's ability to take the place of words in impassioned moments. On the privileging of pantomime in eighteenth-century and nineteenth-century dramaturgy, from Denis Diderot's *Le Fils Naturel* (1757) and *Le Père de Famille* (1758) and Jean-Georges Noverre's *Lettres sur la Danse et sur les Ballets* (Stuttgart and Lyons, 1760), to René Charles Guilbert Pixérécourt's *Coelina, ou l'Enfant du Mystère* (1800) and Alexandre Dumas's *Henri III et sa cour* (1829), see A. Lacey, *Pixerécourt and the French Romantic Drama* (Toronto, University of Toronto Press, 1928); Marie-Antoinette Allévy, *La Mise en scène en France dans la première moitié du dix-neuvième siècle. Edition critique d'une mise en scène romantique* (Paris: Droz, 1938; reprint Geneva: Slatkine, 1978), which contains Albertin's stage directions for *Henri III et sa cour*; Marvin Carlson, *The French Stage in the Nineteenth Century* (Metuchen, NJ: Scarecrow, 1972), 42–55; Peter Brooks, *The Melodramatic Imagination: Balzac, Henry James, Melodrama, and the Mode of Excess* (New York: Columbia University Press, 1985), particularly 56–80; Meisel, *Realizations*, 38–51, 69–87; Marie-Pierre Le Hir, *Le Romantisme aux enchères. Ducange, Pixérecourt, Hugo* (Philadelphia: Benjamin, 1992).

18. See Francis H. Dowley, "The Moment in Eighteenth-Century Art Criticism," *Studies in Eighteenth-Century Culture* 5 (1976): 319–36; James Henry Rubin, "Guérin's Painting of *Phèdre* and the Post-Revolutionary Revival of Racine," *Art Bulletin* 61 (December 1977): 601–18.

19. See Michael Fried, *Absorption and Theatricality: Painting and Beholder in the Age of Diderot* (Berkeley and Los Angeles: University of California Press, 1980), especially 76–106; Peter Szondi, "*Tableau* and *coup de théâtre*: On the Social Psychology of Diderot's Bourgeois Tragedy," *New Literary History* 11, no. 2 (Winter 1980): 323–43.

20. Paillot de Montabert distinguished between an ordinary speaker and an actor, who had to keep the audience's attention: "Enfin le spectateur qui veut être remué, excité, n'apporte souvent qu'une attention languissante: il faut le reveiller, le piquer; il faut par fois crier des bras comme on crie de la voix." *Théorie du geste*, 68. Such momentary visual stridency was permissible in a large public theater, but fatal in a fixed pictorial composition. Theatrical pantomime was not a proper model for painting or sculpture (36).

21. See C.-J.-F. Hénault, preface to *François II, roi de France en cinq actes* (Paris: Prault, 1768), cited by Marthe Trotain in *Les Scènes Historiques. Etudes du théâtre livresque à la veille du drame romantique* (Paris, 1923), 35–6, an excellent introduction to the literary format of the reading- or "closet" drama, practiced by Hugo, Vitet, and Byron.

22. "Chez les Grecs le but de la Tragédie était sensible. Elle devoit nourir le germe républicain, et rendre la Monarchie odieuse." Louis-Sébastien Mercier, "Préface," in *Jenneval ou le Barnevelt français, Drame en cinq actes en Prose* (Paris: Le Jay, 1769), 3–15, 9. See Walter Rex, "The Demise of Classical Tragedy in France," in *The Attraction of the Contrary: Essays on the Literature of the French Enlightenment* (Cambridge: Cambridge University Press, 1987), 172–83, where he discusses Mercier's *Du théâtre ou Nouvel essai sur l'art dramatique* (Amsterdam, 1773), which directly linked classical tragedy and tyrannical mon-

archism. Mercier proposed staging the death of Nero "tombant sur la terre, la grattant de ses mains, poussant des cris aigus en approchant du terme qui ramene tout à l'égalité. Je voudrais voir les mouvemens convulsifs des muscles de son visage" (181).

23. "nulle espèce d'ouvrage ne peut avoir autant d'influence sur l'esprit public; j'avois conçu le projet d'introduire, sur la Scène Françoise, les époques célèbres de l'Histoire Moderne, & particulièrement de l'Histoire Nationale; d'attacher à des passions, à des événemens tragiques, un grand intérêt politique, un grand but moral." M.-J. Chenier, *De la liberté du théâtre en France* (Paris, 1789), 14.

24. Mona Ozouf pointed out that the purpose of such festival enactments was to physically "reshape and contain history in order to relive it in an acceptable form." See "The Festival in the French Revolution," in *Constructing the Past. Essays in Historical Methodology,* ed. Jacques Le Goff and Pierre Nora (Cambridge: Cambridge University Press, 1985), 181–97, 195. On the "aesthetics of embodiment," see Peter Brooks, "The Revolutionary Body," in *Fictions of the French Revolution,* ed. Fort, 35–54.

25. William D. Howarth, "Word and Image in Pixérécourt's Melodramas: The Dramaturgy of the Strip-cartoon," in *Performance and Politics in Popular Drama: Aspects of Popular Entertainment in Theatre, Film and Television, 1800–1976,* ed. David Bradby, Louis James, and Bernard Sharratt (Cambridge: Cambridge University Press, 1980), 17–32, 17. On René-Charles Guilbert de Pixérécourt (1773–1844), whose plays were performed thirty thousand times between 1797 and 1834 in Paris and the provinces (Frank Rahill, *The World of Melodrama* [University Park: Pennsylvania State University Press, 1967], 40), see Willie Gustave Hartog, *Guilbert de Pixérécourt, sa vie, son mélodrame, sa technique et son influence* (Paris: Champion, 1913).

26. Aristotle, *The Poetics,* XIV, 26–7.

27. Brooks describes the melodramatic acting style as "predicated on the plastic figurability of emotion" (*The Melodramatic Imagination,* 47). Meisel contrasts transitive, rhetorical drama with melodrama's serial discontinuity: "Meaning and the sensation of drama inhered in an articulated succession . . . In the new dramaturgy, the unit is intransitive; it is in fact an achieved moment of stasis, a picture" (*Realizations,* 38).

28. Brooks, *The Melodramatic Imagination,* 57. Melodrama's presentation of meaning through mime and facial expression frequently necessitated mutes, foreigners, or those silenced by a vow, such as Pixérécourt's mute Eloi, in *Le Chien de Montargis* (1814), or Francisque, whose tongue has been cut out, in *Coelina, ou L'Enfant du mystère* (1800).

29. [Abel Hugo, Armand Malitourne, and J. Adler], *Traité du Mélodrame par MM. A! A! A!* (Paris: Delaunay, 1817), 47.

30. See Allévy, *La Mise en scène en France,* Act III, Scene 5, page 34. Dumas praised Albertin's staging.

31. quelques sociétaires du Théâtre-Français, prétendant que le genre où Talma excellait ne pouvait plus être utilement exploité, se sont efforcés d'exclure la tragédie de la scène, et de lui substituer des pièces composées à l'imitation des drames les plus bizarres qui puissent offrir les littératures étrangères: drames qu'avant cette époque on n'avait osé reproduire que sur nos théâtres infimes . . . Non seulement ils violent les droits fondés sur les règlements . . . mais pour satisfaire aux exigences de ce genre, qui a moins pour but d'élever l'âme, d'intéresser le coeur, d'occuper l'esprit que d'éblouir les yeux par des moyens matériels, par le fracas des décorations et par l'éclat du spectacle, ils épuisent la caisse du théâtre; ils accroissent sa dette, ils opèrent sa ruine . . . Est-ce pour favoriser l'usurpation du mélodrame, est-ce pour lui livrer la scène tragique que les clefs leur en ont été remises? Les fonds que votre libéralité met à leur disposition . . . tend à asservir le domaine de ces grands hommes à la Melpomène des boulevards.

Le Roy, *L'Aube du théâtre romantique* (Paris, 1904), 92–4. The petition was signed by Lemercier, Arnault, Viennet, Jouy, Andrieux, Jay, and Leroy.

32. Salon of 1819, no. 944, *Jeanne d'Arc, prisonnière à Rouen.* "[*Livret* citation of Lebrun de Charmettes, n. 34 to this chapter.] Raymond est représenté écoutant sur le seuil de la porte les paroles prophétiques de Jeanne d'Arc; le geolier et les cinq soldats, chargés de la garder jour et nuit, sont groupés autour de la colonne où elle est enchaînée." Musée des Beaux-Arts de Rouen, Inv. 931–16–3; 1.39 × 1.75 m, 108 × 84$\frac{1}{2}$ in. See Chaudonneret, *Richard et Révoil*, catalogue no. 15, 135–37; Ziff, "Jeanne d'Arc and French Restoration Art"; *La "Jeanne d'Arc" de Paul Delaroche. Salon de 1824. Dossier d'un oeuvre* (Rouen: Musée des Beaux-Arts, 1983), exhibition catalogue by Marie-Pierre Foissy-Aufrère, catalogue no. 31, 125–7. Ziff cites *Le Moniteur universel* (September 16, 1819), 1216, for its acquisition by the comte d'Artois, but evidently the count had simply expressed interest in the painting, since it was part of the duchesse de Berry's collection according to a list made on April 8, 1820 (*Etat des tableaux de l'Ecole moderne transportés de l'Elysée Bourbon aux Tuileries dans l'appartement de Son Altesse royale Madame La Duchesse de Berry*). Sold from her collection on February 22, 1836 (no. 146). The painting entered the collection of the Musée des Beaux-Arts de Rouen in 1931.

33. "Et vous, phénix des héroïnes et des bergères, félicitez-vous, si un jour vous montez sur le bûcher libérateur; des flammes vont vous régénérer; trop pure et trop chaste pour subir les épreuves du cercueil et les phases de la corruption, votre corps même se sera point souillé par la fangeuse sépultre des hommes." Marchangy, "Troisième Epoque. Trente-Huitième Récit. Jeanne d'Arc. Sujet d'un Poëme en douze chants," *La Gaule Poétique,* 4th ed., 6:55.

34. Raymond de Macy, témoin dans le procès de révision de Jeanne, fait, vingt ans après sa mort, par ordre du roi Charles VII, dit: 'qu'elle avait été conduite au château de Rouen, dans certaine prison du côté des champs, et qu'en ladite ville, durant le tems qu'elle était détenue, arriva Jean de Luxembourg comte de Ligny (le même qui l'avait livrée aux Anglais), en la compagnie duquel était celui qui parle. Et certain jour ledit seigneur compte de Ligny voulut voir ladite Jeanne, et vint à elle en la compagnie des seigneurs comte de Warvick et de Scanffort, présens le Chancelier d'Angleterre, en ce tems-là évêque de Boulogne, le frère du comte de Ligny et celui qui parle. Et ledit comte de Ligny entra en conversation avec Jeanne, lui disant: je suis venu ici pour vous mettre à finance (pour traiter de votre rançon), pourvu que tu veuilles promettre que jamais vous ne vous armerez contre nous. Laquelle répondit: Eh, mon Dieu, vous vous riez de moi, car je sais bien que vous n'en avez ni le pouvoir, ni le vouloir; lesquelles paroles elle répéta plusieurs fois; et comme ledit comte persistait, elle dit en oultre: je sais bien que ces Angloys me feront mourir, croyant après ma mort gaigner le royaume de France; mais fussent-ils cent mille godons plus qu'ils ne sont de présent, ils n'auraient pas ce royaume. Et de ces paroles fut indigné le comte de Scanffort, et il tira son épée pour l'en frapper; mais le comte de Warvick l'en empêcha."

P.-A. Lebrun de Charmettes, *Histoire de Jeanne d'Arc, surnommée la pucelle d'Orléans* (Paris, 1817), 4:73–4.

35. Salon of 1824, no. 457, "*Jeanne d'Arc malade est interrogée dans sa prison par le cardinal de Vinchester. Ce prélat, irrité de ses réponses, la menace des peines éternelles.*" Rouen, Musée des Beaux-Arts; Inv. 982.6.1; 2.77 × 2.175 m; 109 × 85.4 in. See Ziff, *Delaroche,* 34–42, and catalogue no. 15, 276; entry no. 76 by Isabelle Julia, in *Les Années romantiques,* 373–4. In collections of John Arrowsmith and the chevalier Féréol de Bonnemaison; sold from Bonnemaison's collection April 21, 1827; in the collection of Jean-Toussaint, Arrighi de Casanova, duc de Padoue and his heirs until 1982, when it entered the Musée des Beaux-Arts de Rouen. Ziff notes that the duc de Padoue, a Corsican-born general under

Napoleon, was an appropriate owner for this Anglophobic theme ("Jeanne d'Arc," 45). The Wallace Collection, London, contains both a reduced replica (1825; P 300; 46 × 38 cm) and a small, broadly sketched preparatory oil (1824; P 604; 22 × 19 cm). The confrontation occurred offstage in Joseph Loeillard d'Avrigny's play *Jeanne d'Arc à Rouen* (Act IV, Scene 2). It was first performed at the Comédie Française on May 4, 1819 and was published by Ladvocat in the same year. See Barbara T. Cooper, "Creating a Royal Stand-in: History, Politics and Medievalism in a French Restoration Tragedy," *Poetica* 39–40 (1993): 225–45. Foissy-Aufrère also postulates an influence from Reynolds's *Death of Cardinal Beaufort* (1789) for Boydell's Shakespeare Gallery; in Shakespeare's *Henry VI,* Part II, the prelate expires onstage in Act III, Scene 3, visited by demons. She suggests that Delaroche understood this act of his threatening the Maid of Orleans with hellfire as the cause of his remorseful death. A precedent for Delaroche's visual composition can be found in James Northcote's *Feckenham by Order of the Queen Visits Lady Jane Grey in the Tower* (1792), which was engraved by W. Bromley in 1793 for the Bowyer Historic Gallery. Northcote's painting (1792; 77 × 89 in.) was in the Neeld Collection, Grittleton House (T. S. R. Boase, "Macklin and Bowyer," *Journal of the Warburg and Courtauld Institutes* 26 [1973]: 169–77, 175); another, smaller ($10\frac{1}{4}$ × 12 in.) version was sold from the same collection at Christie's on May 3, 1957 (lot 47) (Boase, 177). See Richard Wetherill Hutton, "Robert Bowyer and the Historic Gallery: A Study on the Creation of a Magnificent Work to Promote the Arts in England," Ph.D. diss., University of Chicago, December 1992, catalogue no. 64, 677–84.

36. Rabbe stressed the dramatic insight of this patriotic work, which he thought one of the Salon's best:

> M. Delaroche a choisi le moment le plus pathétique de la vie de cette fille immortelle qui sauva la France et que les Anglais brûlèrent lâchement comme sorcière. Toute la fureur de leur haine, est concentrée dans les regards du fanatique Winchester. Quelle véhémence odieuse anime son geste! et elle, redevenue femme hors de la gloire, accablée de la misère du cachot, frémit en entendant la menace des peines éternelles! Couchée sur la paille qui lui sert de lit, pâle et abattue, elle joint les mains et invoque l'aide de Dieu . . . en présence de cet affreux cardinal comme la gazelle devant le tigre, elle peut croire que la providence de Dieu s'est retirée d'elle. En un mot, ce tableau me paraît l'un des plus dignes d'éloge parmi tous ceux qui ont été loués.

Alphonse Rabbe, *Le Courrier Français,* no. 259 (September 15, 1824), 4. Alphonse Rabbe (1786–1829) was a Liberal historian who had studied painting with David about 1800. His histories were published in Lecointe and Durey's series; see Chapter 5 of the present volume.

37. Thiers praised Delaroche's historical insight: "le goût historique tout à fair original qu'il a montré dans ce tableau extrêmement remarquable." "Peinture Française," *Revue Européenne* 1 (October 1824): 676–90, 680. He admired works by Scheffer, Schnetz, and Cogniet, defining the ideal history painter as one who could idealize forms without sacrificing their local specificity: "il lui faut surtout l'art d'ennoblir les visages en leur conservant leur caractère particulier; il lui faut le véritable *style,* en un mot, celui qui, pour atteindre à la beauté idéale, n'efface pas les caractères individuels et nationaux, et ne tombe pas dans une froide et ennuyeuse uniformité." Adolphe Thiers, *Salon de mil huit cent vingt-quatre, ou Collection des articles insérés au "Constitutionnel" sur l'exposition de cette année* (Paris, 1824), 20–1.

38. Salon of 1827, no. 306, "*Miss Macdonald.* Elle porte des secours au dernier prétendant après la bataille de Culloden, livrée le 27 avril 1746." In the collection of the dealer Schroth when exhibited; 55 × 45 cm; collection of the duchesse de la Roche-Guyon; lost. See Ziff, *Delaroche,* 50–6 and catalogue no. 21, 277; Whiteley, "Art et commerce d'art en France avant l'époque impression-

iste," 70, n. 25. A mezzotint after the painting, by Reynolds and Sixdeniers, was reviewed in *Journal des Artistes* 2 (October 13, 1833), 243–4. Sixdeniers exhibited the engraving in the Salon at Dijon in 1840, no. 394, possibly as a pendant to his engraving (no. 393) after Alexandre Colin's *Charles Ier et ses enfans;* see n. 58 to this chapter.

39. Le sujet de Miss Macdonald portant des secours au dernier prétendant après la bataille de Culloden, est traité de main de maître . . . Ce tableau est un petit chef-d'oeuvre de grâce, de vérité, de charme, de sentiment. La couleur locale et le caractère des personnages y sont parfaitement observés; l'exécution est à la hauteur de la pensée. Cet ouvrage est sans contredit l'un des meilleurs de M. Delaroche, et, de tous les tableaux de chevalet de l'exposition, celui qui, selon nous, approche le plus de la perfection.

Antony Béraud, *Annales de l'école française des beaux-arts . . . d'après les principales productions exposées au Salon du Louvre* (Paris: Pillet aîné, 1827), 59–60. Béraud (1794–1860) had succeeded Landon as the official voice of classicism, and his praise of Delaroche was in part a rebuke to Delacroix. Jal also praised the work as a "diamond." *Esquisses . . . Salon de 1827,* 229–30.

40. "dans le Trocadéro, comme dans Miss Macdonald, M. Delaroche s'est également montré vraiment peintre d'histoire, parce qu'il a eu le grand art de subordonner tous les détails exigés par les sujets qu'il avait à représenter, à l'action, au personnage principal." Delécluze, "Salon de 1827," *Journal des Débats* (January 7, 1828), 2. *La Prise du Trocadéro,* a state commission exhibited in the same Salon, was more than six times the size of *Miss Macdonald.*

41. Comte Horace de Viel-Castel, "Beaux-Arts. Salon de 1831. 1er article," *L'Artiste* 1 (1831): 185–7, 185–6.

42. Chateaubriand cited Barante as the creator of *histoire descriptive:* "l'histoire . . . écrite sans réflexions . . . le simple narré des événements, et . . . la peinture des moeurs . . . un tableau naïf, varié, rempli d'épisodes, laissant chaque lecteur, selon la nature de son esprit, libre de tirer les consequences, des principes, et de dégager les vérités générales des vérités particulières." Thiers and Mignet wrote *histoire fataliste,* less emotionally engaged and less descriptively detailed, preferring to "raconter les faits généraux, en supprimant une partie des détails, substituer l'histoire de l'espèce à celle de l'individu, rester impassible devant le vice et la vertu comme devant les catastrophes les plus tragiques." François-René, vicomte de Chateaubriand, "Ecole Historique Moderne de la France," "Preface," in *Etudes ou Discours Historiques sur la chute de l'empire Romain, la Naissance et les progrès du Christianisme, et l'invasion des Barbares, suivis d'une analyse raisonnée de l'histoire de France,* 4 vols. (Paris: Lefevre, 1831), 1:i–cxli, xliv–xlviii.

43. Chateaubriand, "Ecole Historique Moderne de la France," 1:cli.

44. See Paul Hindson and Tim Gray, *Burke's Dramatic Theory of Politics* (Aldershot, UK: Avebury, 1988); and Christopher Reid, "Burke's Tragic Muse: Sarah Siddons and the 'Feminization' of the *Reflections,*" 1–27, and Frans De Bruyn, "Theater and Countertheater in Burke's *Reflections on the Revolution in France,*" 28–68, both in *Burke and the French Revolution,* ed. Steven Blakemore (Athens: University of Georgia Press, 1992).

45. "We fear God; we look up with awe to kings; with affection to parliaments; with duty to magistrates; with reverence to priests; and with respect to nobility. Why? Because when such ideas are brought before our minds, it is *natural* to be so affected; because all other feelings are false and spurious, and tend to corrupt our minds, to vitiate our primary morals, to render us unfit for rational liberty." Edmund Burke, *Reflections on the Revolution in France, and on the Proceedings in Certain Societies in London Relative to that Event, in a Letter Intended to Have Been Sent to a Gentleman in Paris* (London: J. Dodsley, 1790); modern edition with Thomas Paine, *The Rights of Man* (New York: Doubleday [Dolphin], 1961), 100. Burke's *Reflections* were provoked by Dr. Richard Price's

sermon commemorating the Glorious Revolution, published as *The Evidence for a Future Improvement in the State of Mankind . . . Represented in a Discourse, Delivered . . . At the Meeting House in the Old Jewry, London* (London: H. Goldney, 1787).

46. Burke, *Reflections on the Revolution in France*, 46. On Burke's rhetorical figures, see Ronald Paulson, *Representations of Revolution, 1789–1820* (New Haven: Yale University Press, 1983), 57–73; Steven Blakemore, "Revolution in Representation: Burke's *Reflections on the Revolution in France*," *Eighteenth-Century Life* 15, no. 3 (November 1991): 1–18; Tom Furniss, "Stripping the Queen: Edmund Burke's Magic Lantern Show," in Blakemore, ed., *Burke and the French Revolution*, 69–96.

47. Burke, *Reflections on the Revolution in France*, 99–100.

48. Ibid., 81–2.

49. Cited by Frans De Bruyn (see n. 44 to this chapter) as *Letters on a Regicide Peace*, in *The Works of the Right Honorable Edmund Burke*, 12 vols. (Boston: Little, Brown, 1881), 5:233.

50. Burke, *Reflections on the Revolution in France*, 94.

51. David Hume (1711–76), author of *A Treatise of Human Nature* (1739–40) and *Enquiry concerning Human Understanding* (1748), had written British history "in reverse," from the Stuarts to Julius Caesar, publishing *The History of Great Britain, Containing the Reigns of James I and Charles I* (1754), *The History of Great Britain, Containing the History of the Interregnum to the Revolution of 1688* (1756), *The History of England, Under the House of Tudor*, 2 vols. (1759), and *The History of England from the Invasion of Julius Caesar to the Accession of Henry VII*, 2 vols. (1762). A second, revised edition of the history of the Stuarts appeared in 1759; the entire history was published complete in six volumes in 1762. Hume was secretary to the British Embassy in Paris in 1763–5, where he became friendly with Rousseau. See Nicholas Phillipson, *Hume* (New York: St. Martin's, 1981).

52. The rise of parliamentary power was first perceptible under James I: "Twas under James that the House of Commons began first to raise their Head, & then the Quarrel between Privilege & Prerogative commenc'd. The Government, no longer opprest by the enormous Authority of the Crown, display'd its Genius; and the Factions, which then arose, having an Influence on our present Affairs, form the most curious, interesting, & instructive Part of our History." Phillipson, *Hume,* 78, citing a letter from Hume to Adam Smith in *The Letters of David Hume,* ed. J. Y. T. Greig, 2 vols. (Oxford: Clarendon Press, 1969), 1:168.

53. History, the great mistress of wisdom, furnishes examples of all kinds; and every prudential, as well as moral precept, may be authorized by those events, which her enlarged mirror is able to represent to us. From the memorable revolutions, which passed in England during this period, we may naturally deduce the same useful lesson, which Charles himself, in his latter years, inferred; that it is very dangerous for princes to assume more authority, than the laws have allowed them. But, it must be confessed, that these events furnish us with another instruction, no less natural and no less useful, concerning the madness of the people, the furies of fanaticism, and the danger of mercenary armies.

 David Hume, *History of Great Britain: The Reigns of James I and Charles I* (Harmondsworth, UK: Penguin, 1970), *Charles I,* chap. 10, 687.

54. Voltaire thought Hume's history the best written in any language. See *Gazette Littéraire de l'Europe,* no. 10 (May 2, 1764): 193–200. French editions of Hume were immediate and numerous. For Hume's impact on French conservatives, see Lawrence Bongie, *David Hume: Prophet of the Counter Revolution* (Oxford: Clarendon Press, 1965).

55. The painting by Charles Benazech (1767–94) was engraved by Luigi Schiavonetti (1765–1810) for Colnaghi and published on March 10, 1794. See Aubert and Roux, *Collection de Vinck,* Vol. 3: *La Législative et la Convention,*

tome 30, no. 5123 (also Hennin, *tome* 130, no. 11411); Evelyne Lever, "Le Testament de Louis XVI et la propagande royaliste par l'image pendant la révolution et l'empire," *Gazette des Beaux-Arts*, 6th ser., 94 (November 1979): 159–73; *The Shadow of the Guillotine: Britain and the French Revolution* (London: British Museum, 1989), exhibition catalogue by David Bindman et al.; *The Painted Word: British History Painting: 1750–1830* (London: Heim Gallery/ Woodbridge: Boydell, 1991), exhibition catalogue by Peter Cannon-Brooks et al., catalogue no. 103, 98–100; Jean-Marie Bruson, "Bénazech, Hauer, Kucharski et quelques autres. Les Peintres des derniers moments de la famille royale," in *La Famille royale à Paris,* 125–7; his painting for this print is catalogue no. 3 (Musée du Château de Versailles, MV 5832). Benazech, an Englishman who had studied under Greuze, passed through Paris during the French Revolution on his way back from Rome. Two pendant prints after Benazech (*Separation* and *Last Interview of Louis XVI*) were engraved by Jean-Pierre-Marie Jazet and published by Basset in 1814. Jean-Baptiste Hanet-Cléry (1759–1809) was the servant of an emigré bishop, La Fare, who helped him to write *Journal de ce qui s'est passé à la Tour du Temple* (London, 1798), which became a bestseller. Louis XVIII awarded Cléry the Croix de Saint Louis (ordinarily given in recognition of military service) for his services to the royal family during their imprisonment.

56. Even before the royal decapitations, British newspapers pointed out parallels between contemporary French events and past British history. The *Times* (July 2, 1791) compared the capture of Louis XVI at Varennes to Charles I's flight from Hampton Court to the Isle of Wight in 1647, and the Rump Parliament to the National Assembly. The *Morning Herald* (August 20, 1792) compared Marie-Antoinette to the captive Mary Stuart. See Hutton, "Robert Bowyer and the Historic Gallery," 216–18. On Stothard's *Charles I's Taking Leave of His Children,* see catalogue no. 81, 792–8. Stothard completed the painting for Bowyer by September 25, 1793, and the critics recognized the emotional resonance of Stothard's topical subject. Hutton (227–8, n. 180) cites The *World* (September 25, 1793).

57. Their availability was due to the Peace of Amiens in 1802 and to Bowyer's special trading privileges. The Bibliothèque Nationale spent almost one-twelfth of its annual budget in 1807 to purchase the engravings, in a set of ten folio volumes. See Cabinet des Estampes, ms. Ye.88, *Relevé des Acquisitions faites 1803–1847.* For Boydell's French contacts before the Revolution, see Gerald L. Carr, "David, Boydell, and *Socrates,*" *Apollo,* n.s. 137, no. 375 (May 1993): 307–15.

58. Decaisne exhibited *Adieu de Charles I à ses enfans* with the Société des Amis des Arts in 1829, no. 8; it was reviewed in *Journal des Artistes* 1 (April 19, 1829): 248. Achille Devéria's lithograph *Derniers adieux de Charles Ier à ses enfans* appeared in the suite *Douze sujets 1830* (Paris: E. Ardit; London: Engelmann & Coindet). It was captioned: "And therefore I charge thee do not be made a King by them." Mme Sophie Rude-Frémiet exhibited *Adieux de Charles Ier, roi d'Angleterre, à ses enfans* in the Salon of 1833, no. 210; a copy by Mme Pelletier was given to the Musée de Lisieux in 1836. A print after her painting by Lion was deposited by Frey in December 1832. In 1835, Zachée Prévost showed two engravings after Johannot, one of Cromwell and his family (no. 2441; Johannot had exhibited the watercolor in 1834), the other "*Charles Ier.* Dernière entrevue de ce prince et de ses enfans" (no. 2442). Sixdeniers exhibited an engraving after Alexandre-Marie Colin's *Charles Ier et ses enfans* in the 1836 Paris Salon (no. 2076) and at Dijon in 1840 (no. 393). Also exhibited at Dijon in 1840 was a painted copy after the Colin painting, by Mme S** (no. 326). Paintings of this subject continued to be exhibited in the Salon: Louis Somers, Salon of 1853, no. 1073, *Charles Ier, roi d'Angleterre, reçoit la visite de sa famille avant son supplice*; Claudius Jacquand, Exposition Universelle, 1855, no. 3384, *Dernière entrevue de Charles Ier avec ses enfants,* which cited Lamartine's biography

of Cromwell in *Le Civilisateur*: C'étaient la princesse Elisabeth, le duc de Glocester et le duc de York … Prenant sur ses genoux le petit duc de Glocester … : Mon enfant, lui dit-il gravement, ils vont couper la tête à ton père! … (LAMARTINE. – *Cromwell*). The government bought it from the exhibition for 5,000 francs (mss. Arch. Nat. F²¹ 1-154 fichier Labat and F²¹ 2284² A.3879). See Diane Russcol, "Images of Charles I and Henrietta-Maria in French Art, ca. 1815–1855," *Arts Magazine* 62, no. 7 (March 1988): 44–9, and Beth S. Wright, "Implacable Fathers: The Reinterpretation of Cromwell in French Texts and Images from the Seventeenth to the Nineteenth Century," *Nineteenth-Century Contexts* (1996; in press).

59. Delaroche's *Death of Elisabeth I* repeated Smirke's description of the same subject, his *Jane Grey* repeated Opie's *Execution of Mary Stuart*, his *Joan of Arc*, as we have seen, was influenced by Northcote's *Feckenham Visits Lady Jane Grey*. This was noted by Decamps and Haureau: "on lui a même fait un tort de nous reproduire les scènes des illustrations de l'histoire de David Hume" (Decamps, *Salon de 1834*, 31); "Ceux qui connaissent les charmantes gravures anglaises d'après Smirke, Opie, Stothard, savent tout ce que M. Delaroche a pris dans l'étude de ces trois maîtres" (Barthélemy Haureau, "Variétés. Salon de 1834. 3e article," *La Tribune politique et littéraire*, no. 74 [March 15, 1834]).

60. See Bann's discussion of the calling up of associative fields of reference (*The Clothing of Clio*, 36–7), taking Saussure's distinctions between a syntagmatic linear series of terms (relevant to historical narratives in general) and systematic associative fields (indicating the larger existence of an archive on which the historian has drawn), and Marrinan's discussion of a narrator's exertion of control over the reader by demonstrating mastery of the archive (Marrinan, "Literal / Literary / 'Lexie': History, Text, and Authority in Napoleonic Painting," 182, citing Michel Foucault, *L'Archaéologie du savoir* [Paris: Gallimard, 1969], 166–73).

61. Chateaubriand, *Les Quatre Stuarts*, in *Oeuvres Complètes de Chateaubriand*, 10 vols. (Paris: Eugène & Victor Penaud frères, 1849–50), 3:155–272, 206. I shall be citing this edition. *Les Quatre Stuarts* was first published as part of the twenty-eight volume *Oeuvres Complètes* (Paris: Ladvocat, 1826–31), in *Mélanges et Poésies* (1828), 22: 79–278. John Heywood Thomas dated its composition to 1826. *L'Angleterre dans les oeuvres de Victor Hugo*, vol. 6 of *Bibliothèque de la Fondation Victor Hugo* (Paris: Droz, 1934). Also see Judith-Rae Elias Ross, "Anglo-French Encounters: Images of the English Civil War in France, 1789–1848," Ph.D. diss., University of Illinois, Chicago Circle, 1978, 160. Ross, primarily concerned with the development of a liberal point of view on the English Civil War during the French Revolution and Restoration, concentrates on François Guizot, author of *L'Histoire de la Révolution d'Angleterre depuis l'avènement de Charles Ier jusqu'à sa mort*, 2 vols. (1826–7), and *Collection des Mémoires relatifs de la Révolution d'Angleterre*, 27 vols. (Paris: Pichon-Bechet, 1823–7). On Chateaubriand's resonant doublings (past/present, presence/absence, etc.), see Michael Riffaterre, "Chateaubriand et le monument imaginaire," in *Chateaubriand Today: Proceedings of the Commemoration of the Bicentenary of the Birth of Chateaubriand in 1968*, ed. Richard Switzer (Madison: University of Wisconsin Press, 1970), 63–81. See Dunn, *The Deaths of Louis XVI*, 97–9, on the impact of a letter from Louis XVI's executioner, Sanson, on Chateaubriand's *Essai historique, politique et moral sur les révolutions anciennes et modernes dans leurs rapports avec la révolution française* (London, 1797), published in France in 1826 as part of his collected works. Also see Pierre Macherey, "L'*Essai sur les Révolutions*, ou le laboratoire d'un style," 29–45; Jean-Paul Clément, "Chateaubriand et l'Angleterre," 56–65, both from *Europe*, nos. 775–6 (November–December 1993), special issue on Chateaubriand.

62. His *De la monarchie selon la charte* (1816) hailed a new monarchy supported by popular suffrage. Royalist revenge for Napoleon's Hundred Days resulted in an ultraroyalist "chambre introuvable": it would have been impossible for the king

to find more loyal representatives. But their intractable royalism made it difficult for the king to maneuver or compromise, and parliament was dissolved by order of his minister of police, Elie Decazes. Chateaubriand, horrified by this breech of faith with the Charter, appended a critical postscript to the work; copies were seized, and he was dismissed from his ministerial post. In 1820, though a vocal mourner of the murdered duc de Berry, he ceased publication of his newspaper *Le Conservateur* to avoid the newly rigorous censorship laws. In 1827 he helped to found the Société des Amis de la Presse.

63. When his friend, the comte de Montlosier, reproached him for ceasing to support "doctrines couvertes du sang de Louis XVI et de Charles Ier," he replied: "Je veux la Charte, toute la Charte, les libertés publiques dans toute leur étendue." Letter December 3, 1825; Chateaubriand, *Mémoires d'Outre-Tombe,* ed. Maurice Levaillant and Georges Moulinier, 2 vols. (Paris: Gallimard, 1951), 2:517–28.

64. Chateaubriand wrote *Note sur la Grèce* (1825), delivered a major speech in the Chamber of Peers in 1826, and helped to found the Comité Grec, a philanthropic society assisting the Greek insurgents. See Athanassoglou-Kallmyer, *French Images from the Greek War of Independence.*

65. His political writings were published during the Restoration as *Mélanges de politique (et opinions et discours),* 2 vols. (Paris: Le Normand, 1816), and *Mélanges politiques,* vols. 24–5 of the 28-volume *Oeuvres Complètes* (Paris: Ladvocat, 1826–31). On Chateaubriand's political career, consult (cautiously) his *Mémoires d'Outre-Tombe,* from book 22 on; Jean-Albert Bédé, "Chateaubriand as a Constitutionalist and Political Strategist," in *Chateaubriand Today,* 29–43; Jean-Paul Clément, *François-René de Chateaubriand. De l'Ancien Régime au Nouveau Monde. Ecrits politiques* (Paris: Hachette, 1987); François Furet's discussion of Chateaubriand's distinctive form of Bourbon allegiance, in *Revolutionary France, 1770–1880* (Oxford: Blackwell, 1992), 280–306. See also the annotated edition of his correspondence, ed. Béatrix d'Andlau, Pierre Christophorov, and Pierre Riberette, presently 5 vols. to December 1822 (Paris: Gallimard, 1977–86).

66. Il naquit sans doute dans la Grande-Bretagne en 1603, à l'avènement de Jacques Ier, plusieurs individus qui ne moururent qu'en 1688, à la chute de Jacques II: ainsi tout l'empire des Stuarts en Angleterre ne fut pas plus long que la vie d'un vieil homme. Quatre-vingt-cinq ans suffirent à la disparition totale de quatre rois qui montèrent sur le trône d'Elisabeth, avec la fatalité, les préjugés et les malheurs attachés à leur race.
Chateaubriand, *Les Quatre Stuarts,* 3:155.

67. Jacques expira sans violence dans le lit de la femme qui avait tué Marie d'Ecosse; de cette noble Marie, qui, selon une tradition, créa son bourreau gentilhomme ou chevalier; de cette belle veuve de François de France, laquelle désira avoir *la tête tranchée avec une épée à la française,* raconte Etienne Pasquier. *Le bourreau montra la tête séparée du corps,* dit Pierre de l'Estoile, *et comme en cette montre la coiffure chut en terre, on vit que l'ennui avait rendu toute chauve cette pauvre reine de quarante-cinq ans, après une prison de dix-huit.* Mais Jacques n'en travailla pas moins à établir les principes qui devaient amener la fin tragique de Charles Ier: il mourut toujours tremblant entre l'épée qui l'avait effrayé dans le ventre de sa mère, et le glaive qui devait tomber sur la tête de son fils. Son règne ne fut que l'espace qui sépara les deux échafauds de Fotheringay et de Whitehall; espace obscur s'éteignirent Bacon et Shakespeare.
Chateaubriand, *Les Quatre Stuarts,* 3:155–6.

68. An edition of selected works, *Oeuvres illustrées de Chateaubriand,* was published with illustrations by Janet-Lange [lAnge-Louis Janet] in seven volumes (Paris: H. Boissard, 1852–3); excerpts from *Les Quatre Stuarts* were included in 2:1–35.

69. Chateaubriand, *Les Quatre Stuarts,* 3:267–8.

70. He wrote of the outbreak of civil war in 1641,

> Plus tard on retourna aux principes de Clarendon et de Falkland, mais il fallut dévorer vingt ans de calamités. Ainsi nous sommes revenus en 1814 aux doctrines de 1789: nous aurions pu nous épargner le luxe de nos maux. Cependant (il est triste de le dire), les crimes et les misères des révolutions ne sont pas toujours des trésors de la colère divine, dépensés en vain chez les peuples. Ces crimes et ces misères profitent quelquefois aux générations subséquentes par l'énergie qu'ils leur donnent, les préjugés qu'ils leur enlèvent, les haines dont il les délivrent, les lumières dont ils les éclairent. Ces crimes et ces misères, considérés commes leçons de Dieu, instruisent les nations, les rendent circonspectes, les affermissent dans des principes de liberté raisonnables; principes qu'elles seraient toujours tentées de regarder comme insuffisants, si l'expérience douleureuse d'une liberté sous une autre forme n'avait été fait.

Ibid., 3:185.

71. Louise-Marie-Jeanne Mauduit (1784–1862), Salon of 1819, no. 799,

> *Henriette de France, femme de Charles Ier, roi d'Angleterre.* Cette princesse se voyant l'objet particulier de la haine des parlementaires, et menacée par l'approche de l'armée révoltée, entreprit de passer secrètement en France. S'étant dérobée aux recherches des soldats qui en voulaient à sa vie, il lui fallut pour regagner sa terre natale se confier de nouveau à une mer orageuse qui ne la mit pas à l'abri de ses ennemis. Poursuivi à coups de canon jusque sur les côtes de France, ce fut en montant dans une chaloupe, et traversant des rochers, qu'elle échappa à leur fureur, et aborda dans sa patrie. Des paysans français, en reconnaissant la fille d'un roi qu'ils avaient tant aimé, tombèrent à ses pieds, et lui offrirent leur chaumière. Sur les derniers plans, un paysan Breton montre à un jeune pâtre le vaisseau anglais qui ose encore tirer sur la fille d'Henri IV (Mais. d. R.)

Musée Municipal, Dinan, Inv. 53 39; 1.60 × 1.95 m. Commissioned in 1818 for 2,000 francs (mss. Arch. Nat. O³ 1400, 1401). Mlle Mauduit studied with Meynier and Hersent, whom she married in 1821. See Russcol, "Images of Charles I and Henrietta-Maria in French Art, ca. 1815–1855," 47–8.

72.
> Un pinceau doux, naïf, et gracieux, trouverait difficilement, pour s'exercer, un sujet plus noble, et plus touchant que celui d'une reine persécutée, fugitif, bravant tous les périls, pour chercher son salut sur le sol qui l'a vue naître ... Si Mlle Mauduit projetait de lui donner un pendant, nous l'inviterions à prendre pour sujet l'embarquement de S.A.R. Madame, Duchesse d'Angoulême, à Bordeaux, le 1er avril 1815. Nous sommes loin, pour cela, de vouloir insinuer que ce sujet, qui vient d'être peint par M. Gros, soit encore à traiter, mais les deux tableaux sont de proportions différentes, et ce trait historique est du nombre de ceux qu'on peut rappeler toujours avec un intérêt nouveau.

Landon, *Salon de 1819*, 2:57–9.

73. François-Barthélemy-Augustin Desmoulins (1788–1856), Salon of 1835, no. 593,

> *Fuite de Henriette Marie de France, reine d'Angleterre.* Une cabane déserte, à l'entrée d'un bois, s'offrit à Henriette-Marie; elle y demeura cachée pendant deux jours. Elle entendit défiler les troupes du comte d'Essex, qui parlaient de porter à Londres la tête de la reine, laquelle tête avait été mise à prix pour une somme de six mille livres sterling. (CHATEAUBRIANT [sic], Les Quatre Stuarts.)

Musée Crozatier, Le Puy, Inv. 03.21; 1.39 × 1.79 m. Entered collection of the Musée Crozatier, Le Puy, 1892. The engraving by Narcisse Desmadryl was exhibited in the Salon of 1838, no. 1974.

74. Chateaubriand, *Les Quatre Stuarts*, 3:170–2.

75. "Cette scène, à laquelle on ne peut reprocher que d'être un peu théâtrale, est du petit nombre de celles qui peuvent se passer du livret pour être comprises,

chaque acteur étant bien dans son rôle et ayant l'expression qui lui convient." [Anon] *Annales du musée et de l'ecole moderne des beaux-arts . . . Salon de 1835* (Paris, 1835), 36. The critic praised the "exécution remarquable."

76. Salon of 1831, no. 2720, 2nd supp., "*Cromwel et Charles Ier*. Cromwel, après la décapitation de Charles Ier, dont le cadavre avait été transporté dans les appartemens du palais de Withe-Hall, soulève le couvercle du cercueil pour contempler les restes de ce prince. (Tiré des *Quatre Stuarts* de M. le vicomte de Chateaubriand)." See Ziff, *Delaroche,* 105–14, and catalogue no. 51, 281. Bought by the Ministry of the Interior for 3,000 francs. Exhibited in the Salon at Lille, 1834, no. 82; sent to the Musée des Beaux-Arts, Nîmes, where it remains (2.25 × 2.92m). Also exhibited at the Royal Academy in London in 1850, no. 369. A preliminary drawing (Musée Tavet-Delacour, Pontoise) was dedicated to François Guizot, a Nîmois. A replica (1849; 226 × 291 cm) entered the Hermitage in 1922 (Inv. 7315). A smaller replica (38 × 45 cm) entered the Kunsthalle, Hamburg, in 1846 (Inv. 2265). Numerous engravings were made after the painting; Henriquel Dupont's was exhibited in the Salon of 1833 (supp. no. 3299) and at Troyes in 1841 (no. 104).

77. *Le Globe,* no. 162 (August 2, 1830), 646. Such comparisons were frequent; an anonymous article "L'Angleterre en 1688 et la France en 1830" appeared in *Le Globe* (August 24, 1830) on the front page. Banchou de Penhoën published a book, *Guillaume d'Orange et Louis-Philippe (1688–1830),* in 1835.

78. Guizot also described Cromwell standing before the coffin but had him holding the head, like a puritan Hamlet contemplating a Stuart skull: "L'échafaud demeuré solitaire, on enleva le corps: il était déjà enfermé dans le cerceuil; Cromvell voulut le voir, le considéra attentivement, et soulevant de ses mains la tête comme pour s'assurer qu'elle était bien séparée du tronc: 'C'était là un corps bien constitué, dit-il, et qui promettait une longue vie.'" François Guizot, *Histoire de la Révolution d'Angleterre depuis l'avénement de Charles Ier jusqu'à sa mort* (1826–27), 4th ed., 2 vols. (Paris: Victor Masson, 1850), 2:528. Guizot's *Histoire de la révolution d'Angleterre* was published in three parts: *Histoire de Charles Ier (1625–1649)* (1826–27), *Histoire de la république d'Angleterre et de Cromwell (1649–1658)* (1854), *Histoire du protectorat de Richard Cromwell et du rétablissement des Stuarts (1658–1660)* (1856).

79. Chateaubriand, *Les Quatre Stuarts,* 3:216–17.

80. Sir Thomas Herbert, *Memoirs of the Last Two Years of the Reign of King Charles I* (1813). Edward Hyde, first earl of Clarendon, *The History of the Rebellion and Civil Wars in England* and *Life of Edward Earl of Clarendon* (a new edition was published in London in 1827.

81. La figure de son Cromwell n'exprime ni étonnement, ni stupéfaction, ni agitation quelconque de l'âme; tout au contraire, le spectateur est remué par l'aspect du calme effrayant et horrible du visage de cet homme. Elle nous apparaît, cette figure, ferme et assurée, *brutale comme un fait,* puissant sans pathétique, demoniaque et naturelle, merveilleusement ordinaire, et elle considère son ouvrage comme un bûcheron qui vient d'abattre un chêne.
 Heinrich Heine, *De la France* (Paris: Eugène Renduel, 1833), 340–1. On Heine's approach in the lengthy and significant review of the *Cromwell,* a montage of different voices and visual associations, which he termed "Anchauungsideen," or "dream-image-ideas," see András Sándor, "The Oak Tree and the Ax: Delaroche's Painting and Heine's Montage," in Zantop, ed., *Paintings on the Move,* 51–74.

82. Comte Horace de Viel-Castel, "*Cromwell* par M. Delaroche," *L'Artiste* 1 (1831): 269–70. Cromwell's unprepossessing appearance indicted his character as well as indicating his class:
 Cromwell, puritain et soldat, était peu soigné de sa personne; un large feutre qui couvrait ses tempes laissait échapper quelques mèches grisonnantes de ses cheveux plats . . . sur sa poitrine, mais caché à tous les yeux,

la cuirasse de l'usurpateur inquiet . . . d'une taille moyenne . . . épais, et la tête très-peu hors des épaules. Tout en lui montrant et marquait d'un cachet ineffaçable le représentant du puritanisme. C'était une véritable *tête ronde*, un homme du peuple.

83. Letter of April 17, 1864, from Huet to Sollier, in René-Paul Huet, *Paul Huet d'après son correspondance* (Paris: Laurens, 1911), 381–3. Huet acquired the watercolor (Robaut 368); it was in his collection until 1929, sold April 28–9, 1941, and cannot presently be located; a photograph of it (1-CE-389 [BAP]) is in the collection of the Caisse Nationale des Monuments Historiques (see Fig. 41). See Meisel, *Realizations*, 237–9; Beth S. Wright, "An Image for Imagining the Past: Delacroix, Cromwell, and Romantic Historical Painting," *Clio* 21, no. 3 (Spring 1992): 243–63, where I discuss Delacroix's versions of *Cromwell*, 1826–31 (inspired by Walter Scott's novel *Woodstock*) and Delaroche's *Cromwell*.

84. Le *Cromwell* est en effet, sous tous les rapports, la pire et la plus pauvre de toutes les oeuvres de M. Paul Delaroche . . . Non seulement son Cromwell n'est pas vrai, non seulement il n'est pas vraisemblable; il est impossible. Je défie, en effet, qu'on devine et qu'on surprenne les sentimens et les pensées dont le peintre a voulu animer sa physionomie. Est-ce la joie, le dédain, le mépris, le remords, la crainte de l'avenir, le regret du passé, un soudain retour, une subite intelligence du néant de la grandeur? espérance ou repentir? Je ne vois pas un trait du visage qui ne révèle un seul de ces sentimens. Je suppose que l'auteur . . . s'est enfin décidé pour l'impassibilité; mais il n'a pas, que je sache, réussi même à exprimer ce dernier sentiment.

Gustave Planche, *Salon de 1831* (Paris: Pinard, 1831), 123–30, 124–5, 128–9. Summing up the entire Salon, Planche regretted that Delaroche's *Cromwell*, not Delacroix's *Liberty*, was the most popular work: "*Ce qu'il faut à la multitude, c'est la médiocrité du premier ordre . . . De tout cela que concluerons-nous? C'est que le drame vient d'envahir la peinture qu'on appelle historique*" (297–8).

85. Salon of 1837, no. 497, "*Charles Ier insulté par les soldats de Cromwell.* Le parlement avait consacré à l'habitation du roi, pendant son procès, la maison de sir Robert Cotton, située près de Westminster-Hall. Charles y subissait chaque jour les plus grossiers outrages de la part des soldats chargés de le garder à vue." See Ziff, *Delaroche*, 154–60 and catalogue no. 83, 286. Ziff gives no dimensions; according to the Archives du Louvre for the Salon of 1837 (*KK 31), its framed dimensions were 2.70 × 3.20 m. It was bought by the duke of Sutherland, who exhibited it at the British Institution in 1838 (no. 130); missing since World War II. The Coutan sale in 1830 included (lot 193) Delaroche's *Charles Ier, avant d'aller au supplice, est livrée à la brutalité des soldats de Cromwell.* Martinet exhibited an engraving after the work in the Salon of 1843 (no. 1565) and in the Exposition Universelle of 1855 (no. 4729).

86. Hume, *History of Great Britain, Charles I,* chap. 10, 678.

87. François Guizot, *A Popular History of England from the Earliest Times to the Reign of Queen Victoria,* 4 vols. (Boston: Aldine, 1886), chap. 25, 3:192.

88. "Charles témoigna le désir de parler après la lecture; on lui interdit la parole: il n'était plus vivant aux yeux de la loi." Chateaubriand, *Les Quatre Stuarts,* 3:205–6. Earlier he had described jeering: "Charles, entendant autour de lui les exclamations: 'Justice! justice! Exécution! exécution!' sourit de pitié. Un misérable, peut-être un des juges, lui crache au visage: il s'essuie tranquillement" (202).

89. Ibid. Parallels with Christ's Passion were common in Carlian literature. On January 25, 1661, the Church of England decreed that the date of Charles I's execution, January 30, should be kept as a national day of fasting and humiliation; this continued until 1859. See Sidney Leslie Ollard, *A Dictionary of English Church History,* 2nd ed. (London: Mowbray, 1919), 105–7; F. L. Cross and E. A. Livingstone, *Oxford Dictionary of the Christian Church,* 2nd, rev. ed. (New York: Oxford University Press, 1983), 269.

90. Chateaubriand, *Les Quatre Stuarts,* 3:192.

91. Salon of 1837, no. 496, "*Strafford*. Près de sortir de la tour de Londres pour aller au supplice, Strafford s'arrêta au-dessous de la fenêtre du cachot où était renfermé Laud, archevêque de Cantorbéry, dont les consolations spirituelles lui avaient été refusées, et, s'agenouillant, il lui cria: 'Mylord, votre bénédiction et vos prières!' Le vieillard étendit les mains à travers les barreaux de sa prison et appela sur son ami les bénédictions du Seigneur." It was painted in 1835; its dimensions were 2.65 × 3.14 m. Louis-Pierre Henriquel-Dupont exhibited an engraving after the work in the Salon of 1840 (no. 1792), in Dijon that same year (no. 387), and in the Exposition Universelle of 1855 (no. 4673). See Ziff, *Delaroche*, 155–60 and catalogue no. 81. Acquired by Lord Egerton; Lomb sale, New York, May 11, 1939, no. 64. Smaller version (46 × 56 cm) in San Donato sale, Paris, February 22–3, 1870, no. 24; John Heugh collection, England; lost.

92. Trophime-Gérard, marquis de Lally-Tolendal, *Essai sur la vie de T. Wentworth, comte de Strafford, principal ministre d'Angleterre et lord Lieutenant d'Irlande, sous le règne de Charles I, ainsi que sur l'histoire général d'Angleterre, d'Ecosse et d'Irlande, à cette époque* (London, 1795), 403–4; and in French (Paris: Nicolle, 1814). Both editions were in Delaroche's book collection (see the inventory prepared after his death, Ziff, 158, n. 11). Chateaubriand's text (183) is virtually identical but is written in the third person.

93. *Collection de Vinck. Inventaire analytique par François-Louis Bruel*, Vol. 1: *Ancien Regime* (Paris: Imprimerie Nationale, 1909), tome 4, 238–40, no. 546, fol. 23. The queen refused to make her confession to a priest who had repudiated his vows; there were rumors that royalists had conspired so that she could make her confession to the imprisoned abbé Emmery and receive communion from the abbé Magnin. See Bruson, "Bénazech, Hauer, Kucharski et quelques autres. Les Peintres des derniers moments de la famille royale," in *La Famille royale à Paris* (as in n. 55 to this chapter). The painting for this print is catalogue no. 9: *Marie Antoinette recevant la bénédiction d'un prêtre, à la Conciergerie*; priv. coll. (oil, 36 × 31 cm). Anne-Flore-Millet de Bréhan (c.1752–after 1800) emigrated from France in 1792. She lived in London, then in Germany with the margrave and margravine of Brandenburg until 1796. The stipple engraving by George Keating (1762–1842), an Irish engraver, bookseller, and editor of Catholic works, after the marquise de Bréhan's design was published in London by C. Laurent on March 25, 1796. See mss. Arch. Nat. F^7 5646; F^{17}1263, no. 130a.

94. Chateaubriand, *Les Quatre Stuarts*, 3:182–3. On the day of Charles's execution, his valet, Thomas Herbert, dreams of Archbishop Laud (207). Chateaubriand accompanied his description of the execution by translating a text which he said appeared in London that same night: "Relation Véritable de la mort du Roi de la Grande-Bretagne, avec la Harangue faite par sa majesté sur l'échafaud immédiatement avant son exécution" (210–16). One passage (italicized) refers obliquely to God punishing Charles for Strafford's death: "un injuste arrêt que j'ai souffert être exécuté, est puni à présent par un autre injuste donné contre moi-même" (212). Chateaubriand explains the reference in a note. A French translation by J. Ango, *Relation Véritable de la mort cruelle et barbare de Charles I, roi d'Angleterre . . . Avec la Harangue faite par Sa Majesté sur l'échafaud* (Paris: Lepetit, 1792), reprinted three times in 1792, may have been Chateaubriand's source.

95. Barbier criticized the "jeu de pantomime" of Laud's hands, which distracted from the main subject, Strafford on his knees; such pantomimic affectation had been evident as early as *Joan of Arc* in 1824. Auguste Barbier, "Salon de 1837," *Revue Universelle*, 3:66–89, 69–70.

96. Stendhal suggested such themes as the death of the duc de Guise at Blois, Joan of Arc, the murder of Jean-sans-Peur on the bridge at Montereau, or the peasant revolt of Wat Tyler. See letters 5 and 6, in *Racine et Shakespeare. Texte établi et annoté avec Préface et Avant-Propos par Pierre Martino*, 2 vols. (Paris: Champion, 1925), 1:103–20, 1:121–33.

97. *Charles Premier*, in *Théâtre par le Cte J.-R. de Gain-Montaignac, gouverneur du château royal de Pau* (Paris: Potey, Petit, 1820), 213–400; "Préface," 213–14. The action ranged through Carisbrook Castle, the House of Commons, Whitehall Palace, and other sites. The trial of Charles I was described, so that Lady Fairfax's protest could be seen onstage, but his execution was not shown.

98. Je me suis imaginé que je me promenais dans Paris au mois de mai 1588 . . . et chaque fois qu'une scène pittoresque, un tableau de moeurs, un trait de caractère sont venus s'offrir à mes yeux j'ai essayé d'en reproduire l'image . . . S'il se rencontre dans ces dialogues certains effets de scène, certaines situations qui peuvent à la rigueur passer pour théâtrales, ce sont de purs accidents; ce qui ne veut pas dire que je les doive au hasard; tout au contraire, je les ai cherchés, mais seulement dans le sein de l'histoire . . . ils attestent la vertu dramatique de l'histoire.
Ludovic Vitet, "Avant propos," in *Les Barricades. Scènes historiques. Mai 1588* (Paris, 1826), i–ii. Vitet prefaced the play with an essay on the historical background to the episodes: "Histoire abrégée de la Ligue, depuis son origine jusqu'à la journée des barricades (1576–1588)," vii–lxviii. *Les Etats de Blois ou la Mort de M. de Guise. Scènes historiques. Décembre 1588* (1827) and *La Mort de Henri III* (1829) completed Vitet's trilogy on the League. See Barbara T. Cooper, "Ludovic Vitet: An Historical Dramatist at the Turning Point," *Topic* [Washington and Jefferson College], no. 35 (Fall 1981): 20–5.

99. Charles-Barthélemy-Jean Durupt (1804–35). Salon of 1833, no. 803, *Mort du duc de Guise* (1832; Musée du Château de Blois, Inv. D 880.5.1; 91 × 72 cm, where it is titled more accurately *Henri III poussant du pied le cadavre du duc de Guise, 23 décembre 1588*). Collection of Louis Philippe, no. 136, Château de Fontainebleau; Blois, 1876. In the same Salon of 1833, Durupt exhibited, possibly as a pendant, no. 802, *Le Marquis de Noirmoutiers cherchant à détourner le duc de Guise de se rendre à l'assemblée des Etats de Blois* (Bayeux, Musée Baron Gérard, Inv. 206 P; dépôt du Louvre, Inv. 4332, 92 × 73 cm) Delaroche, Salon of 1835, no. 565, *Assassinat du duc de Guise au château de Blois* (Chantilly, Musée Condé, Inv. 450; 1834; 57 × 98 cm; 22.4 × 48.6 in.) See Ziff, catalogue no. 60, and 146–53; commissioned by the duc d'Orléans, who paid 10,000 francs, twice the agreed-upon fee, to signal his delight with the work. Watercolor versions are in the Musée Fabre, Montpellier (1830; 20 × 30 cm) and the Wallace Collection, London (P 738; 1832; 14.3 × 24.8 cm). Vitet's text was graphic: "Le Roi, dans le couloir qui conduit de sa chambre à son cabinet, soulevant avec précaution un coin de la tapisserie. *Mes amis, cela est-il fait?* Sainte-Malines, essuyant son poignard. *Tenez, Sire, regardez-le, là, par terre, il vous demande pardon.*" *Les Etats de Blois* (Paris: Ponthieu, 1827), Scene 9, pp. 277–314, 305–6.

100. Discussing Gérôme's *Death of Marshal Ney*, exhibited in the Salon of 1868 under the title *December 7, 1815, 9 o'Clock in the Morning* (Graves Art Gallery, Sheffield), Kemp emphasized the temporal and rhetorical implications of adjacent and contiguous compositional arrangements: "in the place of history, happening; instead of manifest intelligibility, contingency; instead of sense, sensory data; instead of comprehension on the part of the beholder, suspense." Wolfgang Kemp, "Death at Work: A Case Study on Constitutive Blanks in Nineteenth-Century Painting," *Representations* 10 (Spring 1985): 102–23, 114. He pointed out (n. 29) that Gérôme's approach had first been employed by his teacher, Delaroche.

101. Many critics worried that such a casually composed presentation of this pathetic subject was fatal to historical representation: "This capacity of the artist to treat serious subjects in miniature . . . can become fatal to pathos and grandeur in art" (A., "Salon de 1835," *Le Constitutionnel* [March 30, 1835]). Vergnaud called it a puppet show (A.-D. Vergnaud, *Petit pamphlet sur quelques tableaux de Salon de 1835* [Paris, 1835], 4). See Ziff, *Delaroche*, 150–2; Patri-

cia Condon, "Historical Subjects," in *The Art of the July Monarchy: France 1830 to 1848,* 80–100, 97–100.

102. In Schoelcher's opinion, Delaroche's dwindling powers of invention and increasingly slick execution had forced him to select bathetic subjects:

> Incapable of having a great conception or of moving his audience by the force of his ideas, in realizing them on canvas, he has based his fame on tears; he has sought touching subjects . . . M. Delaroche's talent has become impoverished thus by the need to impress the spectator; paintings are no longer possible for him without pathos. To the degree that he uses ingenuity in composing his subject, in staging it like the third act of a Franconi melodrama, to that same degree he demonstrates a lack of variation in his ideas. What is always essential for him are tragic dying figures or cadavers: he is the painter of death.

Victor Schoelcher, "Salon de 1835 (2e article)," *Revue de Paris* 16 (1835): 44–61, 45.

103. Chantilly, Musée Condé, Inv. 432, signed and dated 1840; 57 × 98 cm. Commissioned by the duc d'Orléans, who paid Ingres 18,000 francs, the painting passed through the collections of Prince Demidoff (1853) and the duc d'Aumale (1863). See Condon's discussion of Ingres's rivalry with Delaroche, as in n. 102 to this chapter. See also Condon, *In Pursuit of Perfection,* 60–3; Nora M. Heimann, "The Road to Thebes: A Consideration of Ingres's *Antiochus and Stratonice,*" *Rutgers Art Review* 11 (1990): 1–20; Vigne, *Ingres,* 217, 223–8.

104. Paris, Musée du Louvre, RF 1440, c.1807. Graphite and brown wash; 29 × 40 cm, $11\frac{3}{8} \times 15\frac{3}{4}$ in. See Henri Delaborde, *Ingres, sa vie, ses travaux, sa doctrine, d'après les notes manuscrites et les lettres du maître* (Paris, 1870), 188.

105. Ingres told his student Henri Lehmann that he had made two hundred drawings and fifty oil sketches of Antiochus's arm. See Lehmann's letter to Marie d'Agoult, October 6, 1839, in Daniel Ternois, "Ingres et sa méthode," *Revue du Louvre* 4, no. 5 (1967): 195–208, 200, citing Solange Joubert, *Une correspondance romantique. Madame d'Agoult, Liszt, Henri Lehmann* (Paris, 1947).

106. "Un Peintre Anglais," [Prosper Mérimée], "Salon de 1839," *Revue des Deux Mondes,* 4th ser., 18 (April 1, 1839): 83–103, 88–9. Prosper Mérimée (1803–70) was the son of the artist Léonor Mérimée (1757–1836), who served as secrétaire perpétuel of the Académie des Beaux-Arts. An archaeologist, poet, historical novelist, and playwright, Mérimée served as inspecteur général des monuments historiques after 1834. During the Second Empire he became a Senator. Mérimée moved in Liberal circles during the Restoration and was close to both Stendhal and Delécluze. He was particularly interested in social mores; he announced, in his historical novel *Chronique du règne de Charles IX* (1829), that he intended to provide "a truthful depiction of the mores and characters of a particular age" (the Wars of Religion). Popular insurrection was also the focus of *La Jacquerie* (1828), a series of dramatic sketches set in the feudal period.

107. I cannot consider Mr. Burke's book in any other light than a dramatic performance; and he must, I think, have considered it in the same light himself, by the poetical liberties he has taken of omitting some facts, distorting others, and making the whole machinery bend to produce a stage effect . . . It suits his purpose to exhibit the consequences without their causes. It is one of the arts of the drama to do so. If the crimes of men were exhibited with their sufferings, the stage effect would sometimes be lost, and the audience would be inclined to approve where it was intended they should commiserate.

Thomas Paine, *The Rights of Man; Being an Answer to Mr. Burke's Attack on the French Revolution* (1791); in a modern edition with Edmund Burke, *Reflections on the Revolution in France* (as in n. 45 to this chapter) (New York: Doubleday [Dolphin], 1961), 296–7.

108. "En effet, M. Delaroche s'est fait historien; mais pour lui dans l'histoire le peuple ne compte pas, ou s'il aperçoit, c'est pour en faire ou le bourreau des grands, qui ont toute sa sympathie, comme dans sa *Jane Grey*, ou le gêolier brutal des rois, comme dans son *Charles Ier*." Like Schoelcher (n. 102 to this chapter), Piel found Delaroche's calculating reliance on "cet instinct banal qui faire palpiter toute chair à la vue de la chair qui souffre" to be the motivating principle of his *Cromwell, Jane Grey, Charles Ier,* and *Strafford:*

> quatre drames qui manquent du principal élément dramatique, à savoir les passions en jeu, les combat de l'âme humaine . . . Tel qu'il l'a été conçu et exécuté, le *Strafford* de M. Delaroche est, sans l'aide du livret, le dénouement incompréhensible d'un drame qu'il l'aurait pu rendre plein d'intérêt . . . mais pour ce faire il ne fallait pas isoler la scène du grande acte politique joué par Charles Ier et par le Long Parlement . . . M. Delaroche n'a vu dans l'histoire de la révolution anglaise que les mouvements automatiques des Têtes Rondes et des Cavaliers; que les mouvements politiques de 1647 lui ont fourni des poses, des costumes et des meubles, mais rien de plus.

Louis-Alexandre Piel, "Salon de 1837," *L'Européen,* 2nd ser., 2 (July 1837): 24–32, 29–30. Piel was an architect and a Christian socialist, as was Philippe Buchez, the director of *L'Européen.* In 1837 Piel attacked Delaroche's *Sainte Cécile* for its lack of true Christian ideals, exemplified in Ary Scheffer's *Christ consolateur,* with its poignant references to slavery. See Neil McWilliam, *Dreams of Happiness: Social Art and the French Left, 1830–1850* (Princeton: Princeton University Press, 1993), 127–34.

CHAPTER FIVE. PAINTING THOUGHTS

1. Sir David Wilkie (1785–1841). *Chelsea Pensioners* (oil on panel, 97 × 158 cm). The first preparatory sketch (July–December 1818; lost) had elderly figures with visible wounds (a wooden leg) and disabilities (an inflamed eye). When the duke of Wellington objected to the man with ophthalmia, Wilkie painted an alternate sketch between March 7 and June 18, 1819, which contains fewer, younger figures (Royal Hospital, Chelsea; oil on wood; 29 × 40 cm, $11\frac{3}{8}$ × $15\frac{3}{4}$ in.). The work was completed by July 1822, when it was delivered to Apsley House. It was exhibited in the Royal Academy in 1822, the British Institution in 1825 and 1842, and the Royal Scottish Academy in 1837. The seventh duke of Wellington gave Apsley House to the nation in 1947; its contents passed into the collection of the Victoria and Albert Museum. See Allan Cunningham, *The Life of Sir David Wilkie. With His Journals, Tours, and Critical Remarks on Works of Art: and a Selection from his Correspondence,* 3 vols. (London: John Murray, 1843), 2:13–18, 25–9, 45–58, 66–9, 72–3, 109–10; *Sir David Wilkie of Scotland (1785–1841)* (Raleigh: North Carolina Museum of Art, 1987), exhibition catalogue by William J. Chiego et al., H. A. D. Miles's entry no. 22 (preparatory sketch), no. 23 (painting), 184–92, and no. 94 (engraving; Yale Center for British Art), 365–6; Meisel, *Realizations,* 142–65. Wilkie's reputation in France was high, even before his visit to Paris in 1814. He returned to Paris in 1825 and was elected a corresponding member of the Institut in 1836, with his engraver Abraham Raimbach. See Marcia Pointon, "From 'Blind Man's Buff' to 'Le Colin Maillard': Wilkie and his French Audience," *Oxford Art Journal* 7, no. 1 (1984): 15–25.

2. Géricault to Horace Vernet, in a letter headed "Londres, 6 mai," cited in translation by Eitner, in *Géricault,* 218; in French by Charles Clément, in *Géricault. Etude Biographique et Critique avec le catalogue raisonné de l'oeuvre du maître,* 3rd ed. (Paris: Didier, 1879), 199–203. Géricault was in Great Britain between April 10 and June 19, 1820, and between January and December 1821. See Lee Johnson, "The Raft of the Medusa in Great Britain," *Burlington Magazine* 96 (August 1954): 249–54; Suzanne Lodge, "Géricault in England," *Burlington*

Magazine 108 (December 1965): 616–27; Eitner, *Géricault*, 208–37; Christopher Sells, "New Light on Géricault, His Travels and His Friends, 1816–23," *Apollo*, n.s. 123, no. 292 (June 1986): 390–5; *Géricault* (Paris: Grand Palais, 1991), 288–98, where Bruno Chenique proposes (291–2) the date of 1820 for the letter; Germain Bazin, *Théodore Géricault. Etude Critique, Documents et Catalogue Raisonné* Vol. 1: *L'Homme. Biographie, témoignages et documents* (Paris: La Bibliothèque des Arts, 1987), document no. 198 (dated 1821 by Bazin) and 51–3, 61–6. (Hereafter this volume will be cited as *Géricault. Etude Critique*. Vol. 1: *L'Homme.*) Géricault was invited to a Royal Academy banquet of May 5, 1821, organized by Cooper, Collins, and Wilkie, and visited Wilkie's studio on December 1, 1821, with Auguste and Cockerell; see Cockerell's diary, Bazin, *Géricault. Etude Critique.* Vol. 1: *L'Homme*, document no. 204, 1:65.

3. Horace Vernet's *Battle of Jemmapes* (1821; London, National Gallery) was refused by the Salon jury of 1822 because of its subject, with six other works. Vernet's private exhibition in his studio was supported by Bonapartists and Liberals. Vernet shared Géricault's radical political sympathies; on Vernet's Bonapartism and Carbonarist activities, see Athanassoglou-Kallmyer, "Imago Belli: Horace Vernet's *L'Atelier* as an Image of Radical Militarism under the Restoration."

4. See his letter to Soulier (June 6, 1825), in *Eugène Delacroix: Selected Letters, 1813–1863*, ed. and trans. Jean Stewart (New York: St. Martin's, 1970), 122–4, 123; to Pierret (June 18, 1825), 124–5, 124; and to Théophile Silvestre (December 31, 1858), the organizer of a Parisian exhibition of contemporary British painting (350–3). Delacroix was particularly impressed by Wilkie's sketch (oil on panel; $19\frac{1}{2} \times 24\frac{1}{2}$ in.; Petworth) for *The Preaching of Knox before the Lords of the Congregation 10th June 1559* (London, Tate Gallery, 1832; oil on panel; 122.6×165.1 cm, $48\frac{1}{4} \times 65$ in.). Its impact on his *Murder of the Bishop of Liège* (1829; Paris, Musée du Louvre), a subject from Walter Scott's novel *Quentin Durward*, has been noted by Frank Trapp, *The Attainment of Delacroix* (Baltimore: Johns Hopkins University Press, 1971), 54–5 (who also notes the compositional similarities to the 1830 competition sketches *Boissy d'Anglas* and *Mirabeau and Dreux-Brezé*, but without analyzing the historical significance of these choices); Martin Kemp, "Scott and Delacroix, with some Assistance from Hugo and Bonington," in *Scott Bicentenary Essays*, ed. Alan Bell (Edinburgh: Scottish Academic Press, 1973), 213–27; Johnson, *Paintings of Delacroix*, J 135, 1 (1981): 131–4; Bridget J. Elliott, "The Scottish Reformation and English Reform: David Wilkie's *Preaching of Knox* at the Royal Academy Exhibition of 1832," *Art History* 7, no. 3 (September 1984): 313–28; Duncan Macmillan, "Sources of French Narrative Painting: Between Three Cultures," *Apollo*, n.s. 137, no. 375 (May 1993): 297–303. Delacroix's trip to London should be set into the context of his friendship with Bonington, who shared his studio in the rue Jacob in the winter of 1825–6; see *Bonington: "On the Pleasures of Painting,"* 46–55.

5. Charles Nodier, "Marino Faliero, mélodrame en cinq actes et en vers, par M. Casimir Delavigne, membre de l'académie française; représenté le 31 mai 1829, au théâtre de la porte saint-martin," *Revue de Paris* 3 (June 1829), 54–64, 56.

6. See H. J. Hunt, *Le Socialisme et le romantisme en France: étude de la presse socialiste de 1830 à 1848* (Oxford: Clarendon Press, 1935); David Owen Evans, *Social Romanticism in France* (Oxford: Clarendon Press, 1951); Ralph P. Locke, *Music, Musicians and the Saint-Simonians* (Chicago: University of Chicago Press, 1986); Crossley, *French Historians and Romanticism*, 105–38.

7. William Chiego, "David Wilkie and History Painting," in Chiego et al., *Wilkie*, 21–47, 28–9. *Village Politicians* was inspired by Hector MacNeill's poem *Scotland's Scaith; or, the History o' Will and Jean: owre true a tale!* (1795).

8. Victor Hugo, "Préface," in *Cromwell*, in *Théâtre Complet de Victor Hugo*, 2 vols. (Paris: Pléiade, 1963), 1:409–54, 423. Hugo began his drama in August 1826 and had read it aloud several times to friends by March 1827; it was

published that year, although its stage première did not occur until more than a century later, in 1956. See Pierre Georgel, *La Gloire de Victor Hugo* (Paris: Réunion des Musées Nationaux, 1985), catalogue of an exhibition in Paris, Galeries Nationales du Grand Palais, October 1, 1985–January 6, 1986.

9. "Le romantisme, tant de fois mal défini, n'est à tout prendre, et c'est là sa définition réelle . . . que le *libéralisme* en littérature." Victor Hugo, "Préface," in *Hernani* (published March 1830).

10. I also discovered the *Conspiracy of the Spaniards against Venice . . .* and . . . Otway's *Venice Preserved,* which is taken from it and which is one of the most highly admired of all English plays. Saint-Réal's style is all the more magically effective for being simple, really and truly simple. None of those inflated words, deliberately introduced to convey images; he paints effortlessly and with few words; you really know his people: when a catastrophe occurs, it creeps on you unnoticed, without exclamation-marks of emphasis; and indeed on the day when a conspiracy is un-masked, when five or six hundred men are stabbed or drowned, the weather is none the gloomier for that, and the sun runs his course as usual. It seems on the contrary with writers like Chateaubriand that words have to be bigger than things, and that things being too vulgar in themselves for such refined imaginations, the subtlety and inflation of the language have to give them more savor for the poor reader.

Letter to Félix Guillemardet (September 23, 1819), in Delacroix, *Selected Letters,* 56–60, 59–60.

11. *The Journal of Eugène Delacroix,* ed. Hubert Wellington, trans. Lucy Norton (London: Phaidon, 1995), entry for October 8, 1822, 6–7. He reiterated this idea throughout his career; in his entry for July 18, 1850 (134), he wrote that "material" painting was only the pretext for constructing a bridge between the imagination of the painter and that of the beholder. See also his discussion of effect and imagination, January 25, 1857 (370–3).

12. During the 1820s, Bodin, Carrel, and Arnold Scheffer wrote for Lecointe and Durey's "Collection de Résumés de l'Histoire de Tous les Peuples Anciens et Modernes," cultural histories for the mass audience, costing from 2 francs to 3 francs 50; fifty works were planned. See "Résumé de tous les peuples, anciens et modernes, par une Société de publicistes et littérateurs," in Arnold Scheffer, *Résumé de l'histoire de l'empire germanique,* 2nd ed. (Paris: Lecointe & Durey, 1824), 1–3. They had already published, sometimes in several editions: Bodin, on France and England; Carrel, on Scotland (see n. 39 to this chapter); Arnold Scheffer, on the German empire (see n. 61); Alphonse Rabbe, on Spain and Portugal; Léon Thiessé, on Poland; and Barbaroux, on the United States. Both Rabbe and Scheffer wrote art criticism during the Restoration.

13. Thierry, *Histoire de la Conquête de l'Angleterre par les Normands,* 1:429–30.

14. Carlyle, "Sir Walter Scott," an anonymous review of the first six volumes of Lockhart's *Life of Sir Walter Scott, Baronet, London and Westminster Review* 28 (January 1838): 293–345. Meisel (*Realizations,* 201–8) compares Vernet's, Charlet's, and Raffet's Napoleonic battle scenes to the history of mass experience written in the present tense, like those by Scott and Carlyle.

15. On such politically charged terms as "nation" and "people," see Carol Blum, *Rousseau and the Republic of Virtue: The Language of Politics in the French Revolution* (Ithaca, NY: Cornell University Press, 1986); André Chastel, "La Notion de patrimoine," in Nora, ed., *tome* 2: "La Nation" (3 vols.) in *Les Lieux de mémoire* (Paris: Gallimard, 1986), 2:405–49; Poulot, "The Birth of Heritage: 'Le Moment Guizot.'"

16. See Jean Marchand, "Delacroix fut écrivain avant d'être peintre," *Nouvelles littéraires, artistiques et scientifiques,* no. 1302 (August 14, 1952), in which *Alfred* was published, nonpaginated (it occupies two newspaper pages), and Jean Marchand, "Eugène Delacroix, homme de lettres d'après trois oeuvres de jeunesse," *Le Livre et l'estampe* 19, no. 3 (1959): 173–84; the third work (also

owned by Marchand) was a play, *Victoria*. Marchand dated *Alfred* about 1814, on the basis of orthography and Delacroix's visit to Valmont in 1813. *Les Dangers de la cour* (Avignon: Aubanel, 1960) is an eighty-page novella in manuscript, owned by Marchand, who titled, edited, and dated it (c.1816). Athanassoglou-Kallmyer mentions it in *Delacroix: Prints, Politics and Satire, 1814–1822*, 15.

17. Letter to Félix Louvet (January 18, 1814) in Delacroix, *Selected Letters*, 31–2, 32.

18. Letter to Félix Guillemardet (September 28, 1813), in Delacroix, *Selected Letters*, 31.

19. See François Pupil, "Aux sources du romantisme. Le XVIIIe Siècle et les ténèbres," *L'Information d'histoire de l'art* (March 1974): 55–65; André Monglond, *Histoire intérieure du préromantisme français de l'Abbé Prévost à Joubert* (Grenoble: Arthaud, 1929).

20. Delacroix, *Les Dangers de la cour*, 83.

21. Stendhal, letter 9 (written in Paris, August 18, 1825), in *Lettres de Paris*, 2:205–22, 212–13; published in the *London Magazine* (September 1825).

22. Thierry, "Sur la Conquête de l'Angleterre par les Normands. A propos du roman *Ivanhoe*," *Censeur Européen* (May 27, 1820), reprinted in *Dix Ans d'Etudes historiques* (Paris: Just Tessier, 1834), 131–40, 131–4.

23. See Edgar Johnson, *Walter Scott: The Great Unknown*, 2 vols. (New York: Macmillan, 1970); Jane Millgate, *Walter Scott: The Making of the Novelist* (Toronto: University of Toronto Press, 1984). On Scott's historical insight, see Georg Lukács, *The Historical Novel*, trans. Hannah Mitchell and Stanley Mitchell (Boston: Beacon Press, 1963); Francis Hart, *Scott's Novels: The Plotting of Historic Survival* (Charlottesville: University Press of Virginia, 1966); Boris Reizov, "History and Fiction in Walter Scott's Novels," *Neohelicon* 2 (1974): 165–75; David Brown, *Walter Scott and the Historical Imagination* (London: Routledge & Kegan Paul, 1979); Chris R. Vanden Bossche, "Culture and Economy in *Ivanhoe*," *Nineteenth-Century Literature* 42, no. 1 (June 1987): 46–72; Mark Phillips, "Macaulay, Scott, and the Literary Challenge to Historiography," *Journal of the History of Ideas* 50, no. 1 (January–March 1989): 117–33; Ina Ferris, *The Achievement of Literary Authority: Gender, History, and the Waverley Novels* (Ithaca, NY: Cornell University Press, 1991); Ian Duncan, *Modern Romance and the Transformation of the Novel: The Gothic, Scott, Dickens* (Cambridge: Cambridge University Press, 1992); Michael Ragussis, "Writing Nationalist History: England, the Conversion of the Jews, and *Ivanhoe*," *ELH* 60, no. 1 (Spring 1993): 181–215; Katie Trumpener, "National Character, Nationalist Plots: National Tale and Historical Novel in the Age of *Waverley*, 1806–1830," *ELH* 60, no. 3 (Fall–Winter 1993): 685–731.

24. Walter Scott, chap. 72, "A Postscript, which Should have been a Preface," in *Waverley; or, 'Tis Sixty Years Since* [1814] (Harmondsworth, UK: Penguin, 1972), 492–4. "Sixty years" refers to the Jacobite Rebellion of 1745. Scott explains in the "Introductory" that the supposed date of the novel's events is 1805, when he first completed the manuscript.

25. Scott, chap. 5, in *Waverley*, 63.

26. Outre ces caractères qui dérivent de l'état politique du pays, l'auteur d'*Ivanhoe* n'a pas manqué d'en introduire d'autres qui dérivent des opinions du siècle. Il peint le templier à l'esprit hardi, plein d'ambition et de projets, méprisant la croix dont il est le soldat . . . et, en regard, le templier fanatique, esclave passif de sa regle et de sa foi, le prêtre hypocrite et sensuel; le juif, humble, souple et patient, entouré de mépris et de périls.
Thierry, "Sur la conquête de l'Angleterre par les Normands. A propos du roman d'*Ivanhoe*," in *Dix Ans*, 138.

27. Pourquoi permettez-vous de retrancher tel passage ou de vieilles superstitions sont vivement attaquées? Ne voyez-vous pas que l'auteur l'a mis dans la bouche d'un puritain? Pourquoi supprimez-vous, de votre autorité

privée, tout ce qui touche au catholicisme, dans une altercation entre un anglican et un papiste? Ne voyez-vous pas que vous dénaturez ainsi le costume du temps et du pays?

"De Walter Scott et de ses Traducteurs," *Miroir des Spectacles*, no. 506 (June 16, 1822), 3.

28. See Frank Palmeri, "The Capacity of Narrative: Scott and Macaulay on Scottish Highlanders," *Clio* 22, no. 1 (1992): 37–52; he cites Mikhail Bakhtin, "Discourse in the Novel," in *The Dialogic Imagination. Four Essays*, trans. Michael Holquist and Caryl Emerson (Austin: University of Texas Press, 1981), 275–422, which has influenced much of the recent discussion of Scott. The "tumult of dialects and jargons" is also stressed by Duncan: "Language, spoken and written, is the constituent property of its historical scene . . . To read Scott well is to read a narrative syntax that sets different discourses and genres, different textual planes of narration and editorialization, in dynamic relation to one another" (*Modern Romance*, 94–5).

29. Walter Scott, chap. 12, in *Ivanhoe* (New York: New American Library [Signet], 1962), 144. It was first published December 18, 1819; ten thousand copies were sold in a month. See Paul J. deGategno, *Ivanhoe: The Mask of Chivalry* (New York: Twayne Publishers, 1994).

30. Jean-Baptiste Galley cites Thierry's letter to Fauriel (autumn 1824) in *Claude Fauriel, membre de l'Institut, 1772–1843* (Saint-Etienne: Imprimerie de la *Loire républicaine*, 1909), 302.

31. Ces historiens . . . détaillent un seul combat; et puis après, ni Normands ni Saxons, ni vainqueurs, ni vaincus, ne reparaissent plus dans leurs pages . . . Les conséquences de l'invasion semblent se borner pour la nation vaincue, à un simple changement de dynastie. L'asservissement des indigènes de l'Angleterre, leur expropriation en masse et le partage de leurs biens entre les envahisseurs étrangers, tous ces actes de conquête et non de gouvernement, perdent leur caractère véritable pour prendre mal à propos une couleur administrative. Un homme de génie, Walter Scott, vient de présenter une vue réelle de ces événements si défigurés par la phraséologie moderne; et, chose singulière, mais qui ne surprendra point ceux qui ont lu ses précédents ouvrages, c'est dans un roman qu'il a entrepris d'éclairer ce grand point d'histoire, et de présenter vivante et nue cette conquête normande, que les narrateurs philosophiques du dernier siècle, plus faux que les chroniqueurs illetrés du moyen âge, ont élégamment ensevelie sous les formules banales de *succession*, de *gouvernement*, de *mesures d'Etat*.

Thierry, "Sur la conquête de l'Angleterre par les Normands. A propos du roman d'*Ivanhoe*," in *Dix Ans*, 131–2.

32. Scott, chap. 29, *Ivanhoe*, 295.

33. See Catherine Gordon, "The Illustration of Sir Walter Scott: Nineteenth-Century Enthusiasm and Adaptation," *Journal of the Warburg and Courtauld Institutes* 34 (1971): 299–317; Beth S. Wright, "The Influence of the Historical Novels of Walter Scott on the Changing Nature of French History Painting 1815–1855," Ph.D. diss., University of California at Berkeley, 1978; Beth S. Wright, "Scott's Historical Novels and French Historical Painting, 1815–1855," *Art Bulletin* 63, no. 2 (June 1981): 268–87; Beth S. Wright and Paul Joannides, "Les Romans historiques de Sir Walter Scott et la peinture française, 1822–1863," *Bulletin de la Société de l'histoire de l'art français, année 1982* (1984): 119–32 and *année 1983* (1985): 95–115; Beth Wright, "Walter Scott et la gravure française: A propos de la collection des estampes 'scottesques' conservée au Département des Estampes, Paris," *Nouvelles de l'estampe* 93 (July 1987): 6–18; Petra ten-Doesschate Chu, "Pop Culture in the Making: The Romantic Craze for History," in *The Popularization of Images*, ed. Chu and Weisberg, 166–88; Beth Wright, "Walter Scott and French Art: Imagining the Past," in *Romance & Chivalry*, 180–93. On this painting, see Lee Johnson, "A new Delacroix: 'Rebecca and the Wounded Ivanhoe,'" *Burlington Magazine* 126, no. 974 (May

1984): 280–1 (with a color illustration); and Johnson, *Paintings of Delacroix*, L 94, 1 (1981): 203 and 3 (1986): 316. It is signed and dated 1823, 64.7 × 54.2 cm, $25\frac{1}{2} \times 21\frac{3}{8}$ in. It was bought from the artist by Amable Paul Coutan in December 1823; passed in his sale March 9, 1829, in lot 49; was lost from view until 1835, when it was with Susse; appeared in the Oldekop Collection, in the Château de Saint Jean de la Castelle, the Landes; acquired with the contents of the château by Gaulin; bought from the Gaulin family about 1982 by a private collector in New York. Delacroix depicted the same subject about 1858; see Johnson, *Paintings* J 329, 3 (1986): 146–7 and supp., 6 (1989): 204 (26.5 × 21.3 cm; $10\frac{7}{16} \times 8\frac{3}{4}$ in.; collection of the Hon. Mrs. Harriet Cullen, London). Achille Devéria's lithograph appeared as part of a suite called *Illustrations de Walter Scott*, published by Henri Gaugain in 1829 and Etienne Ardit in 1830, to which Delacroix, Camille Roqueplan, Eugène Devéria, and Louis Boulanger contributed. See Beth S. Wright, "Henri Gaugain et le musée Colbert: L'Entreprise d'un directeur de galerie et d'un éditeur d'art à l'époque romantique." Nicolas-Eustache Maurin's lithograph (Bulla, 1836) was in a suite of six lithographs of subjects from *Ivanhoe*.

34. M. G. Devonshire, *The English Novel in France, 1830–1870* (1929; New York: Octagon, 1967), 6. On Scott's impact in France, see Louis Maigron, *Le roman historique à l'époque romantique: essai sur l'influence de Walter Scott* (Paris: Champion, 1898); Eric Partridge, *The French Romantics' Knowledge of English Literature (1820–1848) according to contemporary French memoirs, letters, and periodicals* (Paris: Revue de Littérature Comparée, 1924); Klaus Massmann, *Die Rezeption der historischen Romans Sir Walter Scotts in Frankreich (1816–1832)*, Studia Romantica, no. 24 (Heidelberg, 1972); Martyn Lyons, "The Audience for Romanticism: Walter Scott in France, 1815–51," *European History Quarterly* 14, no. 1 (January 1984): 21–46 (Lyons analyses only French translations).

35. Mignet described *Ivanhoe* as "ce beau roman où respire le génie du 12e siècle avec plus de vérité que dans aucune histoire." "Walter Scott," *Le Courrier Français* (October 19, 1822); cited by Lyons in "The Audience for Romanticism," 31–2.

36. Félix Bodin, "Du nouveau roman de Walter Scott," *Mercure du XIXe siècle* 1 (June 1823): 453–4.

37. Nous sortions d'une longue révolution; nous avions l'esprit sain, l'âme sérieuse et l'imagination retrempée par le spectacle des grands choses. Le bons sens, la vigueur et la réalité de peinture de sir Walter Scott nous convenaient. Nous étions plus dignes de la comprendre que ses compatriotes; nous l'admirâmes avec plus de conscience et de chaleur; le succès fut immense.

"T. J." [Théodore Jouffroy], "*Littérature. Oeuvres Complètes de Sir Walter Scott.* 1e article," *Le Globe* (November 4, 1826), 188–91. Jouffroy was describing the impact of *Old Mortality* in 1816.

38. simple romancier, il a porté sur l'histoire de son pays un coup-d'oeil plus ferme et plus pénétrant que celui des historiens eux-mêmes . . . Jamais il ne présente le tableau d'une révolution politique ou religieuse, sans la rattacher à ce qui la rendait inévitable, à ce qui doit, après elle, en produire d'analogues, au mode d'existence du peuple, à sa division en races distinctes, en classes rivales et en factions ennemis . . . En ne cherchant peut-être que des moyens de frapper plus vivement l'imagination par des contrastes de moeurs et de caractères, il est allé aux sources mêmes de la vérité historique.

Augustin Thierry, "Sur l'histoire d'Ecosse, et sur le caractère national des écossais," [1824] reprinted in *Dix Ans*, 149–56, 154–5.

39. Armand Carrel, *Résumé de l'Histoire d'Ecosse* (Paris: Lecointe & Durey, 1825); he cited *The Abbot* (for Mary Stuart's abdication, 225 n. 1), *The Lord of the Isles* (Edward and Robert Bruce, 93), *The Monastery* (clerical wealth in the sixteenth

century, 160–1), and *Old Mortality* (Claverhouse, 287). Carrel (1800–36) founded the liberal newspaper *Le National* with Thiers in 1830. Ary Scheffer painted Carrel on his deathbed, after his duel with Emile de Girardin (1836; Rouen, Musée des Beaux-Arts, Inv. 897.3.1).

40. "St.-A. B." [Saint-Amand Bazard], "Considérations sur l'Histoire," *Le Producteur. Journal philosophique de l'industrie, des sciences et des beaux-arts* 4 (1826): 390–415, 393. Saint-Amand Bazard (1791–1832) became one of the two "pères suprêmes" of the Saint-Simonian movement in 1829, with Prosper Enfantin; see Locke, *Music, Musicians, and the Saint-Simonians*, 73.

41. Thierry described himself as "fils adoptif de Henri de Saint-Simon" in "Des Nations et de leurs rapports mutuels" for the Comte de Saint-Simon's *L'Industrie, ou discussions politiques, morales et philosophies*; this essay also appeared in *Censeur Européen* 2 (1817): 112–246. Thierry had completely lost his vision by 1826. In 1834, he was appointed librarian to the duc d'Orléans and director of the Collection des Chartes for the newly created Comité des Travaux Historiques, where he edited *Recueil des monuments inédits de l'histoire du Tiers Etat*, part of Guizot's projected *Collection de documents inédits sur l'histoire de France*. Thierry wrote "Considérations sur l'histoire de France" as preface to *Récits des temps mérovingiens* (1840), retelling stories from the chronicle of Gregory of Tours. His *Essai sur l'histoire de la formation et des progrès du tiers-état* (1853) was originally published as a series of articles in the *Revue des Deux Mondes* (1846–50). See Rulon Nephi Smithson, *Augustin Thierry: Social and Political Consciousness in the Evolution of a Historical Method* (Geneva: Droz, 1973); Gossman, "Augustin Thierry and Liberal Historiography"; Marcel Gauchet, "Les *Lettres sur l'histoire de France* d'Augustin Thierry: 'l'Alliance austère du patriotisme et de la science,' " in Nora, ed., *Les Lieux de mémoire, tome 2*: "La Nation" (3 vols.) (Paris: Gallimard, 1986), 1:247–316; Crossley, *French Historians and Romanticism*, 45–70.

42. Pour un historien sincère et juste, Cromwell n'est point le héros de sa propre histoire. Cromwell a un rival dont la destinée heureuse ou malheureuse affecte plus l'âme de lecteur que les batailles gagnées, des tours d'adresse ou des coups de force; ce rival, c'est la liberté; la liberté déjà plein de vie dans le coeur des hommes énergiques, lorsque Cromwell n'est rien encore; la liberté, plus grande que Cromwell dans ses grandeurs, même quand il la tient sous lui abbatue et expirante.

Thierry, "Sur le caractère des grands hommes de la révolution de 1640, à propos de l'Histoire de Cromwell par M. Villemain," *Censeur Européen* (June 21, 1819); reprinted in *Dix Ans*, 60–70, 60. See also *Vue des révolutions d'Angleterre*; part 1 was published in *Censeur Européen* (1817) and reprinted in *Dix Ans*, 1–59. Thierry published four articles on the British Civil War in the *Censeur Européen* between 1817 and 1819.

43. Voilà notre patrimoine d'honneur national; voilà ce que nos enfans devraient livre sous nos yeux. Mais, esclaves affranchis d'hier, notre mémoire ne nous a rappelé long-temps que les familles et les actions de nos maîtres. Il n'y a pas trente ans que nous avisâmes que nos pères étaient la nation. Nous avons tout admiré, tout appris, hors ce qu'ils ont été et ce qu'ils ont fait. Nous sommes patriotes, et nous laissons dans l'oubli ceux qui, durant quatorze siècles, ont cultivé le sol et la patrie, souvent dévasté par d'autres mains: les Gaules étaient avant la France.

Thierry, "Préface. Histoire de mes idées et de mes travaux," in *Dix Ans*, i–xxxv, vii, citing an article from the *Censeur Européen* 7 (1818): 250.

44. On Carbonarism, see P. Savigear, "Carbonarism and the French Army, 1815–1824," *History* 56, no. 181 (1969): 198–211; Alan Spitzer, *Old Hatreds and Young Hopes. The French Carbonari against the Bourbon Restoration* (Cambridge, MA: Harvard University Press, 1971); Furet, *Revolutionary France, 1770–1880*, 294–8; Richard Lansdown, "Byron and the Carbonari," *History*

Today 41, no. 5 (May 1991): 18–25. Thierry saw the renaissance in historical studies between 1823 and 1834 as resulting from the "effervescence révolutionnaire" of 1821–2. See "Histoire de mes idées," in *Dix Ans,* xxv.

45. Thierry, "Première lettre sur l'histoire de France, adressé au rédacteur du *Courrier Français,*" in *Dix Ans,* 322–9, 324–5. This article was originally published on July 13, 1820 and was reprinted in the first edition of *Lettres sur l'Histoire de France* (written 1820–7, published 1827) but omitted from the three subsequent editions.

46. Thierry, "Sur l'affranchissement des communes," *Courrier Français* (October 13, 1820); reprinted in the first edition of *Lettres sur l'histoire de France* (1827) but dropped from subsequent editions; in *Dix Ans,* 346–54, 348. Sycophantic chroniclers were condemned in "Sur la classification de l'Histoire de France par races royales": "Les vieilles chroniques, rédigés dans les couvents, eurent naturellement des préférences pour les hommes qui faisaient le plus de dons aux églises et aux monastères; et l'histoire, ainsi écrite hors de la scène du monde, perdit son caractère public pour prendre celui de simple biographie." *Courrier Français* (1820); *Lettres,* 1st ed.; *Dix Ans,* 330–6, 331.

47. Thierry, "Histoire de mes idées," xv.

48. Thierry, "Sur l'esprit national des Irlandais," *Censeur Européen* (February 28, 1820), in which he urged French poets to imitate Thomas Moore; cited by Boris Reizov, *L'Historiographie romantique française, 1815–1830* (Moscow: Editions en Langues Etrangères, n.d.), 120; Russian edition (Leningrad, 1956). In *Histoire de la Conquête* he praised Fauriel's ethnographic efforts: "La resurrection de la nation grecque prouve que l'on s'abuse étrangement en prenant l'histoire des rois ou même des peuples conquérants pour celle de toute le pays sur lequel ils dominent." ("Voyez les excellentes Dissertations historiques, insérées par M. Fauriel, dans son recueil des *Chants populaires de la Grèce moderne.*") Thierry, "Introduction," in *Histoire de la Conquête de l'Angleterre,* i–xxvii, xiv–xv.

49. Augustin Thierry, prospectus for *Histoire de France traduite et extraite des chroniques originales, mémoires, et autres documens authentiques* (Paris: Lecointe & Durey, 1824), nonpaginated. The prospectus was also printed in *Journal des savants* (1824), 698. The authors (Thierry, P. Lami, and A. J. de Mancy) promised a work in thirty volumes, but it never appeared. See Pierre Nora, "Les Mémoires d'Etat. De Commynes à de Gaulle," in *Les Lieux de mémoire, tome 2: "La Nation"* (3 vols.) (Paris: Gallimard, 1986), 2: 355–400.

50. See my discussion of Hayden White's proposal of the trope of metaphor, which is associational rather than representational, as the model for Romantic historical narratives, in Chapter 1 of the present volume.

51. Thierry, "Introduction," in *Histoire de la Conquête de l'Angleterre,* 1:ix–x.

52. Thierry, *Histoire de la Conquête de l'Angleterre,* 1:429–30.

53. Ibid., 3:288–9.

54. "il comprenait très-bien, au fond de l'âme, que son histoire à lu tant rêvée, n'était rien moins qu'une révolution, une façon de 89 littéraire, qui aurait peut-être un jour ses septembriseurs et ses bonnets rouges." Jules Janin, "Préface," in Amans-Alexis Monteil, *Histoire des Français des Divers Etats aux Cinq Derniers Siècles,* 10 vols. (Paris: W. Coquebert & Furne, 1842–4), i–li, vi–vii.

55. L'histoire de France est, ce semble, l'histoire des Français, et l'histoire des Français est, ce semble aussi, L'HISTOIRE DES FRANCAIS DES DIVERS ETATS. Cet ouvrage, où l'auteur a mis plus de vingt ans, où chaque fait est appuyé sur une note, a surtout pour l'objet de reformer l'histoire, de venger de ses dédains la majesté nationale. La nouvelle Histoire des Français, qu'on annonce, n'est pas l'histoire de deux ou trois états seulement; c'est l'histoire de tous les états: il n'en est aucun depuis celui du roi, de ministre, jusqu'à celui de bûcheron, de berger, qui n'y ait son histoire, d'une étendue plus ou moins grand ... Un pareil ouvrage intéresse toutes les classes des

lecteurs, tous les lecteurs, tous sans exception; qui ne veut savoir l'histoire de son état? Et qui, pouvant la lire lui-même, consentirait à l'apprendre d'un autre?

Amans-Alexis Monteil, "Prospectus," in *Histoire des Français des divers états,* 10 vols. (Paris: Janet, Cotrelle & W. Coquebert, 1828–44), 1:1–4, 1–2.

56. Monteil, "La Décade des Adieux. Décade cxxv," in ibid., 10:506–9, 507–8.

57. "Long-temps j'ai médité sur la forme. Je n'ai peut-être pas choisi la plus grave, la plus usitée; j'ai dû préférer la plus naturelle, la plus vraie. A chaque siècle je l'ai variée; mais je l'ai toujours appropriée au génie, à la physionomie du temps." Monteil, "Introduction," in ibid., 1:v–vii, vi. Life in the fourteenth century, for example, is described in the present tense: "Après midi, l'on va aux courses du marché aux chevaux, qu'on tient dans notre voisinage, près la rue Pierre-Sarrasin." "Paris. Epitre XI," 1:37.

58. Monteil, "La Décade de la Grande Voix," in ibid., 9:3.

59. The *Revue Française* wrote of the volumes on the fourteenth and fifteenth centuries:

> nous ne saurions dire combien est curieux, attachant, instructif, et souvent même amusant, l'ouvrage de M. Monteil: les plus savans auraient à y apprendre, et les plus ignorans peuvent y profiter; il répand sur l'ordre social tout entier une lumière qui ne s'arrête pas à la surface, mais va éclairer les plus obscurs recoins de l'administration du royaume; des singularités discordantes de coutumes aux plus petits détails d'industrie, et même de cuisine, M. Monteil a tout vu, tout examiné; et sur ces objets si divers, il nous instruit toujours, et nous amuse presque contamment.

"Histoire des Français des Divers Etats," *Revue Française,* no. 13 (January 1830): 258–61, 259. Chateaubriand, though impressed by Monteil's knowledge, decried his decision to convey it as fictionalized history; see "Préface," in *Etudes ou Discours Historiques,* 1:l–cxli, lxxii. Janin thought that Monteil's history ("pacifique musée") was a more appropriate model for a museum of the nation than the battle paintings commissioned by Louis-Philippe for the Musée Historique de Versailles, because he instructed his readers about the intellectual and creative accomplishments of the entire nation: literary, agricultural, legal, medical. See Jules Janin, "Préface," in *Histoire des Français des Divers Etats aux Cinq Derniers Siècles* (1842–4), 1:xv.

60. See A.-Augustin Thierry, *Augustin Thierry d'après sa correspondance* (Paris: Plon-Nourrit, 1922), 62–3, on the circle around Lafayette, which included all three Scheffer brothers. Their friendship with Thierry continued during the July Monarchy and afterward; they helped obtain a pension for him in 1834 and visited him in Vésoul in 1855 (133–5). On the Scheffer brothers' political activities, see Marthe Kolb, *Ary Scheffer et son temps, 1795–1858* (Paris: Boivin, 1937), 84–90; Hervé Robert, "Ses goûts littéraires," in *Le Mécénat du duc d'Orléans,* 46–55. Nina Athanassoglou-Kallmyer has discussed the relationship between the views of the Comité Grec and those of liberal artists Vernet, Géricault, Ary Scheffer, d'Angers, and Delacroix. See "*Imago Belli*: Horace Vernet's *L'Atelier*"; *French Images from the Greek War of Independence*; "Liberals of the World Unite: Géricault, His Friends, and *La Liberté des Peuples*," *Gazette des Beaux-Arts,* 6th ser., 116 (December 1990): 227–42, which discusses Géricault's *Opening of the Doors of the Inquisition* (discussed later in this chapter) and *Delacroix: Prints, Politics, and Satire, 1814–1822*; Bazin, *Géricault. Etude Critique,* Vol. 5: *Le Retour à Paris: Synthèse d'expériences plastiques* (Paris: Wildenstein Institute, 1992), "L'Opposant au Régime: Bonapartisme et Libéralisme," 49–67.

61. Charles-Arnold Scheffer (1796–1853). In his history of the German empire from 320 B.C. (the emigration of the Cimbri and the Teutons) to the Treaty of Paris in 1815, Scheffer saw in Henry V's death not only the end of the Swabian dynasty, but the nobility's military vassalage to the emperor, the enslavement of disarmed

peasants, and bourgeois resentment. Arnold Scheffer, *Résumé de l'histoire de l'empire germanique,* 73–4. In 1818, his eighty-page pamphlet *Sur l'Etat de la liberté en France* (Paris, 1817) was judged seditious. Refusing to accept his sentence (prison, surveillance, and a fine), he was expelled from France in May 1819 and sought refuge in Belgium but was pardoned and returned to France in October. On his career as journalist and historian, see *Historical Dictionary of France from the 1815 Restoration to the Second Empire,* ed. Edgar Leon Newman with Robert Lawrence Simpson, 2 vols. (Westport, CT: Greenwood Press, 1987), 2:962–3; *Ary Scheffer, 1795–1858* (Paris: Musée de la Vie Romantique/ Paris-Musées, 1996), exhibition catalogue by Leo Ewals, 18–20, and catalogue no. 48, 70.

62. "Si une morte prématurée ne l'eût enlevé à trente-deux ans, cette école [Romanticism], qui lutte aujourd'hui contre de vieilles admirations, d'anciens habitudes et la routine académique, serait près de triompher. Au tableau du *Radeau de la Méduse* aurait succédé celui de la *Traite des Noirs,* représentant un marché d'esclaves sur la côte du Sénégal." Arnold Scheffer, "Salon de 1827," *Revue Française* 1, no. 1 (1828): 188–212, 196. On the *Traite des Noirs* (Paris, Ecole des Beaux-Arts, Inv. 982), see Eitner, *Géricault,* 274–7; Christopher Sells, "After the *Raft of the Medusa*: Géricault's Later Projects," *Burlington Magazine* 128, no. 1001 (August 1986): 567–70; *Géricault* (Paris: Grand Palais, 1991), catalogue no. 302, and, for Géricault's abolitionist interests, "Libéralisme et Négritude," 236–243.

63. Léon Riesener, Delacroix's cousin, described their close contact while in Guérin's studio. In 1824, when Delacroix was at work on the *Chios,* he met frequently with Henry and Ary Scheffer. See his journal entries for February 29; March 3, 9, 15–17, 28–9; April 4, 20, 22; July 8; August 19. On Delacroix's contact with Ary Scheffer, see L. J. I. Ewals, "Ary Scheffer entre Ingres et Delacroix," in *Actes du Colloque international "Ingres et son Influence"* (Montauban: Musée Ingres, 1980), reprinted in *Bulletin du Musée Ingres* nos. 47–8 (September 1980): 17–32.

64. Salon of 1819, no. 1023,

> *Dévouement patriotique de six bourgeois de Calais.* La ville de Calais, assiégée en 1342, par Edouard, roi d'Angleterre, fut réduite à se rendre par la famine. Le pillage et le massacre allaient punir les habitants de leur noble résistance, quand six d'entre-eux offrirent leur vie pour racheter celle de leurs concitoyens. L'histoire nomme parmi eux Eustache de Saint-Pierre et son fils. Ils sortent en chemise, nu pieds et la corde au cou, pour se rendre au camp des Anglais, où les attend le supplice. Eustache porte les clefs de la ville; leurs parens et leurs amis les ont suivis jusqu'à la porte où doit se faire la fatale séparation. Des soldats anglais les conduisent; parmi la foule, on remarque le Gouverneur de la ville, qui se cache le visage.

> RF, Inv. 7854; 347 × 456 cm. Acquired from the Salon by the state for 2,000 francs; in the Assemblée Nationale; Musée des Beaux-Arts, Calais. See Kolb, *Ary Scheffer,* 281–4; Leonardus Joseph Ignatius Ewals, "Ary Scheffer. Sa Vie. Son Oeuvre," dissertation, Katholieke Universiteit te Nijmegen, the Netherlands, 1987, 58–9, 220; Christian Beutler, "*Les Bourgeois de Calais* de Rodin et d'Ary Scheffer," *Gazette des Beaux-Arts,* 6th ser., 79 (1972): 39–50. Beutler points out that Froissart's text includes Eustache de Saint-Pierre's description of himself as a patriotic martyr and sees Scheffer as utilizing iconography adapted from portrayals of Christ's departure from Jerusalem for Golgotha.

65. *Dévouement de six habitans de Calais. an 1347* Ces martyres du patriotisme sortent de la place, nuds en chemise, la corde au cou, et se présentent à Edouard. Ce prince irrité fait dresser des potences, et ordonne à l'exécuteur de les y attacher. C'en étoit fait de la vie de ces généreuses victimes, si la monarque, qui jusqu'alors s'étoit montré inflexible aux prières des personnages les plus distingués de sa cour, ne se fût laissé attendrir par les armes [larmes?] de la reine qui venoit d'arriver au camp.

Il leur accorda leur grâce, à conditions qu'ils ne rentroient jamais dans Calais. Il chassa ensuite tous les Français de cette ville, et la peupla entièrement d'Anglais.

Antoine Caillot, *Histoire de France, représentée par les figures, accompagnées d'un précis historique,* 3 vols. (Paris: Fr.-A. David, 1817–19), 3:115–17, 115–16, pl. 42); illustrations by François-Anne David. This composition repeats Barthélemy's *L'action courageuse d'Eustache de Saint-Pierre au Siège de Calais* (1779, Laon; Musée Archéologique Municipal), a replica of his 1777 *morceau d'agrément.* See Pupil, *Le Style troubadour,* 361. A direct illustrative precedent was Jean-Michel Moreau le Jeune's *Dévouement patriotique de six bourgeois de Calais, Année 1547,* vignette 161 for *Figures de l'Histoire de France,* an enterprise begun by Jacques-Philippe Le Bas in 1779, revised and continued by Moreau le jeune, 1785 (an VII); the abbé Garnier was cited as author, but in reality Antoine Dingé wrote the text. See Emmanuel Bocher, *Les Gravures Françaises du XVIIIe siècle,* 6 tomes in 3 vols. (Paris: Damascène Morgand & Charles Fatout, 1875–82), 6th fascicle, *Moreau le jeune* 3 (1882): 204–66.

66. Preparatory sketches in the Dordrecht Museum indicate that Scheffer reduced the prominence of the English soldiers escorting the group, who originally held a banner and were silhouetted against the sky, equalizing visual interest across the canvas. See *Ary Scheffer 1795–1858. Dessins, Aquarelles, Esquisses à l'Huile* (Paris, Institut Néerlandais, 1980), exhibition catalogue by J. M. de Groot, catalogue no. 40 DM/S/T45 (watercolor and brown ink over black pencil; 130 × 140 cm) and no. 41 DM/S/T343 (oil and brown ink over black pencil, squared for transfer; 173 × 238 cm).

67. "Voici enfin un sujet national . . . et le peintre est frère d'un jeune écrivain, qu'un arrêt, au moins bien sévère, tient éloigné de sa patrie: ces deux circonstances doivent ajouter à l'intérêt qu'inspire le *dévouement des bourgeois de Calais,* par M. Scheffer." "E. J." [Victor Etienne, known as "Jouy"], "Beaux-Arts. Salon de 1819 (2e article)," *La Minerve Française* 7 (August 1819): 357–67, 360. The *Revue encyclopédique* thought the lugubrious color, although appropriate for the subject, was exaggerated. "P. A." [Philippe-Alexandre Coupin?], "Notice sur l'exposition des Tableaux, en 1819. Troisième article," *Revue encyclopédique* 5 (1820): 45–75, 53.

68. Landon, *Annales du Musée . . . Salon de 1819,* 1:19–20, 20.

69. M. Scheffer (1023) n'a élevé qu'un mince trophée à la gloire des braves Calaisiens. Il les a tous représentées comme des victimes et non comme des héros; leur contenance morne contraste avec la noblesse de leur action; ne doivent-ils pas, ces généreux bourgeois, quelque soit d'ailleurs le chagrin qu'ils paraissent éprouver de quitter leurs familles, ne doivent-ils pas manifester un grand caractère? Leur sombre tristesse est faite pour décourager des hommes auxquels ils ont besoin d'inspirer des sentimens d'espérance et de force; le désespoir apparent de quelques-uns d'entre-eux est un contre-sens impardonnable.

Jal, *Salon de 1819,* 219–20. However, despite the work's flawed conception and faults in the coloring and execution, Jal thought it demonstrated Scheffer's talent.

70. Salon 1819, no. 510 *Scène de naufrage* (Paris, Musée du Louvre; Inv. RF 4884; 4.91 × 7.16 m). See Lorenz Eitner, *Géricault's "Raft of the Medusa"* (London: Phaidon, 1972); Eitner, *Géricault,* 158–210. Géricault was awarded a gold medal in 1819 and given a commission worth 6,000 francs. Bazin, *Géricault. Etude Critique,* vol. 1: *L'Homme,* document nos. 127, 131, 132 (1:42–3). The painting was acquired by the government in 1824, after repeated efforts by the comte de Forbin to purchase it, 1822–4. Bazin, *Géricault. Etude Critique,* vol. 1: *L'Homme,* document no. 215 (1:69), no. 249 (1:76), nos. 306–8 (1:91–2). See also *Géricault* (Paris: Grand Palais, 1991), catalogue nos. 171–217, 374–86; Bazin, *Géricault. Etude Critique,* vol. 6: *Génie et Folie. Le Radeau de la Médusa et les Monomanes* (Paris: Wildenstein Institute, 1994), catalogue no. 1923, 95–7; Crow, *Emulation,* 288–94. I regret that the papers presented at the

1991 Géricault colloquium were published after this manuscript was in press; see Régis Michel, ed., *Géricault. Pour en finir avec l'histoire de l'art*, 2 vols. (Paris: Service Culturel du Louvre et Documentations Française, 1996).

71. Emeric-David thought Géricault was "ingénieux à créer une action, et à rechauffer son tableau par des épisodes pathétiques" (1323); see Bazin, *Géricault. Etude Critique*, vol. 1: *L'Homme*, document no. 144 (1:45). Emeric-David wrote of Scheffer: "Le représentant le dévouement de six bourgeois de Calais, a plus d'un rapport avec celui-là. Une teinte grisâtre, un accent lugubre conviennt pareillement à la scène pathétique que l'artiste nous présente . . . L'idée générale de la composition est assez bien conçue." "T" [Toussaint-Bernard Emeric-David], "Beaux-Arts. Salon. Troisième article," *Le Moniteur universel*, no. 285 (October 12, 1819): 1323–4. He praised the painting's expressivity (particularly the group led by Eustache de Saint-Pierre) and thought it well composed: "L'expression ne manque ni de justesse, ni d'énergie . . . Des épisodes intéressantes animent la scène" (1324), although the group of women on the right was pressed into too shallow a space, and several citizens had coarse facial features. The archaeologist Emeric-David, supporter of the "beau réel," was more willing than Landon to accept naturalistic forms if they were the direct expression of anatomical function and emotional expression. See his treatise *Recherches sur l'art statuaire* (Paris: Nyon aîné, 1805).

72. "If there is anything certain on earth, it is our pain. Suffering is real; joys are delusions." Géricault's letter from Rome to Dedreux-Dorcy; see Bazin, *Géricault. Etude Critique*, vol. 1: *L'Homme*, document no. 103 (1:40), dated about 1817 by Eitner, *Géricault*, 195 n.171.

73. After the *Medusa* was rehung at the Salon, Delacroix wrote: "They have lowered the picture of the Shipwreck, and now they [the figures] can be seen at floor level, so to speak. With the result that one feels as if one already had one foot in the water. One has to see it close enough to appreciate its worth." Delacroix, letter to Félix Guillemardet (November 2, 1819), in *Eugène Delacroix. Lettres intimes. Correspondance inédite publiée avec une préface et des notes par Alfred Dupont* (Paris: Gallimard, 1954), 102–9, 105; cited and translated by Eitner, 188.

74. Noted especially by Bazin, *Géricault. Etude Critique*, vol. 6: *Génie et Folie*, 6:52–7; Crow, *Emulation*, 292.

75. Eitner pointed this out (*Géricault*, 197–201), although Géricault did complain to a friend: "vous entendez un article libéral vanter dans un tel ouvrage un pinceau vraiment patriotique, une touche nationale. Le même ouvrage jugé par l'ultra ne sera plus qu'une composition révolutionnaire où règne une teinte générale de sédition." Charles Clément, *Géricault* (Paris, 1868), 171. See Bazin, *Géricault. Etude Critique*, vol. 1: *L'Homme*, document no. 158, 1:49.

76. Jouy imagined the artist's response to "hypercritiques":
> 'J'avais à peindre une action connue, récente, un malheur sans modèle . . . Dans l'image horrible que j'avais à présenter, de la douleur frénétique, à la vue des crimes de la nuit, de la terreur du jour et de la destruction inévitable du lendemain, je n'avais à peindre que le désespoir, et vous ne devez me demander compte que du succès de mes efforts pour en varier l'expression.' Considéré sous ce point de vue, ce tableau doit ajouter beaucoup à la reputation de son jeune auteur. On y admire quelque chose de cette fougue d'imagination, de ce désordre de l'art, de cette hardiesse de pinceau.

"E. J." [Victor Etienne, known as Jouy], "Salon de 1819," *La Minerve Française* 7 (August 1819): 260–7, 266. See Bazin, *Géricault. Etude Critique*, vol. 1: *L'Homme*, document no. 148, 1:47.

77. Ce tableau n'est indiqué, dans la Notice de l'exposition, que comme une *scène de naufrage*; mais il était depuis long-temps annoncé comme un épisode du naufrage de *la Méduse*. Nous ignorons pourquoi son véritable titre, le seul qui pût lui donner de l'intérêt, a été supprimé: on s'attendrit à la représentation d'une infortune réelle, on est peu touché d'un malheur

imaginaire. [Landon summarized the events, including the first sighting, despair, and rescue.] On ne peut nier que la peinture de cet accident désastreux ne soit digne d'exciter vivement la compassion: mais c'est une scène particulière; et l'on peut s'étonner que, pour en retracer le souvenir, le peintre ait employé cet cadre immense et ces dimensions colossales qui semblent réservées pour la représentation des événements d'un intérêt général, tels qu'une fête nationale, une grande victoire, le couronneinent d'un souverain, ou un de ces traits de dévouement sublime qui honorent la religion, le patriotisme ou l'humanité . . . on ne peut guère considérer cette scène de naufrage que comme une réunion de figures ou de groupes académiques, mis d'une manière quelconque en action. Mais, il faut en convenir, cette action est bien faible et bien peu sentie. Où en est le centre? à quel personnage paraît-elle se rattacher principalement, et quelle est l'expression générale du sujet? Des cadavres à moitié submergés, des morts et des mourans, des hommes livrés au désespoir et d'autres que soutient un faible rayon d'espérance, tels sont les élémens de cette composition, que l'artiste, malgré le talent qu'on lui reconnaît, n'a pu ordonner d'une manière satisfaisante. Serait-ce donc la faute du sujet, dont le récit, tout plein d'intérêt, se prête difficilement aux crayons du peintre d'histoire? L'artiste aurait peut-être atteint son but, s'il n'eût voulu faire qu'un tableau de marine, ou du moins s'il se fît restreint dans les mesures d'un tableau de genre.

Landon, *Annales du Musée . . . Salon de 1819*, 1:65–7. See Bazin, *Géricault. Etude Critique*, vol. 1: *L'Homme*, document no. 146, 1:45–6. Kératry also was appalled by the subject of twenty dead or dying men (*Lettres sur le Salon de 1819*, 25); Bazin document no. 152, 1:48.

78. Drawing in black and red chalk; Paris, Musée du Louvre, RF 42989, 419 × 581 cm; see *Géricault* (Grand Palais, 1991), catalogue no. 304.

79. Quand on se livre tout entier à son âme . . . c'est alors que la capricieuse vous permet le plus grand des bonheurs . . . de la montrer sous milles formes, d'en faire part aux autres, de s'étudier soi-même, de se peindre continuellement dans ses ouvrages . . . de vivre dans l'esprit des autres qui enivre . . . La nouveauté est dans l'esprit qui crée, et non pas dans la nature qui est peinte . . . Si tu cultives ton âme, elle . . . se fera un langage qui vaudra bien les hémistiches de celui-ci et la prose de celui-là . . . Mais que ferai-je? il ne m'est pas permis de faire une tragédie; la loi des unités s'y oppose. – Un poème, etc.

Eugène Delacroix. Journal, 1822–1863, ed. Régis Labourdette (Paris: Plon, 1981), May 14, 1824, 81–2.

80. Salon of 1824, no. 450, "*Scènes des massacres de Scio; familles grecques attendent la mort ou l'esclavage, etc.* (Voir les relations diverses et les journaux du temps)." Paris, Musée du Louvre Inv. 3823; 4.17 × 3.54 m; $164\frac{3}{16} \times 139\frac{3}{8}$ in. Acquired from the Salon by the state for 6,000 francs. See Johnson, *Paintings of Delacroix*, J 105, 1 (1981): 83–91; Athanassoglou-Kallmyer, *French Images from the Greek War of Independence, 1821–1830*, 29–37; F. Haskell, "Chios, the Massacres, and Delacroix," in *Chios. A Conference at the Homereion in Chios. 1984*, ed. John Boardman and C. E. Vaphopoulou-Richardson (Oxford: Clarendon Press, 1986), 335–58; Thomas W. Gaehtgens, "L'Artiste en tant que héros – Eugène Delacroix," in *Triomphe et mort du héros. La Peinture d'histoire en Europe de Rubens à Manet* (Lyon: Musée des Beaux-Arts/Electa, 1988), 120–9, on the selection of a subject that is not a dramatic event, the suppression of distance between actor and spectator, the renunciation of hierarchic order separating figures into those of primary and secondary importance, the removal of the battle to the middle ground. The massacres began on April 22, 1822, and continued for almost two months; 900 inhabitants survived from a population of almost 90,000. As Johnson and Athanassoglou-Kallmyer point out, the massacres were constantly discussed in newspapers in Paris until August 1822, thereaf-

ter giving rise to such books as C. D. Raffenel's *Histoire des événements de la Grèce* (1822) and F. C. H. L. Poqueville's (illustrated) *Histoire de la régénération de la Grèce comprenant un précis des événements depuis 1740 jusqu'en 1824*, 3 vols. (Paris, 1824).

81. Landon pointed this out in his very hostile review: "Le livret du salon ne donne pas une plus longue explication de cette peinture, qui d'ailleurs ne présente ni des personnages connus ni une action déterminée; l'auteur du tableau renvoie le spectateur aux journaux du temps. Ce sujet offre donc aux curieux une grande latitude. Chacun y pourra trouver ce qu'il croira ou voudra voir." Charles-Paul Landon, *Annales du Musée et de l'Ecole Moderne des Beaux-Arts. Salon de 1824* (Paris: C. Ballard, 1824), 53.

82. Delacroix, *Journal*, May 7, 1824, trans. Norton, 39.

83. "D.," "Beaux-Arts. Salon de 1824," *Le Moniteur universel*, no. 252 (September 8, 1824): 1226.

84. Landon, *Annales du Musée . . . Salon de 1824*, 53–5.

85. "L'Amateur sans pretention," "Salon de 1824. Septième article," *Mercure du dix-neuvième siècle* 7 (1824): 199–210, 200, 204.

86. Dans toute production des arts, et surtout dans les scènes dramatiques de la poésie, ou de la peinture, une pensée première doit faire le fondement unique, et se retrouver jusque dans les accessoires, qui doivent concourir à l'effet général. Or, dans la composition de M. Delacroix, je cherche en vain cette pensée unique; car je ne vois gu'une foule de Grecs jetés épars et confusément qui attendent l'esclavage ou la mort, de deux seuls Turcs qui, placés sur les côtés, viennent pour les enchaîner ou les massacrer. Mais si la froide cruauté des Turcs nous fait horreur, la faiblesse des Grecs, qui attendent bénignement la mort dans le désespoir, n'est point un spectacle propre à nous intéresser en leur faveur. M. Delacroix pouvait nous pré-senter un spectacle bien autrement imposant: c'était un groupe de Grecs, restes malheureux échappés au carnage, luttant généreusement contre le nombre de leurs ennemis, et vengeant par d'innombrables victimes la perte des leurs. Cette scène, bien rendue, eût été d'un très-grand effet, et eût mérité tous autres applaudissemens que cette scène odieuse, qui pouvait convenir, en ôtant seulement les deux Turcs, à une épidémie et à une peste, et par la couleur et par l'ordonnance de tous les figures. Il n'y a donc rien de dramatique dans la pensée et dans l'ordonnance de ce tableau.

M***, [Edmé-François-Antoine-Marie Miel], *Revue critique des productions de peinture, sculpture, gravure exposés au Salon de 1824* (Paris: Dentu, 1825), 4–5, reprinting articles originally published in *L'Oriflamme*.

87. "Y." (probably Adolphe Thiers), "Beaux-Arts. – Exposition de 1824. 3e arti-cle," *Le Globe*, no. 7 (September 28, 1824): 27–8. Thiers's review for the *Constitutionnel* repeated many of these points: the composition was intended to render an experience rather than a singular action; the work was powerfully emotive, brilliantly colored, powerfully painted. But the decision to avoid a unified composition had resulted in one that was both calculated and clumsy. The erratic lighting dispersed the viewer's attention, the confused pile of figures meant that neither physical nor emotional situation could be distinguished. And yet, Delacroix's ardent and audacious talent was evident; he would have a great career in the future. Thiers, *Salon de mil huit cent vingt-quatre*, 16–19.

88. Ferdinand Flocon and Marie Aycard, *Salon de 1824* (Paris: Leroux, 1824), 11–13. It is tempting to identify the publisher Leroux as Pierre Leroux, one of the founders of *Le Globe* and a socialist who was in close contact with Thierry and Théodore Jouffroy, both Carbonarists. See Adolphe Lair, "Le Globe. Sa fon-dation – sa rédaction – son influence. D'après des documents inédits," *Séances et travaux de l'Académie des sciences et morales politiques* 161 (May 1904): 570–98. Ferdinand Flocon (1800–66) and Marie Aycard (1794–1859). Flocon was a political journalist; he became a minister during the Second Republic.

89. Flocon and Aycard, *Salon de 1824*, 14–16. They argued that visual beauty

would be moral turpitude ("Français que vous êtes, pour rester le plus joli des peuples, avez-vous résolu de ne plus être une nation?"). Jal, too, welcomed a work that could arouse sympathy from the ignobly neutral French, but his purported dialogue presented a conflicted viewpoint. Jal's philosopher, who thundered against those who hesitated to support the Greeks, thought Delacroix's work the most beautiful in the Salon, because it was the most expressive. Auguste Jal, *L'Artiste et le Philosophe, entretiens critiques sur le Salon de 1824* (Paris: Ponthieu, 1824), 47–53, 48. But Jal's artist, less willing to excuse aesthetic flaws, thought the work was remarkable but lacking in style. Athanassoglou-Kallmyer has pointed out that Flocon's, Aycard's, and Jal's sympathy for the Greek cause made them welcome such passionately committed painting and the chance to criticize French neutrality. *French Images from the Greek War of Independence*, 35–6.

90. Salon of 1827, no. 1733 (2nd supp.), "*Les Femmes Souliotes.* Voyant leurs maris défaits par les troupes d'Ali, pacha de Janina, elles prennent la résolution de se précipiter du haut des rochers." Paris, Musée du Louvre, Inv. 7857; 261.5 × 359.5 cm.; acquired from the Salon by Charles X. See Kolb, *Ary Scheffer*, 309–12; Ewals, *Ary Scheffer*, 65–9 and 243–4; Athanassoglou-Kallmyer, *French Images from the Greek War of Independence*, 104–7; *Romance & Chivalry*, catalogue no. 53 of a preparatory oil sketch (New Jersey, private collection; 39.1 × 51.1 cm; $15\frac{3}{8} \times 20\frac{1}{8}$ in.), 265–6; *Ary Scheffer, 1795–1858* (Paris: Musée de la Vie Romantique, 1996), catalogue no. 20, 31.

91. Claude Fauriel, *Chants populaires de la Grèce moderne, récueillis et publiés avec une traduction française, des éclaircissements et des notes*, 2 vols. (Paris: Firmin Didot, 1824–5), 1:277–8. Fauriel described the women holding hands in a circular dance of death near the edge of the abyss.

92. Athanassoglou-Kallmyer pointed out Scheffer's divergence from the text and the critics' awareness of it; she suggested that Scheffer had decided to change the mood from fierce determination to supplication and despair because of his philhellene sympathies. *French Images from the Greek War of Independence*, 107.

93. On a beaucoup parlé des *femmes souliotes* de M. SCHEFFER aîné; plusieurs personnes en ont vanté l'exécution, et ont signalé cet ouvrage comme un des meilleurs de l'exposition; quant à moi, je ne saurais partager cet avis. Le moment choisi est celui où, voyant leurs maris défaits par les troupes d'Ali, les femmes souliotes prennent la résolution de se précipiter du haut des rochers. Je ne sais si cette action sublime était susceptible d'être représentée en peinture; mais je sais que le tableau de M. SCHEFFER ne me fait pas l'impression que m'a causé le simple récit. Je ne démêle, ni assez juste, ni assez vite, la cause du désespoir que témoignent toutes ces femmes. C'est, je crois, sur le premier plan que j'aurais voulu voir l'une d'elles se jeter dans le précipice, tenant un de ses enfans dans ses bras.

"P. A." [Philippe-Alexandre Coupin], "BEAUX-ARTS. Exposition des tableaux en 1827 et 1828. Cinquième et dernier article," *Revue encyclopédique* 38 (April 1828): 276–86, 278.

94. M. *Scheffer* aîné, l'un des soutiens de l'école moderne, sait du moins se garantir des excès qui la perdent. Il fuit, il est vrai, le propreté de couleur et la netteté de contour, mais il se garde de donner dans l'extravagance, et ses compositions, toujours attachantes et bien ordonnées, permettent à l'oeil de s'arrêter sur elles, sans être repoussé par un aspect dégoûtant d'incorrection et de malpropreté. Les *Femmes Souliotes*, N° 1733, prennant la résolution de se précipiter du haut des rochers, sont entre le tableau d'histoire et le tableau de genre. A la vérité, on a besoin du livret pour savoir au juste de quoi il s'agit; mais il suffisait de savoir que se sont des femmes qui attendent l'issue d'un combat livrés par leurs maris ou leurs enfans, pour prendre intérêt à la scène. Du reste, malgré la couleur terreuse de ces belles grecques,

et l'indécision de leurs formes, on admire leur arrangement savant et pittoresque, et leurs expressions vraies et variées.

"Musée Royal. Exposition de 1827 (15e article) HISTOIRE," *Journal des Artistes*, no. 9 (March 2, 1828): 129–41, 129–30.

95. "*Les Femmes souliotes*, au moment où elles vont se précipiter du haut des rochers, après la défaite de leurs maris, intéressent vivement. On a repris la composition du tableau, on n'a pas approuvé son obliquité. Je ne suis point touché de ce reproche, je l'avoue; je trouve la scène bien entendue, et bien imaginé, le terrain montant à droite pour se terminer en une large saillie au-dessus d'un abîme." Jal, *Esquisses ... Salon de 1827*, 361. He prefaced his review of Scheffer's works by praising his intelligence, imagination, expressiveness, and conscientious efforts (358–9). The political motivation for Jal's praise of the artist's conveyance of popular experience was evident when he discussed Scheffer's *Charlemagne*, painted for the Conseil d'Etat (442); he claimed that Scheffer had originally wished to depict Athenians voting in a free election. See Chap. 1, n. 18, in the present volume.

96. London, Wallace Collection, P 282 ($57\frac{5}{8}$ × 45 in.; 1.464 × 1.143 m). Delacroix gave his fullest description of the painting's subject when it was exhibited in the Galerie Lebrun:

> Le Doge de Venise, Marino Faliero, ayant, à l'âge de plus de quatre-vingts ans, conspiré contre la république, avait été condamné à mort par le Sénat. Conduit sur l'escalier de pierre où les doges prêtaient serment avant d'entrer en charge, on lui tranche la tête, après l'avoir dépouillé du bonnet de doge et du manteau ducal. Un membre du conseil des Dix prit l'épée qui avait servi à l'exécution, et dit en l'élevant en l'air: La justice a puni le traître. Aussitôt après la mort du doge, les portes avaient été ouvertes, et le peuple s'était précipité pour contempler le corps de l'infortuné Marino Faliero. (Voir la tragédie de Lord Byron.)

Explication des ouvrages de peinture exposés au profit des Grecs, Galerie Lebrun, rue du Gros-Chenet, no. 4, le 17 mai 1826, no. 45. Also exhibited at the Salon of 1827, no. 294, withdrawn in January 1828 for exhibition in London at the British Institution, no. 102. See Johnson, *Paintings of Delacroix*, J 112, 1 (1981): 98–102; John Ingamells, *The Wallace Collection: Catalogue of Pictures*, vol. 2: *French Nineteenth Century* (London: Wallace Collection, 1986), 91–6. Delacroix told Lassalle-Bordes in the 1840s that it was his favorite work. He wrote Silvestre (letter of December 31, 1858, about the English school, see n. 4 to this chapter) that Lawrence had considered buying it in 1828. In 1844, Delacroix placed it for sale with the Galerie des Beaux-Arts, boulevard Bonne-Nouvelle, but he quickly took it back. Letter to Hippolyte Gaultron, September 5, 1844, in Delacroix, *Selected Letters*, 256. It remained in his collection until 1856.

97. *Le Constitutionnel* remarked on its color and effect (June 5, 1826). Vergnaud wrote: "Ce tableau de chevalet est vraiment vénitien: voilà un intérieur, des poses et un coloris dignes d'un peintre d'histoire." Armand-Denis Vergnaud, *Examen du Salon de 1827* (Paris: Roret, 1827), 10. These words were quoted sarcastically by "F." (Charles Farcy) in the *Journal des Artistes*; he found the sight of this "debauchery of painting" unbearable. Musée Royal. Exposition de 1827 (5e article), *Journal des Artistes*, no. 24 (December 9, 1827): 777–84, 780, 783. The *Athenaeum* also praised the artist's ability to convey Byron's complicated subjects ("a picture very cleverly managed") and choice of moment ("stopping on the safe side of the horrific"). "The British Institution, Pall Mall," *Athenaeum*, no. 6 (February 5, 1828). The approval of the British critics greatly pleased Delacroix, particularly after French tirades against *Sardanapalus*. See his letter to Charles Soulier, March 11, 1828, in Delacroix, *Selected Letters*, 145–6.

98. Johnson (*Paintings of Delacroix*, J 112, 1 [1981]:100) points out that Delacroix deliberately rejected Byron's stage directions, which specified that Faliero was to be surrounded by the patricians and killed at the top of the staircase. Delacroix placed his corpse among the plebeians he had championed. Johnson suggests that

Delacroix followed the historical note by Marin Sanuto that Byron cited, which said that "the execution should be done on the landing-place [*pato*] of the stone staircase, where the Dukes take their oath when they first enter the palace." George Gordon, Lord Byron, *Marino Faliero, Doge of Venice: An Historical Tragedy in Five Acts with Notes* (Paris: A. & W. Galignani, 1821), 251–2.

99. It was staged by Elliston at Drury Lane in London in 1821 (despite Byron's efforts to gain the lord chancellor's injunction banning it), where it was given seven performances; in Paris, in a verse translation at the Comédie Française, October 1, 1821 (two performances), and in a prose translation at the Théâtre de la Porte Saint-Martin, November 7, 1821. As John Spalding Gatton has pointed out, despite his protests against its staging, Byron's swift transitions from one locale to another could be accomplished by the scenic machinery at Drury Lane and Covent Garden; see " 'Put into scenery': Theatrical Space in Byron's Closet Historical Dramas," in *The Theatrical Space*, Themes in Drama no. 9 (Cambridge: Cambridge University Press, 1987), 139–50. The play was published in Paris as part of three different Ladvocat editions of Byron's *Oeuvres Complètes*: 10 vols in 12 (1819–21), 5 vols. in 8 (1820–2), 10 vols in 18 (1821–2). See Estève, *Byron et le romantisme français*, 80–3 and 525–9; Taborski, *Byron and the Theatre*, 108–13 and 157–68. Lansdown discusses the fifth act as Byron's effort to make explicit the distortions and reverberations that inevitably accompany the reenactment of historical events (*Byron's Historical Dramas*, 134–9). In March 1820, the Cato Street conspirators were arrested; Byron wrote the drama in Ravenna between April and July of 1820, the same year he was appointed captain of the "Turba" section of the Ravenna Carbonari, overseeing the troop called "Cacciatori Americani," for whom he bought guns. On Byron's political views and their influence on this drama, see Edward Dudley Hume Johnson, "A Political Interpretation of Byron's *Marino Faliero*," *Modern Language Quarterly* 3, no. 3 (September 1942): 417–25; Thomas L. Ashton, "*Marino Faliero*: Byron's 'Poetry of Politics,' " *Studies in Romanticism* 13, no. 1 (Winter 1974): 1–13; Daniel P. Watkins, "Violence, Class Consciousness, and Ideology in Byron's History Plays," *ELH* 48, no. 4 (1981): 799–816; D. M. de Silva, "Byron's Politics and the History Plays," in *Byron: Poetry and Politics: Seventh International Byron Symposium*, University of Salzburg, Institut für Anglistik und Amerikanistik, Salzburger Studien zur Anglistik und Amerikanistik, no. 13 (Salzburg: Institut für Anglistik und Amerikanistik, 1981), 113–36; Lansdown, "Byron and the Carbonari."

100. Byron, *Marino Faliero*, Act V, Scene 3, line 214.

101. Ibid., Scene 4, lines 220–1. See Martin Meisel, "Pictorial Engagements: Byron, Delacroix, Ford Madox Brown," *Studies in Romanticism* 27 (Winter 1988): 579–603.

102. "Pourquoi a-t-il fait disparaître si tôt son *Marino Faliero*, où tout était grave, simple et grand, où il y avait tant de nature et tant d'histoire? La foule se passionait pour ce tableau, qui était un drame." Victor Hugo, "Exposition de tableaux au profit des Grecs: la nouvelle école de peinture." Unpublished review, written May 1826, in *Oeuvres complètes, Edition Chronologique publiée sous la direction de Jean Massin*, 18 vols. (1967–70), (Paris: Le Club Français de Livre), vol. 2 (1967): 983–6, 984. In 1836, Dumas suggested to the duc d'Orléans that Delacroix's *Marino Faliero* would be a good choice for a present for Hugo. Johnson, *Paintings of Delacroix*, J 112, 1(1981):102, n.1.

103. Hugo, "Préface," in *Cromwell*, 429. His examples included Rizzio's murder in Mary Stuart's room at Holyrood, Henri IV's murder in the rue de la Ferronerie, Joan of Arc's martyrdom in Rouen's marketplace, the assassination of the duc de Guise at Blois, the decapitation of Charles I at Whitehall and of Louis XVI at the Tuileries. I have compared Hugo's *Cromwell* and Delacroix's painting *Cromwell in Windsor Castle* (c.1827–8, from Scott's *Woodstock*) in "An Image for Imagining the Past: Delacroix, Cromwell, and Romantic Historical Painting."

104. "La Mort de Marino Faliero de M. Delacroix est disposé d'une manière pittoresque, mais non historique, ou si l'on aime mieux, poétique. Ce qui reçoit toute la lumière, ce qui par conséquent attire exclusivement l'oeil, c'est l'escalier du palais." "D." [Etienne-Jean Delécluze], "Beaux-Arts. Salon de 1827," *Journal des Débats* (December 20, 1827): 1–3, 1.

105. "Figaro au Salon. M. Delacroix – M. Saint-Evre," *Le Figaro*, no. 435 (December 21, 1827): 938–9, 938.

106. "Le milieu de la scène, où se concentre ordinairement toute action, est vide ici. L'effet est frappant. Tous les spectateurs occupant le haut de l'escalier s'éloignent avec un effroi silencieux. L'action est vraie, la touche fine, la couleur locale. L'esprit remonte aisement à l'époque et au lieu de l'action." *Visite au Musée du Louvre, ou Guide de l'Amateur à l'exposition des ouvrages . . . des artistes vivans (année 1827–1828) par une société des gens de lettres* (Paris: Leroi, 1828), 106–7.

107. La société changeant de direction philosophique et politique, et renonçant la plupart de ses vieilles croyance, toutes ses expressions doivent changer aussi . . . La mythologie, avec ses sensualités, ennuie . . . Les traditions fabuleuses des premiers âges de la Grèce et de Rome sont désenchantées; c'est le positif des chroniques qui les a tuées. Nous savions très-bien ce qu'avait fait Hercule et Thema, nous apprenons ce qu'a fait Pépin Héristal ou Louis XI. La tragédie ne nous intéresse plus si elle n'est vraie d'action et de langage; la peinture historique n'aura plus de succès qu'à la même condition.

 Jal, *Esquisses . . . Salon de 1827*, 103–4.

108. La revolution romantique ne peut aller aussi loin en peinture qu'en littérature . . . Des costumes fidèles, une action fortement indiquée, une combinaison de scène habile, une expression naïve, sont de grandes qualités, mais ne suffisent pas. Il faut encore que les personnages qui agissent, qui représentent une époque, qui s'agitent sur la toile pour nous émouvoir, il faut que ses gens-là soient vrais autrement que par leurs habits. Je veux voir des bras sous leurs manches, des jambes dans leurs bottines.

 Ibid., 104–5. Jal thought the heads ugly and the drawing more mannered than in any other of Delacroix's works (111).

109. "Ce n'est pas une page historique que M. Delacroix a eu la volonté de tracer, il a fait de la chronique peinte." Ibid., 111. Jal pointed out that this conspiracy and judicial murder were deliberately concealed from the populace:

 Les tableaux d'étiquette doivent être faits selon l'étiquette. Il y avait aussi un maître de cérémonies à Venise pour les décapitations des doges. Si M. Delacroix avait représenté la conspiration de Jaffier, une silhouette de bourreau ne se serait pas dessinée toute seule sur cet escalier qu'on reproche tant au peintre de Marino-Faliero; il en aurait fait le théâtre d'une action violente; il y a placé le dénouement froid d'un drame dont les mouvemens nous sont cachés.

110. Ludovic Vitet, "Exposition de tableaux au bénéfice des Grecs (IIe article). M. Delacroix," *Le Globe* (June 3, 1826): 372–4; reprinted as "M. Delacroix," in *Etudes sur les Beaux-Arts. Essais d'archéologie et fragments littéraires*, 2 vols. (Paris: Charpentier, 1847), 1:189–97, 191–3.

111. Vitet was no less critical of his own theatrical efforts to make a contribution to historical knowledge. His sketches of characters and mores were vivid reproductions of the past, but not art, whose purpose was to re-create reality so that it was more beautiful. In them, he had been obliged to sacrifice aesthetic unity, since their dramatic effect came out of their historical quality itself. See Vitet, "Avant-Propos," in *La Mort de Henri III Août 1589. Scènes Historiques, faisant suite aux Barricades et aux Etats de Blois* (Paris: H. Fournier jeune, 1829), v–xvi.

1. Salon of 1831, no. 511, "*Le 28 juillet. La liberté guidant le peuple.*" Paris, Musée du Louvre, Inv. RF129; 2.60 × 3.50 m; $102\frac{3}{8}$ × 138 in. Acquired from the Salon for 3,000 francs by the Ministry of the Interior; briefly exhibited in the Musée du Luxembourg in 1832, stored, and returned in 1839 to Delacroix. After the Revolution of 1848, Delacroix approached the new government, and the Ministry of the Interior approved a proposal to exhibit it once again. It hung in the Luxembourg from May 1849 to 1850 and was then stored once more, except for exhibition in Delacroix's retrospective during the 1855 Exposition Universelle, at the artist's request and with Napoleon III's authorization. On exhibit at the Musée du Luxembourg during the Second Empire (1861–74); then entered the Louvre, where it has remained. See Hélène Adhémar, "*La Liberté sur les barricades* de Delacroix étudiée d'après des documents inédits," *Gazette des Beaux-Arts*, 6th ser., 43 (1954): 83–92; George Heard Hamilton, "The Iconographical Origins of Delacroix's *Liberty Leading the People*," in *Studies in Art and Literature for Belle da Costa Greene*, ed. Dorothy Miner (Princeton: Princeton University Press, 1954), 55–66; Pierre Gaudibert, "Eugène Delacroix et le Romantisme révolutionnaire: à propos de *la Liberté sur les Barricades*," *Europe* 41, no. 408 (April 1963): 4–21; Nicos Hadjinicolaou, "*La Liberté Guidant le Peuple*" *de Delacroix*, exhibition at the Musée du Louvre, Paris, November 1982–February 7, 1983, catalogue by Hélène Toussaint, *Dossiers du Département des Peintures no.1* (Paris: Réunion des Musées Nationaux, 1982); Patrick Le Nouëne, "Représentations du peuple dans les tableaux d'histoire exposés aux Salons entre 1831 et 1848," in *Exigences de réalisme dans la peinture française entre 1830 et 1870*, catalogue of exhibition at the Musée des Beaux-Arts, Chartres, 1983, (Musée des Beaux-Arts, Chartres, 1984), 14–33; Marrinan, *Painting Politics for Louis-Philippe*, 67–76; Jörg Traeger, "L'Épiphanie de la Liberté. La Révolution vue par Eugène Delacroix," *Revue de l'art*, no. 98 (1992): 9–28.

2. Marrinan commented on Delacroix's expressive distortions of scale, particularly his enlargement of the standing figures so that they dominate those in the foreground, his accelerated spatial recession, and his placing of the spectator's perspectival viewpoint near Liberty's foot. *Painting Politics for Louis-Philippe*, 70–2.

3. See Delacroix's drawings of Greece leading her children into war, preparatory studies for *Greece on the Ruins of Missolonghi* (1826). Musée du Louvre, RF 9145, folio 39 verso; RF 9145, folio 12 verso.

4. En effet, c'est une belle idée et une composition toute patriotique que la *Liberté* menant de la conquête de ses droits une nation jadis l'exemple et la maîtresse de l'Europe, et maintenant humiliée par seize ans d'asservissement au joug de la sottise, des préjugés et d'un fanatisme hypocrite; mais que l'exécution vient mal ici au secours de la pensée! . . . M. Delacroix a été accusé d'avoir calomnié le peuple de Paris; moi, je ne l'accuserai que d'avoir pris ses modèles dans la populace, et non dans le peuple: on ne fait partie d'un peuple que quand on lui est utile, et non quand on lui est un fléau.

 Ambroise Tardieu, *Annales du Musée et de l'école moderne des Beaux-Arts* (Paris: Pillet aîné, 1831), 44, 46. On the relationship between Romantic aesthetics and liberal politics in the July Monarchy, see Nicos Hadjinicolaou, "Art in a Period of Social Upheaval: French Art Criticism and Problems of Change in 1831," *Oxford Art Journal* 6, no. 2 (1984): 29–37.

5. Qu'ils aient l'ordre pour eux, le désordre est pour nous!
 Désordre intelligent, qui second l'audace,
 Qui commande, obéit, marque à chacun sa place,
 Comme un seul nous fait agir tous,
 Et qui prouve à la tyrannie,

En brisant son sceptre abhorré,
Que par la patrie inspiré,
Un peuple, comme un homme, a ses jours de génie.
(Casimir Delavigne, "Une Semaine de Paris," in *Oeuvres Complètes de Casimir Delavigne. Messéniennes. Chants Populaires et Poésies Diverses*, rev. ed., 6 vols. (Paris: Didier, 1855), 5:199–208, 202–3.

6. Avouons d'abord que loin de partager l'avis général nous admirons beaucoup cette alliance de l'allégorie au réel que nous y trouvons. Il ne faut pas oublier que la peinture, comme la musique et les lettres, est faite pour agir sur les masses, et les perfectionner en transmettant à la postérité l'image de ce qui est grand et beau ... M. Delacroix ... ne voulait pas ... traduire un épisode des trois journées; prenant son vol de plus haut, songeant à nos fils, il voulait personnifier la révolution de juillet. Qu'avait-il donc de mieux à faire que de montrer le peuple suivant la Liberté sur un barricade? Les bons tableaux sont ceux qui s'expliquent sans livret.
 Victor Schoelcher, "MM. Delacroix, Léon Cogniet, Decamps, &c., &c.," *L'Artiste* 1 (1831): 226–8, 226–7.

7. Charles Lenormant, "La Barricade de M. Delacroix (Fragment)," in *Les Artistes Contemporains. Salon de 1831*, 2 vols. (Paris: Alexandre Mesnier, 1833), 1:195–7, 196–7.

8. Faut-il blâmer, faut-il louer l'alliance de l'allégorie et de la réalité qui préside à cette composition? Nous blâmerons le principe en lui-même, mais nous louerons l'exécution: le succès absolu. Evidemment, dans la penseur de l'auteur, l'allégorie donne à la scène qu'il veut représenter une grandeur nouvelle et plus imposante; elle ajoute à la réalité le caractère idéale qui lui manque; en l'élevant elle l'éloigne; elle ajoute à nos souvenirs d'hier, la majesté que l'histoire seule et la plus lointaine possède, et semble se reserver comme un privilège exclusif.
 Gustave Planche, "MM. E. Delacroix et Sigalon," *Salon de 1831*, 107–22, 109. On the background and action: "le fond est à une distance indécise, et danse ... nous voyons bien dans ce tableau tous les élémens d'une action, mais que l'action en elle-même nous semble absente. On ne voit pas précisément si le combat est en train, s'il finit ou s'il commence" (111). He compared Delacroix and Delaroche in his conclusion to the Salon review (298); see my discussion of his response to Delaroche's *Cromwell* in Chapter 4 of the present volume.

9. Cet artiste n'a pas de prédilection pour le passé en lui-même, mais pour la représentation de ces temps, pour la reproduction de leur esprit, pour leur histoire écrite avec des couleurs. C'est le goût actuel de la plupart des peintres français; le salon était rempli de scènes empruntées à l'histoire, et les noms de Devéria, Steuben et Johannot méritent un mention des plus distingués.
 Heine, *De la France*, 329; in Ward's translation of Heine's *Französische Maler*, in Zantop, ed., *Paintings on the Move*, 143–4. See also Susanne Zantop, "Liberty Unbound: Heine's 'Historiography in Color,' " in Zantop, ed., *Paintings on the Move*, 31–49.

10. Heine, *French Painters,* trans. Ward, in Zantop, ed., *Paintings on the Move,* 130. Ward points out (168) that Heine's play on words "de Potter's beastly oeuvre" combined criticism of two Potters: Paul Potter (1625–54), noted representational animal painter, and Louis de Potter (1786–1859), who had successfully fomented the Belgian rebellion against Dutch rule. De Potter was head of the Catholic–Liberal Party. The rebellion began with a riot in Brussels on August 25, 1830; Belgium became a separate kingdom in 1831.

11. "L'avènement de Votre Majesté au trône, et le serment prononcé par elle en présence des deux chambres, ont dignement clos la série d'événemens [the history of the legislature during the French Revolution] à laquelle nous devons nos garanties politiques." Guizot, "Rapport au Roi. Tableaux pour la chambre des Députés," *Journal des Artistes* 2, no. 14 (October 3, 1830): 243–4. See also

Guizot, "Rapport au Roi. Tableaux pour la Chambre des Députés," *Moniteur universel,* no. 272 (September 29, 1830): 1181. On the competitions, see Michael Marrinan, "Resistance, Revolution and the July Monarchy: Images to Inspire the Chamber of Deputies," *Oxford Art Journal* 3, no. 2 (October 1980): 26–37; Albert Boime, "The Quasi-Open Competitions of the Quasi-Legitimate July Monarchy," *Arts Magazine* 59, no. 8 (April 1985): 94–105; Marie-Claude Chaudonneret, "Le Concours de 1830 pour la chambre des Députés: Deux esquisses d'A.-E. Fragonard au Louvre," *Revue du Louvre* 35, no. 2 (1987): 128–35; Marrinan, *Painting Politics for Louis-Philippe,* 79–98.

12. On lit dans les vieilles chroniques de France que vers la fin du XIe siècle, je crois, les bons habitans de la ville de Laon, mal satisfaits de l'oppression et des brigandages de leur seigneur évêque, s'émurent en sédition pour affranchir leur commune . . . M. Augustin Thierry, qui est aussi un grand peintre à sa manière, nous a donné dans ses belles lettres sur l'histoire de France un admirable récit de cet épisode, et c'est là sans doute que M. Clément Boulanger est allé chercher pour en faire le sujet d'un grand tableau qui vient d'être rejeté par le jury . . . M. C. Boulanger a eu le tort d'intituler son tableau: *Affranchissement des Communes*; et l'on assure que le jury, torturant la pensée du peintre, a cru y voir une apologie du meurtre au profit de la liberté; il a pris parti pour l'évêque contre la bourgeoisie; il a déclaré cette peinture factieuse, immorale, corruptrice, atteinte et convaincue de *bousingotisme*, et il a lancé son verdict d'expulsion.

Alexandre-Nicolas Barbier, *Salon de 1836* (Paris, 1836), 35, reprinting articles from the *Journal de Paris.*

13. On the term "the Spirit of the Age" and its use by Mill, Carlyle, and French Saint-Simonians during the 1820s and early 1830s, see Culler, *The Victorian Mirror of History,* 50–64.

14. L'ordre de l'histoire doit être conforme à celui de la vie réelle; tout se mêle, tout se confond dans la vie des peuples, comme dans celle de l'homme: il faut de même que l'histoire enchaîne et enlace tout dans un immense tissu, où les acteurs, les événemens, les faits, se montrent à la place qu'ils ont occupée sur la scène du monde. . . . La vérité de l'ordre historique ne veut pas seulement que l'on conserve sa forme naturelle à la société en général, elle demande encore que l'écrivain représente chaque société avec son caractère propre d'ordre ou de confusion, et qu'il évite avec soin de transporter sur des temps antérieurs la clarté et la régularité de son époque. Il n'y a rien qui fausse l'histoire comme ces efforts de presque tous les historiens pour coordonner et arranger méthodiquement et distinctement un état social, où tout était pêle-mêle.

J. Sarrazin, *Du Progrès des Etudes Historiques en France au dix-neuvième siècle; Dissertation présentée à la Faculté des Lettres de Strasbourg . . . le 13 Août 1835* (Strasbourg: F.G. Levrault, 1835), 53, 48–49.

15. Haskell, *History and Its Images,* 254, cites Michelet's *Journal des idées,* entry for February 12, 1826.

16. On French book illustration during the Restoration and the July Monarchy, see Henri-Jean Martin and Roger Chartier, eds., *Histoire de l'édition française,* 4 vols. (Paris: Promodis, 1983–6), vol. 3: *Le temps des éditeurs: Du romantisme à la belle époque* (Paris: Promodis, 1985); Robert J. Bezucha, "The Renaissance of Book Illustration," in *The Art of the July Monarchy,* 192–213.

17. Il ne s'agit plus seulement ici d'apprendre à quelques fils de rois, de grands, de ministres, ce qu'étaient leurs pères, ou d'exciter en eux le désir de mêmes éloges, ou la crainte du même blâme: ici c'est une nation tout entière s'instruisant par ses propres exemples . . . Chaque acte de ce drame extraordinaire a sa physionomie qui lui est propre, son escorte de modes, de coutumes, de langage, d'habillemens, expression de la pensée publique, couleur des partis où se reflète leur politique, effets de grandes causes qui amènent eux-mêmes des causes nouvelles. Chacun de ses actes a sa grande

scène, sa péripétie, ses acteurs, tous différens de costume et d'allure. Dans les temps de commotions populaires, la forme d'une coiffure est une pensée profonde, la coupe d'un habit un symbole adoré.

Antony Béraud, "Introduction," in *Histoire Pittoresque de la Révolution Française* (Paris: Alexandre Mesnier, 1833), nonpaginated. The prospectus promised one hundred drawings by Girardet, Lecouvreur, Prieur, Swebach, Jules David, and Duplessis-Berthaud, as well as reproductions of drawings by Charlet, Delaroche, Delacroix, the Devéria brothers, the Johannot brothers, Roqueplan, the Scheffer brothers, Horace Vernet, and others.

18. Ludovic Vitet, "De la Vignette" (1828), in *Fragments et Mélanges. Etudes sur les Beaux-Arts*, 2 vols. (Paris, 1846), 1:395–400. First published as "Vignettes pour les Chansons de Béranger" (signed "L. V.") in *Le Globe* 7 no. 49 (May 20, 1829); see Jean-Jacques Goblot, *Le Globe 1824–1830. Documents pour servir à l'histoire de la presse littéraire* (Paris: Champion, 1993), 144. Vitet praised the "pur ornament" of medieval manuscripts and the allegories and analogies of sixteenth-century vignettes. He traced the origin of the "false" and "literal" approach to illustration to editions of seventeenth-century plays, whose frontispieces reproduced a tableau vivant: "En tête des tragédies et des comédies on vit assez souvent paraître une estampe représentant presque exactement une scène de la pièce telle qu'elle se passait sur le théâtre. Ce genre de vignettes que nous appelons *littérales* a donc duré, tout faux qu'il est, près de deux siècles" (396).

19. See Barthes's opposition of a linear "articulation of the anecdote" with an associative layering of "abrasions," where "the excitement comes not from a processive haste but from a kind of vertical din." Roland Barthes, *Le Plaisir du texte* (Paris: Seuil, 1973); translated by Richard Miller as *The Pleasure of the Text* (London: Cape, 1975); reprinted in *A Critical and Cultural Theory Reader*, ed. Antony Easthope and Kate McGowan (Toronto: University of Toronto Press, 1992), 96–9, 97.

20. James Henry Rubin, in *Realism and Social Vision in Courbet and Proudhon* (Princeton: Princeton University Press, 1980) has cited the influence of Saint-Simonianism on Courbet. He noted the influence of Michelet's *Le Peuple* (1846) on Proudhon's journal *Le Peuple* (1849) (136, n. 12). Fried stressed Courbet's antitheatrical compositional innovations for "tableaux d'histoire," particularly the incorporation of multiple viewpoints, in *Courbet's Realism*. Thierry's continuing impact was acknowledged in Chesnau's review of Robert-Fleury's *Warsaw, 8 April 1861* (Salon of 1866, Exposition Universelle 1867), which portrayed the Russian massacre of Polish nationalists and was indebted to Delacroix's *Liberty*; see John House, "Manet's Maximilian: History Painting, Censorship and Ambiguity," 87–111, 97, in *Manet: The Execution of Maximilian: Painting, Politics and Censorship*, exhibition at the National Gallery, July 1–September 27, 1992, catalogue by Juliet Wilson-Bareau (London: National Gallery, 1992).

21. "L'histoire, en effet, n'est pas une toile à barbouiller au servicee de telle prévention particulière; l'histoire, pour ainsi dire n'est pas un seul homme avec sa vue myope et ses humeurs fantasques. De quel droit un historien viendra-t-il nous imposer l'infaillibilité de ses arrêts? . . . l'historien . . . a mauvais grâce d'ériger un tribunal que chacun peut, dans son libre arbitre, casser et reconstituer." Henri Martin, "Avertissement," in *Histoire de France depuis les temps les plus reculés jusqu'en juillet 1830; par les principaux historiens et d'après les plans de MM. Guizot, Augustin Thierry et de Barante*, 15 *tomes* in 8 vols. (Paris: L. Mame, 1833–6), 1:1–12, 7.

SELECTED BIBLIOGRAPHY

Exhibition catalogues are listed alphabetically by title. Unsigned art reviews and those identified only by initials are listed with others by the same critic.

Allévy, Marie-Antoinette. *La Mise en scène en France dans la première moitié du dix-neuvième siècle. Edition critique d'un mise en scène romantique.* Paris: Droz, 1938; reprint, Geneva: Slatkine, 1978.

"L'Amateur sans pretention." "Salon de 1824. Septième article." *Mercure du XIX siècle* 7 (1824): 199–210.

Angrand, Pierre. *Le Comte de Forbin et le Louvre en 1819.* Paris: Bibliothèque des Arts, 1972.

Les Années romantiques. La Peinture française de 1815 à 1850. Exhibition at the Musée des Beaux-Arts, Nantes, December 4, 1995–March 17, 1996; Galeries Nationales du Grand Palais, Paris, April 16–July 15, 1996; and Palazzo Gotico, Plaisance, September 6–November 17, 1996. Catalogue by Claude Allemand-Cosneau, Sylvain Boyer, Georges Brunel, et al. Paris: Réunion des Musées Nationaux, 1995.

Aristotle. *On Poetry and Style.* Translated by G. M. A. Grube. Indianapolis: Bobbs-Merrill, 1958.

The Art of the July Monarchy: France 1830 to 1848. Exhibition at the Museum of Art and Archaeology, University of Missouri–Columbia, October 21–December 3, 1989; Memorial Art Gallery of the University of Rochester, January 21–March 12, 1990; Santa Barbara Museum of Art, March 31–May 20, 1990. Catalogue by Patricia Condon. Columbia, MO: University of Missouri Press, 1990.

Athanassoglou-Kallmyer, Nina Maria. "*Imago Belli*: Horace Vernet's *L'Atelier* as an Image of Radical Militarism under the Restoration." *Art Bulletin* 68, no. 2 (June 1986): 268–80.

French Images from the Greek War of Independence, 1821–1830. Art and Politics under the Restoration. New Haven: Yale University Press, 1989.

"Liberals of the World Unite: Géricault, His Friends, and *La Liberté des Peuples.*" *Gazette des Beaux-Arts*, 6th ser., 116 (December 1990): 227–42.

Eugène Delacroix: Prints, Politics and Satire, 1814–1822. New Haven: Yale University Press, 1991.

Aubert, Marcel and Marcel Roux. *Inventaire analytique de la Collection de Vinck.* Vol. 3. *La législative et la Convention.* Paris: Imprimerie Nationale, 1921.

Baczko, Bronislaw. *Comment sortir de la terreur.* Paris: Gallimard, 1989. Translated

as *Ending the Terror: The French Revolution after Robespierre.* Cambridge: Cambridge University Press Maison des Sciences de l'Homme, 1994.

Bakhtin, Mikhail. *The Dialogic Imagination. Four Essays.* Translated by Michael Holquist and Caryl Emerson. Austin: University of Texas Press, 1981.

Bann, Stephen. *The Clothing of Clio: A Study of the Representation of History in Nineteenth-century Britain and France.* Cambridge: Cambridge University Press, 1984.

"Image, Text, and Object in the Formation of Historical Consciousness." In *The New Historicism,* edited by H. Aram Veeser, 102–15. New York: Routledge, 1989.

Romanticism and the Rise of History. New York: Twayne, 1995.

Barante, Amable-Guillaume-Prosper Brugière, baron de. *Histoire des ducs de Bourgogne de la maison de Valois, 1364–1477.* 12 vols., with illustrations by Achille Devéria. Paris: Ladvocat, 1824–6. 3rd ed.: 12 vols. Paris: Ladvocat, 1825–6. 5th ed.: 13 vols. Paris: Dufey, 1837. 6th ed.: 12 vols. Paris: Delloye, 1839. Preface to 1824 edition, 1:1–88.

"De l'Histoire." In *Encyclopédie Moderne, ou Dictionnaire Abrégé des Sciences, des Lettres et des Arts,* edited by Eustache-Marie-Pierre-Marc-Antoine Courtin. 26 vols. Paris, 1824–32. Vol. 14 (1828): 124–59; separately printed as a pamphlet entitled *Histoire, article extrait du 14e volume de l'"Encyclopédie Moderne"* (1828), 3–37.

Barthes, Roland. "Le Discours de l'histoire." *Information sur les sciences sociales* 6, no. 4 (August 1967): 65–75. Translated as "The Discourse of History," with an introduction by Stephen Bann, *Comparative Criticism* 3 (1981): 3–20.

"L'Effet de réel." *Communications* 11 (1968): 84–90. Translated as "The Reality Effect," in Tzvetan Todorov, *French Literary Theory Today,* 11–17. Cambridge: Cambridge University Press, 1982.

La Chambre claire – Note sur la photographie. Paris: Cahiers du Cinéma/Gallimard/Seuil, 1980.

Barzun, Jacques. "Romantic Historiography as a Political Force in France." *Journal of the History of Ideas* 2 (1941): 318–29.

[Bazard, Saint-Amand]. "St.-A. B." "Considérations sur l'Histoire." *Le Producteur. Journal philosophique de l'industrie, des sciences et des beaux-arts* 4 (1826): 390–415.

Bazin, Germain. *Théodore Géricault. Etude critique, documents et catalogue raisonné.* 6 vols. Paris: Bibliotheque des Arts/Wildenstein Institute, 1987–94.

Béraud, Antony. *Annales de l'école française des beaux-arts, recueil de gravures au trait, d'après les principales productions exposées au Salon du Louvre par les artistes vivants; avec des notices historiques et critiques, etc., etc.* Paris: Pillet aîné, 1827.

Beutler, Christian. "*Les Bourgeois de Calais* de Rodin et d'Ary Scheffer." *Gazette des Beaux-Arts,* 6th ser., 79 (1972): 39–50.

Blakemore, Steven, ed. *Burke and the French Revolution.* Athens: University of Georgia Press, 1992.

[Bonington] *Richard Parkes Bonington. "On the Pleasures of Painting."* Exhibition at the Yale Center for British Art, New Haven, November 13, 1991–January 19, 1992, and the Petit Palais, Paris, March 5–May 17, 1992. Catalogue by Patrick Noon. New Haven: Yale University Press, 1991.

Bottineau, Josette. "Le Décor de tableaux à la sacristie de l'ancienne abbatiale de Saint-Denis (1811–1823)." *Bulletin de la Société de l'histoire de l'art français* (1973): 255–81.

Brès, Jean-Pierre. *Souvenirs du musée des monuments français. Collection de 40 dessins perspectifs, au trait, représentant les principaux aspects sous lesquels on a pu considérer les monumens réunis dans ce musée. Dessinée par M. Biet, en 1813, 1814 et 1815, et gravée par MM. Normand père et fils; avec un texte explicatif par M. Brès.* Paris: Brès & Carilian Goeury, 1821.

Brooks, Peter. *The Melodramatic Imagination: Balzac, Henry James, Melodrama, and the Mode of Excess.* New York: Columbia University Press, 1985.

De Bruyn, Frans. "Theater and Countertheater in Burke's *Reflections on the Revolution in France.*" In *Burke and the French Revolution,* edited by Steven Blakemore, 28–68. Athens: University of Georgia Press, 1992.

Bryant, Edward A. "Notes of J. A. D. Ingres' *Entry into Paris of the Dauphin, Future Charles V.*" *Wadsworth Atheneum Bulletin,* 5th ser., 3 (1959): 16–21.

Burke, Edmund. *Reflections on the Revolution in France, and on the Proceedings in Certain Societies in London Relative to that Event, in a Letter Intended to Have Been Sent to a Gentleman in Paris.* London: J. Dodsley, 1790. Modern edition, New York: Doubleday [Dolphin], 1961.

Byron, George Gordon, Lord. *Marino Faliero, Doge of Venice. An Historical Tragedy in Five Acts with Notes.* Paris: A. & W. Galignani, 1821.

Carlyle, Thomas. "Sir Walter Scott." *London and Westminster Review* 28 (January 1838), 293–345.

——— "On History." Originally in *Fraser's Magazine,* no. 10 (1830). Reprinted in *Critical and Miscellaneous Essays,* 2nd ed., 5 vols., 2:378–93. London: James Fraser, 1840.

Castle, Terry. "Phantasmagoria: Spectral Technology and the Metaphorics of Modern Reverie." *Critical Inquiry* 15 (Autumn 1988): 26–61. Reprinted in *The Female Thermometer: Eighteenth-Century Culture and the Invention of the Uncanny.* New York: Oxford University Press, 1995.

Chateaubriand, François-René, vicomte de. *Les Quatre Stuarts.* In *Mélanges et Poésies,* vol. 22 (1828) of *Oeuvres Complètes.* 28 vols. Paris: Ladvocat, 1826–31. In *Oeuvres Complètes de Chateaubriand.* 10 vols. Paris: Eugène & Victor Penaud frères, 1849–50. Excerpts from *Les Quatre Stuarts,* in *Oeuvres illustrées de Chateaubriand.* 7 vols. Illustrations by Janet-Lange [Ange-Louis Janet]. Paris: H. Boissard, 1852–3.

——— "Ecole Historique Moderne de la France." Preface, 1:i–cxli. In *Etudes ou Discours Historiques sur la chute de l'empire Romain, la Naissance et les progrès du Christianisme, et l'invasion des Barbares, suivis d'une analyse raisonnée de l'histoire de France.* 4 vols. Paris: Lefevre, 1831.

——— *Mémoires d'Outre-Tombe.* [1849–50]. Edited by Maurice Levaillant and Georges Moulinier. 2 vols. Paris: Gallimard [Le Livre de Poche.], 1951.

——— *Correspondance générale.* Edited by Béatrix d'Andlau, Pierre Christopohorov, and Pierre Riberette. 5 vols. Paris: Gallimard, 1977–86.

Chaudonneret, Marie-Claude. *Fleury Richard et Pierre Révoil. La Peinture troubadour.* Paris: Arthena, 1980.

——— "Historicism and 'Heritage' in the Louvre, 1820–1840." *Art History* 14, no. 4 (December 1991): 488–520.

——— "'Musées' des origines. De Montfaucon au Musée de Versailles." *Romantisme,* 84, no. 2 (1994): 11–35.

Chu, Petra ten-Doesschate and Gabriel P. Weisberg, eds. *The Popularization of Images: Visual Culture under the July Monarchy.* Princeton: Princeton University Press, 1994.

Clément, Charles. *Géricault. Etude Biographique et Critique avec le catalogue raisonné de l'oeuvre du maître.* 3rd ed. Paris: Didier, 1879.

[Coupin, Philippe-Alexandre] "P. A." "Exposition des tableaux en 1827." *Revue encyclopédique* 37 (1828): 302–16; "BEAUX-ARTS. Exposition des tableaux en 1827 et 1828. Cinquième et dernier article." *Revue encyclopédique* 38 (April 1828): 276–86.

——— "Notice sur l'exposition des Tableaux, en 1819. Troisième article." *Revue encyclopédique* 5 (1820): 45–75.

Crossley, Ceri. *French Historians and Romanticism: Thierry, Guizot, the Saint-Simonians, Quinet, Michelet.* New York: Routledge, 1993.

Crow, Thomas. *Emulation: Making Artists for Revolutionary France.* New Haven: Yale University Press, 1995.

Culler, A. Dwight. *The Victorian Mirror of History*. New Haven: Yale University Press, 1985.

Cunningham, Allan. *The Life of Sir David Wilkie. With His Journals, Tours, and Critical Remarks on Works of Art: and a Selection from his Correspondence*. 3 vols. London: John Murray, 1843.

"D." "Beaux-Arts. Salon de 1824." *Le Moniteur universel*, no. 252 (September 8, 1824): 1226.

Decamps, Alexandre. *Le Musée. Revue du Salon de 1834*. Paris, 1834.

Delacroix, Eugène. *Les Dangers de la cour*. Unpublished novel, edited by Jean Marchand. Avignon: Aubanel, 1960.

 Selected Letters, 1813–1863. Selected and translated by Jean Stewart. New York: St. Martin's, 1970.

 Eugène Delacroix: Journal, 1822–1863. Edited by Régis Labourdette, with a preface by Hubert Damisch, and introduction and notes by André Joubin. Paris: Plon, 1981. Revision of André Joubin edition in 3 vols. Paris: Plon, 1931–2.

 The Journal of Eugène Delacroix. Edited by Hubert Wellington, translated by Lucy Norton. London: Phaidon, 1995.

Delécluze, Etienne-Jean. *Louis David, son école et son temps. Souvenirs*. Paris: Didier, 1855.

 Souvenirs de soixante ans. Paris, 1862.

 Journal de Delécluze, 1824–1828. Edited by Robert Baschet. Paris: Grasset, 1948.

[Delécluze, Etienne-Jean] "D." "Salon de 1827." *Journal des Débats*, December 20, 1827; January 7, 1828.

[Delécluze, Etienne-Jean] "E. J. D." "Lettre au Rédacteur du Lycée Français sur l'exposition des ouvrages de peinture, sculpture, etc. des Artistes vivans." *Le Lycée Français* 2 (1819): 74–86; 182–92.

 "Beaux-Arts. Exposition. Salon de 1822." *Le Moniteur universel*, no. 156 (June 5, 1822): 801–2; no. 169 (June 18, 1822): 859–60.

Delpech, François-Séraphin. *Examen raisonné des ouvrages de peinture, sculpture et gravure exposés au Salon du Louvre en 1814*. Paris, 1814.

Delteil, Loys. *Le Peintre-Graveur illustré. Géricault*. Paris, by the author, 1924.

Duncan, Ian. *Modern Romance and Transformation of the Novel: The Gothic, Scott, Dickens*. Cambridge: Cambridge University Press, 1992.

Dunn, Susan. *The Deaths of Louis XVI: Regicide and the French Political Imagination*. Princeton: Princeton University Press, 1994.

Eggli, Edmond and Pierre Martino. *Le Débat romantique en France (1813–1830). Pamphlets. Manifestes. Polemiques de presse. Vol. 1: (1813–1816)*. Paris, Belles Lettres, 1933.

Eitner, Lorenz. *Géricault's "Raft of the Medusa."* London: Phaidon, 1972.

 Géricault: His Life and Work. Ithaca, NY: Cornell University Press, 1983.

"E. J." *See* Etienne, Victor.

[Emeric-David, Toussaint-Bernard] "T." "Beaux-Arts. Salon. Troisième article." *Le Moniteur universel*, no. 285 (October 12, 1819): 1323–4.

Erdman, David V. "Byron's Stage Fright: The History of His Ambition and Fear of Writing for the Stage." *ELH* 6 (September 1939): 219–43.

[Etienne, Victor] "E.J." Beaux-Arts. Salon de 1819. *La Minerve Française* 7 (August 1819): 260–7; 357–67; 450–61.

Estève, Edmond. *Byron et le romantisme française. Essai sur la fortune et l'influence de l'oeuvre de Byron en France de 1812 à 1850*. 2nd ed. Paris: Boivin, 1929.

 "De l'état actuel des sciences historiques en France." *Revue Européenne* 1 (June 1824): 1–17.

Evans, David Owen. *Social Romanticism in France*. Oxford: Clarendon Press, 1951.

Ewals, Leonardus Joseph Ignatius. "Ary Scheffer. Sa Vie. Son Oeuvre." Dissertation; Katholieke Universiteit te Nijmegen, Netherlands, 1987.

"F." *See* Farcy, Charles.

La Famille royale à Paris. De l'histoire à la légende. Exhibition at the Musée

Carnavalet, October 16, 1993–January 9, 1994. Catalogue by Rosine Trogan and Anne Forray-Carlier, with Charlotte Lacour. Paris: Paris-Musées, 1993.

[Farcy, Charles] "F." "Musée Royal. Exposition de 1827 (5e article)." *Journal des Artistes*, no. 24 (December 9, 1827): 777–84.

Féréol de Bonnemaison, chevalier. *Galerie de S. A. R. la Duchesse de Berry. Ecole française; peintres modernes*. 3 vols. Paris: J. Didot l'aîné, 1822–4.

"Figaro au Salon. M. Delacroix – M. Saint-Evre." *Le Figaro*, no. 435 (December 21, 1827): 938–9.

Flocon, Ferdinand and Marie Aycard. *Salon de 1824*. Paris: Leroux, 1824.

Fort, Bernadette, ed. *Fictions of the French Revolution*. Evanston, IL: Northwestern University Press, 1991.

Fried, Michael. *Absorption and Theatricality: Painting and Beholder in the Age of Diderot*. Berkeley and Los Angeles: University of California Press, 1980.

Courbet's Realism. Chicago: University of Chicago Press, 1990.

Gaehtgens, Thomas W. *Versailles: De la résidence royale au Musée historique. La Galerie des batailles dans le Musée historique de Louis-Philippe*. Paris: Albin Michel, 1984.

Gault de Saint-Germain, Pierre Marie. "Observations sur l'état des arts au dix-neuvième siècle dans le Salon de 1814." *Le Spectateur, ou variétés historiques, littéraires, critiques, poétiques et morales*, no. 29, 3 (1815): 442–57.

Choix des productions de l'art les plus remarquables exposées dans le Salon de 1819. Paris, 1819.

Géricault. Tout l'oeuvre gravé et pièces en rapport. Exhibition at the Musée des Beaux-Arts, Rouen, November 28, 1981–February 28, 1982. Catalogue by François Bergot. Rouen: Musée des Beaux-Arts, 1981.

Géricault. Exhibition at the Galeries Nationales du Grand Palais, Paris, October 10, 1991–January 6, 1992. Catalogue by Sylvain Laveissière, Régis Michel, and Bruno Chenique. Paris: Réunion des Musées Nationaux, 1991.

Girodet-Trioson, Anne-Louis. *Oeuvres Posthumes de Girodet–Trioson, peintre d'histoire, suivies de sa correspondance; précédées d'une Notice historique, et mises en ordre par P. A. Coupin*. 2 vols. Paris, 1829.

Gossman, Lionel. *Between History and Literature*. Cambridge, MA: Harvard University Press, 1990. Reprints "Augustin Thierry and Liberal Historiography" [1976], 83–151; "History and Literature: Reproduction or Signification?" [1978], 227–56; "History as Decipherment: Romantic Historiography and the Discovery of the Other" [1986], 257–84.

"History as (Auto)Biography: A Revolution in Historiography." In *Autobiography, Historiography, Rhetoric: A Festschrift in Honor of Frank Paul Bowman*, edited by Mary Donaldson-Evans, Lucienne Frappier-Mazur, and Gerald Prince, 103–29. Atlanta: Rodopi, 1994.

Le "Gothique" retrouvé avant Viollet-le-Duc. Exhibition at the Hôtel de Sully, October 31, 1979–February 17, 1980. Catalogue by Louis Grodecki, Jacques Henriet, Claude Malecot et al. Paris: Caisse Nationale des Monuments Historiques et des Sites, 1979.

Grate, Pontus. *Deux critiques d'art de l'époque romantique: Gustave Planche et Théophile Thoré*. Stockholm: Almquist & Wiksell, 1959.

Greene, Christopher M. "Alexandre Lenoir and the Musée des monuments français during the French Revolution." *French Historical Studies* 12 (1981): 200–22.

Guizot, François. *De l'état des beaux-arts en France et du Salon de 1810*. Paris, 1810. Reprinted in *Etudes sur les Beaux-Arts en général*. 2nd ed. Paris: Didier, 1852.

Histoire de la Révolution d'Angleterre depuis l'avénement de Charles Ier jusqu'à sa mort. [1826–7]. 4th ed. 2 vols. Paris: Victor Masson, 1850.

Hamm, Francine. "Etude sur Louis-Antoine-François de Marchangy. Contribution à l'histoire des idées en France sous la Restauration." Dissertation, Faculté des Lettres, Université de Strasbourg, 1962.

Hart, Francis. *Scott's Novels: The Plotting of Historic Survival.* Charlottesville: University Press of Virginia, 1966.

Haskell, Francis. *Past & Present in Art & Taste: Selected Essays.* New Haven: Yale University Press, 1987. Reprints "The Manufacture of the Past in Nineteenth-Century Painting" [1971], 75–89, and "Art and the Language of Politics" [1974], 65–74.

History and Its Images: Art and the Interpretation of the Past. New Haven: Yale University Press, 1993.

Haureau, Barthélemy. "Variétés. Salon de 1834. 3e article." *La Tribune politique et littéraire,* no. 74 (March 15, 1834).

Heine, Henri. *Französische Maler,* articles reviewing the Salon of 1831 for the *Morgenblatt für gebildete Stände* (October–November 1831). Translated as *De la France.* Paris: Eugène Renduel, 1833. Modern translation by David Ward of an uncensored version, in *Paintings on the Move: Heinrich Heine and the Visual Arts,* edited by Susanne Zantop. Lincoln, NE: University of Nebraska Press, 1989.

Lutèce. Lettres sur la vie politique, artistique et sociale de la France [1855]. Edited by Ephraïm Harpaz. Reprint, Geneva: Slatkine, 1979.

Hovenkamp, J. W. *Mérimée et la couleur locale. Contribution à l'étude de la couleur locale.* Paris: Belles Lettres, 1928.

Huet, Marie-Hélène. "Performing Arts: Theatricality and the Terror." In *Representing the French Revolution: Literature, Historiography, and Art,* edited by James A. W. Heffernan, 135–49. Hanover, NH: University Press of New England for Dartmouth College, 1992.

Hugo, Victor. "Exposition de tableaux au profit des Grecs: La nouvelle école de peinture." Unpublished review, written May 1826. In *Oeuvres complètes.* Edited by Jean Massin. Vol. 2 (1967), 983–86. Paris: Club Français de Livre.

Cromwell [1827]. In *Théâtre complet de Victor Hugo.* Vol. 1. Paris: Pléiade, 1963.

Hume, David. *History of Great Britain: The Reigns of James I and Charles I* [1754]. Harmondsworth, UK: Penguin, 1970.

Hunt, H. J. *Le Socialisme et le romantisme en France: Étude de la presse socialiste de 1830 à 1848.* Oxford: Clarendon Press, 1935.

Hutton, Patrick. "The Art of Memory Reconceived: From Rhetoric to Psychoanalysis." *Journal of the History of Ideas* 48, no. 3 (July–September 1987): 371–92.

History as an Art of Memory. Hanover, NH: University Press of New England for University of Vermont, 1993.

Hutton, Richard Wetherill. "Robert Bowyer and the Historic Gallery: A Study on the Creation of a Magnificent Work to Promote the Arts in England." Ph.D. diss., University of Chicago, 1992.

Iknayan, Marguerite. *The Concave Mirror: From Imitation to Expression in French Esthetic Theory, 1800–1830.* Stanford French and Italian Studies, no. 30. Palo Alto, CA: ANMA Libri, 1983.

Ingres. Exhibition at the Musée du Petit Palais, Paris, October 27, 1967–January 29, 1968. Exhibition organized by Michel Laclotte, Adeline Cacan, Maurice Sérullaz, Pierre Rosenberg. Catalogue by Lise Duclaux, Jacques Foucart, Hans Naef, Maurice Sérullaz, Daniel Ternois. Paris: Réunion des Musées Nationaux, 1967.

[Ingres] *In Pursuit of Perfection: The Art of J.-A.-D. Ingres.* Exhibition at the J. B. Speed Museum and the Kimbell Art Museum. Louisville, KY: The J. B. Speed Museum, December 6, 1983–January 29, 1984; Fort Worth, TX: Kimbell Art Museum, March 3, 1984–May 6, 1984. Catalogue by Patricia Condon, with Marjorie B. Cohn and Agnes Mongan. Louisville, KY: J. B. Speed Museum/ Indiana University Press, 1983.

Jacoubet, Henri. *Le Genre troubadour et les origines françaises du romantisme.* Paris: Belles Lettres, 1928.

Jal, Auguste. *L'Artiste et le Philosophe, entretiens critiques sur le Salon de 1824.* Paris: Ponthieu, 1824.

 Esquisses, croquis, pochades, ou Tout ce qu'on voudra sur le Salon de 1827. Paris: Ambroise Dupont, 1828.

[Jal, Auguste] J***, Gustave [*sic*]. *Mes Visites au Musée Royal du Luxembourg, ou Coup d'oeil critique de la Galerie des Peintres Vivans.* Paris: Ladvocat, 1818.

[Jal, Auguste] Jal, Gustave [*sic*]. *L'Ombre de Diderot et le bossu du Marais, dialogue critique sur le Salon de 1819.* Paris: Corréard, 1819.

Janin, Jules, *See* Monteil, Amans-Alexis.

"J.-P. P." *See* Pages, Jean-Pierre.

La "Jeanne d'Arc" de Paul Delaroche. Salon de 1824. Dossier d'un oeuvre. Exhibition at the Musée des Beaux-Arts de Rouen, January 15–March 14, 1983. Catalogue by Marie-Pierre Foissy-Aufrère. Rouen, 1983.

Joannides, Paul. "Toward the Dating of Géricault's Lithographs." *Burlington Magazine* 115, no. 847 (October 1973): 666–71.

Johnson, Dorothy. "Corporality and Communication: The Gestural Revolution of Diderot, David, and *The Oath of the Horatii.*" *Art Bulletin* 71, no. 1 (March 1989): 92–113.

 Jacques-Louis David: Art in Metamorphosis. Princeton: Princeton University Press, 1993.

Johnson, Edgar. *Walter Scott. The Great Unknown.* 2 vols. New York: Macmillan, 1970.

Johnson, Lee. *The Paintings of Eugène Delacroix: A Critical Catalogue.* 6 vols. Oxford: Clarendon Press, 1981–9.

Jonker, Marijke. "Diderot's Shade: The Discussion on 'Ut pictura poesis' and Expression in French Art Criticism, 1819–1840." Dissertation, University of Amsterdam, 1994.

"E. J." *See* Etienne, Victor, known as Jouy.

Jouy, E. and A. Jay. *Salon d'Horace Vernet. Analyse historique et pittoresque de quarante-cinq tableaux exposés chez lui en 1822.* Paris, 1822.

Kemp, Martin. "Scott and Delacroix, with some Assistance from Hugo and Bonington." In *Scott Bicentenary Essays*, edited by Alan Bell, 213–27. Edinburgh: Scottish Academic Press, 1973.

Kératry, Auguste-Hilarion, comte de. *Annuaire de l'école française de peinture, ou Lettres sur le Salon de 1819.* Paris, 1820.

Kolb, Marthe. *Ary Scheffer et son temps, 1795–1858.* Paris: Boivin, 1937.

L***, Alphonse. *Réflexions sur l'art de la peinture et son état actuel en France.* Paris: Gillé, 1815.

Lacambre, Geneviève and Jean Lacambre. "La Politique d'acquisition sous la Restauration: Les Tableaux d'histoire." *Bulletin de la Société de l'histoire de l'art français* (1972): 331–44.

Lamicq, Pierre C. "Henri IV et le château de Pau dans l'oeuvre de Millin Du Perreux. Les peintures de la Galerie de Diane à Fontainebleau." *Bulletin de la Société des amis du Château de Pau*, n.s. 72 (1977): 25–40.

Landon, Charles-Paul. *Salon de 1817. Recueil de morceaux choisis parmi les ouvrages de peinture et de sculpture exposés au Louvre le 24 avril 1817.* Paris: Imprimerie Royale, 1817.

 Annales du Musée et de l'école moderne des beaux-arts. Salon de 1819. Recueil de morceaux choisis parmi les ouvrages de peinture et de sculpture exposés au Louvre le 25 août 1819. 2 vols. Paris: Imprimerie Royale, 1819.

 Annales du Musée et de l'Ecole Moderne des Beaux-Arts. Salon de 1824. Paris: C. Ballard, 1824.

Lansdown, Richard. "Byron and the Carbonari." *History Today* 41, no. 5 (May 1991): 18–25.

 Byron's Historical Dramas. Oxford: Clarendon Press, 1992.

Lanson, René. *Le Goût du moyen âge en France au XVIIIe siècle.* Paris: Architecture et Arts Décoratifs/Brussels: Van Oest, 1926.

Lee, Rensselaer W. " 'Ut pictura poesis': The Humanistic Theory of Painting." *Art Bulletin* 22, no. 4 (1940): 197–269. Revised as book of same title, New York: Norton, 1967.

Le Hir, Marie-Pierre. *Le Romantisme aux enchères. Ducange, Pixérécourt, Hugo.* Purdue University Monographs in Romance Languages, no. 42. Philadelphia: Benjamin, 1992.

Lenoir, Alexandre. *Musée des Monumens Français ou Description historique et chronologique des Statues en marbre et en bronze, Bas-reliefs et Tombeaux des Hommes et des Femmes célèbres, pour servir à l'Histoire de France et à celle de l'Art.* 8 vols. Paris: Guilleminet or Nepveu, 1800–21.

Lenormant, Charles. *Les Artistes Contemporains. Salon de 1831.* 2 vols. Paris: Alexandre Mesnier, 1833.

Le Tourneur, Pierre. *Histoire d'Angleterre représentée par figures, accompagnées d'un Précis historique.* Engravings by François-Anne David. 2 *tomes* in 1 vol. Paris: David, 1784.

Levie, Françoise. *Etienne-Gaspard Robertson. La Vie d'un fantasmagore.* Quebec: Préambule, 1990.

Locke, Ralph P. *Music, Musicians and the Saint-Simonians.* Chicago: University of Chicago Press, 1986.

"L. V." *See* Vitet, Louis.

M***. *See* Miel, Edmé-François-Antoine-Marie.

Macaulay, Thomas Babington, Lord. "History." Originally published in *Edinburgh Review* (May 1828). Reprinted in *The Miscellaneous Writings of Lord Macaulay,* 1: 270–309. 2 vols. London: Longman, Green, Longman, & Roberts, 1860.

Maigron, Louis. *Le roman historique à l'époque romantique: essai sur l'influence de Walter Scott.* Paris: Champion, 1898.

Marchand, Jean. "Delacroix fut écrivain avant d'être peintre." *Nouvelles littéraires, artistiques et scientifiques,* no. 1302 (August 14, 1952): no pagination.
 "Eugène Delacroix, homme de lettres d'après trois oeuvres de jeunesse." *Le Livre et l'estampe* 19, no. 3 (1959): 173–84.

Marchangy, Louis-Antoine-François de. *La Gaule Poétique, ou l'Histoire de France considérée dans ses rapports avec la Poésie, l'Eloquence et les Beaux-Arts.* 8 vols. Paris: C. F. Patris, 1813–17. 3rd ed., illustrated, 4 vols. Paris: C.-F. Patris, Lecointe & Durey, Chaumerot jeune, 1819. 4th ed., 6 *tomes* in 3 vols. Paris; Baudouin frères & F.-M. Maurice, 1824.
 Tristan le Voyageur, ou la France au XIVe siècle. 6 vols. Paris: F.-M. Maurice and Urbain Canel, 1825–6, 2nd ed., 6 vols. Paris: Urbain Canel, 1826.

Marmontel, Jean-François. "Histoire." In *Elemens de littérature:* vols. 5–10 of *Oeuvres Completes de M. Marmontel,* 8: 70–128. Paris: Née de la Rochelle, 1787.

Marrinan, Michael. *Painting Politics for Louis Philippe: Art and Ideology in Orléanist France, 1830–1848.* New Haven: Yale University Press, 1988.
 "Literal/ Literary/ 'Lexie': History, Text, and Authority in Napoleonic Painting." *Word & Image* 7, no. 3 (July–September 1991): 177–200.

Martin, Henri. *Histoire de France depuis les temps les plus reculés jusqu'en juillet 1830; par les principaux historiens et d'après les plans de MM. Guizot, Augustin Thierry et de Barante.* 15 *tomes* in 8 vols. Paris: L. Mame, 1833–6.

Martin, Henri-Jean and Roger Chartier, eds. *Histoire de l'édition française.* 4 vols. Paris: Promodis, 1983–6. Vol. 3: *Le temps des éditeurs: Du romantisme à la belle époque.* Paris: Promodis, 1985.

Massmann, Klaus. *Die Rezeption der historischen Romans Sir Walter Scotts in Frankreich (1816–1832).* Studia Romantica, no. 24. Heidelberg, 1972.

McAllister Johnson, W. *French Lithography: The Restoration Salons, 1817–1824.* Kingston, Canada: Agnes Etherington Art Centre, 1977.

McClellan, Andrew. *Inventing the Louvre: Art, Politics, and the Origins of the Modern Museum in Eighteenth-Century Paris.* Cambridge: Cambridge University Press, 1994.

McWilliam, Neil. *Dreams of Happiness: Social Art and the French Left, 1830–1850*. Princeton: Princeton University Press, 1993.

McWilliam, Neil, Vera Schuster, and Richard Wrigley, eds. *A Bibliography of Salon Criticism in Paris from the Ancien Régime to the Restoration, 1699–1827*. Cambridge: Cambridge University Press, 1991.

Le Mécénat du duc d'Orléans, 1830–1842. Exhibition organized by the Délégation à l'Action Artistique de la Ville de Paris. Catalogue edited by Hervé Robert et al. Paris: Délégation à l'Action Artistique de la Ville de Paris, 1993.

Meisel, Martin. *Realizations: Narrative, Pictorial, and Theatrical Arts in Nineteenth-Century England*. Princeton: Princeton University Press, 1983.

Mellon, Stanley. *The Political Uses of History: A Study of Historians in the French Restoration*. Stanford: Stanford University Press, 1958.

Mercier, Louis-Sébastien. *Le Nouveau Paris*. 2nd ed. 6 vols. Genoa, c.1798.

Michelet, Jules. *Mother Death: The Journal of Jules Michelet, 1815–1850*. Edited and translated by Edward K. Kaplan. Amherst: University of Massachusetts Press, 1984.

[Miel, Edmé-François-Antoine-Marie] M***. *Essai sur le Salon de 1817, ou Examen critique des principaux ouvrages dont l'exposition se compose, accompagné de gravures au trait*. Paris: Delaunay & Pélicier, de l'imprimerie de Didot le jeune, 1817.

Revue critique des productions de peinture, sculpture, gravure exposés au Salon de 1824. Paris: Dentu, 1825.

Millin, Aubin-Louis. *Dictionnaire des Beaux-Arts*. 3 vols. Paris: Crapelet-Desray, 1806.

Mitzman, Arthur. *Michelet, Historian: Rebirth and Romanticism in Nineteenth-Century France*. New Haven: Yale University Press, 1990.

Monteil, Amans-Alexis. *Histoire des Français des divers états*. 10 vols. Paris: Janet, Cotrelle & W. Coquebert, 1828–1844.

Histoire des Français des Divers Etats aux Cinq Derniers Siècles. 10 vols. Paris: W. Coquebert & Furne, 1842–4. Contains "Préface" by Jules Janin, i–li.

Nodier, Charles. "Introduction." In *Voyages pittoresques et romantiques dans l'ancienne France: Ancienne Normandie*, ed. Nodier, J. Taylor, and Alph. de Cailleux. 1:1–15. 3 vols. Paris, 1820–25.

Nora, Pierre. "Entre Mémoire et histoire. La Problématique des lieux." In Nora, ed., *Les Lieux de mémoire*. Tome 1: "La République," xvii–xliii. Paris: Gallimard, 1984. Translated by Marc Roudebush as "Between Memory and History." *Representations* 26 (1989): 7–25.

Nora, Pierre, ed. *Les Lieux de mémoire*. Tome 1: "La République"; *tome* 2: "La Nation" (3 vols.); *tome* 3: "Les France" (3 vols.). Paris: Gallimard, 1984–93.

O'Mahoney, comte Arthur. "Exposition des tableaux. Ve et dernière article. Tableaux de genre." *Le Conservateur* 5 (1819): 371–83.

"P. A." See Coupin, Philippe-Alexandre.

[Pages, Jean-Pierre]. "J.-P. P." "REVOLUTION (*Politique*)." *Encyclopédie Moderne* 20 (1830): 198–215.

Paillot de Montabert, Jacques-Nicolas. *Théorie du geste dans l'art de la peinture renfermant plusieurs préceptes applicables à l'art du théâtre*. Paris: Magimel, 1813.

Traité de la Peinture. 9 vols. Paris: Bossange, 1829.

The Painted Word: British History Painting: 1750–1830. Exhibition at the Heim Gallery, London. Catalogue edited by Peter Cannon-Brooks et al. Woodbridge, UK: Boydell, 1991.

Phillipson, Nicholas. *Hume*. New York: St. Martin's, 1981.

Piel, Louis-Alexandre. "Salon de 1837." *L'Européen*, 2nd ser., 2 (July 1837): 24–32.

Planche, Gustave. *Salon de 1831*. Paris: Pinard, 1831.

"Histoire et philosophique de l'Art. IV. De l'Ecole Française au Salon de 1834." *Revue des Deux Mondes*, 3rd ser., 2 (April 1, 1834): 47–84.

Ponce. "Nouveau moyen d'augmenter l'utilité, l'influence et l'illustration des beaux-arts." *Journal des Artistes,* 1, no. 5 (February 1, 1829): 71–4.

Pougetoux, Alain. "Peinture 'troubadour,' histoire et littérature; autour de deux tableaux des collections de l'impératrice Joséphine." *Revue du Louvre* 44, no. 2 (April 1994): 51–60.

Poulot, Dominique. "Alexandre Lenoir et les Musées des monuments français." In Nora, ed., *Les Lieux de mémoire, tome* 2: "La Nation," 3 vols., 2:496–531. Paris: Gallimard, 1986.

"The Birth of Heritage. 'Le Moment Guizot.'" *Oxford Art Journal* 11, no. 2 (1988): 40–56.

Pouthas, Charles-Henri. *Guizot pendant la Restauration, préparation de l'homme d'Etat.* Paris: Plon, 1923.

Pupil, François. *Le Style troubadour ou la nostalgie du bon vieux temps.* Nancy: Presses Universitaires de Nancy, 1985.

Puttfarken, Thomas. *Roger de Piles' Theory of Art.* New Haven: Yale University Press, 1985.

Rabbe, Alphonse. *Le Courrier Français,* no. 259 (September 15, 1824).

Recueil des discours prononcés dans la séance publique annuelle. Paris: Firmin Didot, 1825.

Recueil des Notices Historiques lues dans les séances publiques de l'Académie Royale des Beaux-Arts. 2 vols. Paris, 1834–7.

Reizov, Boris. *L'Historiographie romantique française, 1815–1830.* Moscow: Editions en Langues Etrangères, n.d. In Russian, Leningrad, 1956.

Rex, Walter. *The Attraction of the Contrary: Essays on the Literature of the French Enlightenment.* Cambridge: Cambridge University Press, 1987.

Richard, Fleury François. "Peintres Lyonnais contemporains. Autobiographie de Fleury Richard." *Revue du Lyonnais,* n.s. 3 (1851): 244–55.

Ricoeur, Paul. "Narrative Time." *Critical Inquiry* 7, no. 1 (Autumn 1980): 169–90.

Temps et récit. 3 vols. Paris: Seuil, 1983–5. Translated as *Time and Narrative* by Kathleen McLaughlin and David Pellauer. 3 vols. Chicago: University of Chicago Press, 1984–8.

Rigney, Ann. *The Rhetoric of Historical Representation: Three Narrative Histories of the French Revolution.* Cambridge: Cambridge University Press, 1990.

Robertson [Robert], Etienne-Gaspard. *Mémoires récréatifs, scientifiques et anecdotiques du physicien-aéronaute E.-G. Robertson.* 2 vols. Paris: Wurtz, 1831–3.

Romance & Chivalry: History and Literature Reflected in Early Nineteenth-Century French Painting. Exhibition at the New Orleans Museum of Art, June 23–August 25, 1996; Stair Sainty Matthiesen Inc., New York, September 25–November 2, 1996; Taft Museum, Cincinnati, December 12, 1996–February 9, 1997. Catalogue by Nadia Tscherny and Guy Stair Sainty et al. London: Matthiesen Fine Art Ltd/New York: Stair Sainty Matthiesen Inc., 1996.

Rosenvallon, Pierre. *Le Moment Guizot.* Paris: Gallimard, 1985.

Ross, Judith-Rae Elias. "Anglo-French Encounters: Images of the English Civil War in France, 1789–1848." Ph.D. diss., University of Illinois, Chicago Circle, 1978.

Russcol, Diane. "Images of Charles I and Henrietta-Maria in French Art, ca. 1815–1855." *Arts Magazine* 62, no. 7 (March 1988): 44–9.

Sarrazin, J. *Du Progrès des Etudes Historiques en France au dix-neuvième siècle; Dissertation présentée à la Faculté des Lettres de Strasbourg . . . le 13 Août 1835.* Strasbourg: F. G. Levrault, 1835.

Scheffer, Arnold. *Résumé de l'histoire de l'empire germanique.* 2nd ed. Paris: Lecointe & Durey, 1824.

"Salon de 1827." *Revue Française* 1, no. 1 (1828): 188–212.

[Scheffer] *Ary Scheffer, 1795–1858. Dessins, aquarelles, esquisses à l'huile.* Exhibition at the Institut Néerlandais, Paris, October 16–November 30, 1980. Catalogue by L. Ewals, J. M. de Groot, and J. J. Heij. Paris: Institut Néerlandais, 1980.

[Scheffer] *Ary Scheffer, 1795–1858, gevierd romanticus.* Exhibition at the Dor-

drechts Museum, the Netherlands, December 1995–March 1996; Paris: Musée de la vie romantique, April 10–July 28, 1996. Catalogue by Leo Ewals. Waanders: Dordrechts Museum, 1995. French exhibition organized by Denis Cailleaux. Translated by Françoise Everaars and Françoise Gaillard as *Ary Scheffer, 1795–1858*. Paris: Paris-Musées, 1996.

Schoelcher, Victor. "MM. Delacroix, Léon Cogniet, Decamps, &c., &c." *L'Artiste* 1 (1831): 226–8.

"Salon de 1835 (2e article)." *Revue de Paris* 16 (1835): 44–61.

Scott, Sir Walter. *Waverley; or, 'Tis Sixty Years Since*. [1814]. Harmondsworth, UK: Penguin, 1972.

Ivanhoe. [1819]. New York: New American Library/Signet, 1962.

Sells, Christopher. "After the *Raft of the Medusa*: Géricault's Later Projects." *Burlington Magazine* 128, no. 1001 (August 1986): 567–70.

The Shadow of the Guillotine: Britain and the French Revolution. Exhibition at the British Museum, London, 1989. Catalogue by David Bindman, with Aileen Davson and Mark Jones. London: British Museum, 1989.

Smithson, Rulon Nephi. *Augustin Thierry: Social and Political Consciousness in the Evolution of a Historical Method*. Geneva: Droz, 1973.

Spitzer, Alan. *Old Hatreds and Young Hopes: The French Carbonari against the Bourbon Restoration*. Cambridge, MA: Harvard University Press, 1971.

The French Generation of 1820. Princeton: Princeton University Press, 1987.

"St.-A. B." *See* Bazard, Saint-Amand.

Stendhal [Henri Beyle]. *Lettres de Paris par le petit-fils de Grimm. Chroniques 1825–1829*. Edited by José-Luis Diaz from the French edition by Henri Martineau titled *Courrier anglais*. Paris: Divan, 1935–6. 2 vols. Paris: Sycomore, 1983.

Racine et Shakespeare. Texte établi et annoté avec Préface et Avant-Propos par Pierre Martino. 2 vols. Paris: Edouard Champion, 1925.

Strong, Roy. *Recreating the Past: British History and the Victorian Painter*. New York: Thames & Hudson/Pierpont Morgan Library, 1978.

"T." *See* Emeric-David, Toussaint-Bernard.

Taborski, Boleslaw. *Byron and the Theatre*. Ed. James Hogg. Salzburg Studies in English Literature, no. 1. Institut für englische Sprache und Literatur, University of Salzburg. Salzburg: Institut für englishe Sprache und Literature, 1972.

Tardieu, Ambroise. *Annales du Musée et de l'école moderne des Beaux-Arts*. Paris: Pillet aîné, 1831.

Theis, Laurent. "Guizot et les institutions de mémoire." In Pierre Nora, ed., *Les Lieux de mémoire. Tome* 2: "La Nation" (3 vols.), 2: 568–92. Paris: Gallimard, 1986.

Thierry, Augustin. Prospectus for *Histoire de France traduite et extraite des chroniques originales, mémoires, et autres documens authentiques*. Paris: Lecointe & Durey, 1824.

Histoire de la Conquête de l'Angleterre par les Normands; de ses causes, et de ses suites jusqu'à nos jours, en Angleterre, en Ecosse, en Irlande et sur le continent. 3 vols. Paris: Firmin Didot, 1825.

Lettres sur l'Histoire de France pour servir d'introduction à l'étude de cette histoire. Paris: Sautelet, 1827. Reprints "Première lettre sur l'histoire de France, adressé au rédacteur du *Courrier Français*" [1820], "Sur l'affranchissement des communes" [1820]. In *Oeuvres Complètes*. 5 vols. Paris: Furne, 1851.

Dix Ans d'Etudes historiques. Paris: Just Tessier, 1834. Contains "Préface. Histoire de mes idées et de mes travaux," i–xxxv. Reprints "Sur le caractère des grands hommes de la révolution de 1640, à propos de l'Histoire de Cromwell par M. Villemain" [1819], "Sur la conquête de l'Angleterre par les Normands. A propos du roman d'*Ivanhoe*" [1820], "Première lettre sur l'histoire de France, adressé au rédacteur du *Courrier Français*" [1820], "Sur l'histoire d'Ecosse, et sur le caractère national des écossais" [1824].

[Thiers, Adolphe] "Y." "Beaux-Arts. – Exposition de 1824. 3e article." *Le Globe*, no. 7 (September 28, 1824): 27–8.

Salon de mil huit cent vingt-quatre, ou Collection des articles insérés au "Constitutionnel" sur l'exposition de cette année. Paris, 1824.

"Peinture Française." *Revue Européenne* 1 (October 1824): 676–90.

Trapp, Frank. *The Attainment of Delacroix.* Baltimore: Johns Hopkins University Press, 1971.

Tressan, Louis-Elisabeth de La Vergne, comte de. *Oeuvres du comte de Tressan,* 10 vols. With illustrations by Clément-Pierre Marillier (1787–9) and Colin. Paris: Nepveu & Aimé-André, 1823. Contains François-Nicolas-Vincent Campenon, "Sur M. de Tressan et ses Ouvrages," 1:iii–xxxiv.

Triomphe et Mort du héros. La peinture d'histoire en Europe de Rubens à Manet. Exhibition at the Musée des Beaux-Arts, Lyon, May 19–July 17, 1988. Conceived by Ekkehard Mai and Anke Repp-Eckert; organized at Lyon by Guy Cogeval and Philippe Durey, in collaboration with the Wallraf-Richartz Museum (Cologne) and the Kunsthaus (Zurich). Lyon: Electa, 1988.

Trotain, Marthe. *Les Scènes historiques. Etudes du théâtre livresque à la veille du drame romantique.* Paris, 1923.

Vanuxem, Jacques. "Aperçus sur quelques tableaux représentant le Musée des monuments français de Lenoir." *Bulletin de la Société de l'histoire de l'art français* (1971): 145–51.

Vatout, Jean and J. P. Quénot. *Catalogue historique et descriptif des tableaux appartenans à S. A. R. Mgr le duc d'Orléans.* 4 vols. Paris: Gaultier-Laguionie, 1823–6.

Galerie lithographiée de S. A. R. Mgr le Duc d'Orléans. 2 vols. Paris: Charles Motte, 1824–9.

Vergnaud, Armand-Denis. *Examen du Salon de 1827.* Paris: Roret, 1827.

Viel-Castel, comte Horace de. "Beaux-Arts. Salon de 1831. 1er article." *L'Artiste* 1 (1831): 185–7.

"*Cromwell* par M. Delaroche." *L'Artiste* 1 (1831): 269–70.

Vigne, Georges. *Ingres.* Translated by John Goodman. New York: Abbeville, 1995.

Visite au Musée du Louvre, ou Guide de l'Amateur à l'exposition des ouvrages de peinture, sculpture, gravure, lithographie et architecture des artistes vivans (année 1827–1828) par une société des gens de lettres. Paris: Leroi, 1828.

Vitet, Ludovic [Louis]. "Exposition de tableaux au bénéfice des Grecs (IIe article). M. Delacroix." *Le Globe*, June 3, 1826, 372–4. Reprinted as "M. Delacroix" in *Etudes sur les Beaux-Arts. Essais d'archéologie et fragments littéraires.* Paris: Charpentier, 1847.

Les Barricades. Scènes historiques. Mai 1588. Paris, 1826.

Les Etats de Blois ou la Mort de M. de Guise. Scènes historiques. Décembre 1588. Paris: Ponthieu, 1827.

[Vitet, Louis] "L.V." "Salon de peinture. IIIe article." *Le Globe*, February 6, 1828, 181.

Vitet, Ludovic. *La Mort de Henri III Août 1589. Scènes Historiques, faisant suite aux Barricades et aux Etats de Blois.* Paris: H. Fournier jeune, 1829.

Fragments et Mélanges. Etudes sur les Beaux-Arts. 2 vols. Paris, 1846.

Watelet, Claude-Henri and Pierre-Charles Levesque. *Dictionnaire de Peinture, Sculpture, et Gravure.* 5 vols. Paris, 1792.

White, Hayden. *Metahistory: The Historical Imagination in Nineteenth-Century Europe.* Baltimore: Johns Hopkins University Press, 1973.

Tropics of Discourse: Essays in Cultural Criticism. Baltimore: Johns Hopkins University Press, 1978. Reprints "The Burden of History" [1966], 27–50; "Interpretation in History" [1973], 51–80; "The Historical Text as Literary Artifact" [1974], 81–100.

The Content of the Form: Narrative Discourse and Historical Representation.

Baltimore: Johns Hopkins University Press, 1987. Reprints "The Question of Narrative in Contemporary Historical Theory" [1984], 26–57.

Whiteley, Linda. "Art et commerce d'art en France." *Romantisme* 4 (1983): 65–75.

[Wilkie] *Sir David Wilkie of Scotland (1785–1841)*. Exhibition at the Yale Center for British Art, January 20–March 15, 1987; North Carolina Museum of Art, Raleigh, April 4–May 31, 1987. Organized by William J. Chiego. Catalogue by H. A. D. Miles and David Blayney Brown. Raleigh: North Carolina Museum of Art, 1987.

Willemin, Nicolas-Xavier. *Monumens Français Inédits. Des Costumes Civils et Militaires, Armes et Armures, Instrumens de Musique, Meubles de toute espèce, et Décorations intérieurs et extérieurs des Maisons, dessinés, coloriés et gravés d'après les originaux pour servir à l'histoire des arts depuis le VIᵉ siècle jusqu'au commencement du XVIIᵉ*. Paris: Leblanc, 1825.

Wright, Beth S. "Scott and Shakespeare in Nineteenth-Century France: Achille Devéria's Pendant Lithographs of 'Minna et Brenda' and 'Les Enfans d'Edouard.' " *Arts Magazine* 55, no. 6 (February 1981): 129–33.

——— "Scott's Historical Novels and French Historical Painting, 1815–1855." *Art Bulletin* 63, no. 2 (June 1981): 268–87.

——— "The Auld Alliance in Nineteenth-Century French Painting: The Changing Concept of Mary Stuart, 1814–1833." *Arts Magazine* 58, no. 7 (March 1984): 97–107.

——— "Walter Scott et la gravure française. A propos de la collection des estampes 'scottesques' conservée au Département des Estampes, Paris." *Nouvelles de l'estampe*, no. 93 (July 1987): 6–18.

——— "Henri Gaugain et le Musée Colbert: l'entreprise d'un directeur de galerie et d'un éditeur d'art à l'époque romantique." *Nouvelles de l'estampe*, no. 114 (December 1990): 24–30.

——— "An Image for Imagining the Past: Delacroix, Cromwell, and Romantic Historical Painting." *Clio* 21, no. 3 (Spring 1992): 243–63.

——— "Implacable Fathers: The Reinterpretation of Cromwell in French Texts and Images from the Seventeenth to the Nineteenth Century." *Nineteenth-Century Contexts* (1996; in press).

——— " 'Interrogating the Debris': Revolutionary Vandalism and Marchangy's Phantasmagoric History." *Transactions of the Ninth International Congress on the Enlightenment; International Society of Eighteenth-Century Studies, Münster 1995. Studies on Voltaire and the Eighteenth-Century* (in press).

Wright, Beth S. and Paul Joannides. "Les Romans historiques de Sir Walter Scott et la peinture française, 1822–1863," pts. 1 and 2. *Bulletin de la Société de l'histoire de l'art français, année 1982* (1984): 119–32; *année 1983* (1985): 95–115.

Wrigley, Richard. *The Origins of French Art Criticism from the Ancien Régime to the Restoration*. Oxford: Clarendon Press, 1993.

"Y." *See* Thiers, Adolphe.

Zantop, Susanne, ed. *Paintings on the Move: Heinrich Heine and the Visual Arts*. Dartmouth Colloquium on Heine, October 1985. Lincoln: University of Nebraska Press, 1989.

Ziff, Norman. *Paul Delaroche: A Study in Nineteenth-Century French History Painting*. Ph.D. diss., New York University, 1974. New York: Garland, 1977.

——— "Jeanne d'Arc and French Restoration Art." *Gazette des Beaux-Arts*, 6th ser., 93 (January 1979): 37–48.

INDEX

Page numbers for illustrations are in italics